art for spaces
spaces for art

Interior spaces as works of art –
discovered in palaces, castles and
monasteries in Germany

art for spaces
spaces for art

Interior spaces as works of art –
discovered in palaces, castles and
monasteries in Germany

An official guide from the heritage trusts of:

Baden-Württemberg
Bavaria
Berlin-Brandenburg
Hesse
Mecklenburg-Western Pomerania
Rhineland-Palatinate
Saxony
Saxony-Anhalt
Thuringia

SCHNELL + STEINER

With contributions by:

Baden-Württemberg: Saskia Esser (S. E.), Carla Fandrey (C. F.), Catharina J. Fehrendt (C. J. F.),
Ulrike Grimm (U. G.), Gabriele Kleiber (G. K.), Carla Th. Mueller (C. T. M.), Melanie Prange (M. P.),
Joachim Stolz (J. St.), Ulrike Seeger (U. S.), Wolfgang Wiese (W. W.)

Bavaria: Johannes Erichsen (J. E.), Werner Helmberger (W. H.), Sabine Heym (S. H.), Kerstin Knirr (K. K.),
Peter O. Krückmann (P. K.), Brigitte Langer (B. L.), Elmar D. Schmid (E. D. S.), Alfred Schelter (A. S.),
Friederike Ulrichs (F. U.)

Berlin-Brandenburg: Burkhardt Göres (B. G.)

Hesse: Friedl Brunckhorst (F. B.), Christian Ottersbach (C. O.), Dagmar Sommer (D. S.), Sabine Schürholz (S. S.)

Mecklenburg-Western Pomerania: Heike Kramer (H. K.)

Rhineland-Palatinate: Agnes Allroggen-Bedel (A. A-B.), Jan Meißner (J. M.)

Saxony: Ingolf Gräßler (I. G.), Simone Schellenberger (S. Sch.), Dirk Welich (D. W.)

Saxony-Anhalt: Jörg Peukert (J. P.), Joachim Schymalla (J. S.), Wolfgang Savelsberg (W. S.), Katrin Tille (K. T.)

Thuringia: Helmut-Eberhard Paulus (H. E. P.), Irene Plein (I. P.), Susanne Rott (S. R.)

English translation by Katherine Vanovitch

Bibliographic information published by Die Deutsche Bibliothek

Die Deutsche Bibliothek lists this publication in the Deutsche Nationalbibliografie;
detailed bibliographic data are available in the Internet at http://dnb.ddb.de

1st edition 2005
© 2005 Verlag Schnell & Steiner GmbH,
Leibnizstrasse 13, D-93055 Regensburg
and the listed heritage trusts

Planning, preparation and co-ordination:
Henrik Bärnighausen (Saxony)
Helmut-Eberhard Paulus (Thuringia)
Susanne Rott (Thuringia)
Wolfgang Wiese (Baden-Württemberg)

Editorial support:
Catharina J. Fehrendt
Bettina C. Kohlstedt
Katrin Rössler

Cover design: Astrid Moosburger, Regensburg
Typography, plates and printing: Erhardi Druck GmbH, Regensburg
ISBN 3-7954-1734-1

For more information about the publisher's listings see:
www.schnell-und-steiner.de

CONTENTS

Symbols

i Information

⊘ Hours of opening

⊞ Museum shop

♿ Disabled access

✕ Restaurants

DB Railway station

🚂 Traditional narrow-gauge railway

P Car/coach park

🚌 Bus/tram

Ⓢ City rail network

⛴ Ferry/riverboat

A Other museums in trust buildings

Editors' note:

Hours of opening are subject to change. Up-to-date information can be obtained from the telephone number, e-mail address or website indicated in the margin.

These sources will also provide details of management publications and secondary literature.

Welcome

The German Working Group on Stately Homes and Gardens was set up in 1990 as a response to Germany overcoming its division in order to facilitate exchange between bodies with public responsibility for managing stately homes about their diverse and long-established experience of preserving, maintaining and displaying the unique cultural and natural heritage entrusted to them and to build on this for the sake of both our monuments and our visitors. Since the establishment in 2004 of a heritage trust for Mecklenburg-Western Pomerania, the working group now brings together ten such management bodies working across the country in different federal states. With a view to similar collaboration and book projects, we hope that other states, such as Lower Saxony, North Rhine-Westphalia and Schleswig-Holstein, will see their way to founding administrative structures of this kind.

In 1999 the working group launched a series of volumes which has proved surprisingly successful, beginning with "Time to Travel – Travel in Time to Germany's finest stately homes, gardens, castles, abbeys and Roman remains". It was therefore decided in 2003 to devote an entire volume to the art of gardens, and this led to "Pleasure Gardens – Garden Pleasures: Germany's most beautiful historical gardens". Gardens do, after all, have a very specific role to play within the context of these heritage sites, and the conservatory effort undertaken by managements in this respect deserves its own acknowledgement. This series compiled by the working group is now to be completed with a volume devoted to decorative interiors, once again a particular hallmark of our palaces, castles and abbeys, and one which distinguishes them from other museums.

You may be familiar with some of the best-known interiors in Germany from coverage in the media. Many will have heard about such fascinating creative achievements as the Marble Hall at Schloss Bruchsal, the Amalienburg kitchen at the Nymphenburg in Munich or the Marble Hall at Schloss Sanssouci in Potsdam. But there are a whole range of hidden interiors in Germany just waiting to be discovered as the works of art they truly are. Have you ever seen the chapel at Kriebstein Castle in Saxony, for example, with its impressive Late Gothic wall paintings? Have you experienced the romantic furbishing of Schloss Stolzenfels on the banks of the Rhine? Could we lure you to the Marble Baths at Karlsaue in Kassel or bid you dwell a while in the ballroom at Schloss Heidecksburg in Rudolstadt? Or would you prefer to investigate the inner structure of Schloss Wörlitz?

You will be surprised at the diversity of these artistic interiors in Germany, at the high standards which once governed the appointment of such rooms at the heart of Europe, and at the supreme craftsmanship cultivated in Germany's stately homes from the Middle Ages to the early 20th century. And you can still experience them for yourselves.

Palaces and gardens are total art works. Inspired by aristocratic dynasties, they blend the prowess of many generations of artists once admired by our ancestors. You, too, will have an opportunity, as you explore these buildings, to relive the artistic rivalry between noble families (often related to one another) and the international exchange which, as a peaceful form of contest, fostered these unsurpassable accomplishments. You will encounter different generations of artistic families who also made their mark in Italy, France, Holland and England, creating these art works in the service of temporal and ecclesiastical overlords as symbols of the surrounding landscape which lend enduring resonance to the names of local seats and abbeys.

Let this third joint official guide, like its forebears, arouse your interest and tempt you into further discoveries. We at the German heritage trusts are happy to accompany you on these exploits, and we wish you a warm welcome.

Staatliche Schlösser und Gärten Baden-Württemberg
Public Stately Homes and Gardens of Baden-Württemberg

Bayerische Verwaltung der staatlichen Schlösser, Gärten und Seen
Bavarian Department for State-owned Palaces, Gardens and Lakes

Stiftung Preußische Schlösser und Gärten Berlin-Brandenburg
Prussian Palaces and Gardens Foundation Berlin-Brandenburg

Verwaltung der Staatlichen Schlösser und Gärten Hessen
Stately Homes and Gardens of Hesse

Staatliche Schlösser und Gärten Mecklenburg-Vorpommern
Stately Homes and Gardens of Mecklenburg-Western Pomerania

Burgen, Schlösser, Altertümer Rheinland-Pfalz
Castles, Stately Homes and Ancient Monuments of Rhineland-Palatinate

Staatliche Schlösser, Burgen und Gärten Sachsen
Stately Homes, Castles and Gardens of Saxony

Stiftung Dome und Schlösser in Sachsen-Anhalt und Kulturstiftung DessauWörlitz
Foundation for Cathedrals and Stately Homes in Saxony-Anhalt and Cultural Foundation of DessauWörlitz

Stiftung Thüringer Schlösser und Gärten
Palace, Castle and Gardens Trust of Thuringia

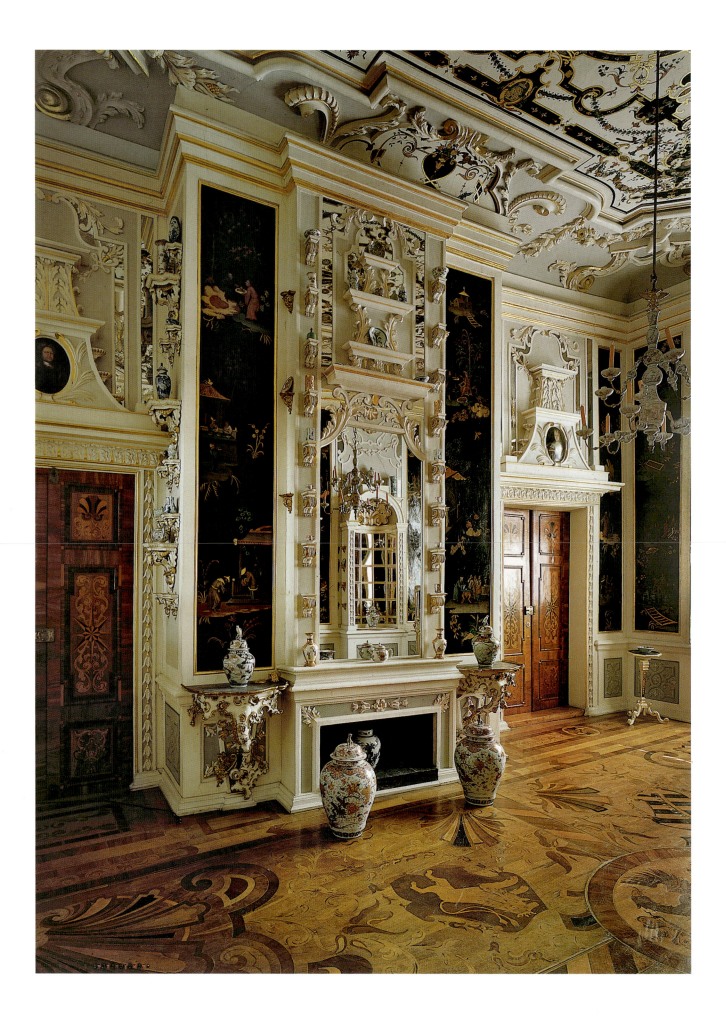

THE GERMAN WORKING GROUP ON STATELY HOMES AND GARDENS

Sharing responsibility for Germany's valuable artistic interiors

The German Working Group on Stately Homes and Gardens (*Facharbeitskreis Schlösser und Gärten in Deutschland*) promotes exchange of experience in the field and the elaboration of joint projects by public trusts for the management of heritage sites around the country. The administrations which run stately homes and gardens in Germany were established to preserve this holistic artistic and historical legacy, to conduct research, repair as appropriate and convey this unique heritage to the public. It is a fusion of buildings, museums, objets d'art, entire artistic landscapes, including gardens as expressions of art, and in particular those interior designs – also works of art – to which this volume has been devoted.

The listed monuments entrusted to the administrations are total art works of major artistic and historical significance and, at the same time, records of the history that has shaped a region and its culture. Given that they are so crucial to the cultural identity of a federal state, their preservation and display are matters of public interest. A total art work is understood to be an ensemble that has evolved over the centuries as an architectural whole with its historical buildings and interior designs. They are characterised by an orchestration of different artistic genres resulting in a coherent overall symphony. An interior is an architectural space which can be experienced from the inside, furbished by artistic means and functioning in some ways as a museum. One important component will be the historical items on display – a prince's one-time collection, perhaps – which turn these stately homes into veritable treasure chambers.

To appreciate these spatial art works fully, we must delve into the history they render visible, especially the history of the artists who made them, but also the local dynasties who commissioned them and the political geography. Hence Germany's heritage trusts have the important task of preserving, maintaining and cherishing not only the buildings in their care but also the furniture and fittings that have evolved within them as a unity. This task ranges from scientific research and the presentation of knowledge to – wherever required – the reconstitution of lost features or parts thereof. The goal is to make these sites comprehensible to the public, so that visitors find them accessible and are able to enjoy them as total art works.

The members of the German Working Group on Stately Homes and Gardens regard themselves as institutions in the service of the public while at the same time striving for financially viable strategies. They believe that an awareness of culture can be reconciled with a commercial spirit, just as it has been in former centuries. In a period of growing tourism and diversifying proposals for use, but also of dwindling funds and human resources, these tasks can only be fulfilled if the technical knowledge and prerequisites remain clustered under one roof. Reflecting the structure of the total art works in their charge, the heritage trusts integrate technical and service departments under a common management. Backed by their own scientific research and without losing sight of the monument at the heart of their activity, they focus on results in pursuit of the following activities:

- construction-related tasks: encompassing both architecture and interior design, with primacy attached to the buildings' history and the preservation of the monument;
- museum-related tasks: presenting the work of art within the context of a monument ensemble that has evolved over time, including research, the chronicling of art history and efforts to make good any gaps identified;
- restoration, in its various aspects of conservation, restoration in the stricter sense and ongoing care;
- garden landscaping to maintain the garden and conserve the landscape, with primacy attached to the history of the garden and preservation of the garden monument;
- public relations and communication, including presentation by means of publications, guided tours, educational visits, exhibitions, advertising, etc.;
- property management to maintain the assets, provide appropriate stewardship and ensure that monument sites are prudently used;
- initial and continuous training to assure the efficient performance of tasks and methods specific to heritage administration and to contribute to the acquisition of professional skills.

◁ *Cabinet of Mirrors at Schloss Heidecksburg in Rudolstadt*

Historical Rooms as Works of Art

With their magnificent historical furbishing and their gardens,
palaces and residences are of inestimable value as unique total art works
that have evolved over the course of history. Stately homes are more than museums.
(Wörlitz Resolution of 1994,
German National Committee of ICOMOS)

As works of art, historical interiors are no ordinary realm of experience. It lies within their nature to defy the first glance and demand a closer look. If the experience is special, that is due to a dialogue between the arts, the way they play with space and time and the history of human intellect that is reflected within this. That is why it takes time to unravel the multiple layers, observing from inside and out, pacing the room and then dwelling at a single point, always collecting impressions. Historical interiors are multifaceted ensembles, consisting of the overall site as a framework, the overarching architectural space and the artistic appointment that finds its place within. This appointment is always individually geared to the room's function and how people made use of it. An interaction between the artistic genres, comparable to what we may observe with other total art works, gives rise to spatial creations where myriad artistic accomplishments blend into a single three-dimensional experience and merge into a single, broader work of art that embraces all these elements. A spatial art work vividly implements the insight, formulated long ago by Aristotle, that "the whole is more than the sum of its parts." The most common manifestation of the spatial art work is interior design. But it also occurs out-of-doors, perhaps as a garden or in conjunction with a piazza-like arrangement. Then it is usually seen as part of the garden landscaping or architecture. The spatial art work to which we are referring here is associated primarily, however, with the furbishing of an indoor room.

The particular hallmark of a spatial art work is that people can move about within it and thus experience it from the inside. As a consequence, art works which take the form of interiors are, of course, particularly at risk with regard to their original condition, be it because they suffer wear and tear or changes in function, or due to alterations of whatever kind. That is why particular conservatory effort is required to preserve them. In its Wörlitz Resolution of 1994 the German National Committee of ICOMOS warned that the extraordinary fusion of architecture and furbishing that is so specific to interiors, and which has been retained for the most part in stately homes, is now increasingly in jeopardy, and that the combination of cultural and natural heritage sought by our predecessors is in need of special protection. The resolution emphasised the tremendous importance to stately homes and gardens of their original decoration, furniture and fittings, recalling that such sites can only be experienced as total art works if they are preserved as a historically evolved whole. Hence some of the vital demands of this resolution:

"The unity of the building and park must be retained as a historical total art work. Fragmentation and divisions of any kind must be avoided.

Wherever possible, cross-references in the furbishing shall be reconstituted. As monuments to art and history, stately homes can only express their character adequately as a totality."

However, this particular conservatory responsibility that derives from the spatial art work also creates specific problems for the custodians of the monument. For interiors in palaces and gardens, castles and monasteries more than any others, these problems derive from the diversity of the precious cultural heritage that has evolved historically within the setting, a heritage which characterises European civilisation. Losses of original features, but also the changes entailed by new domestic or ceremonial functions, generate particular problems that are difficult to resolve in the context of museum use. The presentation of interiors raises a complex issue. Because a spatial art work is not just a monument to its period of origin, not just the record of a particular historical date, but the witness of historical transformations over a protracted period which have brought in their wake new designs and alterations, the question arises as to precisely which historical condition the visitor should be offered. And as interiors react with extreme sensitivity to any historical change, they are notable for their ability to convey historical information. The mirror they hold up to entire historical processes means that they provide evidence of more than simple dates or single stylistic eras. They are the chronicles of a longer-term approach to testimony, to the way the evidence of each period is perceived or suppressed by later ages. It is a long-established and fairly plausible practice of heritage managers to leave the furniture of any given room much as it was left behind by the last occupant. The interior is thus presented as the final outcome of a lengthy development in which living habits and ceremonial rites always aspired to high standards. In order, then, to preserve the full spectrum of cultural history contained within the interior and to uphold the sequence of overlays expressed by different states of furbishing, a mix of styles or a persistent gap is often inevitably tolerated in interiors. It is important to leave tangible traces, as directly as possible, of the course of history and the impact of human activity on these artistically conceived

spaces. And yet responsible curatorship can impose changes in order to protect a unique item from damage or theft. Besides, an interior that has been robbed of its original furniture or severely damaged by war is often no longer recognisable as a spatial art work. In such instances it may be necessary to restore the room to an earlier historical state or admissible to engage in a reconstruction nourished by scientific research in order to fill any gaps in the ensemble as a total art work.

As the presentation of spatial art works invariably entails use and ageing, they need continuous care, and above all a secure footing for their structural maintenance and restoration. It is ultimately thanks to this continuous care by past generations that we can still benefit from the high quality of appointment we still enjoy today in our palaces and gardens, castles and monasteries.

Spatial art works always contain a message, and this can range from the aesthetic experience of the room's atmosphere to the ideological statement made by its iconography. Whatever the case, an interior offers graphic testimony to a bygone era, an immediate record of the intellectual and material world in which it was born, a historical monument to specific formats of use or functions and an artistic illustration of historical change. It is essential to decipher the secret idiom of each room and to apply this key to draw out the full message from its partially cryptic matrix. An important aspect of the custodian's work is to investigate and disseminate the history and functions of the room. A proper appreciation of these interiors will not only protect them from serious onslaughts on their fabric, but will also facilitate insights into appropriate treatment. Apart from defending them physically in this way, it is often necessary to restrict usage to ensure that the interior continues to be experienced as it should. Misleading interpretations often need to be curtailed. The Wörlitz Resolution raises a number of points where care must be taken to prevent a destructive approach to these spatial art works:

"Stately homes and their furbishing are the indispensable heritage of any civilised nation and should not be marketed for any reason.

In the light of their significance to future generations, stately homes require maximum prudence in their preservation and protection, respecting their dignity and upholding the full wealth of their authenticity.

The use of historical interiors and gardens for purposes other than viewing may irresponsibly cause fundamental damage and should be reviewed in the light of conservatory factors (no restoration can replace the fabric once lost).

Forms of 'gentle tourism' should be devised specifically for stately homes and their furbishing."

Helmut-Eberhard Paulus

Backdrops for life at court:
Historical interiors in Germany's stately homes

Castles, palaces and abbeys – we are familiar with them as landmarks in our cultural landscapes, and yet they are more than just stage sets in a picturesque scenery. Tucked away inside them are rooms from the past that continue to make an impact on today's visitors: austere or magnificent, intimate or grandiose, well preserved or less so. It is the duty of Germany's heritage trusts to look after these rooms and make them accessible to the public. We are the stewards of the most significant castles and residences, summer pavilions and hunting lodges, where regional overlords once manifested their power and displayed their prestige. The rooms in these buildings reveal such an impressive diversity of historical decoration and art that every visit brings new reasons to marvel, enjoy and learn. These are spatial art works of the past that we can admire, study or simply allow to take effect.

From pomp to privacy

Stately homes and the items that furnished them were once the meticulously planned backdrops for aristocratic and courtly life. It would not do them full justice to

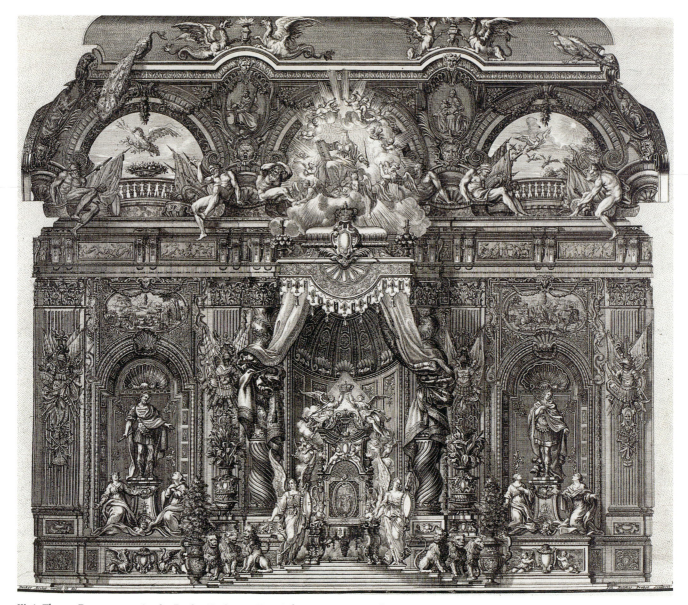

Ill. 1: Throne Room, engraving by Paulus Decker, in: Fürstlicher Baumeister, Architectura Civilis, Augsburg 1711, plate 26

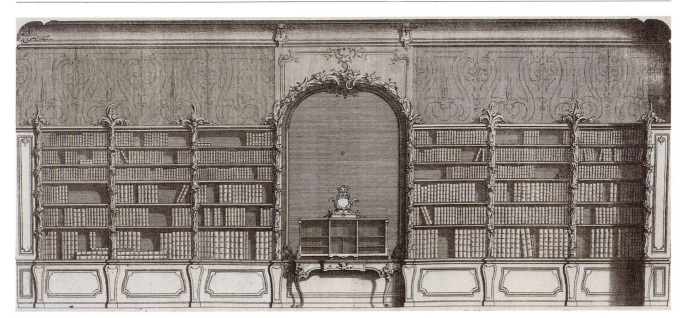

Ill. 2: The Prince's Reference Library in the Hôtel de Soubise, engraving by: Mariette, L'architecture françoise, vol. 2, Paris 1727, plate 105

regard these artistic interiors only as an expression of a bygone stylistic period or a chronicle of changing fashion. Rooms of court were subject to laws of their own, setting them apart from a nobleman's palace or a grand bourgeois mansion. The sequence, the dimensions and the furniture and fittings were determined by the requirements of court ceremony, reflecting a sophisticated and jealously supervised hierarchy among the governing elite of Germany and Europe. There were rules, for example, about what type of furniture was allowed to stand where and how it must be arranged. Moreover, the splendour of the furbishing mirrored the competition between those who commissioned these rooms, who wished to demonstrate their wealth, their taste and their knowledge of international fashion. The aim, without transgressing the boundaries of estate and ceremony, was to show the world just how powerful and innovative one was.

It is hardly surprising, then, that designers and craftsmen well initiated in these matters would be recruited to transform a room into a total art work, complete with wall coverings, fabrics, stucco work, paintings and furniture (Ill. 1), and that cloth and ornate items were, if necessary, purchased from Europe's leading workshops, so that the mercantilist principle of producing as much as possible in one's own territory was not applied to the pomp of princes. The peculiar relationship between ceremonial obligations and artistic contest that marks the stately halls of Germany's overlords holds up a mirror to the political system in the Holy Roman Empire, with its strict class order and its local aristocrats striving for elevation to a higher rung. As ecclesiastical authority was integrated into the structures of temporal government, power is reflected not only in the palaces of bishops, but also in monasteries. The prelates of the abbeys and reli-

gious foundations that owed obedience directly to the Emperor held sway over small territories of their own, and needed to display their command and status to the outside world.

It is also no surprise, given these pressures to perform and comply, that more and more 18th-century rulers preferred – as the system became increasingly refined – not to live in their rooms of state. Just as Louis XV retreated at Versailles from the ritual halls of Louis XIV to a cosier "petit appartement", so Germany's great aristocrats had private suites built for themselves alongside their lavish "chambres de parade" (Ill. 2). Here they had greater scope to develop their personal tastes. Their consorts lived among their ladies-in-waiting in apartments of their own where the innermost rooms adjoined those of their husband, or else in an analogous sequence on a separate floor, with secret stairs to facilitate communication between the marital couple. But even these residential quarters were subordinate to ceremony, as proximity and access to the man in power evolved into a mark of social differentiation in this feudal caste order. There were strict provisions to determine who was allowed to enter which room in the ruler's suite, and courtiers kept a suspicious eye on their fellows' movements. A duke was rarely alone and undisturbed even in his private quarters (Ill. 2). At the court in Munich, for example, the Elector was obliged to tell his servants in no uncertain terms that they should not allow petitioners into his innermost rooms or let them ensconce themselves before his toilet.

It was not until the constitutional 19th century, when a clearer distinction was drawn between the state and its ruling dynasty, that the families of German princes began to enjoy a genuinely private sphere. Now they could give rein to their own ideas and predilections. It

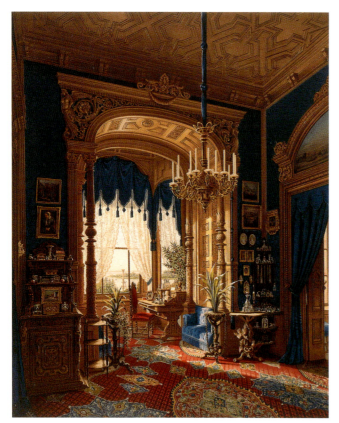

Ill. 3: Oriel room in Schloss Schwerin, in: A. Stüler, E. Prosch and H. Willebrand, Das Schloss zu Schwerin, Berlin 1869, plate 27

scenes that unfolded here, but also offer us an occasional glimpse behind the scenes and an encounter in our mind's eye with the incumbents and visitors of yesteryear, all without a hint of voyeurism. Although the official receptions and banquets are over, the joy and despair of the residents long forgotten, we can still tell how the people who lived and placed themselves on display in this atmosphere interpreted their role in this drama, and we can still discern their personal likes, ambitions and foibles.

Of course, it is not easy in every room of our stately homes to decipher the signs about the original patron, the architect or the residents. It is extremely unusual, after all, for an interior created at a particular moment in history to come down to us without bearing the traces of subsequent ages. In most cases, the very fact that they have been preserved is an indication that later generations have made their homes there, but changing them in the process, and so these rooms are often marked by historical overlays from various periods. This even includes the orderly efforts of 20th-century custodians who, after the abdication of Germany's monarchs and again after the destruction wrought by the Second World War, attempted to (re)create homogeneous prototypes of rooms devoted to a single historical style. This frequently entailed a generous sacrificing of subsequent alterations with the aim of restoring the "original" condition, or compiling a museum-like ensemble from surviving fragments and inventoried items. All the more precious, then, are those rooms which have entirely or broadly retained their authenticity and are now the voluble records, with their fixed wall trappings and their portable accoutrements, of a specific period and domestic scenario. Today custodians and restorers make it their priority to preserve such authentic situations or to recover them with the help of items from old inventories (Ill. 5), but they nevertheless also respect the historical value of changes made by later users. Indeed, in recent years there has been a recognition that the authentic appointment of a stately interior is valuable precisely because – unlike a museum display based on the alternating formats of contemporary curators – it is an ensemble which has been defined by history and reflects the will of a patron, and whose parts must be appreciated in context, rather than being arbitrarily exchangeable. This volume contains a selection of authentic ensembles of this kind, or of ensembles where the salient features have at least been preserved. They paint a picture of the abundance of artistically outstanding and historically illuminating rooms which can still be found and which constitute such an essential component of our cultural heritage.

Flicking through these pages, it is also clear that this selection of authentically preserved residential and ceremonial interiors from our stately homes only represents certain aspects of our palaces, castles and monasteries, and that the working environment of the many court

follows that the most intimate and personal rooms in Germany's stately homes date from the years of Biedermeier and Historicism (Ill. 3). This withdrawal into a private realm assumed its most extreme forms at the end of the 19th century in the castles of the Bavarian king Ludwig II. The monarch created monumental escapist dream worlds for himself, stage sets for the "true" life of a king who was gradually losing touch with constitutional reality. Herrenchiemsee, his copy of Versailles, was not built to serve the rites of absolutism, but as a monument where its owner could yield to his fantasies, for absolute monarchy was now a thing of the past. To use a modern term, one might call it a theme park for obsolete forms of rule. The age of building palaces to express the grandeur of the state was evidently drawing to a close.

And so the interiors we find in our mansions and castles, our churches and our theatres, are more than just supreme accomplishments of aesthetic spatial design. Whether they functioned as halls of state, residential accommodation or even servants' quarters, they were always theatres of history, and we can still feel it today as we stand there (Ill. 4). Like time capsules, they offer us a chance to plunge into a past age which rarely appears to us with such a vivid presence. Whether they were constructed as a backdrop to courtly life or as a private refuge, today they not only help us to imagine the

retainers and domestic servants who were crucial to the smooth functioning of state machinery has survived to a much lesser degree. Anyone who has had a chance to investigate the rooms of the butlers and housekeepers, the silverware and lamp stores, the kitchens and larders of English country houses knows what is missing in almost all our stately homes today. The need to use the available space for other purposes in times of economic hardship led almost a life span ago to the preservation of the grander rooms and the conversion of ancillary spaces considered unimportant at the time. All the more precious are the few remaining examples of kitchens and bathrooms, guest rooms and servants' quarters, where we can derive some idea of past social structures and of the gulf between magnificence and day-to-day routine. Undisguised by the pomp and circumstance of state ceremony, the atmosphere of bygone historical eras comes to life with particular vitality in rooms such as this.

Changing interiors

The history of interior design is closely linked with the history of architecture, for one cannot consider the furbishing of stately homes in isolation from their layout or built fabric. It makes sense, therefore, before addressing selected specimens of interior design in German stately homes and abbeys, to undertake a brief summary of how their architecture evolved.

The residences of medieval overlords tended to be castles, and these would be scattered around their territory for pragmatic reasons. As kings and counts adopted a nomadic approach to governance in those days, they usually took the fabrics and utensils they needed to furnish their austere rooms along with them. (The French word "meuble" and its German counterpart "Möbel" betray this mobility.) There are few documents extant today and also few surviving examples – like the hall of Gnandstein Castle in Saxony – to supply information about how rooms used for worship, state affairs and domestic needs were actually appointed. Living quarters and official halls were usually very frugal, with at most heraldic emblems or ancestral portraits to underscore the incumbent's claim to power, whereas chapels as the focus of clerical activity were often richly painted. Not until the Gothic period did warm panelling and decorative painting for living quarters catch on – usually with imitations of wall hangings and arabesques like we see at Kriebstein Castle in Saxony. As the modern age dawned, hilltop castles became uncomfortable and were often abandoned for more permanent seats in the towns, while castles on the plains near to urban communities (Berlin, Stuttgart, Munich, Ansbach) developed into the fixed residences of their territorial masters. Only a few of the high-lying strongholds, such as Landshut and

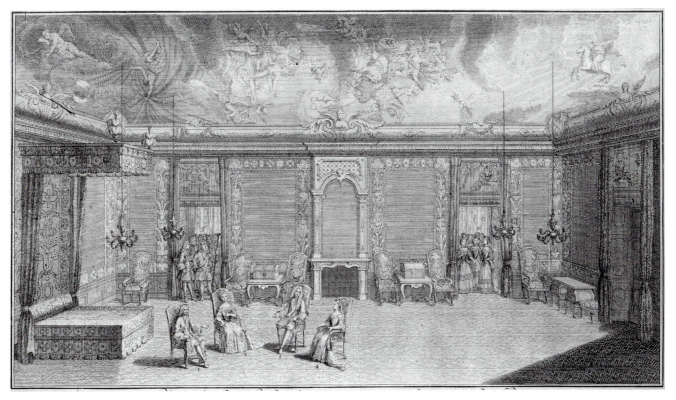

Ill. 4: Residenzschloss Dresden, Ceremonial Bedroom with a Reception by the King and Queen for the Electoress and Elector on the Occasion of Their Marriage on 19 August 1719, engraving c. 1720, Dresden Kupferstichkabinett

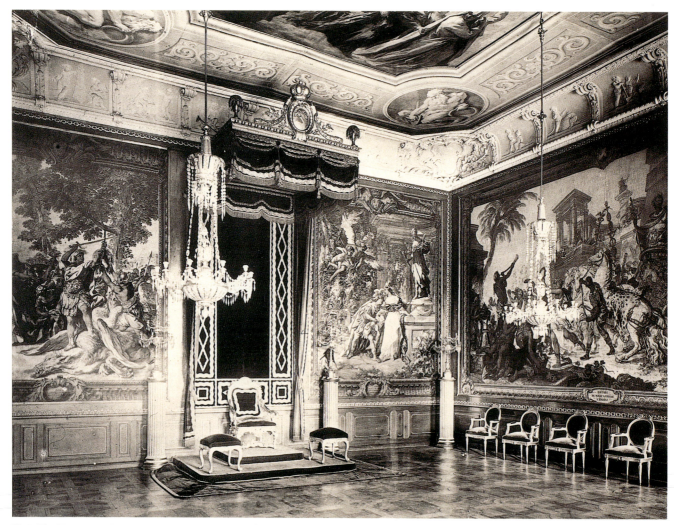

Ill. 5: The Emperor's Quarters. Hall of Audience in Schloss Mannheim, 1888.
Photograph in Rudolf Tillessen, Das Grossh. Schloss zu Mannheim. Ausgewählte Innendekorationen, Mannheim 1897, plate 25

Kulmbach, Eichstätt and Heidelberg, had been converted into splendid palaces by the time of the Thirty Years' War. The best example of a precinct barely changed since the High Middle Ages is the Imperial Castle in Nuremberg, which dates from the 12th and 13th centuries. But a few Gothic palaces have also survived relatively unaltered. The outstanding example of aristocratic aspiration and prestige is the Albrechtsburg in Meissen, which required no fortifications of its own because it was incorporated into the Meissen castle precincts. Conceived as a residence for two brothers of the House of Wettin who ruled together, it remains striking even today with its wealth of spatial forms and vaults, leaving no doubt that – functional as the floor plan may be – these buildings were intended to play an elegant ceremonial role.

As the Middle Ages gave way to the Modern Age in the 16th century, Germany looked for its style to Italy. The town residence in Landshut, with its Italian inspired interiors from around 1540, must be seen as a key work in the appropriation of new ideas about the theatre of state and its stylistic expression. The Renaissance spread quickly through stately residences, radically altering both architecture and furnishings. Good examples of this are Torgau (1533–1544) and Heidelberg (1548–1556), Schwerin (1553–1565) and Güstrow (1558–1563) and also Aschaffenburg (1604–1614), where older structures were converted and acquired forms reminiscent of Antiquity. During the subsequent period, Dutch influences set their stamp on Northern Germany, while Southern Germany took its cue from Italy and France. In Heidelberg we encounter a mix of styles. Ottheinrich's wing, constructed in 1556/59, ranks as one of the supreme achievements of contemporary sculpture with its finely worked and lovingly detailed door jambs and fireplaces by the Dutch sculptor Alexander Colin. But we also find spectacular highlights of the courtly Late Renaissance at the residence in Munich, restructured in the late 16th century. The Antiquarium, created in 1568–1571 as a museum of antiquities but soon converted to functions of state, was an open admission that architectural motifs

were being adopted from Italy, and the Grotto Court with its halls and carved ornamentation became the focus of an urban seat that aspired to Mannerist refinement. It was not only the Empire's electoral princes who indulged in this modern architecture; the counts and landed knights of the realm also pledged their wealth to the new taste. The big Knights' Hall at Schloss Weikersheim is the very model of an early modern interior at the dawn of the 17th century. Its ceiling painted in the Dutch style and its portal resembling a triumphal arch show that the counts of the region were also keen to demonstrate their importance. Even before the Thirty Years' War, the splendid extensions undertaken by Maximilian I (1600–1620) at the Residence in Munich were guided by the latest developments in Italy, and the rooms of state here adopted a new formal arrangement later held in high esteem by the French – the enfilade, along which all the rooms were aligned in a row with their doors following a straight axis (Ill. 6) – combined with an allegorical programme for the painted ceilings to express an early absolutist view of governance.

After the Thirty Years' War, which undermined the old order in Germany's Holy Roman Empire and sealed France's destiny as the ascending superpower, the French court became the new cultural beacon upon which German aristocrats set their sights. France demonstrated the patent advantages of absolute rule, centralised administration of the economy based on mercantilist principles, and the alliance between luxury wares and prospering crafts. The court maintained by the Sun King at Versailles was the yardstick not only for architecture, but also for courtly structures, the very incarnation of a European residence. In the last quarter of the 17th century Germany's princes began to imitate Louis XIV's creations and to develop their own residences in the baroque style, even though recurrent belligerence between the Empire and France, such as the Palatine Wars and the struggle over the Spanish succession, often prevented their construction projects from proceeding as smoothly as they did from 1650 onwards among their French neighbours. The first serious plans to erect a rigorously absolutist palace founded on the French model were drawn up by the Electors of the Palatinate in 1670, but their new residence in Mannheim remained on the drawing-board. In Rastatt the Margrave of Baden commissioned a residence around 1700 which still betrays Italian influence without denying its debt to Versailles, for on each side of the festive hall in the centre of the upper storey a suite of ante-chamber, hall of audience, ceremonial bedroom and cabinet serves

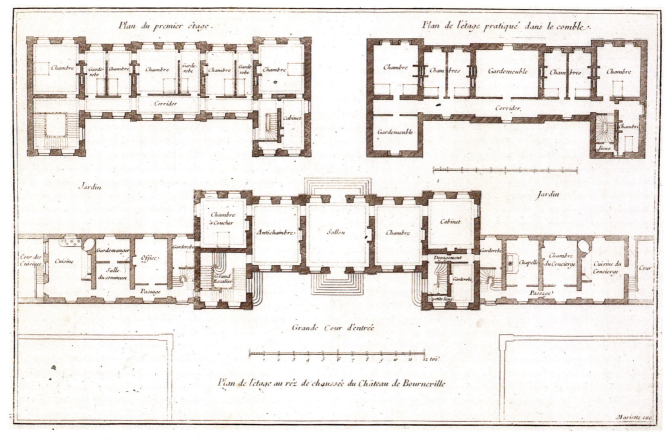

Ill. 6: Floor plans for the three storeys of the Château de Bourneville, each with an enfilade, engraving by Mariette, in: L'architecture françoise, vol. 2, Paris 1727, plate 8

either the margrave or the margravine. Rastatt unleashed a euphoric wave of baroque buildings along the Upper Rhine, and their greatest intensity of expression is to be discovered in their interiors. In Karlsruhe (1715) and Mannheim (1720) the palatial complexes became even more expansive; the Duke of Württemberg established a new seat in Ludwigsburg in 1704. Artistic design was governed by strict formal rules and by mythological themes. The decorative iconography, prefabricated at the court of Louis XIV and serving the glorification of princes, spread across ceilings, walls and fittings; the appointment of rooms presented political messages in graphic terms. It was not only French themes that set the tone in many places, but also French taste, illustrated by the furnishing for Bavarian elector Max Emanuel in Nymphenburg (1701–1704, 1714–1723) and Schleissheim (1701–1704, 1714–1726).

Meanwhile in Vienna the Habsburg emperors adhered to their own ceremonies and their more Italian tastes, attempting to uphold a counter-model to Versailles. The clerical rulers of Southern Germany, intricately woven into the Empire's ecclesiastical structure, followed the Viennese rites and preferences. Most notable among these magnates were the Schönborn family, who produced a number of prince-bishops and elector-archbishops. In the first half of the 18th century they built a veritable garland of baroque palaces, from Schloss Favorite near Mainz (1704–1722) and Pommersfelden (1711–1724) to the residences at Würzburg (from 1720) and Bruchsal (from 1725) – with Würzburg attempting to blend Viennese and French features. Even magnificent stairways became an important stage for courtly ceremony, as the host would venture this far to receive guests of the higher calibre.

In the early 18th century the electors of Saxony, Prussia and Hanover were elevated to the rank of kings, and they required appropriate new buildings to signal this sovereignty. King August I of Poland in Dresden and King Friedrich I of Prussia in Berlin developed their residences in the baroque style of the times. The design principles and decorative programmes observe the universal formal canon disseminated in exemplary form by Paul Decker in his *"Fürstlicher Baumeister"* of 1711 (Ill. 7), with paintings and sculptures, stucco work, ornamenta-

Ill. 7: Chambre de Parade, engraving by Paulus Decker, in: Fürstlicher Baumeister, Architectura Civilis, Augsburg 1711, plate 29

Ill. 8: Salon, engraving by J.F. Blondel, in: Planches pour le cinquième volume du cours d'architecture, Paris 1777, plate 47

tion, fabrics, furniture and fittings combined into a splendid, richly detailed opus of spatial adornment. Numerous pleasure pavilions and festive structures were built to provide a worthy framework for the cultural galas fostered at court. The Zwinger (1711–1728) and Schloss Pillnitz (1721–1730) are pertinent examples in the courtly environs at Dresden.

During the 18th century many rulers built secondary residences, country seats and summer pavilions around their capital cities. Nymphenburg near Munich and Charlottenburg outside the gates of Berlin (1699–1713, 1744–1747) demonstrate newly acquired power, incorporating a distinctive approach to a casual summertime existence "in villa". The indoor spaces, closely linked through garden rooms to the gardens outside, are no longer simply venues for state business, but also places of pleasure where, at least for a while, life can be led without the burdens of representation. The by now conventional division between "appartements de parade" (ceremonial) and "appartements de commodité" (private), described in 1737/38 by French architect Jacques-François Blondel in a book about the layout and furbishing of "maisons de plaisance" that became a seminal work in Germany, was gradually complemented by a third zone, the "appartement de société" (Ill. 8), for convivial occasions with friends and family. Changing

views on décor and etiquette were also reflected in the perfection or redecoration of older buildings in fashionable rococo forms inspired by French example. Painted and sculpted adornment proliferated in full glory on the inside of these pavilions. Ceilings, walls and floors drew on French prototypes with the help of contemporary documentation. Walls and ceiling seem to dissolve into floral arabesques, trellis work and bouquets of fruit. The finest specimens of the French-inspired "maison de plaisance" with its delicate balance between "convenance" and "commodité" were the work of a Walloon based in Munich, François Cuvilliés. They are the little hunting lodge at Falkenlust near Brühl for the electors of Cologne (1729–1741) and Wilhelmsthal near Kassel in the federal state of Hesse (1747–1756).

In the 18th century little pavilions and summer palaces for private or intimate sojourns away from court society grew increasingly popular among the ruling aristocracy. The Amalienburg built in 1734–1739 in the park at Nymphenburg is considered the ideal. Sanssouci ("without a care") was the refuge created near Potsdam by Friedrich II of Prussia (from 1740), and its name testifies to its character, reflected in an unconventional rococo appointment; equally distinctive are the rooms made for his sister, Margravine Wilhelmine, in the old palace at her Hermitage near Bayreuth (from 1736). Schloss Soli-

tude near Stuttgart (1763–1770) and the Bath House in the gardens at Schwetzingen (1773–1775) marked the endpoints of this development, already curtailing the untrammelled vivacity of ornamentation.

Here we see the first signs of that neo-classicism fostered by the Enlightenment Age, which was prompted by its cardinal commitment to reason and nature to relinquish baroque pomposity and rococo artificiality. Typical early examples survive in secondary residences such as Ludwigslust (1772–1776) in Mecklenburg and Hohenheim (1775–1782) in Württemberg, and also in the Marble Palace at Potsdam (1787–1792). They are all overshadowed, however, by the country seat of Wörlitz in the tiny principality of Anhalt (1769–1773), where enthusiasm for the Ancient world and the formally severe "rationality" of English culture was fused with a passion for atmospheric garden landscaping akin to nature to create a unique blend that soon attracted admirers. A similar path was taken in the landscaped park of Schönbusch near Aschaffenburg, made for the Elector of Mainz, with a charming casino for smaller gatherings (1778–1782); a grander scheme underlies Wilhelmshöhe near Kassel (1786–1798), similarly integrated into a park of natural appearance and one of the last great palace projects before the French Revolution signalled the demise of the Old Empire.

Alongside the palaces built by worldly and clerical dignitaries, the monasteries figured among the architectural highlights in Germany's cultural landscape. They also functioned as territorial nodes, expanding steadily from the early Middle Ages and generously furbished. Their external and internal design also moved with the times. Whereas the outstanding architectural achievements produced in medieval abbeys had been independent in spirit, during the baroque period – after the Reformation had put an end to this uninterrupted growth – they frequently followed in the tracks of palaces. They blossomed again in the 18th century, when a wave of baroque communities spread across Southern Germany in particular. After their dissolution as the result either of the Reformation or of secularisation, many of these buildings passed into the hands of the regional nobility, and some were then transformed into palaces.

Napoleon, who sought to construct a grand imperial Europe on the ruins of the Ancien Régime and the Holy Roman Empire, set his stamp on the German courts that fell under his influence through the pompous severity of the Empire style. Once again stately homes became the stage for demonstrations of power, even if the grandiose rooms that now emerged were subject to simpler forms of ceremony. The residences in Karlsruhe, Kassel and Stuttgart and Bavaria's Nymphenburg were made over in the French manner and endowed with a monumental air dominated by mahogany, gold-plated bronze and silken fabrics in bright hues. Cubes, simplified forms and borrowings from the repertoire of Ancient architecture characterised the furniture for private areas of these

regal mansions, and this was a domestic style that was to live on in the Biedermeier style. Glienicke (1815–1827) and Charlottenhof (1826–1829) in Potsdam are still superb examples of that Prussian version of neo-classicism fathered by Karl Friedrich Schinkel, in which a formal severity learned from the Ancients is forged into striking elegance. Artists and patrons alike demonstrated their learning with quotations from Ancient forms and reminiscences of Italy's Ancient sites, which it behove a German prince to visit in the course of his education. This explains why a building such as the Pompeianum in Aschaffenburg (1840–1848), King Ludwig I of Bavaria's replica of a Roman house, is not counted among the neo-classical palaces, but is an educational testimony of its own ilk.

Some aristocrats had begun in the 18th century to delve into their own ancestral history, compiling monuments to their forefathers in order to derive enjoyment, edification and political legitimacy from this glorious past. The Gothic House in Wörlitz Park (1773–1813) is the best preserved harbinger of this dynastic evoking of shades, and it was soon followed by the romantic Löwenburg (1793–1801) in the hill park of Wilhelmshöhe in Kassel. During the Romantic and Restoration periods, interest spread in what were believed to be manifestations of a national German spirit during the Middle Ages and castles were rebuilt as symbols of a grander era. Privately, these were settings for a different, highly nostalgic lifestyle, and politically they were symptomatic of a quest to justify power in historical terms. The conversion of Schloss Rosenau near Coburg (from 1806), the repair of Stolzenfels near Koblenz (1836–1845) for Prussia's crown prince and of Schloss Hohenschwangau (1833–1851) for his Bavarian counterpart, like the reconstruction of the Hohenzollerns' original castle on the Swabian Alb at Hechingen (1853–1867), are all significant examples of this reference to a past when princely power was never challenged and the bonds between a sovereign and his people seemed uncomplicated. Schloss Babelsberg by Potsdam (1833–1849) pays tribute to English Gothic, while the reconversion of Schloss Schwerin (1843–1857) took its orientation from the Renaissance châteaux of the Loire, in many ways preempting the second half of the 19th century as it harped back to the German Renaissance and also the Stuttgart Wilhelma (1842–1853), which drew on Orientalist style (Ill. 9). Now room arrangements began to change as well, discarding the fixed 18th-century canon. The regular layout gave way to a shielded domestic environment. Once subordinate functional rooms now acquired a new significance: the salons and dining rooms, music and billiard rooms, libraries and studies that served social communication.

In the latter half of the century, while Germany was being united under a Prussian Kaiser, palace building was governed by Historicism and its recourse to the old aristocratic styles. The problems of the present were con-

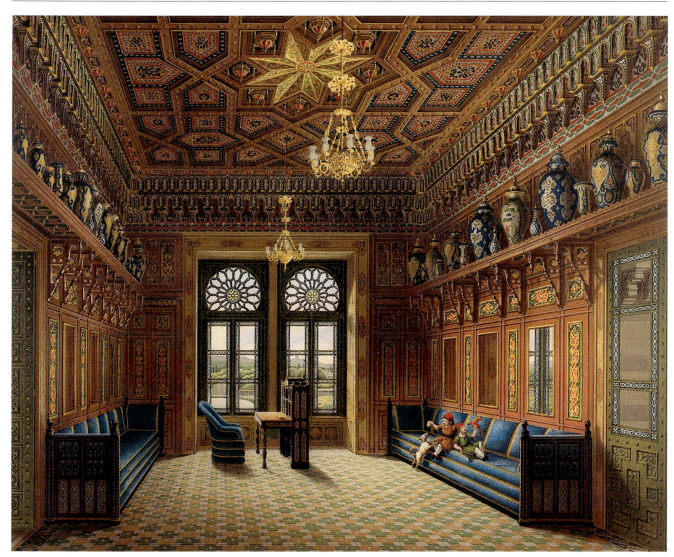

Ill. 9: View of the living room in the Stuttgart Wilhelma, in: L. von Zanth, Die Wilhelma. Maurische Villa, Paris 1855, plate 5

cealed beneath the dignity of the past. Germany's courts do, however, deserve credit for no longer capriciously overturning the historical rooms appointed by their forebears, preferring instead to inhabit and preserve them. King Ludwig II of Bavaria did more than construct fairy-tale castles; he also had the various buildings where he was allowed to hold court prudently restored. This awareness of the value of our historical heritage and the achievements of our ancestors is no modern invention, therefore, and it contributed early to enabling us today to study the evidence of bygone princely culture in well maintained interiors. Germany's heritage trusts are attempting to honour the obligation which now falls to them to cherish these precious and fragile rooms and to hand this task down to future generations of skilled specialists.

Johannes Erichsen *Wolfgang Wiese*

Source of illustrations:
Landesmedienzentrum Baden-Württemberg: p. 12, 13, 14, 16, 17, 18, 19, 21
Landesbibliothek – Staats-Universitätsbibliothek Dresden: p. 15

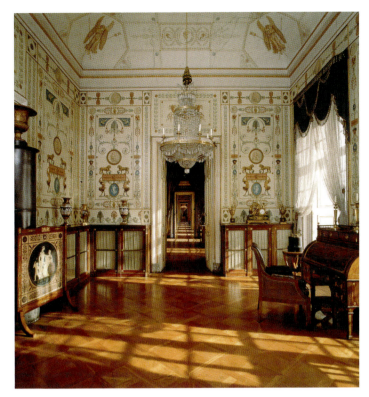

Baden-Württemberg

STAATLICHE SCHLÖSSER UND GÄRTEN
BADEN-WÜRTTEMBERG
PUBLIC STATELY HOMES AND GARDENS
OF BADEN-WÜRTTEMBERG

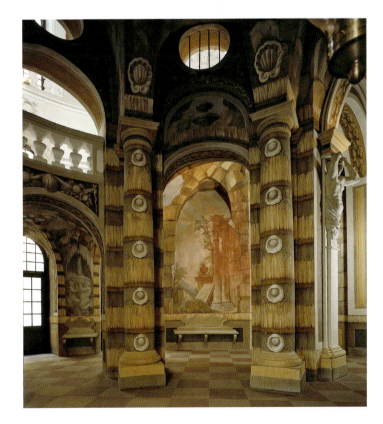

STAATLICHE SCHLÖSSER UND GÄRTEN BADEN-WÜRTTEMBERG

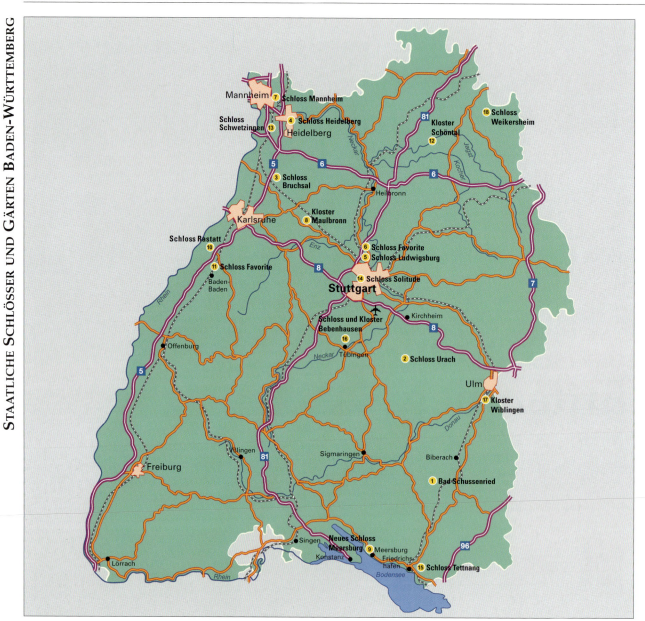

Bad Schussenried
1 Schussenried Monastery
(p. 25)

Bad Urach
2 Schloss Urach (p. 26)

Bruchsal
3 Schloss Bruchsal (p. 27)

Heidelberg
4 Schloss Heidelberg
(pp. 28–29)

Ludwigsburg
5 Schloss Ludwigsburg
(pp. 30–33)
6 Schloss Favorite (p. 34)

Mannheim
7 Schloss Mannheim (p. 35)

Maulbronn
8 Maulbronn Abbey
(pp. 36–38)

Meersburg
9 New Palace (p. 39)

Rastatt
10 Schloss Rastatt (pp. 40–41)
11 Schloss Favorite
(pp. 42–43)

Schöntal
12 Schöntal Abbey (p. 44)

Schwetzingen
13 Schloss Schwetzingen
(pp. 45–47)

Stuttgart
14 Schloss Solitude
(p. 48)

Tettnang
15 New Palace, Tettnang
(p. 49)

Tübingen
16 Bebenhausen Monastery
and Schloss (pp. 50–51)

Ulm-Wiblingen
17 Wiblingen Abbey
(pp. 52–53)

Weikersheim
18 Schloss Weikersheim
(pp. 54–57)

For information about other sites managed by Staatliche Schlösser
und Gärten Baden-Württemberg, see: www.schloesser-und-gaerten.de

◁ Top:
The Registry at Schloss Ludwigsburg

Bottom:
The stairs at Schloss Bruchsal

Schussenried Monastery
Library

In the mid-18th century Dominikus Zimmermann drew up plans for new monastery buildings for the Premonstratensian community founded in 1183. These were never completed, but the brightly sunlit library was built nevertheless. The collection is housed in closed bookcases on two levels, with a continuous gallery around the upper floor. The doors of the cases are painted to resemble the spines of books. Apart from the volumes, they contain folding tables and chairs for those wishing to use the library. The appointment of this interior pursues one of the richest and most detailed programmes of the 18th century.

In 1757 Franz Georg Hermann of Kempten finished the ceiling fresco which illustrates and glorifies divine wisdom in bewildering abundance, displaying the Apocalypse, the sciences, arts and technology.

It takes time to appreciate this severely geometrical work in its full complexity, with its vertical axes and horizontal tiers of hierarchy.

Abbot Nikolaus Cloos (1756–1775) adopted an almost encyclopaedic iconography which is also reflected in the sculptural features. The final touch was added by Fidelis Sporer of Weingarten in 1766: eight groups of figures representing misguided teachings face the eight imposing statues of Church teachers.

G. K.

ℹ Vermögen und Bau Baden-Württemberg, Amt Ulm
Tel. (+49/0) 731/50-2 89 75
Fax (+49/0) 731/50-2 89 25
info@kloster-schussenried.de
www.schloesser-und-gaerten.de

🕐 Library:
April – October:
Tu–Fr 10 am–1 pm
and 2–5 pm
Sa, Su, public holidays
10 am–5 pm
November – March:
Sa, Su, public holidays
1–4 pm
Closed 24, 25, 31 December

Abbey church:
Easter – 1 November: open daily from 1.30–5.30 pm
Sa 9.30–11.30 am

Group and special tours all year round by prior arrangement

▦ – ♿

✖ Restaurants available locally

🅿 by the abbey

DB

🚌 from the station towards town, stop Alte Post

Schussenried Monastery, the former Premonstratensian library

i Schloss Urach
Bismarckstraße 18
D-72574 Bad Urach
Tel. (+49/0) 71 25/158-490
Fax (+49/0) 71 25/158-499
info@schloss-urach.de
www.schloesser-und-
gaerten.de

⊙ all year round
10 am–6 pm
Closed Mo except on public
holidays
Closed on 1 January, 24, 25,
31 December
Guided tours daily
11 am and 2 pm
Group and special tours
all year round by prior
arrangement
Audio guides

♿ elevator

✕

🅿 guided parking system

🚆 from Stuttgart or Tübingen
take the Ermstalbahn from
Metzingen

🚌 /Tram
bus 7645 from Münsingen
or Ulm

A Other museums
in SSG buildings

Permanent exhibition:
Ceremonial Sledges
(Württemberg Regional
Museum)

Schloss Urach
Golden Hall

In 1474 Count Eberhard im Bart of Württemberg-Urach – later to become the first Duke of Württemberg – celebrated his marriage to Barbara Gonzaga of Mantua in his residence at Urach. He took this opportunity to improve the late medieval palace. Once again it was a wedding that prompted conversions in the early 17th century. It resulted in the Golden Hall, one of the finest Renaissance festive halls surviving today. Duke Johann Friedrich of Württemberg married Barbara Sophie of Brandenburg in 1609. Although the ceremony itself took place in Stuttgart, the seat of his duchy, it seems that the Duke wished to offer his lady consort rooms worthy of the age at his hunting lodge in Urach.

The low-ceilinged hall is lit by windows on three sides and divided by columns with Corinthian capitals. Palms sporting Eberhard's motto "Attempto" (I dare) adorn the walls in ornamental framing. As soon as we enter the room it is clear from the precious gold applications on the columns and walls how this resplendent hall acquired its name.

M. P.

Schloss Urach, Golden Hall

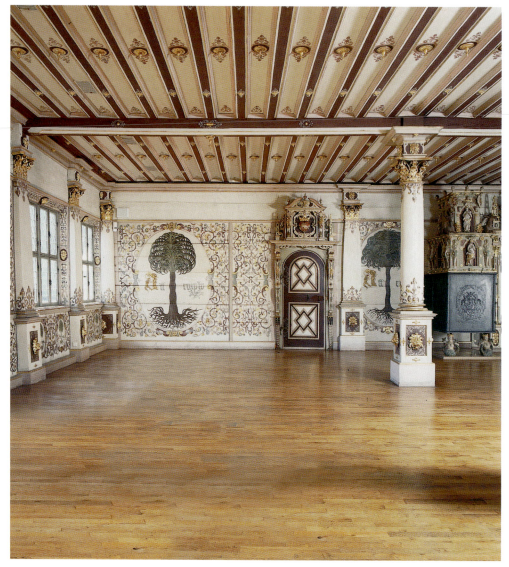

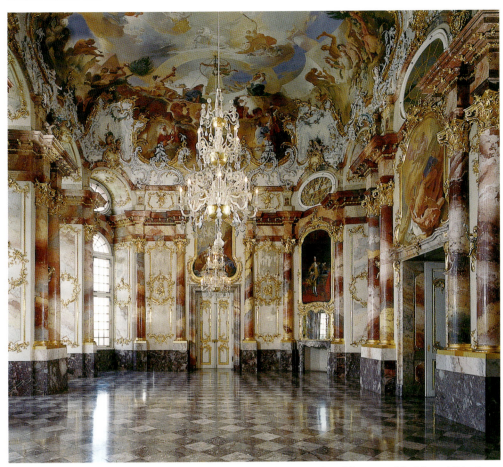

Schloss Bruchsal, Marble Hall (reconstructed). The frescos by Johannes Zick and Stucco work by Johann Michael Feuchtmayer were completed in 1755

ℹ Schlossverwaltung Bruchsal
Schlossraum 4
D-76646 Bruchsal
Tel. (+49/0) 72 51 / 74 26 61
Fax (+49/0) 72 51 / 74 26 64
info@schloss-bruchsal.de
www.schloesser-und-
gaerten.de

🕗 Permanent exhibition
"Schloss Bruchsal, Built,
Destroyed and
Resurrected"
Tu–Su 9.30 am–5 pm,
Mondays if public holidays

Guided tours all day
Special tours, children's
tours and events all year
round by prior arrangement
under:

Service Centre
Tel. (+49/0) 72 22 / 93 41 70
Visitors' Centre /
Palace ticket office
Tel. (+49/0) 72 51 / 74 26 61

▦

♿ elevator

✗

🅿

DB Ⓢ
from Karlsruhe S 3
to Bruchsal Hbf or S 31
to Schlossgarten

🚌 Buses 125, 131 or 132 to
Schloss, or local Stadtbus

A Other museums in SSG
buildings:
Museum of Mechanical
Musical Instruments

Schloss Bruchsal
Marble Hall

Schloss Bruchsal, a former residence of the prince-bishops of Speyer, is "an ensemble of quite overwhelming effect" (Jacob Burkhardt, 1877).

Damian Hugo von Schönborn salvaged the ailing project for a new residence, launched in Bruchsal in 1721, by appointing Balthasar Neumann in 1728. His ingenious design created a double stairway at the heart of the corps de logis, clasped by the domed hall above and leading to the two grand reception halls: the Prince's Hall facing the town and the Marble (or Emperor's) Hall onto the garden. This grandiose spatial invention is matched by the shell's festive decoration in ornamental rococo. Later Franz Christoph von Hutten contracted stucco work from Johann Michael Feuchtmayer and frescos from Johannes Zick, completed in 1755. The mythological idiom of the frescos impressively narrates the past, present and future of the diocesan principality. As the architectural and iconographic linchpin of this ecclesiastical seat, the Marble Hall radiates a vision of "the eternal constancy of happiness in the Bishopric of Speyer".

The building was damaged just before the end of the Second World War, and reconstruction ended 30 years later in February 1975. Thanks to detailed recreation of the stairwell and the festive halls, a visit to Schloss Bruchsal once again conveys a lively impression of the former splendour of this clerical seat on the Upper Rhine.

U. G.

i Schlossverwaltung
Heidelberg
Schlosshof 1
D-69117 Heidelberg
Tel. (+49/0) 62 21/53 84-0
Fax (+49/0) 62 21/53 84-10
info@schloss-heidelberg.de
www.schloesser-und-
gaerten.de

Palace, Great Wine Vat and
permanent exhibitions on
Middle Ages and
Romanticism in Haus der
Schlossgeschichte open for
viewing

☉ all year 8 am–5.30 pm daily
Guided tours of the site as
required in German or
English (other languages
by prior arrangement),
special tours, children's
tours and activities all
year subject to prior
arrangement by phone:

Service Centre
Tel. (+49/0) 62 21/53 84 31
Fax (+49/0) 62 21/53 84 30
info@service-center-schloss-
heidelberg.com

Audio tour (for non-
restricted areas)
Tel. (+49/0) 62 21/65 44 29

✗ Sattelkammer,
Bistro Backhaus,
Schlossweinstube

P Coach park: reservations
tel. (+49/0) 172/6 20 00 63)
Cars: Schlosswolfs-
brunnenweg
(April – October weekdays
only)
Multi-storey car park
Kornmarkt/Schloss

DB Bus link: 11 or 33 from main
station to Bergbahn;
continue to the Palace by
cable car or on foot

Events
Schlossfestspiele
and concerts in summer

A German Apothecary's
Museum

Schloss Heidelberg
Friedrich's Wing

Friedrich's Wing, built in Renaissance style in 1601–1610 under the Palatine Elector Friedrich IV, is the stateliest section of the castle in Heidelberg. After the devastating fires in 1693 and 1764 it was the only wing to be rebuilt, and it was refurbished in the 19th century during the age of Historicism. Around 1900 it triggered a controversial debate among conservationists about how historical interiors should be recreated. The indoor architecture was to make stylistic reference to the Renaissance façade. In 1895 the government of Baden therefore commissioned architect Karl Schaefer to reappoint the building in the neo-Renaissance manner. The richly ornamented stucco ceiling of the fourth second-floor room, the lavish stuccolustro floor and the heavy gable architecture of the dark timber pseudo-Classical doors are free-minded compositions born of stylistic pluralism. The art historian Georg Dehio opposed this approach, arguing that the building should retain the structure that had evolved organically. After this refurbishment the rooms were no longer used for the residential purposes of princes. Instead this became one of the first museums of cultural history in Baden to be accommodated in a former palace. It was used purely for collections. Following purchases from the princely dynasty of Baden in 1995, the rooms acquired the historical furniture from the Neues Schloss in Baden-Baden. C. J. F.

Schloss Heidelberg, Friedrich's Wing, ▷
the fourth room on the second floor

Schloss Heidelberg, Friedrich's Wing, ceiling in the fourth room on the second floor

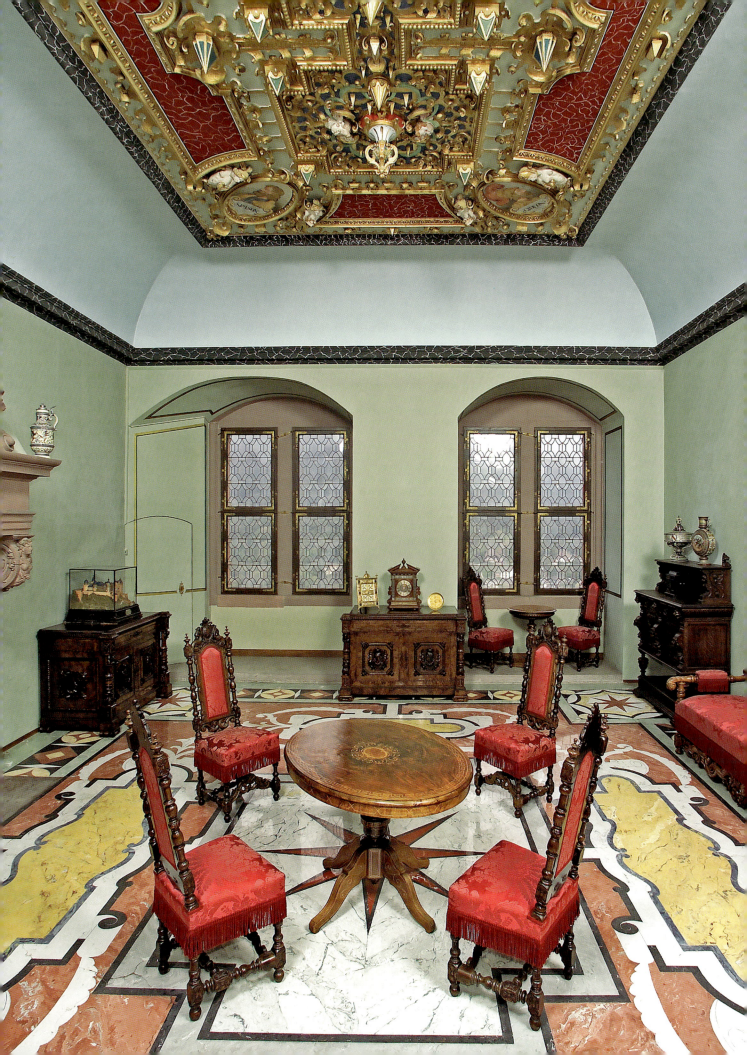

STAATLICHE SCHLÖSSER UND GÄRTEN BADEN-WÜRTTEMBERG

ℹ Schloss Ludwigsburg
Schlossstr. 30
D-71634 Ludwigsburg
Tel. (+49/0) 7141/18 20 04
Fax (+49/0) 7141/18 64 34
Palace ticket office
Tel. (+49/0) 7141/186410
info@schloss-
ludwigsburg.de
www.schloss-ludwigs-
burg.de

🕙 Palace ticket office and
museums:
10 am–6 pm
Daily guided tours
mid-March –
mid-November:
Mo–Fr 10 am–5 pm
all day
Sa, So, public holidays
11.00 am, 1.30 pm, 3.15 pm
English tours
Mo–Fr 1.30 pm

mid-November –
mid-March
Mo–Fr 10.30 am, 11.45 am,
1.30 pm, 3 pm and 4 pm
Sa, So, public holidays
10.30 am, 11.30 am, 12 noon
and 1–4 pm
every 30 minutes
English tours
daily at 1.30 pm
Group tours, event tours,
children's tours and special
tours by arrangement
under
tel. (+49/0) 71 41/18 20 04

⊞

♿

✕ in Blossoming Baroque and
palace complex

Ⓢ S 4 or S 5 to Ludwigsburg

🅿 coach park
Multi-storey car park
Schloss/Marstall

🚌 Buses 421, 427, 430, 443 or
444, stop Residenzschloss

🅰 Museum of Fashion
Pottery Museum
Baroque Gallery
State Gallery

Schloss Ludwigsburg

Marble Saletta
in the Hunting Pavilion

The marble saletta and the three small
rooms to the west of it on the first floor of
the hunting pavilion have fared better
than most other rooms in the Schloss at
Ludwigsburg in retaining their baroque
design. The vivacious forms and rich
hues testify to the very high standards
that pertained during the early phase of
the palace's appointment in the early 18th
century.

The room, furbished in 1715/16, owes
its name to its decorative stuccolustro
walls. Antonio Corbellini adorned the
pilasters with colourful lacing. On the
walls themselves we see the cross of the
Hunting Order of St Hubertus and the
monogram of its founder, Duke Eberhard
Ludwig of Württemberg, for whom these
works were carried out. Lively ribbons of
stucco by Riccardo Retti frame the ceiling
painted by Luca Antonio Colomba, which
shows Apollo and the Muses.

Two of the design features which play a
key role in this interior have been pre-
served: the two strikingly framed fire-
places with their tall mirrors and the floor
with its broad oval described in wood to
add a festive vitality to the rectangular
room.

Schloss Ludwigsburg, marble saletta ▷
on the first floor of the hunting pavilion

Schloss Ludwigsburg, ceiling of the marble saletta

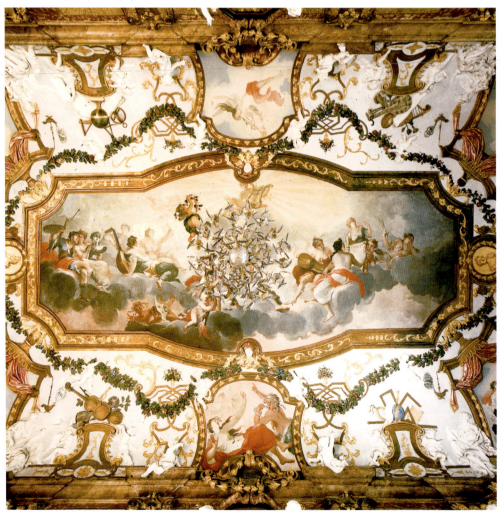

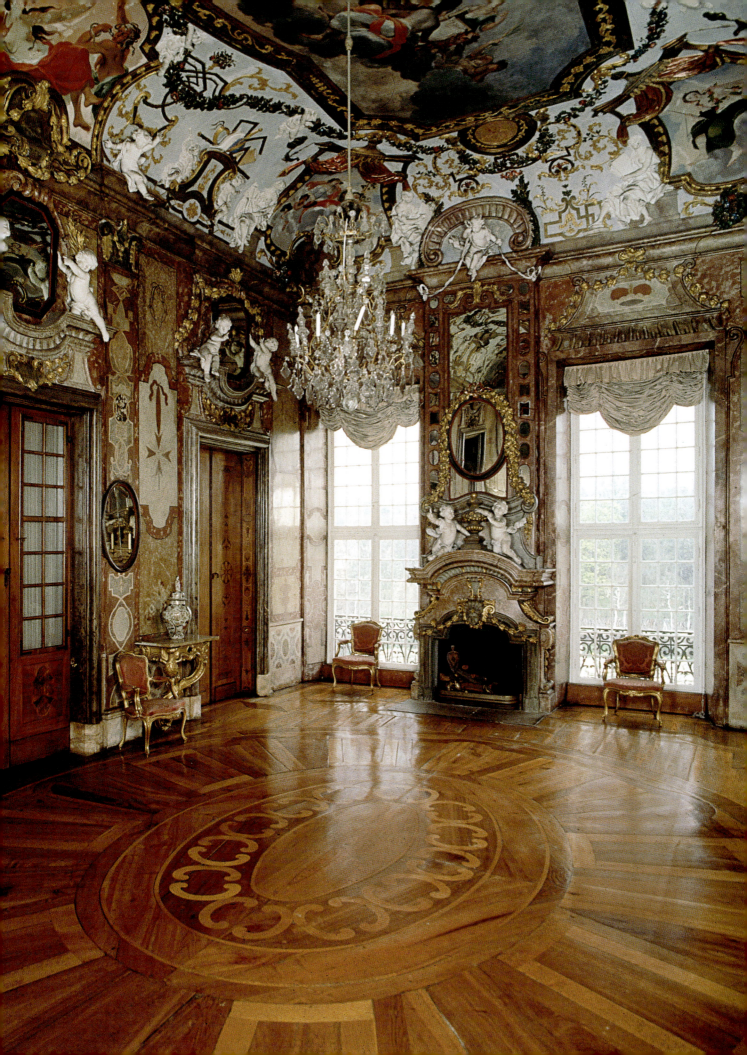

Second Ante-Chamber in Duke Carl Eugen's Apartment

From 1757 to 1759 Duke Carl Eugen had an apartment for social occasions created in elegant French-style rococo on the second floor of the new corps de logis. His court architect Philippe de La Guêpière – hired to build the Neues Schloss in Stuttgart – designed every detail of this beautifully preserved suite. A stately vestibule with stucco work is followed by two ante-chambers as a prelude to the central assembly room; two smaller rooms and a bedroom incompletely appointed complete the sequence.

The second ante-chamber is the only room in the apartment which is fully panelled, and as a result its built fabric is the best preserved. The panel work is by sculptor Michel Fressancourt, who also made wall tables and seating for Duke Carl Eugen of Württemberg. The other rooms were given silk wall coverings, recently reconstructed to historical details on the inventory.

The entire apartment has kept its original decorative paintings over the doors and fireplaces. The ones in the second ante-chamber are particularly delightful. They show various pleasures of court society, including the kind of social gathering which might have taken place in this very room. Another picture illustrates an entertaining "jeu du pied de boeuf", a popular game of gallantry in which the male loser forfeited a wish to the female winner (or vice versa). The artist Matthäus Günther, recruited by the Duke like de La Guêpière for his new palace in Stuttgart, based these paintings on French engravings.

The apartment is furnished with sumptuous pieces bearing the insignia of master craftsmen. Duke Carl Eugen purchased these in Paris for his various building projects. They include chests of drawers, writing desks in various formats and cleverly devised smaller items. The carved and gilded wall-mounted tables were made at the Württemberg court by sculptors trained in French techniques. S.E.

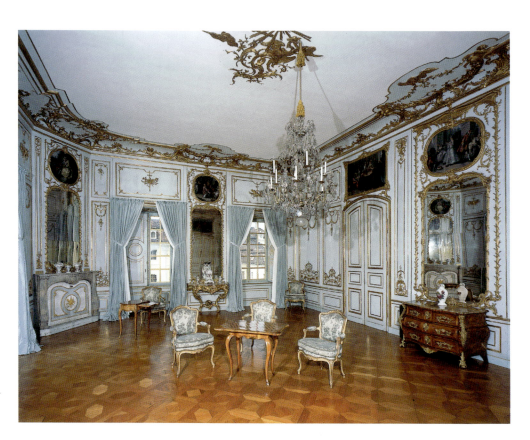

Schloss Ludwigsburg, second ante-chamber in Duke Carl Eugen's apartment on the second floor

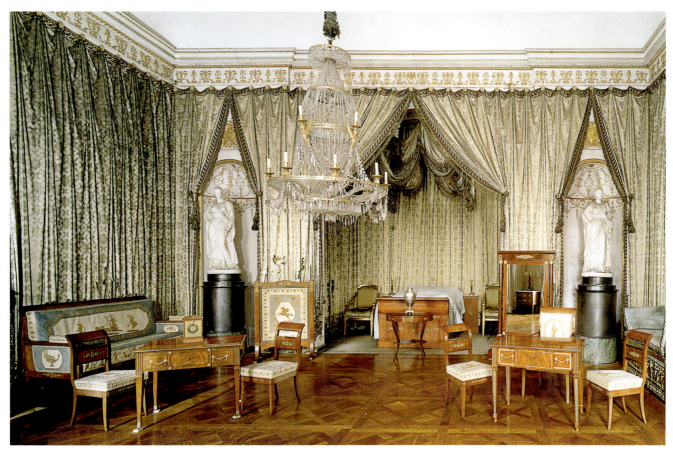

Schloss Ludwigsburg, King Friedrich's bedroom

King Friedrich's Bedroom

When the future King Friedrich I of Württemberg assumed government as duke, Schloss Ludwigsburg had been slumbering in oblivion. The once magnificent rooms of his forefathers had aged. Johann Wolfgang von Goethe wrote at the time: *"the well-known and spacious Schloss most habitable, but both old and new decorated and furnished in comparatively foul taste"*. The first thing Friedrich did in Ludwigsburg, in keeping with its future use as a summer residence, was to have the extensive garden and its pavilions modernised. Next came the rooms in the new corps de logis that were used for stately and social occasions. A suite from the period 1802 to 1811 has been preserved here in its stylistic unity. After a sumptuous hall of audience exclusively in red and gold, the bedroom draped in pale blue is one of its highlights. Friedrich drew here on Napoleonic models after he was raised from duke to king in 1806. The accurately pleated textiles with borders and tressage were intended to suggest a field marshal's tent. The ceiling addresses the theme of sleep with its golden stars and rosette of poppy capsules. Bright blue cornflowers echo the colour of the wall covering.

The neo-classical revamping of Schloss Ludwigsburg achieved a major impact with relatively little input. This was the great strength of architect Nikolaus Friedrich von Thouret, who had outstanding assistants in sculptor Antonio Isopi and ébeniste Johannes Klinckerfuss. The registry adjoining the bedroom was decorated with grotesques in clearly structured fields, inspired by Raphael's famous Vatican loggia. The cupboards designed by Klinckerfuss to hold the records bear inscriptions in golden lettering – INTERNA, EXTERNA and PUBLICA – and convey an impression of orderly royal administration.

U. S.

STAATLICHE SCHLÖSSER UND GÄRTEN BADEN-WÜRTTEMBERG

ℹ Schloss Ludwigsburg
Schlossstr. 30
D-71634 Ludwigsburg
Tel. (+49/0) 71 41 / 18 20 04
Fax (+49/0) 71 41 / 18 64 34
info@schloss-
ludwigsburg.de
www.schloss-
ludwigsburg.de

🕐 mid-March – 1 November:
10 am–12.30 pm, 1.30–5 pm
2 November – mid-March
Tu–Su 10 am–12.30 pm,
1.30–4 pm
Guided tours all day,
Last tour:
March – 1 November:
12 noon and 5 pm
2 November – mid-March
12 noon and 4 pm
Additional group tours
by prior arrangement

🎫 in the Residenzschloss

🍴 in Blossoming Baroque and
palace complex

🅿 coach park at the
Residenzschloss
Multi-storey car park
Schloss / Marstall

Ⓢ S 4 or S 5 to Ludwigsburg

🚌 Buses 421, 427, 430, 443 or
444, stop Favoriteschloss

Schloss Favorite
Banqueting Hall

Barely a hundred years after its construction as a summer house and hunting lodge, Duke Friedrich II (the future King Friedrich I) of Württemberg decided to update the interior of his baroque Schloss Favorite. Some of the rooms, designed by Nikolaus Friedrich von Thouret from 1798, were decorated with French wallpapers inspired by Antiquity, while others were painted in Pompeian style. The large room in the centre of the building was to convey a sense of Ancient solemnity. A cool neo-classical air is maintained by the dominance of white and pale blue. Fluted Ionic pilasters are crowned by a smooth entablature under a high attic. A flat coffered ceiling with stucco rosettes has replaced the former baroque vaulting. In the niches over the four fireplaces are statues of the Four Seasons in Ancient garb made by Johann Heinrich Dannecker and Philipp Jakob Scheffauer. A table set with china owned by King Friedrich recalls the room's one-time function as a banqueting and dining room.

U. S.

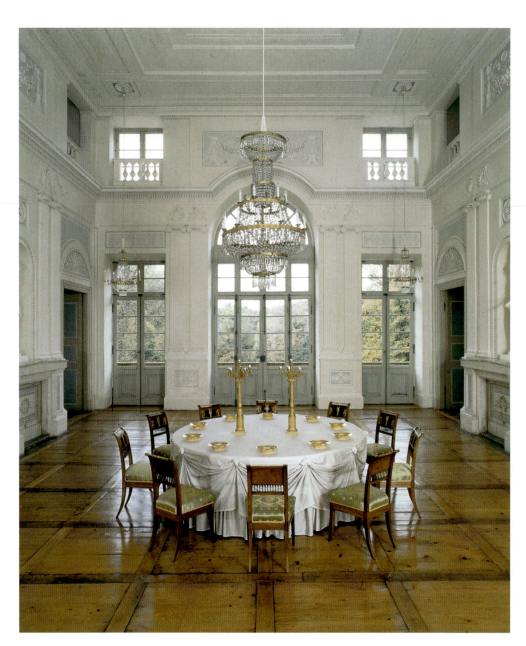

Schloss Favorite,
central banqueting hall

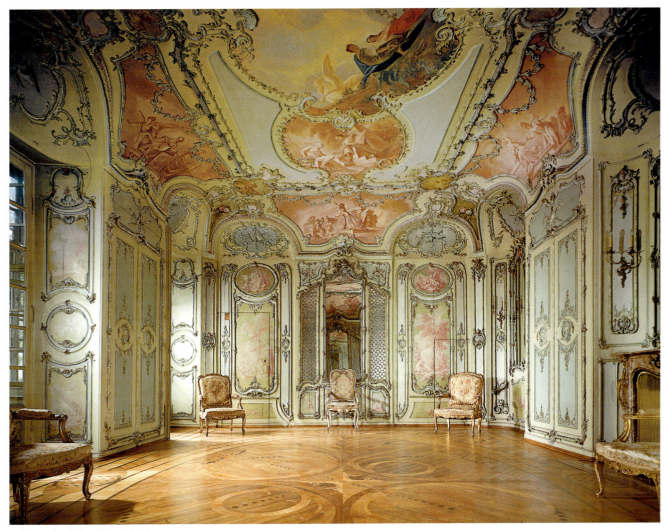

Schloss Mannheim, the Lady's Library

Schloss Mannheim
The Lady's Library

The library made for Elisabeth Auguste (1721–1794), the wife of Palatine Elector Carl Theodor (1724–1799), on the ground floor of the corps de logis in Schloss Mannheim can be described as a rococo gem. The rectangular room in pale pastel colours radiates a lightness and frivolity typical of the period around 1760. No less an architect than the celebrated Nicolas de Pigage (1723–1796) provided the drawings for this highly ornate late rococo interior. It was destroyed in the Second World War but later restored to its original splendour.

Filigree, subtly raised decorative elements recur throughout the room. The reconstructed floor of domestic and exotic woods contains the characteristic floral patterns of the 18th century in elegant curving forms.

The window niches through which light floods the interior are symmetrically echoed by the structure of the walls. The room coheres in a harmonious whole. The painted wooden panelling with its gilt carvings, cherub scenes and ornamentation reflects the stucco work and paintings. The interplay of shape and colour so typical of rococo is demonstrated in exemplary fashion by the allegorical grisaille which Philipp Hieronymus Brinckmann implemented in the haunches and on the ceiling (Apollo surrounded by Muses). C. J. F.

ℹ Vermögen und Bau
Baden-Württemberg,
Amt Mannheim
L 4, 4-6
D-68131 Mannheim
Tel. (+49/0) 62 02/8 14 82
info@schloss-
schwetzingen.de
www.schloesser-und-
gaerten.de

⊖ Forthcoming: viewing
of bel étage and permanent
exhibition on the ground
floor with cabinet library.

Due to extensive
construction work the
Schloss is scheduled to
remain closed until 2007.

STAATLICHE SCHLÖSSER UND GÄRTEN BADEN-WÜRTTEMBERG

i Kloster Maulbronn
Infozentrum
Klosterhof 5
D-75433 Maulbronn
Tel. (+49/0) 7043/926610
Fax (+49/0) 7043/926611
info@kloster-maulbronn.de
www.schloesser-und-
gaerten.de

🕐 November – February:
Tu–Su 9.30 am–5 pm
March – October:
9 am–5.30 pm daily
Guided tours at 11.15 am
and 3 pm
Guided tours in English
and French for groups
by prior arrangement
Special tours
Children's tours

⊞

♿ disabled access with minor
limitations

✕ in the vicinity

🅿 outside the abbey

Ⓢ from Bruchsal or Mühlacker
to Maulbronn-West,
then 3.5 km on foot

🚌 Bus 700 from Bretten-
Mühlacker, bus 734
from Pforzheim

🚎 Klosterstadtexpress in
summer (Su, public
holidays)

UNESCO World Heritage Site: Maulbronn Abbey

The Monks' Choir in the former abbey church

The former Cistercian abbey in the Salzach valley between Bretten in Baden and Mühlacker in Württemberg was founded in 1147 on land then held by the Bishops of Speyer. Since 1993 this monastic complex with a cultural landscape moulded by the Cistercians has been a recognised UNESCO World Heritage site. The complex centres on the old monastery church, consecrated in 1178, an early Maulbronn structure from the first heyday of the abbey. As in all Cistercian churches, the adoration of Christ is combined with the adoration of Mary, patroness of the Order. A choir screen partitions off the western end of the church used by lay brothers, now the parish church. To the east, as an extension of the nave, lies the inner chancel used by the monks, consisting of the typically rectangular Cistercian choir and the presbytery. The monks could enter the church directly from the cloisters, a closed residential area which in the old days was exclusively reserved for them. Lighting improved vastly in the choir when a huge tracery window was installed in the latter 14th century. The pews made around 1450 hold 92 seats. The monks prayed and sang together here eight times a day, usually standing before folded seats, and also attended Mass here.

*Maulbronn Abbey, view from the choir screen ▷
into the presbytery with stalls and eastern choir*

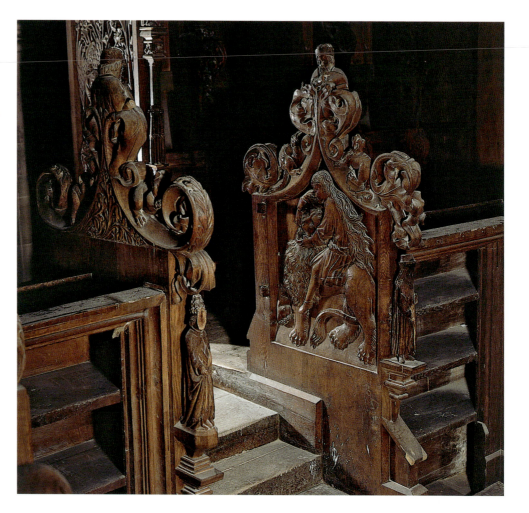

*Maulbronn Abbey,
detail from the choir stalls.
The bas relief shows Simon
fighting the lion, and Old
Testament precursor of Christ
overpowering Death*

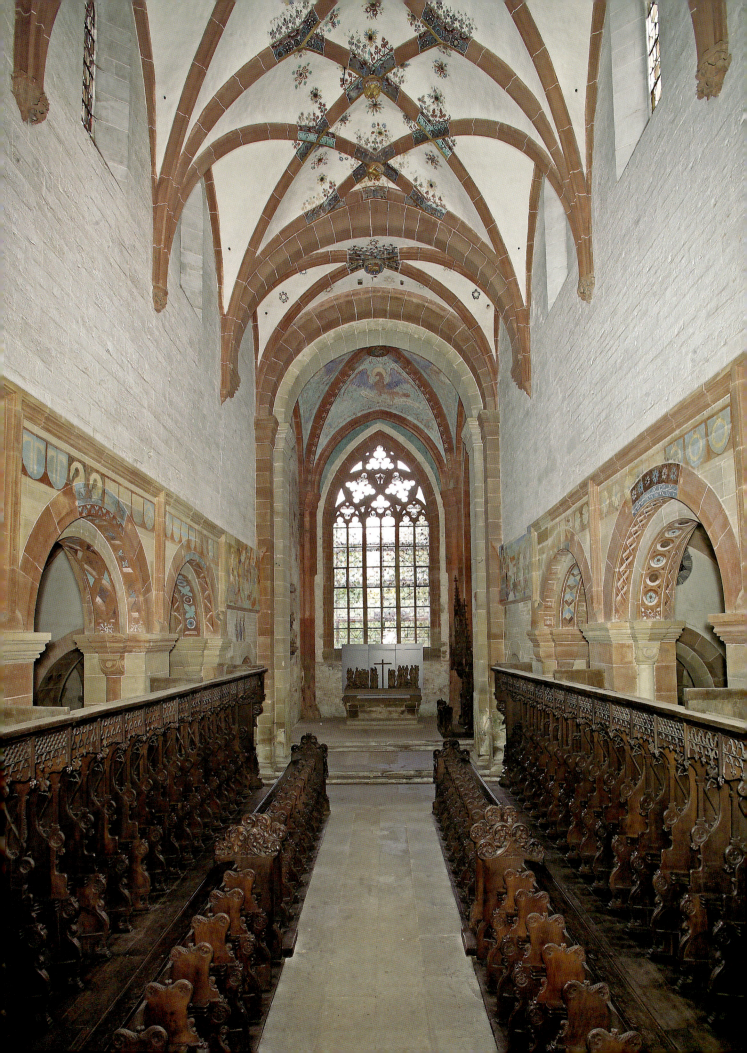

STAATLICHE SCHLÖSSER UND GÄRTEN BADEN-WÜRTTEMBERG

Old Refectory

Maulbronn Abbey boasts one of the finest Early Gothic refectories with its impressive dining hall for the monks. Seven sturdy, towering round pillars divide the room built around 1220 into two parts while supporting the thick Early Gothic ribbing of the vaults. The Latin root "refectio" (refreshment) indicates the function it served: the monks and their abbot met here to recuperate over food and drink after their physical toils and prayer. For their spiritual nourishment a reader would declaim passages from the Holy Scriptures from an elevated pulpit

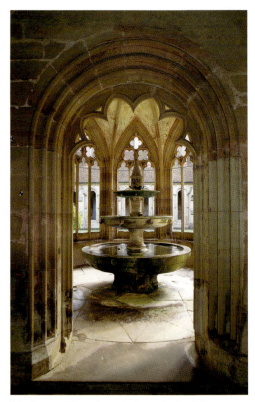

Maulbronn Abbey, the water-house in the cloister opposite the refectory

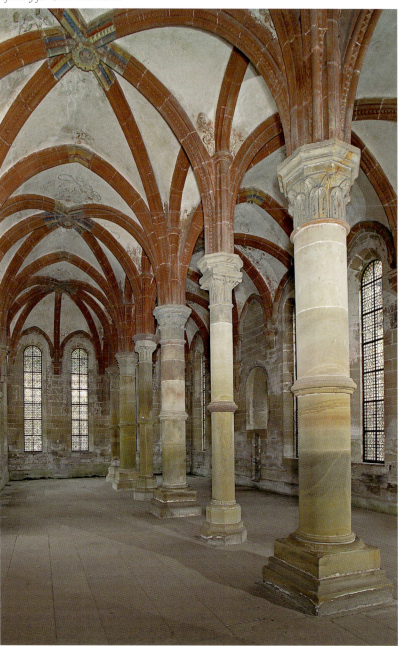

Maulbronn Abbey, former refectory for Cistercian monks

attached to the east wall specifically for this purpose. In prosperous days up to a hundred Cistercians would take their meals here together and in silence, listening and contemplating.

In terms of its size and the work and quality invested by stonemasons in its capitals, this grand dining hall would be worthy of a king's banquets. It stands on the northern cloister, an area similarly once reserved for the monks, between the abbey kitchen and the warm room, and measures about 27.20 m long by 11.50 m wide and 10.40 m high. Reflecting these interior dimensions, the external structure also stands out imposingly against the ensemble. The monks washed their hands before eating at the water-house opposite the entrance to the refectory. On this spot a spring watered the cloister gardens in the early 13th century. The water-house and refectory are both typical specimens of Cistercian monastic architecture.

C. T. M.

New Palace for the Prince-Bishops of Constance
The Stairway

Not until the magnificent stairway was later added did the new residence for the prince-bishops of Constance fulfil its function as a palace of state. It was built in 1710–1712 without the stairs by Prince-Bishop Johann Franz Schenk von Stauffenberg, enjoying a prime location in town with a marvellous panorama of the lake and the Alps. He himself resided in the old castle at Meersburg, which the prince-bishops had chosen as their seat on the north shores of the lake when Constance, with its Imperial charter, sided with the Reformation.

Extensions to the new palace were initiated, like many other construction projects, by Damian Hugo von Schönborn, who was already Prince-Bishop of Speyer when he also became Bishop of Constance in 1740. Balthasar Neumann influenced the architecture decisively from Bruchsal, his employer's summer residence. On status drawings prepared for him by Carlo Pozzi, he designed the stairwell, which juts well out into the forecourt, and other rooms on the bel étage. The foundations proved inadequate, and in 1759/60 Franz Anton Bagnato had to renew them using Neumann's blueprint. The imposing open stairway, in three parts on each side, embraces the space to form a generous vestibule, receiving guests and uniting the two upper floors in a single interior. The ceiling frescos by Giuseppe Appiani draw the eye to Cardinal von Rodt, who completed the project, illustrating how his virtues brought blessings to his diocese and ecclesiastic affairs during his princely reign. Beneath Rodt's coat-of-arms, wrought in stucco by Carlo Pozzi, today's visitors, like the state guests of the past, enter the festive hall through the central door.

C. T. M.

ℹ Vermögen und Bau
Baden-Württemberg,
Amt Ulm
Postfach 4120
D-89031 Ulm
Tel. (+49/0) 731/5 02 89-75
Fax (+49/0) 731/5 02 89-25
info@vbaul.fv.bwl.de
www.schloesser-und-gaerten.de

Meersburg Tourist Office
Tel. (+49/0) 75 32/440 400
info@meersburg.de

Palace Museum on the bel étage with Prince-Bishop's rooms

⊘ April – October:
10 am–1 pm, 2–6 pm
Closed November – 31 March
Special tours by arrangement

✕ Restaurants in town, Schlosscafé in summer

🅿 Multi-storey car park nearby

🚌 to Überlingen or Friedrichshafen; every half hour

⛴ Meersburg pier

🅰 Town Gallery
Dornier Museum of Aviation History

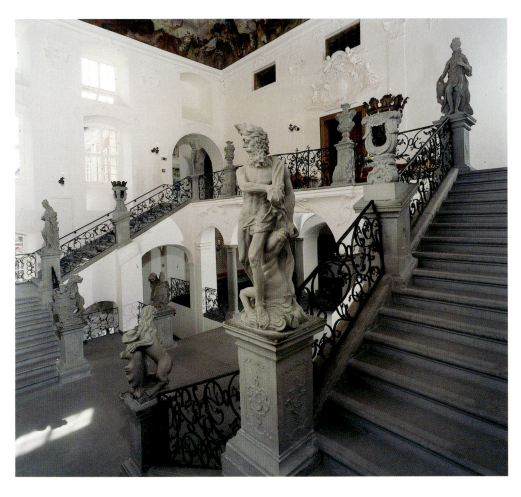

Meersburg, stairway in the New Palace. The four gods on corner plinths personify the four elements earth, water, air and fire; the lions hold the heraldic emblems marking out the territory under the prince-bishop's rule

STAATLICHE SCHLÖSSER UND GÄRTEN BADEN-WÜRTTEMBERG

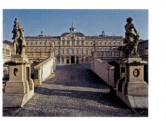

i Schloss Rastatt
Herrenstr. 18
76437 Rastatt
D-76437 Rastatt
Information Centre
Tel. (+49/0) 72 22/97 83 85
Fax (+49/0) 72 22/97 83 92
info@schloss-rastatt.de
www.schloesser-und-
gaerten.de

🕐 April – October:
Tu–Su 10 am–5 pm
November – March:
Tu–Su 10 am–4 pm
Guided tours every hour
Special tours, Children's
tours and activities all year
round by arrangement
under

Service-Center
Tel. 0 72 22/93 41 70

⊞

✕

P Coach park

S S 4 and S 41 to main station
(Hbf.)

🚌 Bus 222, 232 or 235
to Schloss

A Memorial to German
Freedom Movements
Tel. (+49/0) 72 22/77 1 39-0

Military History Museum
Tel. (+49/0) 72 22/3 42 44

Schloss Rastatt
Ancestral Hall

A proud series of baroque residences were built along the Upper Rhine. Schloss Rastatt was the first, founded by Margrave Ludwig Wilhelm of Baden-Baden (1655–1707), nicknamed "Turk Louis" by locals due to his spectacular military success in the recent Turkish Wars. Following his services on behalf of the Viennese aristocracy, the painter and architect Domenico Egidio Rossi was entrusted with developing the new palace and the town. The taste that appealed to the Liechtensteins and Prince Eugen in the early 18th century can still be witnessed in Rastatt during a tour of the residence. The splendid stucco work with figures in haut-relief that dominates the ceilings of the margrave's state apartment has been preserved virtually unchanged. The quadratura painters that Rossi brought from Italy in 1705 decorated the ceiling in the Ancestral Hall and the margravine's adjacent ceremonial chambers. Little survives of the original luxurious furnishings with many items of silver, apart from the series of tapestries devoted to the "art of war". These Flemish works from the Van der Borght manufactory illustrate the great merits of the army commander in the margrave's antechamber and hall of audience. U. G.

Schloss Rastatt, Ancestral Hall, frescos by Giuseppe ▷
Roli, 1705, stucco relief by Giovanni Battista Artario

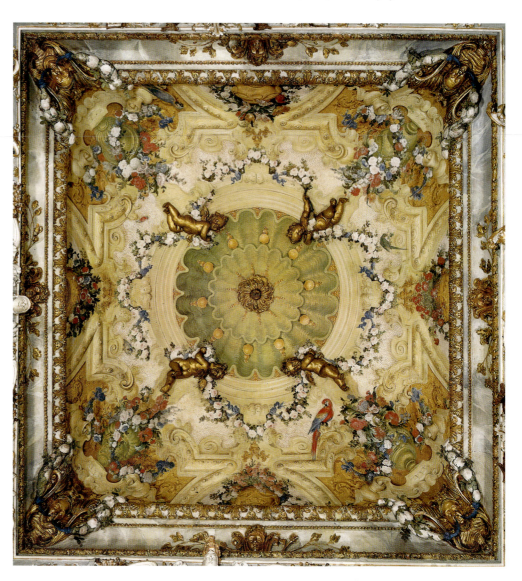

Schloss Rastatt, Porcelain Room,
ceiling with quadratura
by Pietro Antonio Farina, 1705

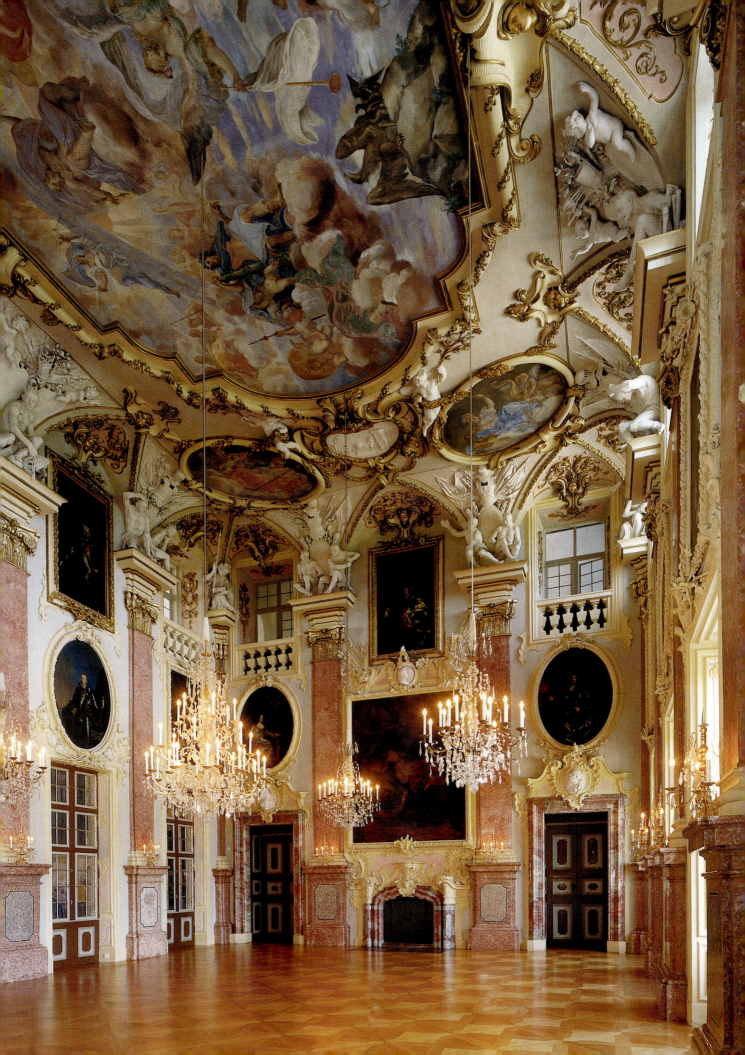

i Schloss Favorite
Rastatt-Förch
D-76437 Rastatt
Visitors' centre
Tel. (+49/0) 72 22/4 12 07
Fax (+49/0) 72 22/40 89 57
info@schloss-rastatt.de
www.schloesser-und-
gaerten.de

🕐 Opening times:
16 March – 30 September:
Tu–Su 10 am–5 pm
1 October – 15 November:
Tu–Su 10 am–4 pm
Free access to the park
Open for viewing: Garden
documents at the end
of the Orangery
Hourly guided tours of the
palace
Special tours during the
high season and by
arrangement with

Service Centre
Tel. (+49/0) 72 22/93 41 70

⊞

✕ Café

ℙ

🚌 from centre of Rastatt bus
241 or 243 to Rastatt-Förch

Ⓢ S 41 to Kuppenheim

STAATLICHE SCHLÖSSER UND GÄRTEN BADEN-WÜRTTEMBERG

Schloss Favorite (Baden)
Mirror Room and Pietra Dura Room

In the first decades of the 18th century Sibylla Augusta, Margravine of Baden-Baden, built a summer pavilion near her Rastatt residence that remains uniquely complete along with its furnishings. The splendid rooms on the bel étage of Schloss Favorite are fitted with the most precious of silks, and in combination with the radiance from the decorative stucco-lustro floors they create that darkly luminescent colour which lends the rooms their distinctive atmosphere. Painted furniture, most of it made in the court workshop, and the most select chandeliers, probably from Bohemia, add to the sumptuous character of these late baroque ensembles.

Sibylla Augusta, born a princess of Saxe-Lauenburg, had an unusual artistic sense. This is particularly reflected in the two rooms at the garden end of the two apartments. To be in these is like standing in a jewellery case. The Mirror Room, reminiscent of Marot, displays European and Asian porcelain. The vases, bowls and statuettes are fixed on and in front of con-vex and concave wall mirrors, so that Sibylla Augusta's room conveys an overwhelming illusion of myriad treasures. This exotic spatial impression is enhanced further by a series of costume drawings that was already arousing the wonder of visitors 300 years ago.

The Pietra Dura Room similarly draws its appeal from this characteristic combination of materials used typically in furnishing of the day and techniques based on the personal predilections of Turk Louis's lady consort. The pictures of polished semi-precious stone built into the walls, also found in sumptuous cabinets of the period, were probably brought back by Sibylla Augusta from her trip to Florence in 1719. In conjunction with tablets of mother-of-pearl, stained glass and varnished images they lend this room its unmistakable flavour.

A visit to Schloss Favorite is a unique demonstration of interior design at a time when Europe's fascination with Asia was reaching its first crescendo.

U. G.

Schloss Favorite, Mirror Room ▷

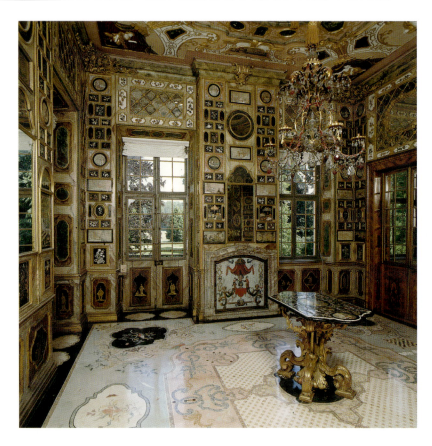

Schloss Favorite, Pietra Dura Room

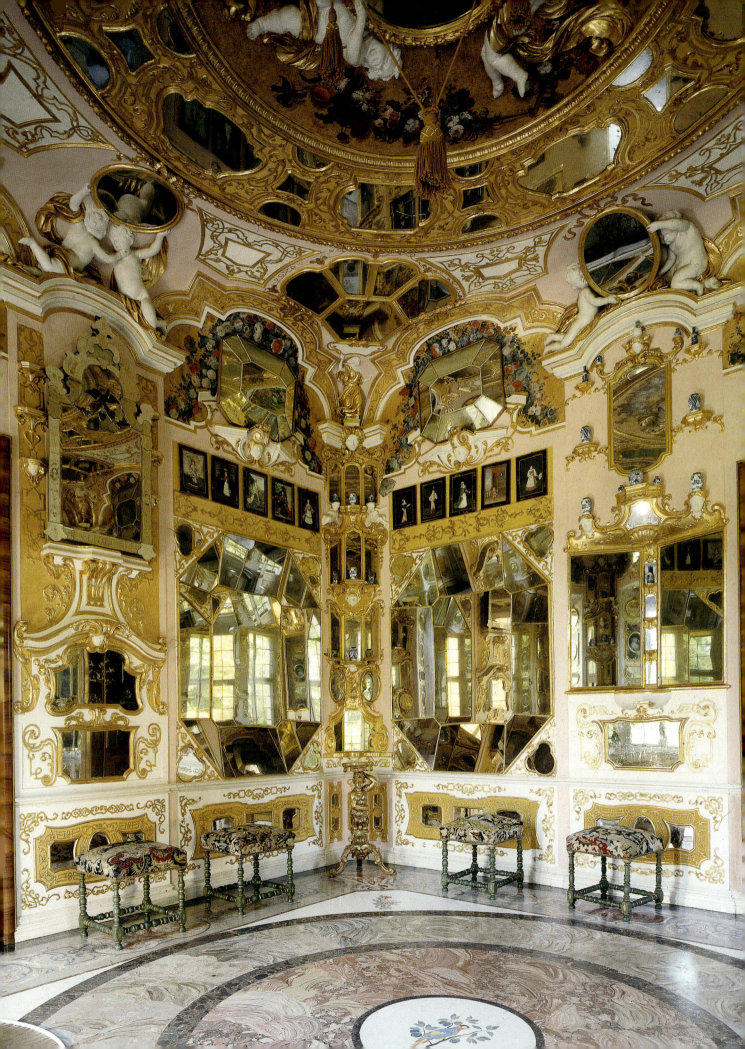

ℹ Bildungshaus
Kloster Schöntal
Klosterhof 6
D-74214 Schöntal
Tel. (+49 / 0) 79 43 / 8 94-0
Fax (+49 / 0) 79 43 / 8 94-100
bildungshaus@
kloster-schoental.de
www.schloesser-und-
gaerten.de

🕗 Abbey church: 8 am–6 pm
New Abbey:
April – October:
11 am, 2 pm and 4 pm
November – March:
11 am and 2 pm
Old Abbey, Information
Centre with permanent
exhibition
May – September:
Tu–Sa 11 am–4 pm,
Su 1–6 pm
Special tours by
arrangement

▦

♿ disabled access with res-
trictions

✕ Klostercafé
Gasthof Zur Post

🅿

🚌 from Möckmühl rail station
take bus 11 to the abbey

Schöntal Abbey
Monks' Hall

The River Jagst carves a large bow around the former Cistercian monastery at Schöntal, founded in the 12th century. This imposing complex owes much of its appearance to the abbot Benedikt Knittel (1683–1732), who appointed Johann Leonhard Dientzenhofer from 1701 to build a new church and many other buildings.

Via the splendid baroque stairway we reach the first floor of the New Abbey, constructed from 1737 to 1746, where the abbots used to live and work. A glass door separates the final three axes of the southern wing at the end of the corridor.

After passing these we find ourselves in the Monks' Hall in the middle of a "clerical cosmos". The space created by the glass door is fully panelled. Three well clad doors lead from here to other rooms, the hunting room and the picture hall. Small wood pilasters with capitals which dissolve into rocaille stretch to the groin vaults above. Canvas paintings illustrating secular and religious themes adorn the vaulting and blind arches. The walls are covered in 302 little canvas paintings, each representing a member of one of the known Orders of the time in the appropriate habit. G. K.

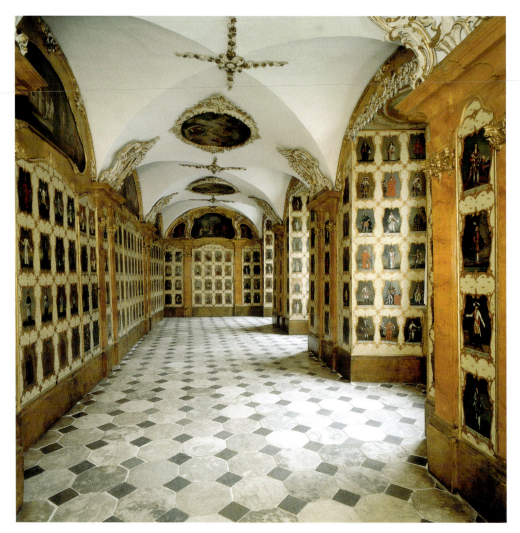

Schöntal Abbey, Monks' Hall

i Schloss Schwetzingen
Schloss Mittelbau
D-68723 Schwetzingen
Tel. (+49/0) 62 02/8 14 82
Fax (+49/0) 62 02/8 13 86
info@schloss-
schwetzingen.de
www.schloesser-und-
gaerten.de

Permanent exhibitions on
the history of the Palace
Garden, the Orangery and
historical garden tools,
Lapidarium with original
sculptures

☉ Guided tours of the palace
April – October:
Tu–Fr 11 am–4 pm
Sa, Su and on public
holidays
11 am, 2 pm and 3 pm
November – March:
Fr 2 pm, Sa, Su and
on public holidays
11 am, 2 pm and 3 pm
Garden open all day
throughout the year

Special tours, children's
tours and activities all year
round subject to
arrangement by phone:

Service Centre
Tel. (+49/0) 62 21/53 84 31
Fax (+49/0) 62 21/53 84 30
info@service-center-schloss-
heidelberg.com

♿ disabled access to Garden

⊞

✕ Schlossrestaurant

P public parking in town

DB 5 minutes on foot

Special events:
Schwetzinger Festspiele
May to June
Mozart Festival
in September
Art exhibitions

Schloss Schwetzingen, panoramic wallpaper
"Vues de Suisse", 1804

Schloss Schwetzingen

Swiss Room

The Swiss mountain world portrayed in the Swiss Room at Schloss Schwetzingen reflects the idealisation of Switzerland known as philhelvetism that was triggered by a series of travel journals at the dawn of the 19th century. The original panoramic wallpaper made in 1804 and entitled "Vues de Suisse" encompasses the space in framed sections depicting idyllic alpine landscapes and groups of figures embedded in a mountain environment of waterfalls and lakes. It is an idealised picture of the world which stylises sublime nature in peaceful co-existence with man and beast, apparently untouched by civilisation. This new Arcadia finds material form in Switzerland.

The popular and widely sold series was made by Zuber, an Alsatian company based in Rixheim near Mulhouse, from designs by the French painter Pierre Antoine Mongin (1761–1827), whose work can also be admired in the Grand Trianon at Versailles. Here in Schwetzingen we have the rare privilege of enjoying the original. Functionally this room once served the Imperial Countess of Hochberg (1768–1820), second wife of the Elector and later Grand Duke Carl Friedrich of Baden (1728–1811), as a "compagnie" room. It has been reconstructed with neo-Gothic seating by using items in the collection which date from around 1804. The design of the furniture seems to reflect a desire to escape the here and now of everyday life.

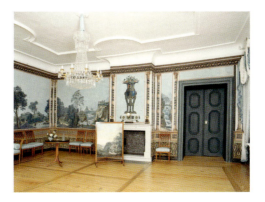

Schloss Schwetzingen,
Swiss Room

The Bathhouse Study

Schwetzingen was to become the favourite summer residence of the Palatine electors who held court in Mannheim. Shielded from the rigid ceremonies of court, Elector Carl Theodor (1724–1799) would retreat to his private pavilion, built in 1775 and known as the Bathhouse, within the extensive palace gardens.

As in Mannheim, Pigage took charge of the interior design. But here we find incipient tones of a neo-classical symbolism taking its departure from heavily charged baroque and dainty rococo. The Elector's study derives its appeal from a strict formal organisation and choice materials. White marble columns in the style of Antiquity, with gilt bases, capitals and entablature, frame the canopied settee in its alcove where the Elector could rest from his writing. The return to stylistic features of bygone ages, above all Antiquity, is a hallmark of neo-classicism. The decoration is full of contrasts. Islands of retreat conjured up by spatial means draw the gaze with landscapes by court painter Ferdinand Kobell (1740–1799) in typically cool colours. These bucolic shepherd scenes convey a yearning for Arcadian idylls. An absolutist prince of enlightened spirit seeks open spaces, nature and simplicity. The guiding principles of English landscaped gardens no doubt provided inspiration, and Dutch influence is also felt in vedute reminiscent of van Ruisdael

Landscape veduta by Ferdinand Kobell

Opposite page:
Schloss Schwetzingen,
Bathhouse study

Palatine Elector Carl Theodor

and Everdingen ranked "among the best German landscapes of the transitional period to neo-classicism" (Adolph Feulner, 1929). The exquisite appointment is exemplified in furniture and wall panelling of grained rosewood by the Mannheim court ébeniste Jakob Kieser (1734–1786). The room today is faithful to records of the authentic ensemble.

C. J. F.

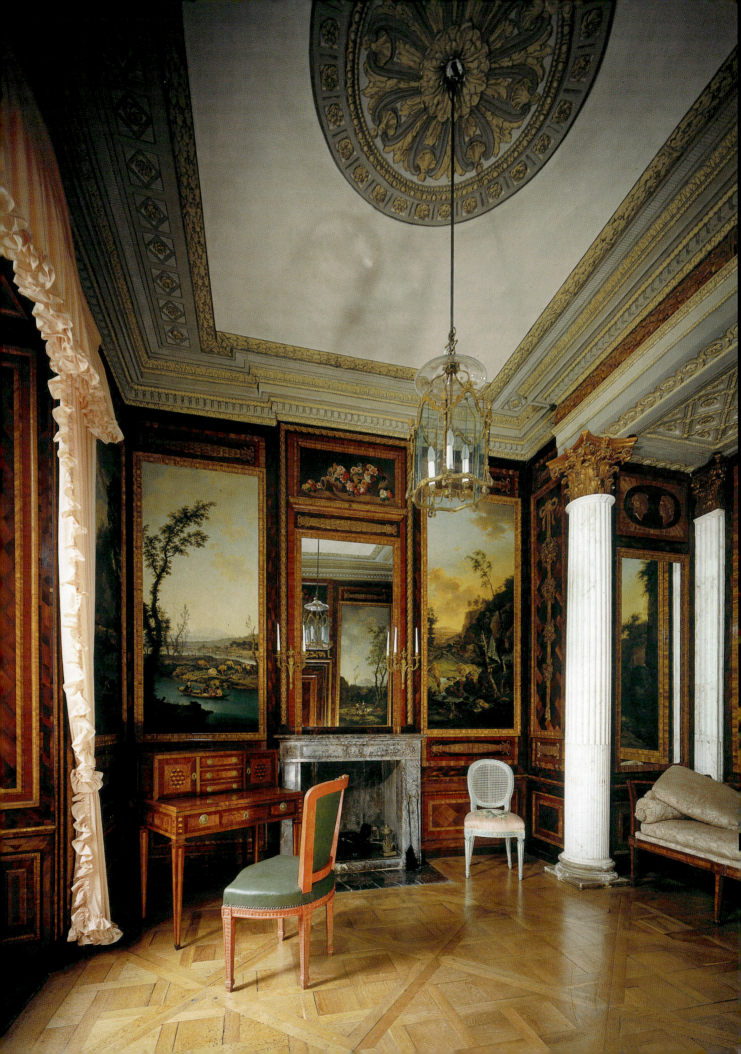

STAATLICHE SCHLÖSSER UND GÄRTEN BADEN-WÜRTTEMBERG

Solitude 1
70197 Stuttgart

ℹ Schloss Solitude
Tel. & Fax
(+49/0) 711/69 66 99
info@schloss-solitude.de
www.schloss-solitude.de

🕐 April – October
10 am–12.30 pm, 1.30–5 pm
November – March
Tu–Su 10 am–12.30 pm
1.30–4 pm
Guided tours all day
Last tour:
April – October:
12 noon and 5 pm
November – March:
12 noon and 4 pm
Group tours and tours
in English by arrangement

✳ Schlossrestaurant

🅿

🚌 from Stuttgart Bus Station
Bus 92 towards Leonberg

Schloss Solitude
Marble Hall

Duke Carl Eugen of Württemberg, a man much devoted to the construction and appointment of residences, began Schloss Solitude in 1763 as an ideal framework for informal socialising in a small group. The rooms on the bel étage were earmarked for entertainment in company, with a ballroom, an assembly and music room, an apartment for the Duke's receptions and several smaller, more intimate cabinets. French doors offered access to a terrace right round the building offering superb views of the once extensive garden and the open landscape. The Duke's own rooms are the culmination of an exquisite appointment by Philippe de La Guêpière. They are entered from the splendid Marble Hall with columns and walls of pink and ochre stuccolustro. The sumptuous marquetry floor was made by Johann Georg Beyer. It leads to the Palm Room finished in pink and gold, a bedroom with a bed draped in Chinese embroidery, a study and a library on a bean-shaped plan.

U. S.

Schloss Solitude, Marble Hall and Palm Room beyond

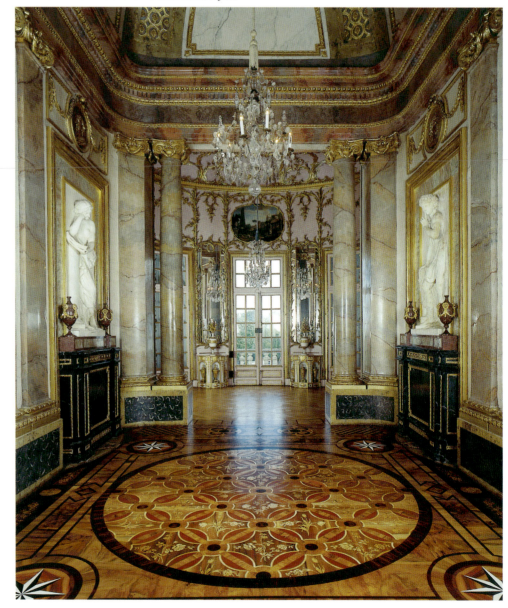

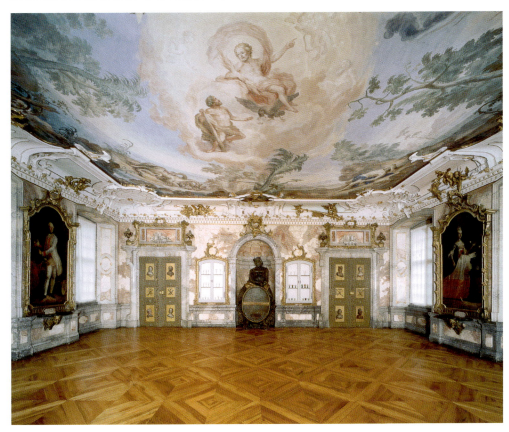

The New Palace at Tettnang, Bacchus Hall

ℹ️ Neues Schloss Tettnang
Montfortplatz 1
D-88069 Tettnang
Tourist Information Office
Tel. (+49/0) 75 42-93 33 33
Fax (+49/0) 75 42-93 91 96
tourist-info@tettnang.de
www.tettnang.de
www.schloesser-und-
gaerten.de

Vermögen und Bau
Baden-Württemberg,
Amt Ulm
Tel. (+49/0) 731-5 02 89 75
Fax (+49/0) 731-5 02 89 25
info@vbaul.fv.bwl.de

🕑 Palace Museum (access
restricted to guided tours):
April – October:
2.30 pm and 4 pm
July and August also
Wed and Fr 10.30 am
Combined tour of palace
and town: Su 10.30 am
Unrestricted daytime access
to stairs, corridors and
courtyard
Group tours all year must
be booked with the Tourist
Information Office

✖️ in town

🅿️ charged car park adjacent
to Palace

🚌 coming from
Friedrichshafen or Ulm
alight at Meckenbeueren
and take a bus to Tettnang

New Palace, Tettnang
Bacchus Hall

After a devastating fire in 1753 Count Franz Xaver von Montfort decided to re-appoint the palace that was but a few decades old. Although heavily burdened by debt, he called on the services of one of Upper Swabia's most celebrated artists. Joseph Anton Feuchtmayer created the stucco for many rooms, including the especially delightful Green Cabinet, which has walls faced with panes of green glass through which shine painted bouquets of flowers.

The Bacchus Hall was furbished around 1770 as a dining and banqueting hall. It is square and relatively low, but lit by windows on two sides. The walls were designed by Johann Caspar Gigl in forms that mark the transition from rococo to early neo-classicism. The hall was named after the wine god, for a drunken Bacchus sits in a niche over a barrel which cunningly disguises a stove. The ceiling was expansively painted by Andreas Brugger

to show Hercules kneeling before Jupiter and four of his deeds symbolising the four elements.

J. St.

The New Palace at Tettnang,
Stucco sculpture by J.A.
Feuchtmayer in the Green Cabinet

STAATLICHE SCHLÖSSER UND GÄRTEN BADEN-WÜRTTEMBERG

ℹ Kloster- und Schloss-
museum Bebenhausen
Im Schloss 3
D-72074 Tübingen
Tel. (+49/0) 7071/602-802
(+49/0) 707071/602-804
Fax (+49/0) 7071/602-803
info@kloster-
bebenhausen.de
www.schloesser-und-
gaerten.de

⊘ Monastery
open all year except
1 Jan and 24, 25 and 31 Dec
April – October:
Mo 9 am–12 noon and
1–6 pm
Tu–Su 9 am–6 pm
hourly tours
Sa, Su and public holidays
November – March:
Tu–Su 9 am–12 noon and
1–5 pm
The church is temporaly
closed
Group tours and special
tours can be booked all year
round

⊞

♿ Monastery

✕ Restaurants Sonne,
Hirsch, Waldhorn

🅿 guided parking system

🚆🚌
train to Tübingen or
Stuttgart, continue
by bus 754 or 826, 828, stop
Gasthof Waldhorn

*Bebenhausen Monastery,
summer refectory*

Bebenhausen Monastery and Schloss

Summer Refectory

The monastery at Bebenhausen near Tübingen was founded by Premonstratensians in the late 12th century and taken over by Cistercians in 1190. The summer refectory annexed to the south wing of the cloisters is its most noteworthy architectural component. The double-aisled dining hall was built around 1335 under Upper Rhenish influence from regular masonry blocks pierced by ornate tracery windows. The interior is dominated by umbrella-like vaults which seem to float gracefully. Their ribs rise from three slender octagonal pillars and culminate in painted keystones on a gold background. The stained glass windows and the paint-ed arabesques in the caps, with scatterings of blossoms, ornaments and animals, were restored in 1874/75 with the aid of surviving fragments. The panelling and floor tiles are also neo-Gothic and blend with the High Gothic architecture.

Breakfast Room

The kings of Württemberg had some monastery buildings converted into a hunting lodge in accordance with their particular tastes. The rooms of the former guest-house (built in 1522) were re-designed around 1870 to plans by Stuttgart architect August von Beyer. Beyer largely retained the original wall

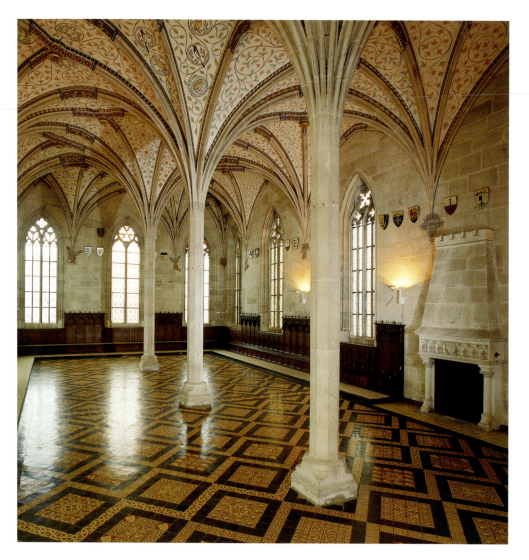

panelling, adding to it in places in neo-Gothic style. The appointment gives an impressive insight into the domestic culture, grand bourgeois in style, of the last king and queen of Württemberg to reside in Bebenhausen. The private quarters of the hunting lodge include the breakfast room. In monastery days it accommodated guests of superior status. The wall panelling and doors are the originals from around 1550. The furniture was made after 1870 in Stuttgart, some in neo-Renaissance style. The stoneware vessels are primarily 17th-century Westerwald products.

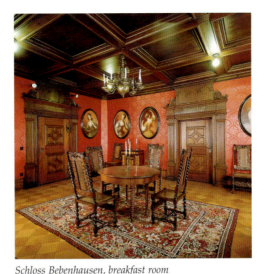

Schloss Bebenhausen, breakfast room

Palace Kitchen

The striking half-timber Kapff wing once used as a monastic hospital was adapted for use by the court retinue during the First World War (1914–1918). A large kitchen with the latest technical equipment was set up in the southern section of the basement. The kitchen complex as a whole measured about 185 square metres, with an office for the kitchen mistress, a kitchen with a large wood-fired range incorporating various hotplates and warming cupboards, a hot water tank, a washing-up room with big terrazzo boards, a silver-polishing room, a washroom, larders for meat and provisions containing big cooling chests run on bars of natural ice, a telephone kiosk and a serving dresser with ice cupboards. A hand-operated food lift (manufactured by Haushahn) linked the kitchen to the serving room on the first floor. The kitchen furniture, ice cupboards and stoves were industrial products purchased by the court's household managers from licensed suppliers in Stuttgart. C. F.

ℹ Kloster- und Schloss-
museum Bebenhausen
Im Schloss 3
D-72074 Tübingen
Tel. (+49/0) 70 71/6 02-8 02
(+49/0) 70 70 71/6 02-8 04
Fax (+49/0) 70 71/6 02-8 03
info@kloster-
bebenhausen.de
www.schloesser-und-
gaerten.de

⊘ Schloss
open all year except
1 Jan and 24, 25 and 31 Dec
Closed on Mondays exept
public holidays
Can only be viewed with
hourly tours,
last tour
April – October: 5 pm
November – March: 4 pm
April – October:
Tu–Fr 9 am–12 noon
and 2–5 pm
Sa, Su and public holidays
10 am–12 noon
and 2–5 pm
November – March:
Tu–Fr 9 am–12 noon
and 2–4 pm
Sa, Su and public holidays
10 am–12 noon
and 2–4 pm
Group tours and special
tours can be booked all year
round

⊞

✕ Restaurants Sonne, Hirsch,
Waldhorn

🅿 guided parking system

DB **🚌**
train to Tübingen or
Stuttgart, continue by bus
754 or 826, 828, stop
Gasthof Waldhorn

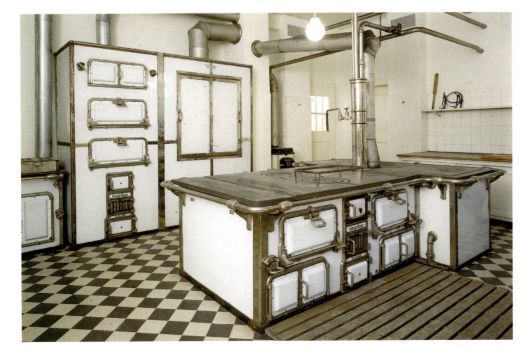

*Schloss Bebenhausen,
palace kitchen*

Wiblingen
Kloster Wiblingen

ℹ Vermögen und Bau
Baden-Württemberg,
Amt Ulm
Postfach 4120
D-89031 Ulm
Tel. (+49/0) 731/50-28975
Fax (+49/0) 731/50-28925
info@kloster-wiblingen.de
www.schloesser-und-
gaerten.de

🕐 Library:
April – October:
Tu–Fr 10 am–1 pm, 2–5 pm
Sa, So, public holidays
10 am–5 pm
November – March:
Sa, So and on public
holidays
1–4 pm
Closed on 24, 25 and
31 December
Opening times will change
when the Abbey Museum
opens in September 2005
St. Martin's Basilica:
9 am–6 pm daily,
9 am–5 pm in winter
Group tours and special
tours can be booked all year
round

▦

♿ elevator

✖ in immediate vicinity

🅿

🚆 Bus from Ulm bus station
take Bus 3 or 8 to Pranger

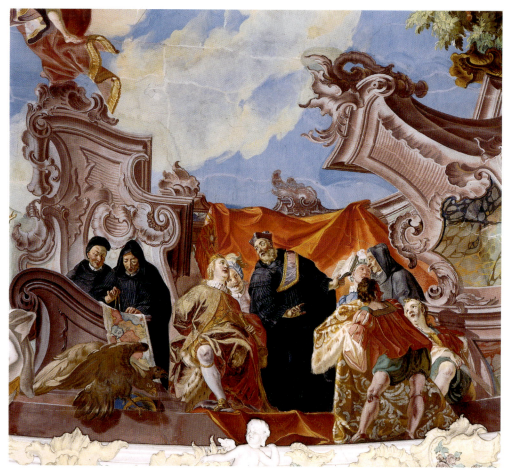

Wiblingen Abbey, "Missionaries to the New World", detail from the library ceiling fresco by Franz Martin Kuen

Wiblingen Abbey
Library

The inscription over the superb rococo portal at the end of the corridor where the monastery's guest apartments were once located prepares the visitor for the room beyond: "In quo omnes thesauri sapientiae et scientiae" (in which are stored all treasures of knowledge and science). By this door we enter the place in the former Benedictine abbey of Wiblingen where contemporary knowledge was presented: the magnificent library, already considered a sight worth seeing in the 18th century.

It is an impressive, elongated room with the original sumptuous furbishing. The scholarly iconography ridden with theological and philosophical references was implemented in 1744 by painter Franz Martin Kuen and sculptor Dominikus Hermenegild Herberger. A gallery runs around it with balustrades curving bal-cony-fashion. Open bookshelves adorn the walls on both levels, and these are linked by shielded spiral stairways. Human knowledge and divine wisdom are glorified with an abundance of detail and quotation. Divine wisdom is embodied in a female figure enthroned at the centre of the ceiling with angels around her.

Opulent imagery illustrates the Ancient and Christian sources of western knowledge. The sciences of the Ancient and Christian worlds are also symbolised. Sculpted figures represent monastic virtues and secular learning. All the elements in this room – used as a library but also for official receptions – are linked by a web of cross-references. The visual programme is astonishingly sophisticated and also indicates the scholarly standards maintained by the monks.

Today the former abbey at Wiblingen is an imposing architectural complex with a large inner forecourt. In 1093 consecration of the first building initiated a turbulent history with many waves of destruction. A great fire in 1271 put an end to the first period of prosperity for the abbey. Further havoc was wreaked during the Peasants' War in 1536 and in the Thirty Years' War.

During the age of baroque a growing demand for expressions of prestige took hold of temporal and ecclesiastical overlords alike. Abbot Modestus Huber (1692–1729) decided to redevelop the complex to plans by Christian Wiedemann. The ambitious project was launched in 1714. The north wing containing the splendid library was completed in 1740. The early neo-classical abbey church with frescos by Januarius Zick was built between 1772 and 1783, but its towers were never finished. G. K.

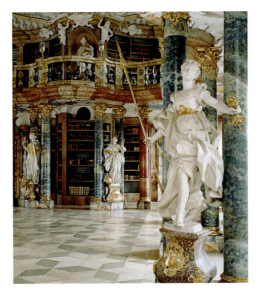

Wiblingen Abbey, library, personification of "Natural Science" with lightning and spear by Dominikus Hermenegild Herberger

Wiblingen Abbey, inside the library from the guest quarters in the west towards the cloisters

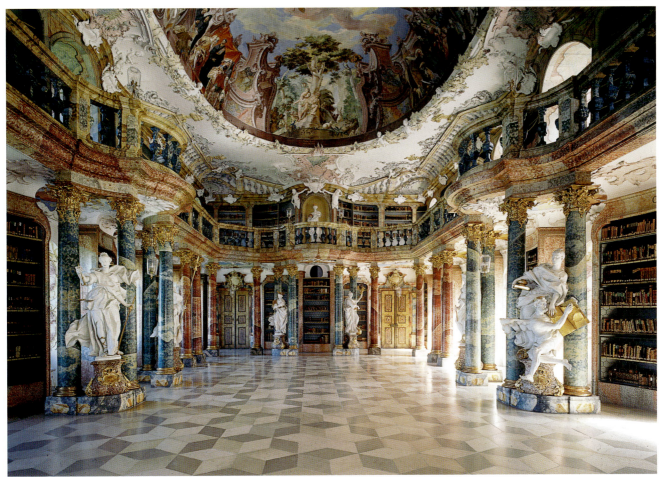

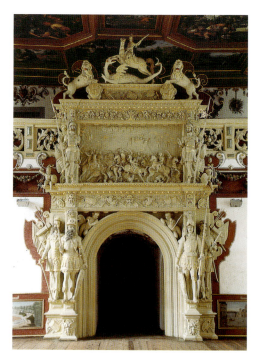

i Schloss Weikersheim
Schlossverwaltung
Marktplatz 11
D-97990 Weikersheim
Tel. (+49/0) 7934/99295-0
Fax (+49/0) 7934-99295-12
info@schloss-
weikersheim.de
www.schloss-
weikersheim.de
www.schloesser-und-
gaerten.de

🕓 April – October:
9 am–6 pm
November – March:
10 am–12 noon and
1.30–4.30 pm
open on Mondays
Interiors can only
be viewed on guided tours
Permanent exhibition
on Garden History
Audio Guide to the
Baroque Garden
Alchemy Exhibition in
former Kitchen
Alchemical Garden
by the Rose Garden
Guided tours every hour
(Texts available in English,
French, Span., Ital. & Jap.)
Group tours, special tours
and children's tours all year
round upon arrangement
by phone

⊞

✕ in immediate vicinity
outside Schloss

🅿 free car park near Schloss:
Heiliges Wöhr

🅿 drop-off point on market
square in front of Schloss.
Free coach park

🚌 train from Crailsheim –
DB Bad Mergentheim
Lauda
Würzburg

Schloss Weikersheim

Knights' Hall

After a division of inherited estates, Count Wolfgang II of Hohenlohe-Langenburg chose Weikersheim as his residence. In 1595 he initiated construction of a Renaissance palace to replace a medieval moated castle. The principal room of state took shape in the south wing: an impressive hall 40 m long, 12 m wide and 8.5 m high. Balthasar Katzenberger of Würzburg painted a series of hunting scenes for the coffered ceiling. The life-size stucco animals on the long walls, sporting genuine antlers, are another hunting reference. However, they do number an exotic outsider – the elephant. The same artist, Gerhard Schmidt, made the recumbent figures of Count Wolfgang and his lady consort with their ancestral plaques each

Schloss Weikersheim, Knights' Hall portal by Gerhard Schmidt

Schloss Weikersheim, Knights' Hall

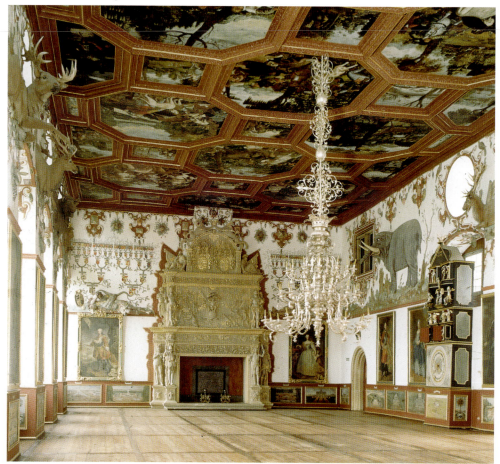

side of the big fireplace adorned with bas-relief.

The Knights' Hall in Weikersheim is one of the few festive halls of the period around 1600 still to be found in their original state. Only the lambris paintings, an artistic clock and the large chandelier were added in the 18th century.

Count Carl Ludwig's Hall of Audience

During the baroque period Count Carl Ludwig of Hohenlohe-Weikersheim (1674–1756) updated the palace, having a baroque garden laid and many rooms refurbished. The key functions of state were no longer performed in the Knights' Hall, but in the Count's own apartment. Carl Ludwig had a suite created from 1708 on the second floor of the east wing. It consisted of an ante-chamber, hall of audience and bedroom. The walls in the hall of audience are structured by red stuccolustro pilasters, while sturdy baroque stucco work adorns the walls and ceiling. Four sumptuous wall tapestries were fitted into the vacant zones. Carl Ludwig bought these from the weavers' manufactory in Schwabach. Like the painted ceiling, they illustrate the Classical myth of the hunter Cephalos. The furniture includes four armchairs and two stools with woven covers to match the tapestries, also made in Schwabach. There are several partially gilt tables, used as a base for faience from Ansbach and Hanau.

Schloss Weikersheim, hall of audience of Count Carl Ludwig of Hohenlohe-Weikersheim

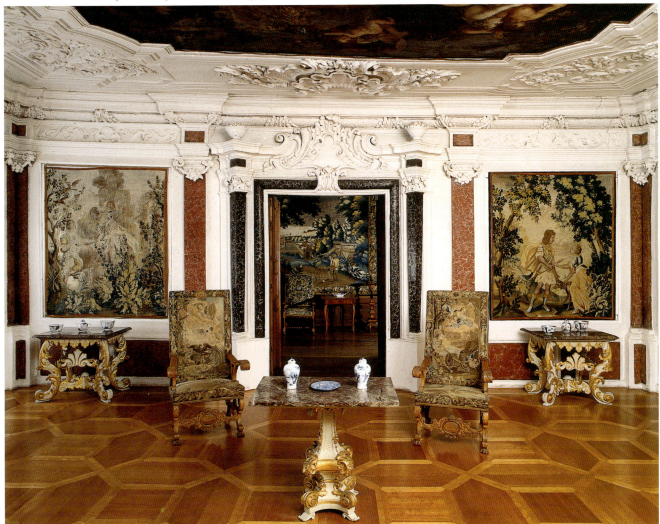

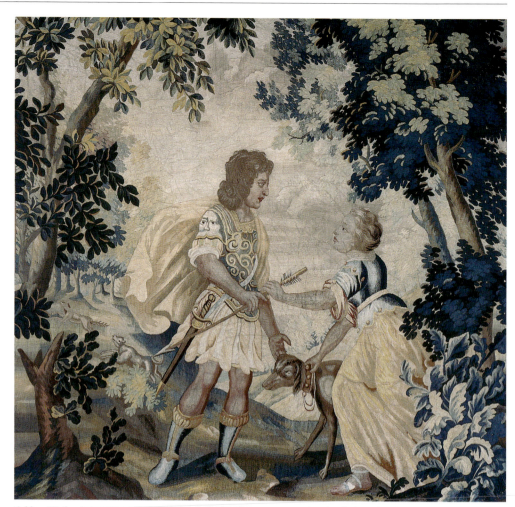

Schloss Weikersheim, Count Carl Ludwig's hall of audience, tapestry showing "The Gifts of Procris"

The Apartment of Princess Elisabeth Friederike Sophie von Oettingen-Oettingen

Count Carl Ludwig's second marriage, in 1713, was to Princess Elisabeth Friederike Sophie from the house of Oettingen-Oettingen. As she was of superior birth, the best rooms in the palace were reserved for her. The ceremonial apartment on the second floor includes an ante-chamber, hall of audience and bedroom, as well as a sumptuous cabinet of porcelain and mirrors.

The principal room, the hall of audience, was baptised "beautiful room" in the 18th century by virtue of its outstanding appointment. Its walls were hung almost entirely with tapestries, the most luxurious option for covering walls, with threads of gold and silver worked in. The gobelin covers for the seating reflect in part the same allegorical themes as the walls. A beehive, for example, indicates diligence. According to the 18th-century inventories the magnificent interior was complemented by solid silver gueridons and other silver or silver-plated items.

Schloss Weikersheim, beehive on a chair cover

Porcelain and Mirror Cabinet

A particular gem in this stately suite is the cabinet adjoining the hall of audience. It was completed in 1717 at a time when rooms of porcelain and mirrors were all the rage in German palace-building. The Weikersheim cabinet is one of the earlier specimens of its kind and has been uniquely preserved. The walls are covered with a pattern of shallow wood carvings. Fully plated with gold or silver, they stand out in contrast against the wine-red silk damask behind. The carvings create corbels to hold dozens of Chinese porcelain figures and little vases. Numerous little mirrors are embedded within this ornamentation. There are also mirrors around the window, on the breast, lintel and jambs. The biggest mirrors are those on the ceiling. Their arrangement is echoed in the pattern of the walnut root flooring. J. St.

Schloss Weikersheim, detail from the cabinet

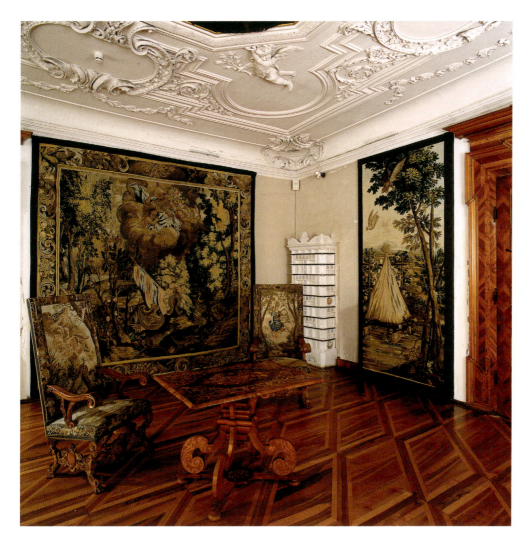

Schloss Weikersheim, hall of audience of Princess Elisabeth Friederike Sophie

STAATLICHE SCHLÖSSER UND GÄRTEN BADEN-WÜRTTEMBERG

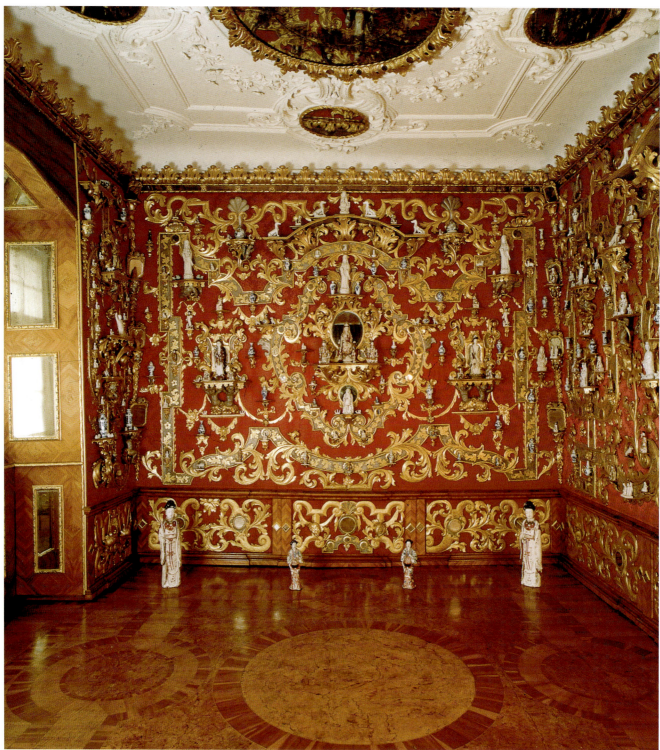

Schloss Weikersheim, Porcelain and Mirror Cabinet

Source of illustrations:
Landesmedienzentrum Baden-Württemberg: p. 23, 27 right, 28 top, 33, 34, 42, 48, 49 top left, 50, 51 bottom, 54, 55, 56 bottom, 57;
Hauswirth: p. 36 bottom, 45 top right, 52, 53; Weischer: p. 25, 28 bottom, 29, 30 bottom, 31, 36 top, 37, 38, 39, 40 top, 45 top left, 45 bottom, 46, 47, 58;
Spaeth: p. 44 top
Staatliche Schlösser und Gärten Baden-Württemberg: p. 27 left, 35, 40 bottom, 43; Augustin: p. 26 top; Cohen: p. 30 top, 32; Exner: p. 41;
Feist, Plietzhausen, p. 44 bottom, 49 bottom, 51 top, 56 top; Philippi: p. 26 bottom
Vermögen und Bau Baden Württemberg, Amt Ravensburg: p. 49 top right

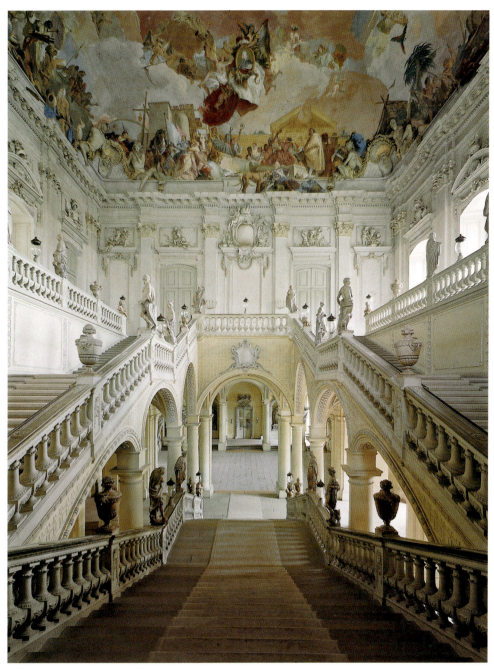

Bavaria

Bayerische Verwaltung der
staatlichen Schlösser, Gärten und Seen

Bavarian Department for State-owned
Palaces, Gardens and Lakes

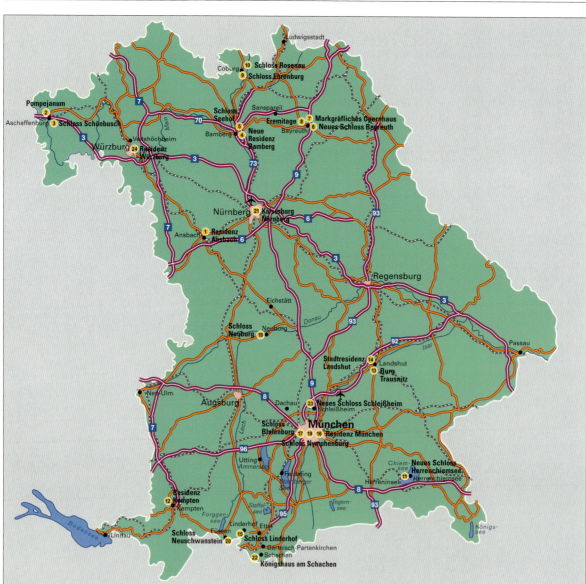

For information about other sites managed by Bayerische Verwaltung
der Staatlichen Schlösser, Gärten und Seen: www.schloesser.bayern.de

◁ *The stairs in the Residence at Würzburg*

Ansbach Residence

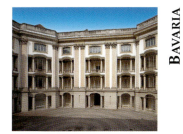

The Margrave's Audience Chamber

The town palace for the margraves of Brandenburg-Ansbach evolved from a medieval complex and is famous for the quality of its interior furnishing, most of which was done under the artistic guidance of architect Leopold Retti between 1734 and 1745. The financial resources were provided by the dowry of Prussian princess Friederike Luise, who married the owner, Margrave Carl-Wilhelm-Friedrich (r. 1729–1757) in 1729.

The interior of the Audience Chamber has been dominated since 1773 by the superb red and white cloth, in which only the green foliage has faded over the centuries. The silk lampas of French origin replaced the former wall tapestries. The "en suite" textiles still include not only the wall coverings, but also curtains, baldachin drapes and furniture covers. Complete and exquisitely preserved in its original composition, it constitutes a first-class textile monument unique for the period, at least in German-speaking countries.

ℹ Schloss- und Garten-
verwaltung Ansbach
Promenade 27
D-91522 Ansbach
Tel. (+49/0) 981/95 38 39-0
Fax (+49/0) 881/95 38 39-40
sgvansbach@bsv.bayern.de

⊘ April – September:
9 am–6 pm
October – March:
10 am–4 pm
Closed on Mondays
Guided tours every hour
(approx. 50 min.)

Last tour:
April – September: 5 pm
October–March: 3 pm

The Margrave's Audience Chamber, Ansbach Residence

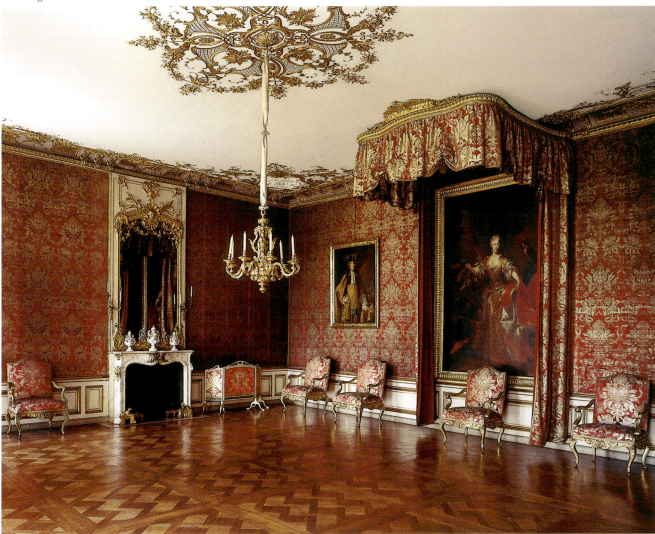

 ♿ Lift for disabled visitors

 ✕ Orangery Restaurant

 🚆 Ansbach

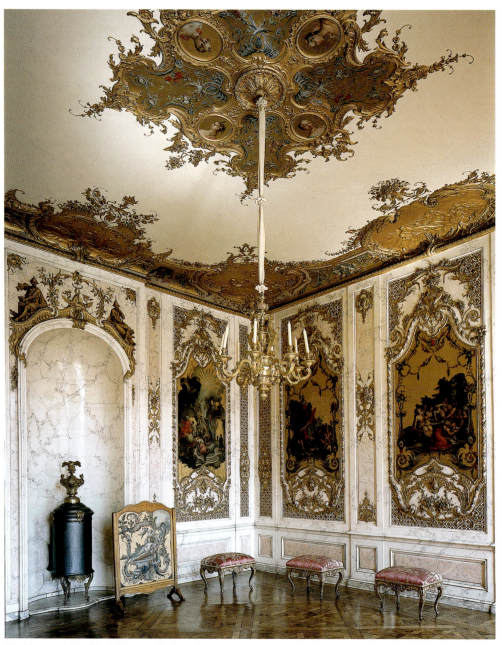

The Margrave's Marble Cabinet, Ansbach Residence

Opposite page:
The Margravine's Cabinet of
Mirrors, Ansbach Residence

The Margrave's Marble Cabinet

At the end of their ceremonial apartments, it was fashionable for the nobility to install sumptuous and exotic cabinets. The Marble Cabinet is set between the two apartments for the lord and lady of Ansbach. The strictly organised stucco-lustro surfaces in gentle hues are offset by ornamental and background gold to create one of the most elegant rococo interiors in Germany. The stucco was made by a Bavarian specialist around 1740 and the paintings are by Johann Adolf Biarelle, who was working in Ansbach.

Unusually, the six wall paintings – grotesques combined with fantastical rocaille in the manner of Lajoue – illustrate princely vices rather than virtues. The settings, however, are remote Arcadian and exotic worlds, which reflect the fascination for things Oriental and also a touch of Europe's sense of superiority. This is by no means an imitative "Oriental" cabinet, but a witty hybrid full of associations and potential discoveries.

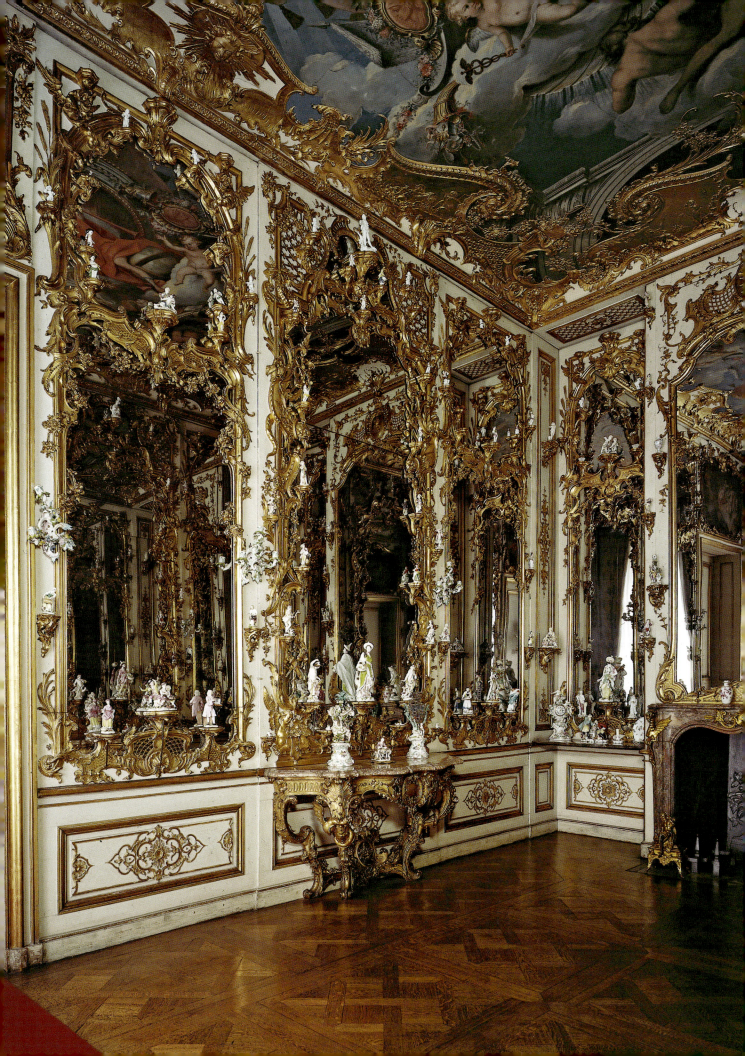

*Detail from the ceiling
in the Cabinet of Mirrors*

The Margravine's Cabinet of Mirrors

The cabinet of mirrors is an archetypal interior exemplifying the illusionist spirit of baroque art, which presents the world as appearance and reflection. Mirrors open up the walls into shimmering sequences of pseudo-spaces, and we must imagine the effects of reflected candle-light and the glittering of gold and porcelain. At the same time, the severely symmetrical arrangement of the mirrors in Ansbach respects court etiquette and exploits the wealth of colourful china figures on numerous frame-mounted consoles to the full. The ceiling with its painting of Pallas Athena encased in gilt stucco work illustrates the room's general theme of "Art and Science". Unlike the Marble Cabinet, where polychrome walls combine with a white ceiling, these essentially colourless walls bear an illusionist canopy of strong hues.

This fine cabinet in the apartment of Margravine Friederike Luise was made in 1739 to plans by Paul Amadeus Biarelle.

Pompeiianum
The Kitchen

King Ludwig I of Bavaria had the Pompeiianum in Aschaffenburg built by his architect Friedrich von Gärtner in 1840–1848. He wanted this ideal replica of a Roman house to recreate the derelict objects then being unearthed at Pompeii in a manner as true to the originals as possible, but without bearing the marks of damage. Before construction was over, an almost complete inventory had been acquired for the kitchen. All the vessels and utensils now on open display belonged to this original furnishing. The kitchen utensils of bronze are copies of originals excavated at Pompeii and Herculaneum. The sculptor and art expert Martin von Wagner had seen them in Naples Museum and proposed them as models. Ludwig I had these faithful replicas made in Rome by the sculptor and brass founder Wilhelm Hopfgarten in 1845–1850. The six large clay amphorae of various shapes then held wine and oil. They are actually Roman originals purchased at the time.

W. H.

i Schloss- und Gartenverwaltung Aschaffenburg
Schlossplatz 4
D-63739 Aschaffenburg
Tel. (+49/0) 60 21 / 3 86 57-0
Fax (+49/0) 60 21 / 3 86 57-16
sgvaschaffenburg@
bsv.bayern.de

⊖ April – September:
9 am–6 pm
October – March: closed
Closed on Mondays

♿ Most viewing on ground level, 1st floor only accessible via stairs

Park and grounds

A Local gallery of the State Classical Collections and Munich Glyptotheque

DB Aschaffenburg
🚌

The Kitchen, Pompeiianum

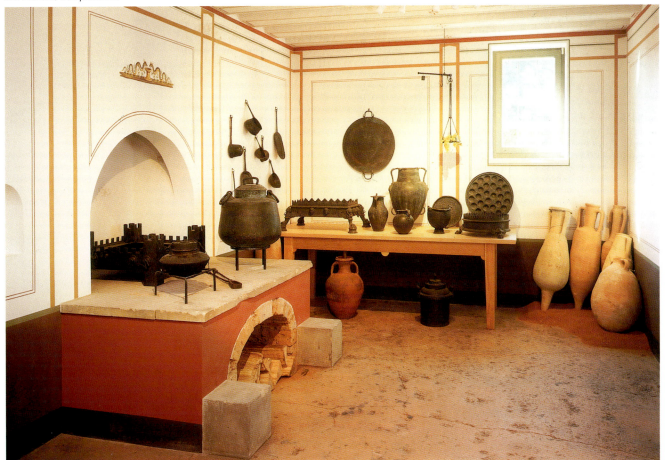

ℹ Schloss und
Park Schönbusch
Kleine Schönbuschallee 1
D-63741 Aschaffenburg
Tel. (+49/0) 60 21/8 73 08

ℹ Schloss- und Garten-
verwaltung Aschaffenburg
Schlossplatz 4
D-63739 Aschaffenburg
Tel. (+49/0) 60 21/3 86 57-0
Fax (+49/0) 60 21/3 86 57-16

🕓 April – September:
9 am–6 pm
October–March: closed
Closed on Mondays

Exhibition in the park
(kitchen wing)

🕓 April – September:
Sa, Su, public holidays
11 am–6 pm
Guided tours every hour
(approx. 20 min.)
Last tour:
April – September
5 pm

♿ Viewing areas only
accessible via stairs

✕ Hotel/Restaurant/Café
Schönbusch

DB Aschaffenburg

🚌

Schönbusch Palace
The Central Hall

The first building that Friedrich Carl von Erthal, Archbishop and Elector of Mainz, commissioned for his new landscape garden at Schönbusch near Aschaffenburg was a garden palace (1778–1782). The Central Hall on the upper floor is a fine example of transposing a baroque idea – the hall of mirrors – into the formal idiom of early neo-classicism. The three large French windows to the balcony are matched by mirrored doors on the inner walls. All the doors and the fireplace projection are flanked by ionic double pilasters worked in stucco with an entablature binding them. In the cavity moulding above there are mezzanine windows and matching oblong mirrors. When designing the flat ceiling organised by fields of stucco, the architect Emanuel Joseph von Herigoyen used a drawing from the collection "A Book of Ceilings", published in 1776 by the Englishman George Richardson, which the Elector had purchased for his library. The colour scheme, with cool yet strong hues, echoes its hand colouring. W. H.

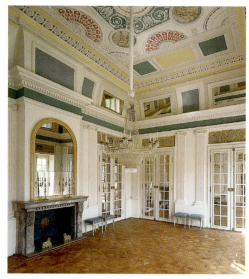

The Central Hall in Schönbusch Palace

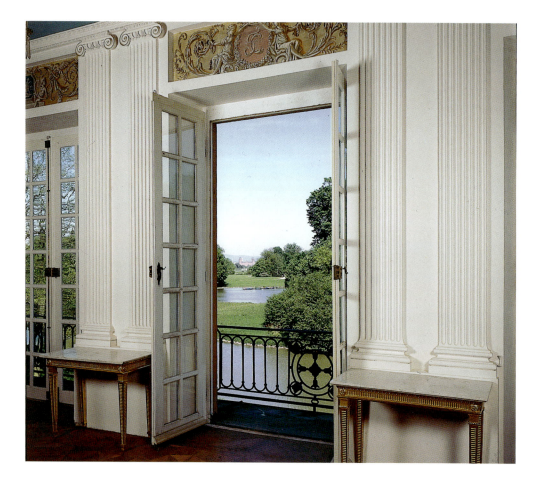

View from the Central Hall towards the town palace of Johannisburg

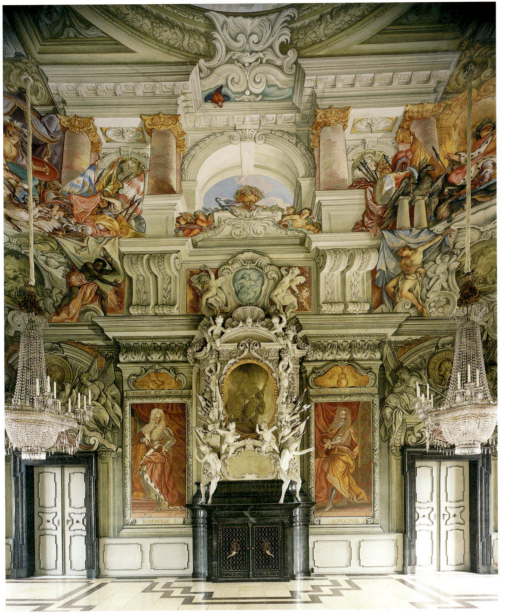

ℹ Schloss- und Garten-
verwaltung Bamberg
Domplatz 8
D-96409 Bamberg
Tel. (+49/0) 951/5 19 39-0
and (+49/0) 951/5 19 39-114
Fax 5 19 39-129
sgvbamberg@bsv.bayern.de

⊘ April – September:
9 am–6 pm
October – March:
10 am–4 pm
Guided tours
(approx. 45 min.)

⊘ Tour of the Domberg:
approx. 90 minutes
(cathedral, old court, New
Residence, Imperial Hall)

♿ Lift available

Together with the old town
this is a Unesco World
Heritage site

⊞ Museum shop

✗ Café im Rosengarten

🄳🄱 Bamberg

North-east wall, Imperial Hall

New Residence in Bamberg
The Imperial Hall

The New Residence on the cathedral square was the seat of the prince-bishops of Bamberg. The Imperial Hall constructed around 1700 under Lothar Franz von Schönborn was relatively low because it was on the first floor. Melchior Steidl, an artist from the Tyrol, tried to remedy the effect when he painted the room in 1707–1709. With trompe l'oeil architecture he opened the room upwards to an illusionist view of the heavens. The programme begins at the window piers with 16 larger-than-life portraits of German Emperors from Heinrich II, who founded the Bamberg diocese in 1007, to Joseph I, since 1705 the reigning Habsburg. The ceiling follows with allegories of the four world empires, the diurnal phases and the seasons. The composition is crowned at the centre by a timeless allegory of Good Governance in triumphant procession across the sky. – Owner Lothar Franz von Schönborn was also Prince-Bishop of Mainz and Imperial Chancellor. With this room he paid enduring tribute to his close links with the Habsburg court in Vienna.

i Schloss und Park Seehof
D-96117 Memmelsdorf
Information:
Tel. (+49/0) 951/4095-71
Fax (+49/0) 951/4095-72

⊙ April – October:
9 am–6 pm
November – March: closed
Closed on Mondays

♿ Viewing areas only
accessible via stairs

Historical gardens

⊞ Museum shop

DB Bamberg

🚌

Detail: Diana group, White Hall

Seehof Palace
The White Hall

White Hall, Seehof Palace

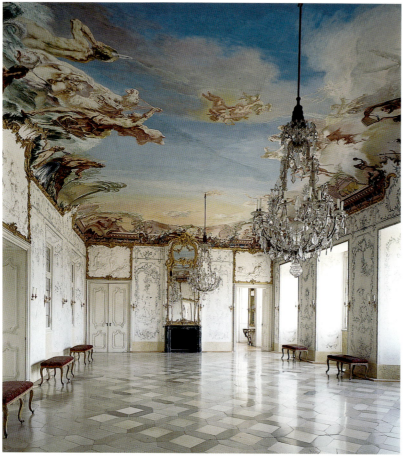

Schloss Marquardtsburg, or Seehof, was the summer residence of Bamberg's prince-bishops. Under Johann Philipp Anton von Franckenstein several rooms were modernised to suit contemporary taste. One was the principal room, the White Hall. It was gently furbished with white polished stuccolustro walls and delicate blue ornamental groups reminiscent of porcelain painting. The court artist from Mainz, Giuseppe Appiani, was appointed in 1751 to paint the ceiling. His complicated programme of gods, with references to the hunt, the garden, fishing and other economic pursuits at Seehof, is a balanced composition packed with activity between night and dawn. The powerful hues of the ceiling harmonise beautifully with the white and blue walls. Thanks to mirrors over the fireplaces and by the inner windows the room stretches optically into infinity. Its artistic design makes it not only the most elaborate room in Schloss Seehof, but also one of the most original late rococo interiors in Franconia.

A.S.

New Palace in Bayreuth
The Palm Room

A fire at the old residence in 1753 offered Margrave Friedrich of Bayreuth and his lady Wilhelmine an opportunity to build their new palace. Its impact is due less to a pompous exterior than to the superb decoration of its interiors. The margravine wrote to her brother, Friedrich the Great, that she was much involved in the planning. Wilhelmine's claim is credible once one begins to appreciate the witty references in the decoration. The Palm Room is an excellent example. As an archetype, this kind of gallery was often found in such palaces, but there is no design like it anywhere else. Sculpted palms line the walls creating the illusion that we are standing in a palm grove. The inspiration was the Holy of Holies in Solomon's Temple as described in the Bible. The room was probably also used for meetings of the Freemasons' Lodge in Bayreuth founded by Margrave Friedrich.

P.K.

ℹ Schloss- und
Gartenverwaltung
Bayreuth-Eremitage
Ludwigstr. 21
D-95444 Bayreuth
Tel. (+49/0) 921/7 59 69-21
Fax (+49/0) 921/7 59 69-15
sgvbayreuth@bsv.bayern.de

🕐 April – September:
9 am–6 pm
October – March:
10 am–4 pm

🅿 Disabled parking available

🅰 Archaeology Museum
of the Upper Franconian
History Society

DB Bayreuth

Palm Room, New Palace in Bayreuth

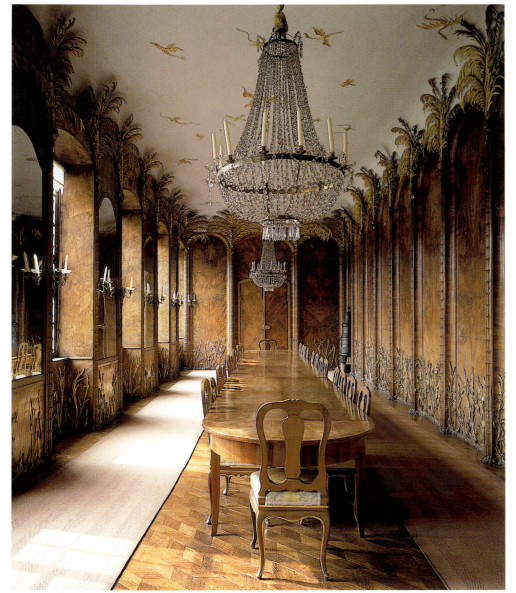

Detail: stucco ornament on the Palm Room ceiling

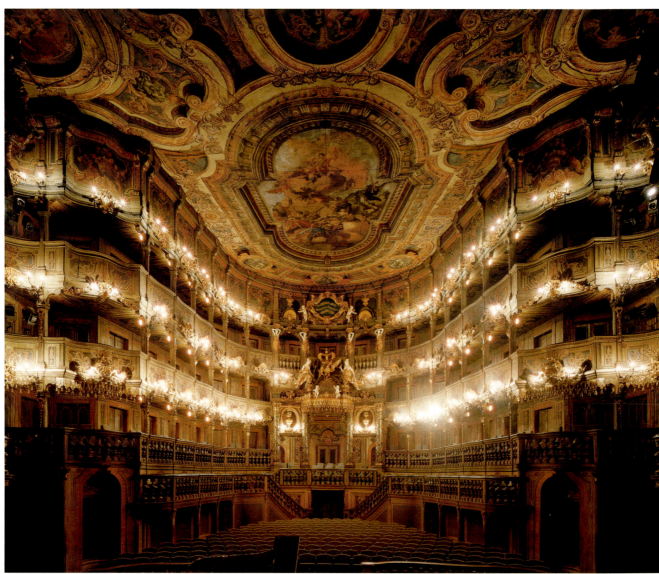

Auditorium, Margravial Opera House

Bayreuth
Markgräfliches Opernhaus
Opernstraße 14
D-95444 Bayreuth

ℹ Schloss- und
Gartenverwaltung
Bayreuth-Eremitage
Ludwigstr. 21
D-95444 Bayreuth
Tel. (+49/0) 921/759 69-22
Fax (+49/0) 921/759 69-32
sgvbayreuth@bsv.bayern.de

🕙 April – September:
9 am–6 pm
October – March:
10 am–4 pm

🅿 Disabled parking available

⊞ Museum shop

✕ Café an der Oper

🚉 Bayreuth

Bayreuth
The Margravial Opera House

The biggest festivity ever celebrated in Bayreuth in the days of the margraves was the wedding of Princess Friederike to Duke Carl II Eugen of Württemberg. The highlight was the opening of the Margravial Opera House in 1748 with the performance of two operas. Planning began in 1744. Europe's most celebrated theatre architect, Giuseppe Galli Bibiena of Parma, was recruited to design the interior. Borrowing from the court opera house in Vienna built by his uncle Ferdinando, Giuseppe created an auditorium on a bell-shaped plan. Compared with Vienna the forms are more modern and the dimensions greater. Three tiers clasp at their apex the magnificent Prince's Box with its triumphal arch motif and baldachin. The Brandenburg eagle is just landing. This is one of the world's major surviving historical theatres. It testifies both to the high standards of stately representation to which the margraves of Bayreuth aspired and to their proverbial love of opera.

P. K.

Hermitage
The Old Palace

A noble birthday present! After Crown Prince Friedrich became Margrave of Brandenburg-Bayreuth in 1735 he celebrated his wife Wilhelmine's birthday by presenting her with the Hermitage. Wilhelmine immediately set about plans for redesigning the whole complex. She kept the sections built by Margrave Georg Wilhelm from 1718, especially the grotto with its unusual fountains, the ballroom and the monastic courtyard. She extended the ballroom section to the east and west by adding two little apartments. The rooms on the margravine's side are noteworthy, their highlights being the Japanese Cabinet and the Music Room. The cabinet is faced entirely with lacquered panels. Two were given to her by her brother Friedrich the Great and she is reported to have made the others herself. They show scenes from the court of the Chinese Emperor. The serene and carefree life was naturally supposed to suggest Friedrich and Wilhelmine's court at Bayreuth. The theme in the adjoining Music Room is "Friendship" and "Harmony", personified in portraits of Wilhelmine's ladies-in-waiting along with musical instruments in stucco relief.

P. K.

Altes Schloss und
Hofgarten Eremitage
Eremitage Haus Nr. 1
D-95448 Bayreuth

i Schloss- und
Gartenverwaltung
Bayreuth-Eremitage
Ludwigstr. 21
D-95444 Bayreuth
Tel. (+49/0) 921/7 59 69-37
Fax (+49/0) 921/7 59 69-41
sgvbayreuth@bsv.bayern.de

⊙ April – September:
9 am–6 pm
1–15 October:
10 am–4 pm
16 October – March:
closed

Fountains
May – 15 October
10 am–5 pm on the hour

Inner Grotto with fountains
playing: access with guide
for groups of 10 or more

♿ € 1.50; wheelchairs
available

▦ Museum shop

✕ Hotel/Restaurant
Orangery/Café Orangery

DB Bayreuth

🚌

Japanese Cabinet, Hermitage

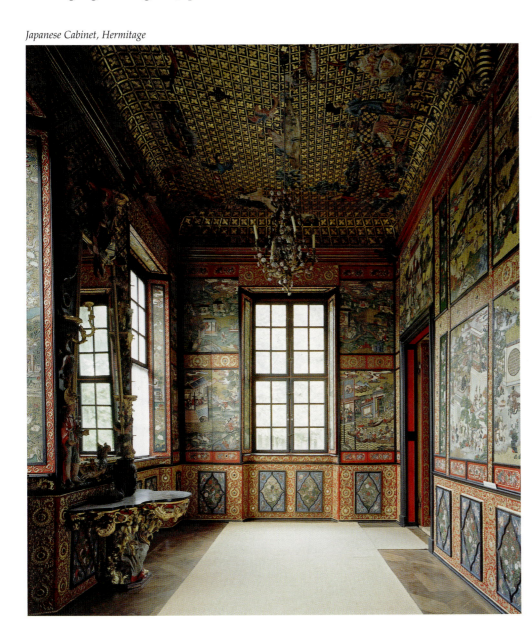

BAYERISCHE VERWALTUNG DER STAATLICHEN SCHLÖSSER, GÄRTEN UND SEEN

i Schloss Ehrenburg
Schloss- und
Gartenverwaltung Coburg
Schloss Ehrenburg
D-96450 Coburg
Tel. (+49/0) 95 61/80 88-0
Fax (+49/0) 95 61/80 88-40
ehrenburg@sgv.coburg.de
www.sgvcoburg.de

⊙ April – September:
9 am–6 pm
October – March:
10 am–4 pm
Closed on Mondays
Guided tours every hour
Last tour:
April – September
5 pm
October – March
3 pm

♿ Wheelchair access
by arrangement

⊞ Museum shop

✗ Cafeteria

DB Bayreuth

🚌

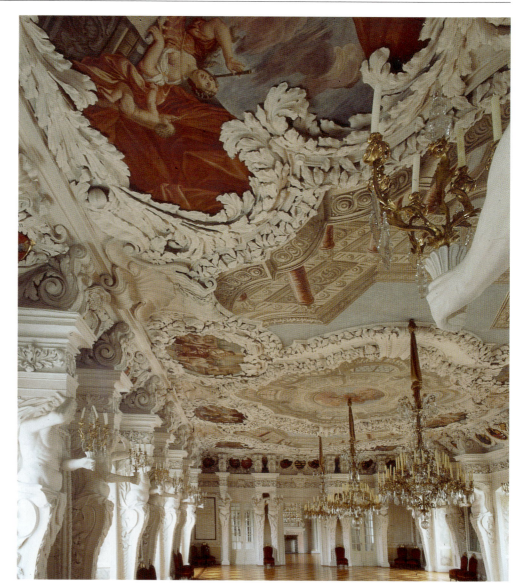

Hall of Giants, Ehrenburg Palace

Ehrenburg Palace

The Hall of Giants

The Ehrenburg at Coburg evolved from a monastery dissolved in the 16th century. Among the older buildings still extant is the south wing, renewed after a fire in 1690. It includes the palace church and above it the broad span, equal in size, of the Hall of Giants. The brothers Carlo Domenico and Bartolomeo Lucchese did the stucco work in 1697–1699. The heavy entablature is supported by the "giants", figures of Atlas before the window piers. The coats-of-arms embedded in pairs in this entablature stand for former Wettin territories reflecting the claims of the dynasty. Allegories of the fine arts and the sciences take their place on the ceiling between billowing garlands of foliage and flowers. A false dome in painted form crowns the hall at the centre. Minerva, patroness of art and science, floats down on a bed of clouds from the open sky. With its impressive stucco work the Hall of Giants remained the grandest room of state in the Duchy of Saxe-Coburg and Gotha until the end of the monarchy.

Duke Ernst I's Bedroom

This room, better known in later years as the bedroom where Queen Victoria slept, was originally used by Duke Ernst I. Spiral stairs link this with the Duchess's bedroom below. After 1860 a gathered curtain of light silk replaced the partition originally built to separate the alcove. Comfort meant sacrifices, and the mahogany faced WC from England and brown floral wallpaper date from around the same time.

The particular quality of this interior derives from the outstanding furniture, a mahogany suite with swan motifs made in Paris in 1815. Traditionally, the bed is the focus. The coat-of-arms, symbolising the alliance between Saxony and Baden, is a reference to Ernst II and Alexandrine. Along with the adjacent rooms, the library and dressing room, this suite of rooms is one of the most sumptuous residential ensembles anywhere in Germany.

A. S.

Bedroom, Ehrenburg Palace

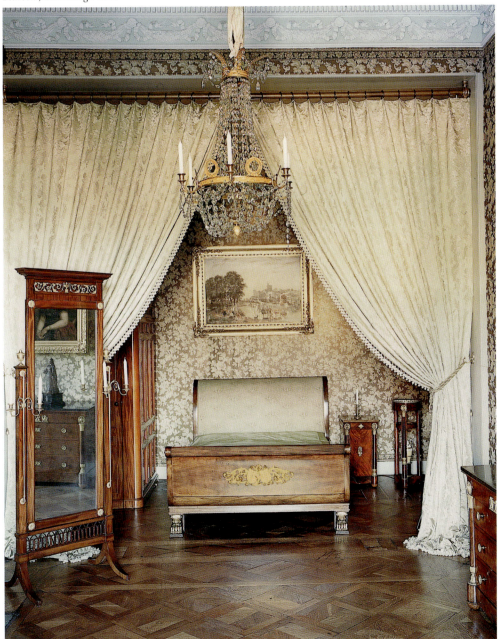

BAYERISCHE VERWALTUNG DER STAATLICHEN SCHLÖSSER, GÄRTEN UND SEEN

i Schloss und Park Rosenau
Schloss- und Gartenverwal-
tung Coburg
Schloss Rosenau
D-96472 Rödental
Tel. (+49/0) 95 63/30 84-0
Fax (+49/0) 95 63/30 84-29
rosenau@sgv.coburg.de
www.sgvcoburg.de

⊘ April – September:
9 am–6 pm
October – March:
10 am–4 pm
Closed on Mondays
Guided tours every hour
Last tour:
April – September
5 pm
October–March
3 pm

♿ No lift available

A Orangery in Rosenau Park,
Modern Glass Museum

▦ Museum shop

✕ Park Restaurant Rosenau

DB Rödental/Oeslau

Rosenau Palace

The Marble Hall

Duke Ernst I of Saxe-Coburg and Gotha (1806–1844) dreamt of a medieval castle and he fulfilled his dreams by converting the medieval Burg Rosenau into a summer pavilion. The Gothic conversions began in 1814. The old layout was irregular, but this was concealed by turning the Marble Hall, the principal room of the old structure, into a three-aisled hall with groin vaulting. Pearl grey stuccolustro lines the walls and clustered piers; arabesques in delicate gold weave across the vaults. Below these gilt Viennese chandeliers in Gothic forms provide light. Stucco work, paint and gold leaf put elegant finishing touches to the chosen materials, blending seamlessly into this vision of medieval architecture that also pervaded the library and other rooms as well as the landscaped park with its jousting ground. Rosenau was one of the first buildings in Germany where the Middle Ages were revived as a romantic ideal in concrete form.

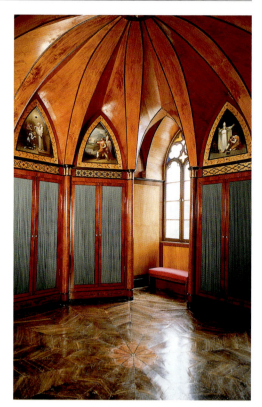

Library, Rosenau Palace

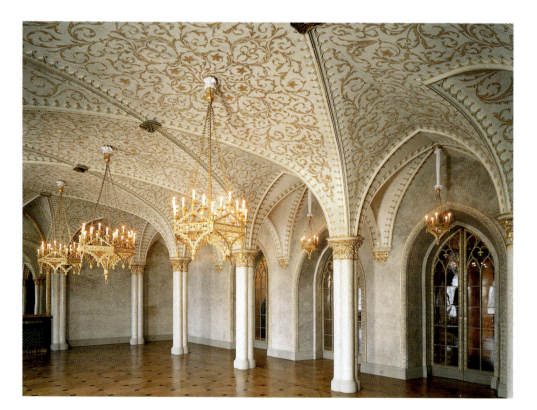

Marble Hall, Rosenau Palace

The Duchess's Salon

When the restoration of Rosenau's upper floors began in 1972, following their use for other purposes, help was provided by inventories, finds and interior views from the mid-19th century. Most of the furniture had also survived. This made it possible to restore the Duchess's former salon on the first floor and show how a medieval lifestyle was imitated in 1815. The stylistic references focus entirely on the wallpaper-like mini-formats of the wall painting with its Gothic motifs. This has not been exposed throughout, but reconstructed from findings. The black polished Viennese furniture is Biedermeier in style. The transparent curtains were recreated from Ferdinand Rothbart's interior watercolour of around 1850. The overall appointment of the salon recalls a generously furnished bourgeois living room rather than a princely apartment, with contemporary views of domestic comfort taking precedence over antiquarian fidelity.

A.S.

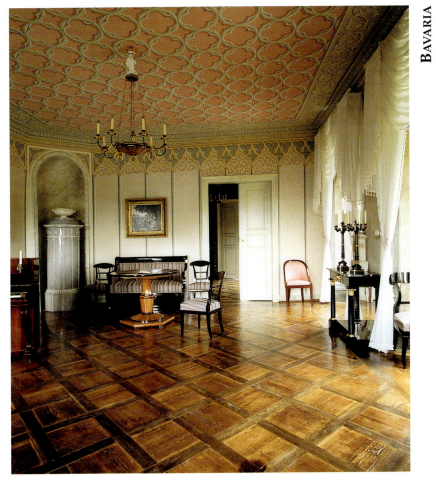

The Duchess's Salon, Rosenau Palace

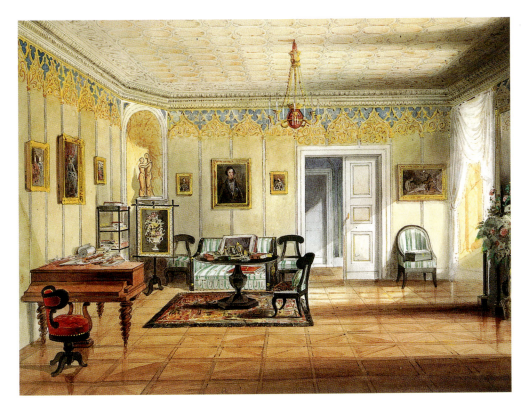

Watercolour (Rothbart, c. 1850), The Duchess's Salon

i Schloss- und
Gartenverwaltung
Herrenchiemsee
D-83209 Herrenchiemsee
Tel. (+49/0) 80 51/68 87- 0
Fax (+49/0) 80 51/68 87-99
Infoline 08051/6887-91
info@herren-chiemsee.de
www.herrenchiemsee.de

☉ April – September:
9 am–6 pm
October–March:
9.40 am–4 pm

☉ Guided tours
(approx. 35 min)
for groups of
max. 70 people
Last tour:
April – September
5.15 pm
October
4.40 pm
November – March
3.40 pm

Fountains:
May – 3 October:
9.35 am–5.25 pm daily
at 15 minute intervals

♿ Lift available for disabled
visitors

Visitors' Centre

DB Prien

⛴

Herrenchiemsee New Palace

The State Bedroom

The State Bedroom was the first room to be completed in the New Palace at Herrenchiemsee. It was handed over to its owner, King Ludwig II of Bavaria, on 18 September 1881. "Under the sign of the Sun" – this extraordinary late Historicist room of state is a unique homage to King Louis XIV of France, who personified Ludwig II's idealised views of absolute monarchy.

As the setting for the "lever" and "coucher", the first and last session of audience each day, the bedroom also functioned as a throne room in Louis XIV's ceremonies of court at Versailles. Taking this much admired model as his point of departure, Ludwig made his State Bedroom the linchpin of the palace, an interior of solemn dignity unsurpassable in rich splendour, a "monument " not to use but to "observe", as Ludwig II put it. The state bed is aligned to the sunrise via the central window. The painting of Apollo in his sun chariot on the ceiling thus

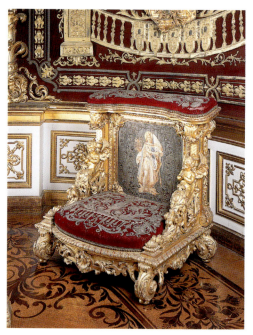

Prayer seat "Prie-dieu" in the State Bedroom

acquires cult significance as an apotheosis of the "Sun King".

E. D. S.

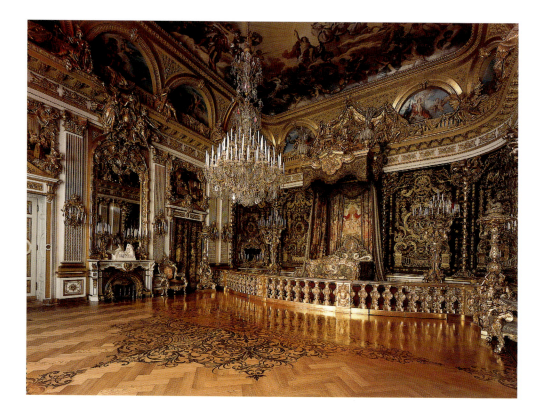

State Bedroom, Herrenchiemsee New Palace

The Porcelain Cabinet

At Herrenchiemsee New Palace, built in 1878–1886 in imitation of Versailles, Ludwig II sought to turn the clock back to the days of absolute monarchy. The Porcelain Cabinet accordingly draws on a courtly archetype of the baroque and rococo periods. During the 17th- and 18th-century fashion in Europe for anything Chinese, many porcelain cabinets were built as showcases for priceless Oriental (and after 1708 European) china. Apart from the vases, wall and floor lamps of Meissen porcelain, even mirror frames, wall tables and desk inlays, were made from porcelain specifically for this room. When the king died in 1886 the Porcelain Cabinet – like the palace complex as a whole – remained unfinished. The original intention had been to fill the wall panelling with china insets. F. U.

Porcelain Cabinet, Herrenchiemsee New Palace

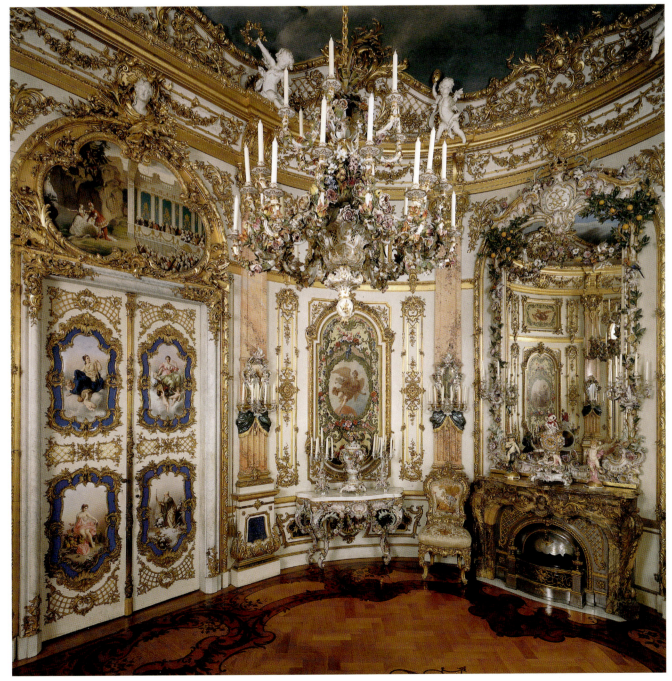

BAYERISCHE VERWALTUNG DER STAATLICHEN SCHLÖSSER, GÄRTEN UND SEEN

Residenz Kempten
Residenzplatz 4–6
D-87435 Kempten

i Bayerische
Schlösserverwaltung
– Außenstelle Kempten –
Mr Josef Hiemer
Am Stadtpark 3
D-87435 Kempten
Tel. (+49/0) 831/256-251
Fax (+49/0) 831/256-260

⊙ April – September:
9 am–4 pm
October:
10 am–4 pm
November,
January – March:
Saturdays 10 am–4 pm
December:
see local newspapers
Closed on Mondays
Guided tours every
45 minutes

 ♿ Lift available for disabled
visitors

DB Kempten

Residence
The Throne Room

The first impression one gains of the prince-bishops' residence in Kempten is of sturdy and severe architecture that largely dispenses with decoration. In fact, this complex built from 1651 to 1670 was the first monumental baroque monastery after the Thirty Years' War. From 1728 the art-loving prince-abbot Anselm von Reichlin-Meldegg set about refurbishing his living quarters. The result is a suite of rooms which indulge effusively in adorn-ment, a crescendo of Bavarian rococo. The Throne Room, created in 1740–1743 probably by Dominikus Zimmermann, is unmatched. The painter Franz Georg Hermann, the sculptor Aegid Verhelst and the stucco artist Johann Georg Üblher contributed to the decoration. All the figures and the ceiling glorify the abbey and its history, which dates back to 750 when it was founded as an offshoot of St. Gallen. P. K.

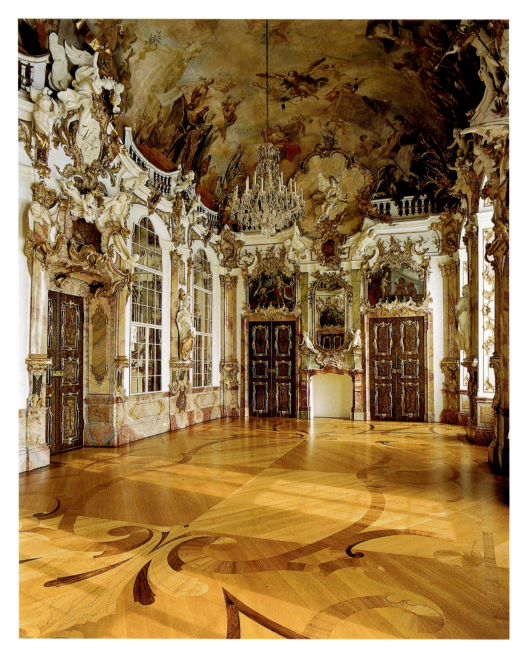

Throne Room, Kempten Residence

BAVARIA

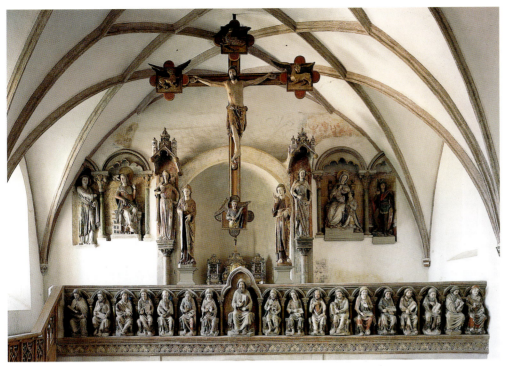

East gallery with figures, chapel at Trausnitz Castle

ℹ Burg Trausnitz
Burgverwaltung Landshut
Burg Trausnitz 168
D-84036 Landshut
Tel. (+49/0) 871/9 24 11-0
and -44 (Infoline)
Fax (+49/0) 871/9 24 11-40
burgverwaltung.landshut@
bsv.bayern.de
www.burgtrausnitz.de

⊘ April – September:
9 am–6 pm
October–March:
10 am–4 pm
Guided tours
(approx. 45 min.)
Evening tours by request

♿ Viewing areas only
accessible via stairs

⊞ Museum shop

✗ Burgschänke

Chamber of Art and
Curiosities

DB Landshut

Trausnitz Castle

The Castle Chapel of St George

The "Kelheim Duke" Ludwig founded this Bavarian seat of the Wittelsbach dynasty in 1204. It later evolved into an imposing castle, acquiring considerable status between 1255 and 1503 as the residence of the dukes of Lower Bavaria.

The Chapel of St George is one of the original buildings in the medieval castle. Its sculpture dating from 1230/35 – a monumental carved Crucifixion scene and the coloured stucco figures on the altar wall and gallery balustrade – is held in great esteem by art historians. SS. Catherine and Barbara and the Annunciating Angel are especially intriguing for their similarity to French cathedral statuary. In the 14th century the Rich Dukes of Bavaria-Landshut donated three Gothic winged altars, major works of Old Bavarian painting. Duke Ludwig X modernised the chapel in 1517 with a Late Gothic ribbed vault. Even King Ludwig II left his mark in 1871 by commissioning a relief of the Virgin Mary and St George incorporating his own portrait as patron.

Wing of the high altar showing its donor Duke Heinrich the Rich, chapel at Trausnitz Castle

Bayerische Verwaltung der staatlichen Schlösser, Gärten und Seen

Detail: Pantalone sits astride a donkey while Zanni plunges an enema into its gut

Pantalone's Serenade, Stairway of Fools, Trausnitz Castle

Stairway of Fools

In the 16th century Trausnitz served to maintain the court of Bavaria's crown princes. Wilhelm, who moved to Munich in 1579 as Duke Wilhelm V, turned it into a Renaissance Court of Muses. He had multi storcy arbours created around the castle yard, the Italian annexe built and pleasure gardens laid out.

The famous Stairway of Fools remains today, painted with life-size scenes of Italian commedia dell'arte. This farce of love and jealousy, improvised by travelling players, always centres on the same characters, including the Venetian merchant Pantalone and his servant Zanni. The Stairway of Fools at Landshut is the earliest and only monumental specimen of visual art devoted to this popular court entertainment.

Friedrich Sustris, who trained in Florence, designed the paintings. They were implemented by Alessandro Padovano around 1575–1579 and Antonio Ponzano added the grotesques. This team was soon to provide another major work for the Antiquarium of the Munich Residence.

B. L.

Landshut Town Residence

The Italian Hall

In 1536 Duke Ludwig X of Bavaria (r. 1516–1545), who resided in Landshut as its governor, began building a new seat in the centre of town. Much struck by his recent Italian journey, the duke altered the plans. By 1543 a courtyard with arcades linked the completed German Building with the new Italian Building. The result was a spectacular ensemble which remains unique – the first palazzo in Italian Renaissance style north of the Alps.

The Italian Hall exemplifies the interior appointment of this stately suite. The coffered barrel vault was inspired by Giulio Romano's Palazzo Te in Mantua and stucco artists were brought from there to decorate the ceiling. The Salzburg painter Hans Bocksberger the Elder produced a scholarly programme reflecting Humanist ideas with portraits of celebrated Ancients. The bas-relief medallions depicting the Deeds of Hercules along the walls are sculptural masterpieces of the Renaissance.

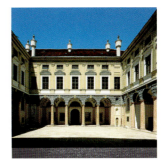

Stadtresidenz Landshut
Altstadt 79
D-84028 Landshut

ℹ Burgverwaltung Landshut
Burg Trausnitz 168
D-84036 Landshut
Tel: (+49/0) 871/9 24 11-0
and -44 (Infoline)
Fax (+49/0) 871/9 24 11-40

Italian Hall, Landshut Town Residence

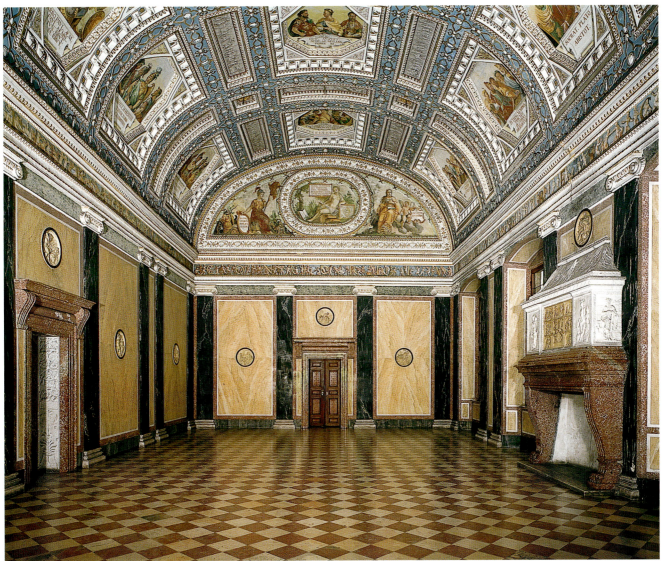

BAYERISCHE VERWALTUNG DER STAATLICHEN SCHLÖSSER, GÄRTEN UND SEEN

⊘ April – September:
9 am–6 pm
October – March:
10 am–4 pm
Closed on Mondays
Guided tours
(approx. 45 min.)

♿ Lift available

✖ Residenzcafé

🅰 Landshut Town Museums

🆔 Landshut

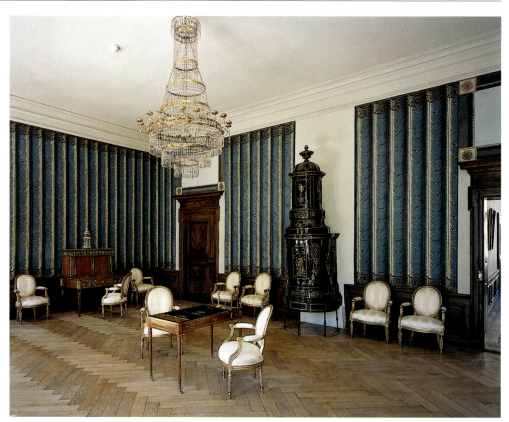

Reception room in the Birkenfeld Rooms, Landshut Town Residence

*Detail: arabesque wallpaper,
bedroom in the Birkenfeld Rooms*

The Birkenfeld Rooms

The Birkenfeld Rooms in the German Building were refurbished in neo-classical style around 1780 as quarters for Count Palatinate Wilhelm of Birkenfeld-Gelnhausen, brother-in-law to Bavaria's future first king. The furniture and typical local tiled stoves recall this period in court life at Landshut.

The dominant feature today is the wallpaper, discovered a few years ago during restoration of the suite and now fully exposed to view. Applied in 1803, when the young prince and future King Ludwig I of Bavaria was living here as a student, they are one of the earliest and hence especially valuable specimens of this heyday of wallpaper art. Each room has a different paper decoration – a deceptive imitation of textile drapes, in fashionable Pompeian style or with bright arabesques. They were made in French manufactories from individual sheets of hand-made paper and hand-printed using wooden moulds.

B. L.

Linderhof Palace

The Dining Room

King Ludwig II of Bavaria had intended to build a new Versailles here in the Graswang valley in honour of his Bourbon namesake.

Instead he conceived a royal villa in rococo style with many Bourbon associations, constructed from 1870 to 1878. The few rooms are intimate but overloaded with decoration and were intended for use without company. The oval Dining Room in red, white and gold was finished in 1872.

The panelling shows how raw produce was obtained for the royal table: by gardening, hunting, fishing and farming. One highlight is the "self-laying" table in the middle of the room which the king had specially made based on 18th-century French models.

It would sink into the floor, where it would be laid on ground level below and raised with the aid of a lift. This enabled the king to dine undisturbed by servants and to cultivate imaginary conversations.

K. K.

Detail: painted ceiling in the Dining Room

ℹ Schloss und Park Linderhof
Schloss- und Garten-
verwaltung Linderhof
Linderhof 12
D-82488 Ettal
Tel. (+49/0) 88 22 / 92 03-0
Fax (+49/0) 88 22 / 92 03-11
sgvlinderhof@bsv.bayern.de
www.linderhof.de

🕑 April – September:
9 am–6 pm
October – March:
10 am–4 pm

Guided indoor tours
(approx. 25 min.) for groups
of max. 40 people;
special tours by request

Fountains: early
April – 31 October
9 am–6 pm every half hour

♿ Wheelchairs available
at the ticket office

⊞ Museum shop

✗ Schlosshotel

DB Oberau or Oberammergau

🚌

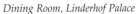

Dining Room, Linderhof Palace

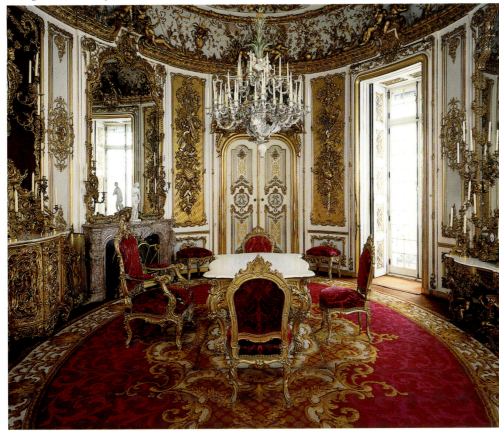

Park and park buildings
(Grotto, Moorish Kiosk,
Moroccan House,
Hurding's Hut and
Gurnemanz Hermitage):

ℹ Schloss- und Garten-
verwaltung Linderhof
Linderhof 12
D-82488 Ettal
Tel. (+49/0) 88 22/92 03-0
Fax (+49/0) 88 22/92 03-11
sgvlinderhof@bsv.bayern.de
www.linderhof.de

🕙 April– September:
9 am–6 pm
October – March:
closed
Opening times may vary as
seasonal weather permits

Guided tours in the Grotto
(approx. 15 min.) for
max. 100 people; special
tours by arrangement

Park tours by arrangement

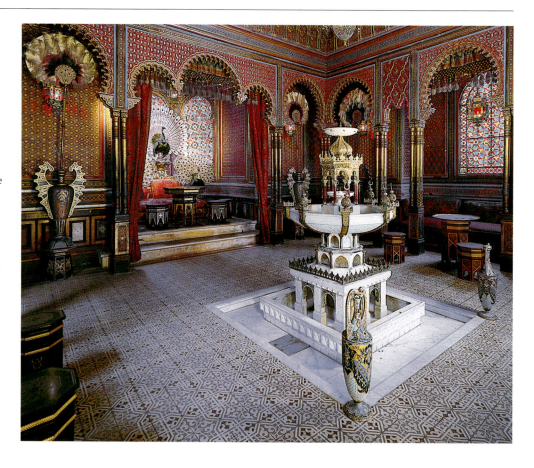

*Interior of the Moorish Kiosk,
Schloss Linderhof*

The Moorish Kiosk

The domed Moorish Kiosk was originally
a Prussian contribution to the World Exhi-
bition at Paris in 1867. It was designed by
Karl von Diebitsch, a connoisseur of mock
Oriental architecture and its leading pro-
ponent in Berlin. King Ludwig II of
Bavaria saw the structure at the exhibi-
tion, where he discovered the internation-
al dimensions of the contemporary Orien-
tal vogue.

Diebitsch's much admired pavilion was
first acquired by the industrialist Bethel
Henry Strousberg, one of the richest men
in Germany, but Ludwig II managed to
purchase it for the park at Schloss Linder-
hof in 1876. Court architect Georg Doll-
mann transformed it by 1878 into an Ori-
ental throne room with a direct reference
to the Bavarian king. Dollmann added the
semi-circular apse for the peacock throne
and in general the appointment grew
more lavish. F. X. Zettler, a Munich com-
pany, made new stained glass windows to
a design by Franz Seitz, with imaginative
ornament that makes the colours glow
like in a kaleidoscope. The shapes and
colours combine in subdued light to cre-
ate a captivating celebration of Oriental
fairy-tale glamour.

E. D. S.

Peacock throne, Moorish Kiosk

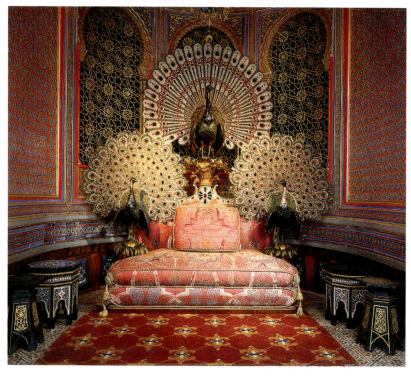

Munich Residence

The Antiquarium (Hall of Antiquities)

From 1508 to 1918 the Munich Residence was the seat of Bavaria's dukes, electors and kings, the Wittelsbach dynasty. The Antiquarium is the oldest hall of state to have survived. Duke Albrecht V commissioned this 66-metre long vaulted Renaissance hall in 1568–1571 to display his large collection of Ancient sculptures. In 1580–1590 Friedrich Sustris converted the Antiquarium into a banqueting hall for Albrecht's successor Wilhelm V. The grotesques date from this period, as do the views of Bavarian towns in the vaults and the two sideboards in the window niches, used as dressers for the festive table on the podium in front of the fireplace. Around 1600 Duke Maximilian I asked Hans Krumper to redesign the superstructures for the fireplace and portal on the end walls, and around 1615–1620 he had court painter Peter Candid renew the allegories of Glory and the Virtues in the apex of the vault. Thus evolved an interior which projected the prestige its Bavarian owners wished to convey.

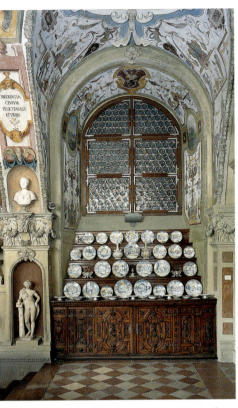

Window niche with sideboard and majolica service for Albrecht V in the Antiquarium

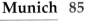

ℹ Residenz München
Verwaltung der Residenz München
Residenzstraße 1
D-80333 München
Tel. (+49/0) 89/2 90 67-1
Fax (+49/0) 89/2 90 67-225
residenzmuenchen@
bsv.bayern.de

⊘ April – 15 October:
9 am–6 pm
16 October – March:
10 am–4 pm

Separate morning and afternoon tours
Free audio-guide available

♿ Viewing areas accessible via steps

Court Garden (Hofgarten)

🚆 Munich

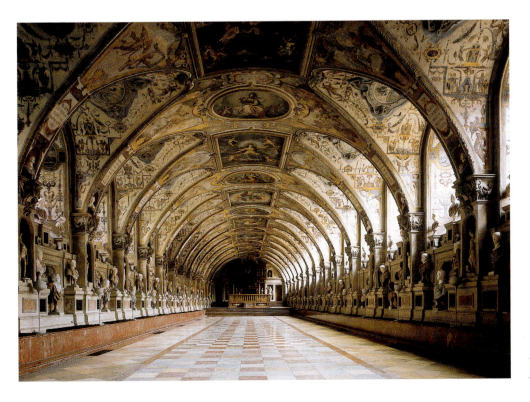

The Antiquarium, Munich Residence

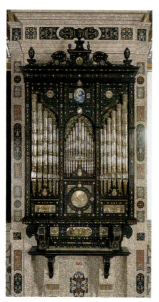

The organ display in the Ornate Chapel

The Ornate Chapel

The Ornate Chapel was consecrated in 1607 as a private chapel of vigil and prayer for Duke Maximilian I and his wife Elisabeth of Lorraine. It housed the "sacred treasures" of the Munich court, a collection of precious relics. The Rich Chapel reflected the personal piety of the Catholic ruler and was also the religious pivot of a Residence which Maximilian had substantially extended and lavishly appointed.

The chapel walls were inlaid with scagliola (colourful stuccolustro) by Blasius and Wilhelm Pfeiffer ("Fistulator"). The altar with silver relief made in Augsburg, the superb organ, the reliquary and the painted glass windows of the dome belonged to the original furbishing of the chapel, severely damaged in 1944 but later restored. Whereas the gilt stucco ceiling against a background the colour of lapis lazuli had to be remade, the gilt terracotta relief was reconstructed from preserved fragments.

The Ornate Chapel, Munich Residence

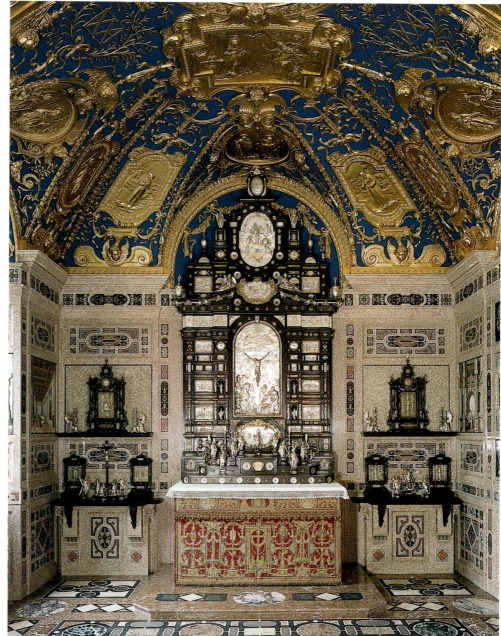

The Ancestral Gallery and Treasure Cabinet

Elector Karl Albrecht had the Ancestral Gallery built in 1726–1730 from drawings by Joseph Effner to replace an open conservatory. Soon afterwards in 1730–1733 the new court architect François Cuvilliés the Elder added a Treasure Cabinet. The stucco work for the ceiling was mode by Johann Baptist Zimmermann and the gilt carvings by Wenzeslaus Miroffsky. The carvings in the cabinet are by Johann Joachim Dietrich.

The Ancestral Gallery and Treasure Cabinet were used to present the dynastic claim to power, arguing the right of the Bavarian electors to wear the Imperial crown in the Holy Roman Empire. Amid the 121 portraits of Bavarian overlords and their lady consorts, we therefore find Theodo, the legendary first duke of Bavaria, Charlemagne (to whom the family traced their roots) and Emperor Ludwig the Bavarian, the first of the Wittels-

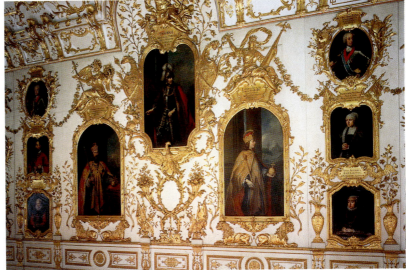

The Ancestral Gallery in the Munich Residence, portraits of Charlemagne, Theodo and Ludwig the Bavarian with Elector Karl Albrecht top right

bach emperors. The adjoining cabinet housed the family treasures. The new Rich Rooms were built on the same plan one storey higher.

The Treasure Cabinet (now Porcelain Cabinet) in the Munich Residence

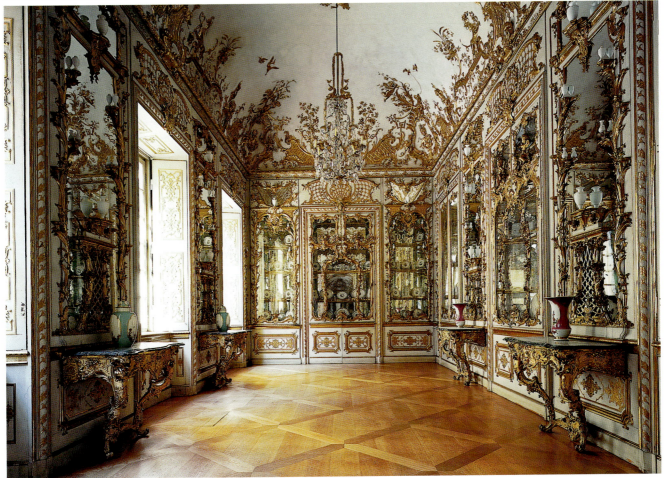

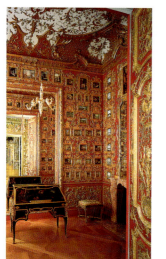

The Cabinet of Miniatures in the Ornate Rooms

Opposite page:
Green Gallery in the Ornate
Rooms of the Munich Residence

The Ornate Rooms

The Ornate Rooms were Elector Karl Albrecht's ceremonial apartment. (He later became Emperor Karl VII.) They were not used as living quarters but exclusively for diplomatic and public ceremonies.

Court architect Joseph Effner began construction in 1726. After a fire at the Residence François Cuvilliés the Elder was appointed from 1729 to rebuild the structure, arrange the rooms and implement the magnificent new furbishing. The suite was completed in 1737.

Although they were badly damaged in the Second World War, the Ornate Rooms rank among the most significant surviving rococo interiors in Southern Germany. In appointing them the Paris-trained architect Cuvilliés ventured far beyond the French prototypes. The ornamentation of the ceiling stucco work by Johann Baptist Zimmermann, for example, has been complemented by figurative and representational motifs. The stucco thereby acquires both structuring and iconographic functions. The inexhaustible variety of forms is typical of this period of courtly rococo in the Munich Residence. Cuvilliés designed not only the wall decoration, but also the seating and nearly all the wall-mounted tables. He collaborated

Ceiling stucco (detail): Allegory of Morning, ceremonial bedroom, Ornate Rooms

closely with the court artists to create unique total art works, interiors enriched by luxury furniture from Paris, sumptuous cloths, Oriental porcelain and great mirrors. The wealth and sophistication of the decorative features intensifies from one room to the next, from the functional appointment of the ante-chamber and Audience Chamber, governed by the needs of ceremony, vie the majestic pomp of the integrated gallery of paintings (Green Gallery), to the State Bedroom with its adjoining Cabinet of Mirrors and Cabinet of Miniatures.

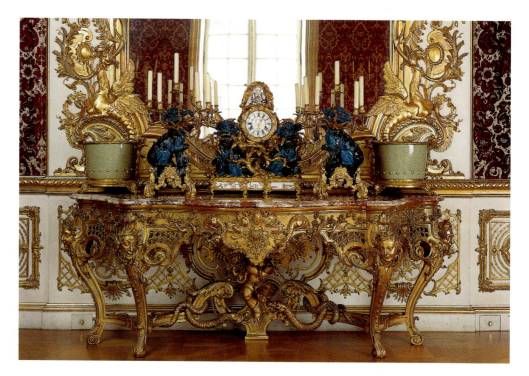

Wall table with objets d'art in the Conference Chamber of the Ornate Rooms, Munich Residence

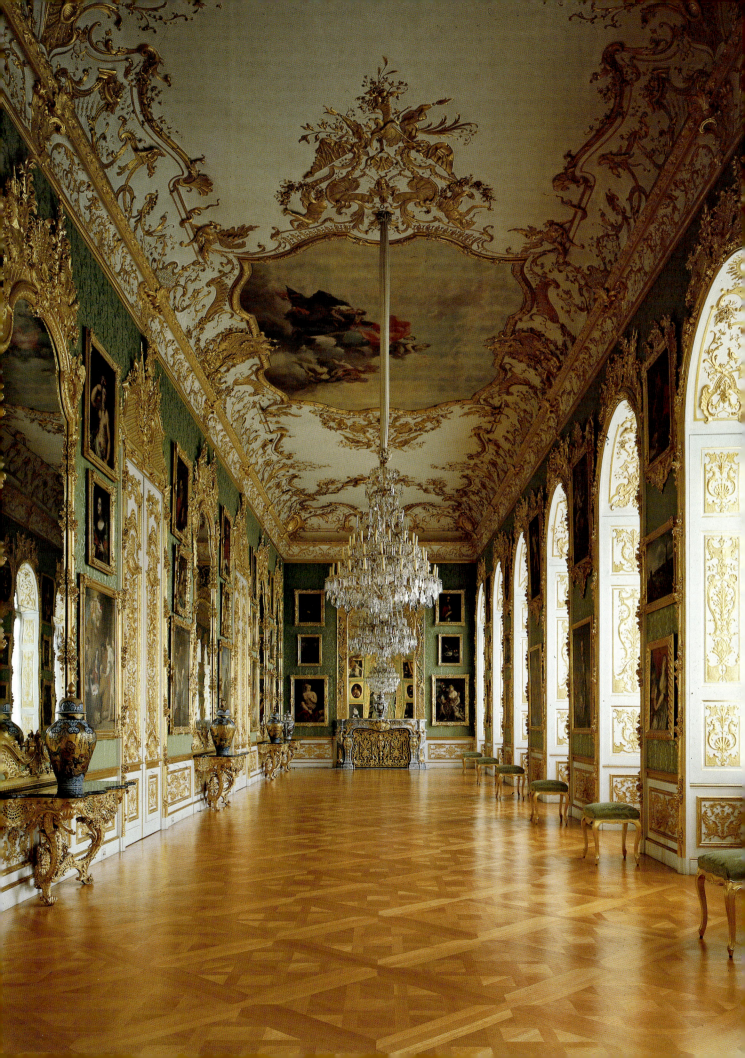

The King's Tract

The King's Tract was built in 1826–1835 from drawings by architect Leo von Klenze as a home for King Ludwig I of Bavaria and Queen Therese. This wing put the finishing touch to the Residence on its southern edge, facing the newly built square Max-Joseph-Platz. The apartments for the royal couple are on the main floor. They reflect Ludwig's love of Italy, Antiquity and literature, with painting and relief depicting scenes from the works of outstanding Greek and German poets.

Leo von Klenze, the leading proponent of neo-classicism in Munich, designed not only the architecture but also the appointment of the entire suite, applying a unified style to the walls, floor and furnishings. Although the interiors were only partly reconstructed after the destruction of the Second World War, the principal rooms can once again be experienced as a self-contained late neo-classical ensemble thanks to the near-complete preservation of the furniture.

Queen Therese's Salon in the King's Tract, Munich Residence

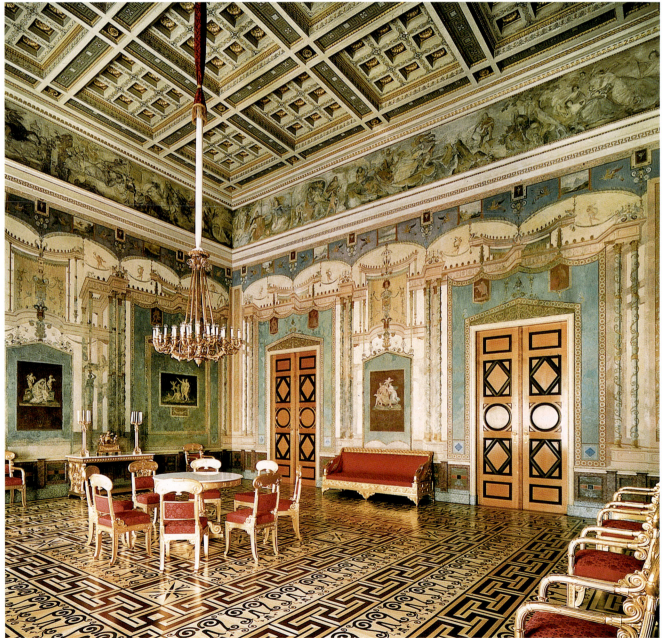

The Nibelungen Halls

The five ground-floor rooms with frescos in Ludwig I's palace are devoted to the Song of Nibelungen which dates back to around 1200. In the 19th century it was regarded as the very epitome of a German heroic epic. The rooms were intended for public visiting to promote civic enthusiasm for the nation. The tall pictorial halls inspired by Italian models contain major works of 19th-century German painting.

The walls and ceiling were painted by Julius Schnorr von Carolsfeld in 1828–1834 and 1843–1867 with the assistance of Friedrich von Olivier and Wilhelm Hauschild. In spite of the damage caused in 1944 the rooms have been largely restored. The first hall introduces the Nibelungen heroes. The monumental wall paintings in the next three depict Siegfried's wedding to Princess Kriemhild, Siegfried's murder by Hagen and Kriemhild's cruel revenge. The fifth hall laments the decline of the Nibelungen.

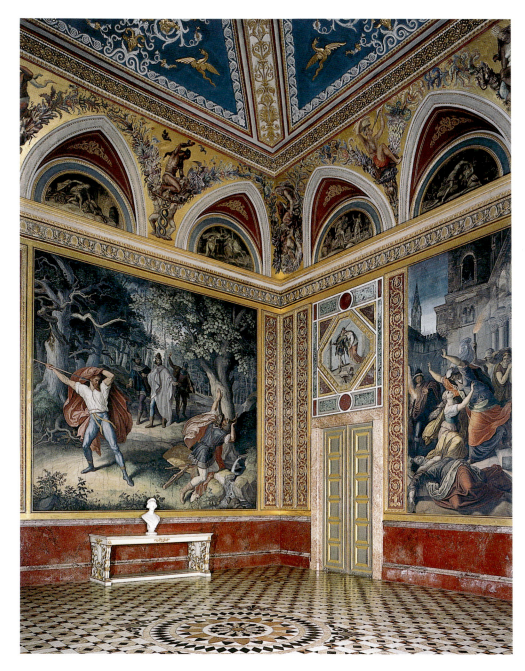

The Hall of Betrayal, Nibelungen Halls, Munich Residence

BAYERISCHE VERWALTUNG DER STAATLICHEN SCHLÖSSER, GÄRTEN UND SEEN

The proscenium box, Cuvilliés Theatre

Cuvilliés Theater
in the Apothekenhof,
Residenz München

ℹ Verwaltung der Residenz
München
Residenzstraße 1
D-80333 München
Tel. (+49/0) 89/2 90 67-1
Fax (+49/0) 89/2 90 67-225
residenzmuenchen@
bsv.bayern.de

🕐 April – 15 October:
9 am–6 pm
16 October–March:
10 am–4 pm

Closed at times for
rehearsals

♿ Viewing areas accessible
via steps

DB Munich

🚌

The Cuvilliés Theatre

The Cuvilliés Theatre, now named after the architect who designed it, François Cuvilliés the Elder, is the auditorium from the "new opera house" built next to the Residence for Elector Max II Joseph in 1751–1755. During the Second World War everything was destroyed apart from the decoration for the boxes, which had been removed for safety. In 1956–1958, during the restoration of the Residence, this salvaged interior was re-installed on the "Apothecary's floor" by the fountain yard.

Even if all that remains of an auditorium once crowned by Johann Baptist Zimmermann's ceiling fresco are the colourful tiers of boxes with their effusive figurative, floral and ornamental decoration in rocaille style, the Cuvilliés Theatre deserves to be admired not just as a major specimen of rococo for Bavaria's electors but as a total art work of European significance.

S. H.

The Elector's box, Cuvilliés Theatre

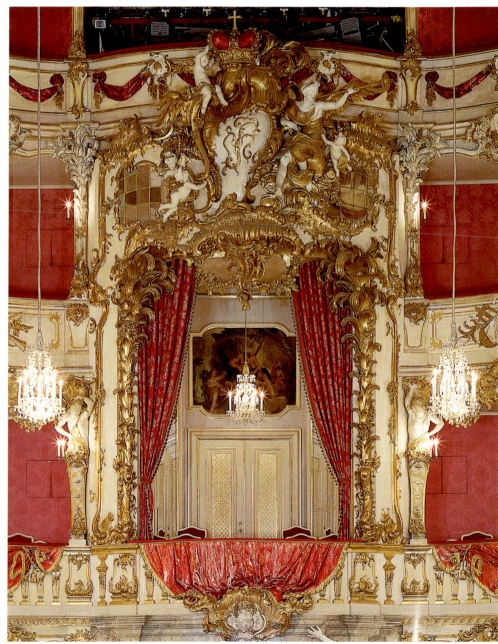

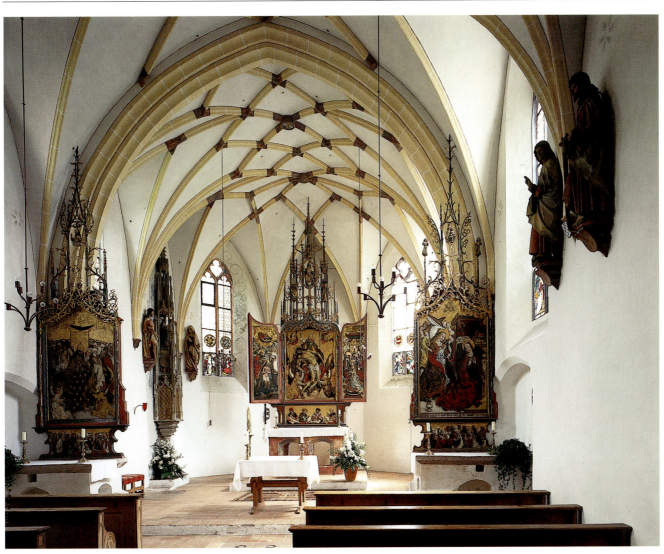

Chapel, Blutenburg Palace

Blutenburg Palace
The Palace Chapel

The palace chapel at Blutenburg boasts one of the finest Late Gothic interiors in Germany with its original features, an ensemble of rare unity, harmony and quality. Duke Sigismund of Bavaria (1439–1501), ousted from power by his brother, built it in 1488 for his seat of retirement. It took until 1497 to furbish with three splendid altars, sculpture, stained glass and wall paintings.

Sigismund created not just a treasure house of Late Gothic court art in Munich, but also a monument to his own status.

This being the Church of the Holy Trinity, he instructed Jan Pollak to paint the altars with an image of celestial rule to match the temporal power below. God the Father is depicted as a German emperor (the baldachin poles of the heavenly throne sport Bavarian lozenges!), the Virgin Mary is the queen of heaven and Christ the King is the salvator mundi. The series of Apostles by the "Blutenburg master", placed at the bases of the vaults as "pillars of the Church", reinforce the lofty analogy. J. E.

Schloss Blutenburg
Seldweg 15
D-81247 München

ℹ Schloss- und Gartenverwaltung Nymphenburg
Schloss Nymphenburg,
Eingang 19
D-80638 München
Tel. (+49/0) 89/1 79 08-0
Fax (+49/0) 89/1 79 08-627
sgvnymphenburg@
bsv.bayern.de

Schloss Blutenburg now houses the International Youth Library.

The church is open for viewing.

⊙ April – September:
9 am–5 pm
October – March
10 am–4 pm

♿ Access to the church via steps

✕ Schlossschänke

🄳🄱 München-Pasing

🅿

Ceiling fresco by Johann Baptist Zimmermann in the Stone Hall

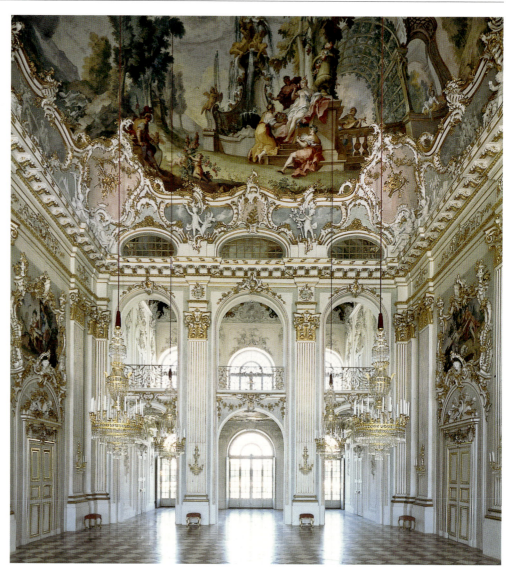

The Stone Hall, Nymphenburg Palace

Schloss und
Park Nymphenburg

i Schloss- und Garten-
verwaltung Nymphenburg
Schloss Nymphenburg,
Eingang 19
D-80638 München
Tel. (+49/0) 89/1 79 08-0
Fax (+49/0) 89/1 79 08-627
sgvnymphenburg@
bsv.bayern.de

⊙ April – 15 October:
9 am–6 pm
16 October – March:
10 am–4 pm
Audio-guide available

♿ Only accessible via steps

⊞ Museum shop

✗ Restaurant Zur Schwaige
Café Palmenhaus

DB Munich

🚌

Nymphenburg Palace

The Stone Hall

Today's visitors to Nymphenburg Palace, the summer residence of the Wittelsbach dynasty, find themselves walking through a Bavarian history book. From the laying of the foundation stone in 1664 until the 1840s, almost two hundred years, the electors and kings of Bavaria left their traces here, converting and refurbishing the complex. But they never discarded the intentions of its original mistress, Henriette Adelaide of Savoy. She called the palace, then much smaller, her "Borgo delle Ninfe" or castle of nymphs. When Elector Max III Joseph requested lavish stucco work and paintings for the Great Hall from an ageing Johann Baptist Zimmermann in 1755–1757, the painted ceiling once again played upon this name. In an Arcadian landscape intended to resemble the palace park, nymphs venerate the goddess Flora. Around the sides of the vaults we witness the three major pastimes of an 18th-century summer palace: the hunt with the goddess Diana, music with Apollo and the Muses, and love with Venus. During the evening party-making the hall would glow in the candlelight while court musicians played in the gallery.

The North Salettl
(First Ante-chamber)

When Elector Max Emanuel extended his mother's palace from 1700 and built new living quarters for himself, access was via the ante-chamber of the old apartment, which thus became a hall of passage. Following the Spanish War of Succession the elector made this room a monument to his success in the field, redecorating the walls with military motifs in the elegant formal idiom of the French Régence. The focus is the full-figure portrait of the elec-

tor in victor's pose. In the background we discern the town of Namur which he conquered as Governor of the Netherlands. Evidently the room was already regarded as a monument in the 18th century, because Elector Max III Joseph had an analogous memorial built around 1760 for his father Karl Albrecht, who had been elected Emperor of the Holy Roman Empire for a few years. In this way Henriette Adelaide's palace of Muses was expressing an unmistakable political claim.

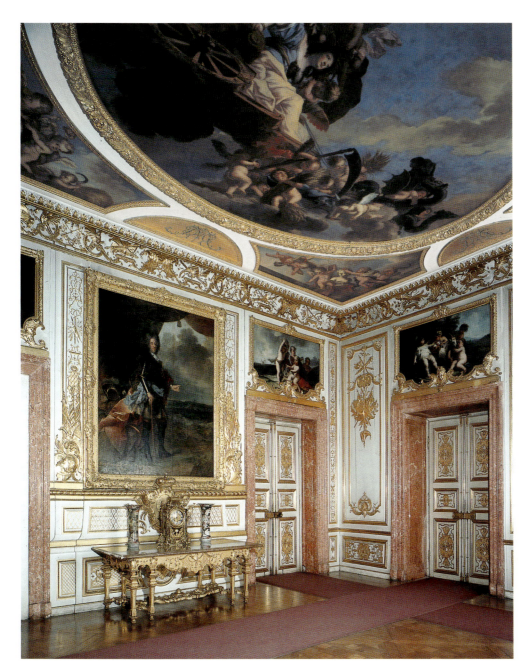

The North Salettl
(1st ante-chamber)
Nymphenburg Palace

BAYERISCHE VERWALTUNG DER STAATLICHEN SCHLÖSSER, GÄRTEN UND SEEN

Amalienburg in
Schlosspark Nymphenburg

ℹ Schloss- und Garten-
verwaltung Nymphenburg
Schloss Nymphenburg,
Eingang 19
D-80638 München
Tel. (+49/0) 89/1 79 08-0
Fax (+49/0) 89/1 79 08-627
sgvnymphenburg@
bsv.bayern.de

🕐 April – 15 October:
9 am–6 pm
16 October–March:
10 am–4 pm

♿ Access via steps

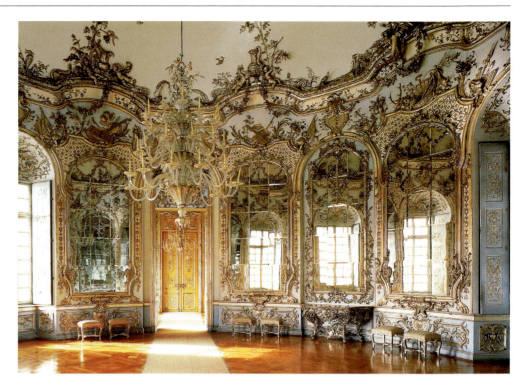

The Hall of Mirrors, Amalienburg

Amalienburg –
The Hall of Mirrors

One distinctive feature of the Nymphen-
burg Palace park are its four sumptuous
pavilions known as the park castles.
Apart from the hermitage at the Magdale-
nenklause they were used for court enter-
tainments, and they are accordingly
diverse and unconventional. The fourth
and final castle was built by Elector Karl

Albrecht for his wife, the Habsburg Maria
Amalia, from 1734 to 1739. It is not only,
along with the Old Residence Theatre, the
major accomplishment of its architect
François Cuvilliés, but perhaps also the
most characteristic specimen of Bavarian,
if not European rococo. The building's
function is announced in the elaborate
sculpture: it was to be a pavilion for the
pheasant hunt. A domed space is at the
centre and the platform above allowed
the Electoress to take aim. Its interior is
unique. Even the circular plan is unusual.
The lack of corners and the entire decora-
tion conceal the existence of walls. Mir-
rors the size of windows stand edge to
edge between ornate stucco frames. The
cornice, which conceals rather than high-
lights the transition from wall to dome,
depicts rural hunting scenes. A flock of
birds populate the sky above and orna-
ment in the apex suggests the sun. In the
evenings, when thousands of candle
flames were seen refracted in the mirrors
and the room melted through open doors
and windows into the surrounding park,
the borders of reality crumbled into an
ungraspable realm of fantasy.

*Reflection of reflections …,
the Hall of Mirrors*

Amalienburg – The Kitchen

Each room in the Amalienburg is more fascinating than the last: the Cabinet of Dogs, the Retirade, the Resting Room with its bed niche and the Hunting Room with scenes of court parties and hunts. The highlight, apart from the Hall of Mirrors, is the grand kitchen. The walls are entirely covered with thousands of Delft tiles. They show elaborate, colourful vases of flowers or striking scenes of Chinese life in the style of Chinese vase painting. The kitchen owes its splendid appointment to the fact that "Madame the Electoress, rest her soul, did cook herself", as Nannerl and Wolfgang Amadeus Mozart were informed in 1763. This, then, is a show kitchen in honour of the highborn housewife, also found in the houses of Dutch patricians.

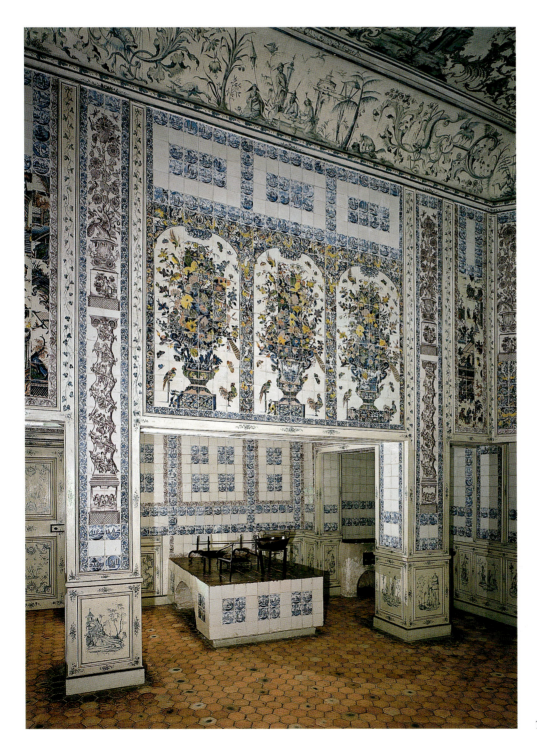

The Kitchen, Amalienburg

BAYERISCHE VERWALTUNG DER STAATLICHEN SCHLÖSSER, GÄRTEN UND SEEN

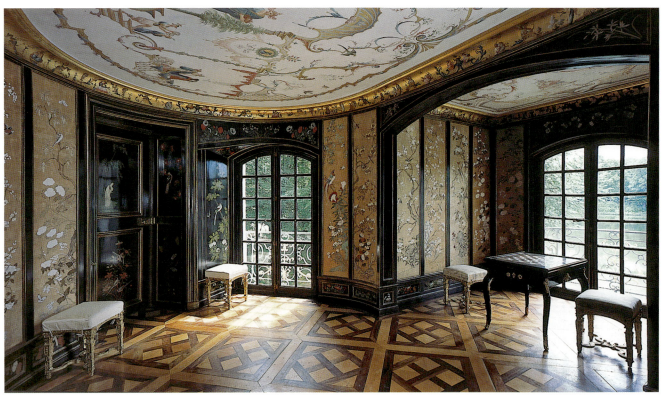

The Chinese Salon in the Pagodenburg

Lacquered chest of drawers in the Chinese Cabinet, Pagodenburg

Pagodenburg

The "pagoda castle" was the first of the "park castles", built for Max Emanuel from 1716 to 1719 by his architect Joseph Effner but allegedly designed by the elector himself. The external architecture conforms utterly to French tradition, and not until the miniature apartment upstairs do we guess the reason for its name. Two of the three rooms have been designed in mock Chinese style. Two chests of drawers stand in the smaller, red-lacquered Chinese Cabinet. Much of the original furniture was actually Japanese. Clean clothes were kept here so the elector could change if a little too warm from his game of pall-mall. The wall panelling in the larger Chinese Salon, an elegant living room, is varnished in black and red. Embedded in the rear wall are hand-painted wallpapers from China that Max Emanuel presumably purchased in Paris.

Badenburg

The Pagodenburg was not yet finished when Joseph Effner began work on another "castle" for the Nymphenburg park (1718–1721). Its distinctive attraction is the famous bath, which reaches down to the cellar. The pool is at least a metre deep and offers a marble bench for sitting to chat or take a snack. Above water level the sides are clad with blue and white "Dutch" tiles. The walls of the main floor are finished in superb stuccolustro. Courtiers could watch the aqueous proceedings from a perimeter gallery. The canvas painting by the French artist Nicolas Bertin which fills the ceiling depicts fountain themes and mythological scenes with a bathing reference. Two taps controlled hot and cold water entering the pool. The heating system in the cellar alongside has survived, although its achievements were probably modest. P. K.

Badenburg, Pagodenburg and Magdalenenklause in Schlosspark Nymphenburg

ℹ Schloss- und Gartenverwaltung Nymphenburg
Schloss Nymphenburg,
Eingang 19
D-80638 München
Tel. (+49/0) 89/1 79 08-0
Fax (+49/0) 89/1 79 08-627
sgvnymphenburg@
bsv.bayern.de

⊙ April – 15 October:
9 am–6 pm
16 October – March:
closed

♿ Access via steps

Hot and cold taps in the Bathing Hall

The Bathing Hall, Badenburg

BAYERISCHE VERWALTUNG DER STAATLICHEN SCHLÖSSER, GÄRTEN UND SEEN

ℹ Schloss Neuburg
Schlossverwaltung
Neuburg
Residenzstraße 2
D-86633 Neuburg
Tel. (+49/0) 84 31/88 97
Fax (+49/0) 84 31/4 26 89
sgvneuburg@bsv.bayern.de

🕓 April – September:
9 am–6 pm
October – March:
10 am–4 pm
Closed on Mondays

♿ Access to entrance via
ramp, lift available

🏧 Museum shop

✖ Cafeteria

A Archaeology Museum
Schloss Neuburg

State Gallery of Flemish Art

🚉 Neuburg

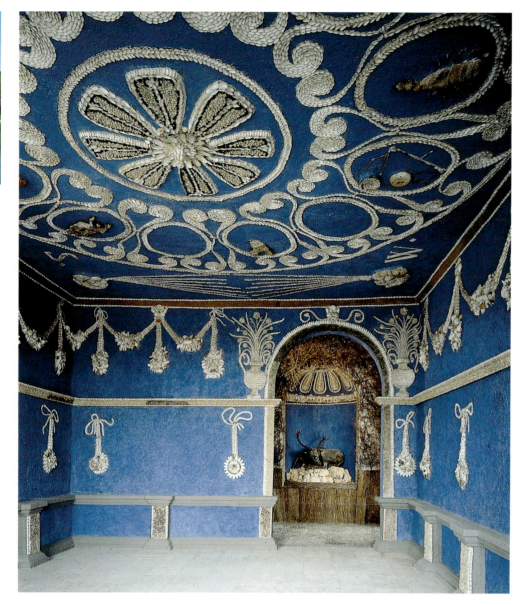

Zodiac signs and Stag Grotto,
Neuburg Palace

Neuburg Palace
The Grottos

This stout Renaissance palace, the seat of the Palatinate of Neuburg founded in 1505, was begun by Count Palatine (later Elector) Ottheinrich in 1527. His successor Philipp Wilhelm added a baroque tract in 1667–1670 with extensive grotto interiors of Italian and French inspiration.

These versatile grottos occupy the ground floor in one of two round baroque towers. They are complemented by a grotto hall, a little fountain court and a loggia. Originally combined with elaborate fountains whose play took unprepared visitors by surprise, the grotto played an integral part in the pleasures of court.

Each room has its own character. The entrée, a high tuff-clad hall with a statue of the sea god Neptune, led to a bright blue room representing the cosmos. Its decoration beset with seashells depicts the winds and the zodiac. Pan's Cave follows with the four seasons. Thousands of glass stalactites create a grotto of ice.

B. L.

Neuschwanstein Castle

The King's Bedroom

Neuschwanstein is the dream palace the King Ludwig II of Bavaria hoped would bring to life the poetry of the German Middle Ages and immortalise his association with Richard Wagner. It was begun in 1869 but was still unfinished when the king died in 1886.

Like all other rooms, the neo-Gothic bedroom evokes a medieval epic: Gottfried von Strassburg's "Tristan". In 1881 Anton Spiess translated its scenes into wall paintings, portraying the protagonists on the door and stove. The room's focal point is the richly carved bed, with Bavarian lions and lozenges and His Majesty's own swan emblem embroidered on the blue silk. Here Lohengrin meets the Knight of Schwangau. Another swan can be found on the tap of the washing table. Thus the king could embark on a journey into the past or distil for the present the poetic essence of history.

K. K.

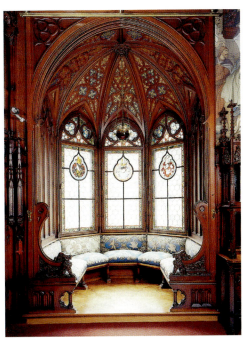

Bedroom oriel

i Schloss Neuschwanstein
Schlossverwaltung
Neuschwanstein
Neuschwansteinstr. 20
D-87645 Schwangau
Tel. (+49/0) 83 62 / 9 39 88-0
Fax (+49/0) 83 62 / 9 39 88-19
svneuschwanstein@
bsv.bayern.de
www.neuschwanstein.de

i Ticket reservations /
ticket centre
Tel. (+49/0) 83 62 / 9 30 83-0
Fax (+49/0) 83 62 / 9 30 83-20
www.ticket-center-
hohenschwangau.de

☉ April – September:
9 am–6 pm
October – March:
10 am–4 pm
Guided tours (approx.
35min.) in German or
English, or audio-guide
in eleven languages

♿ By arrangement
on Wednesdays:
tours for people with
impaired mobility and tours
for wheelchair users

⊞ Museum shop

✕ Cafeteria Schlosswirtschaft

Multivision show

DB Füssen

🚌

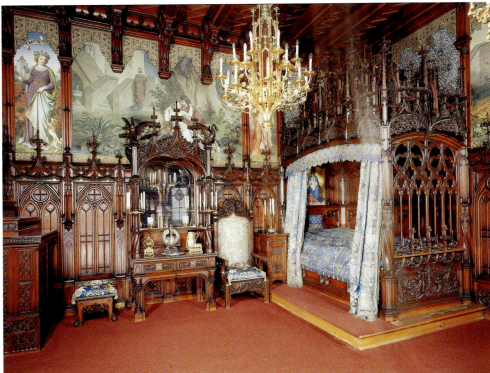

Bedroom, Neuschwanstein Castle

St George, wall painting in the Throne Room

The Throne Hall

The Throne Hall with its Byzantine forms was begun by Julius Hofmann in 1884. It was one of Ludwig's last additions to the Neuschwanstein programme. The king was not seeking concrete expression for an imaginary abundance of power. He had a personal theological problem: the pure kingdom of God's Grace, the mediating role between God and humanity.

The room accordingly evolved from stage sets of the Castle of the Grail. The image of Mount Salvation now took precedence over his former Wartburg prototype, the Singers' Hall. The king personally selected the pictorial decoration: Christ Pantocrator and the deeds of holy kings – six of them depicted in the apse – along with SS. George and Michael, pugnacious warriors against evil and protectors of the Christian faith.

Had the throne ever been made, the king would have taken his place among holy predecessors. Instead he was deposed and met his death. E. D. S.

Throne Hall, Neuschwanstein Castle

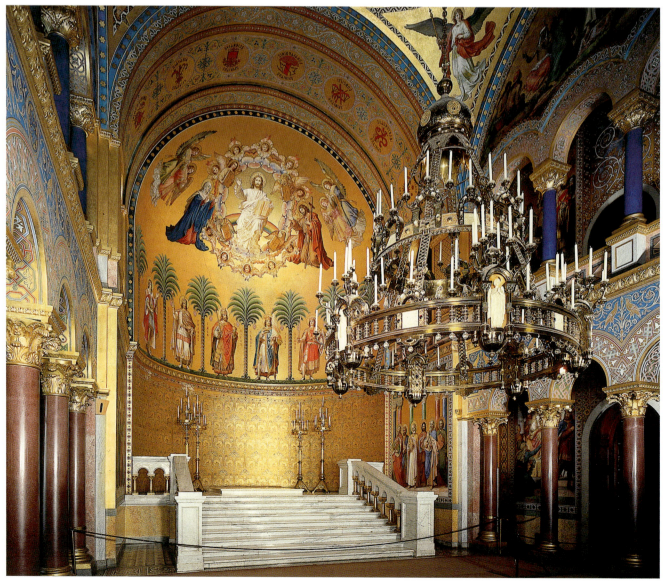

Imperial Castle of Nuremberg
The Imperial Chapel

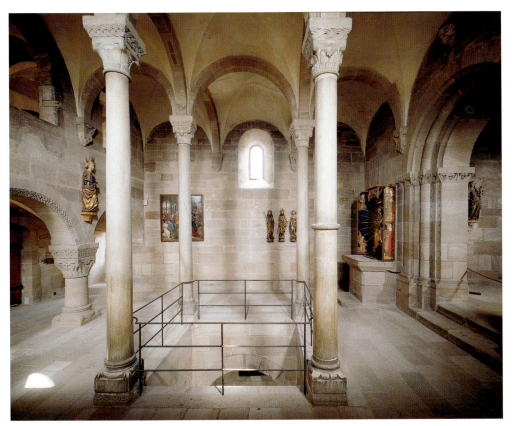

Upper chapel, Imperial Castle

Kaiserburg with garden,
Deep Well and
Sinwell tower

ℹ Burgverwaltung Nürnberg
Auf der Burg 13
D-90403 Nürnberg
Tel. (+49/0) 911/22 57 26
Fax (+49/0) 911/2 05 91 17
burgnuernberg@
bsv.bayern.de

⊘ April – September:
9 am–6 pm
October – March:
10 am–4 pm

Guided tours of the whole
castle last approx. 90 mins.

Ⓐ Local section of the
Germanic Museum
in the Bowers

DB Nuremberg

From 1050 to 1571 the emperors and kings of the Holy Roman Empire pronounced sentence and held their diets in the Imperial Castle (Kaiserburg) at Nuremberg. This made it one of the key imperial palaces of the Middle Ages, and the Imperial Chapel is one of the most impressive interiors in Germany associated with the rulers of the age.

The chapel was built around 1200 in the days of the Staufen emperors. It consists of a lower chapel for lesser servants and an upper chapel for the higher ranking retinue with a west balcony for the monarch's family. Spatially and liturgically the two chapels are linked only by a hole in the floor. As a result, the Imperial Chapel at Nuremberg is a unique combination of two archetypes: the double chapel and the sovereign chapel with its western balcony. The social hierarchy of its users is emphasised by the contrast between the squat forms of the crypt-like lower chapel and the tall, airy upper chapel. F. U.

Lower chapel, Imperial Castle

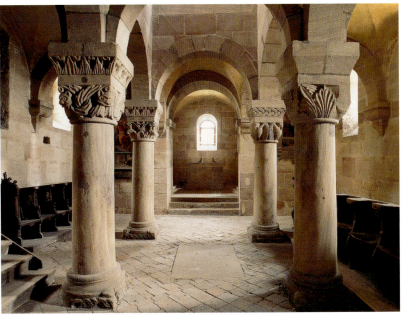

BAYERISCHE VERWALTUNG DER STAATLICHEN SCHLÖSSER, GÄRTEN UND SEEN

Königshaus am Schachen
with Alpine Garden
D-82467 Garmisch-
Partenkirchen
Tel. (+49 / 0) 172 / 8 76 88 68

ℹ Schloss- und Garten-
verwaltung Linderhof
Linderhof 12
D-82488 Ettal
Tel. (+49 / 0) 88 22 / 92 03-0
Fax (+49 / 0) 88 22 / 92 03-11

May / June–early October as
seasonal weather permits

🕙 Guided tours at 11 am,
1 pm, 2 pm and 3 pm

Alpine Garden

🍴 Berggaststätte

♿ Only accessible on foot
(at least 3 hours)

🚆 Klais or
Garmisch-Partenkirchen

King's House on Schachen
The Turkish Hall

The King's House on the Schachen Alp enjoys one of the most beautiful locations in the Bavarian Alps with the rugged Wetterstein to its south, the peaks of the Zugspitze to its west and the Loisach valley with Garmisch-Partenkirchen to its north.

Begun in 1870 in the style of a Swiss chalet, the lavish conversions requested by Ludwig II took until 1872. The Turkish Hall on the upper floor was based on a well-published room in the sultan's palace at Eyüb (Constantinople). But Ludwig II and his architects determined the appointment, colour scheme and overall effect.

Its arrangement reflects the Oriental fashion of the time and also the king's desire to retreat into dream worlds undisturbed by everyday problems. Visitors still feel they are crossing into another world as they suddenly pass from the alpine environment downstairs to the sensually overwhelming Oriental magnificence and bright hues of the Turkish Hall above.

E. D. S.

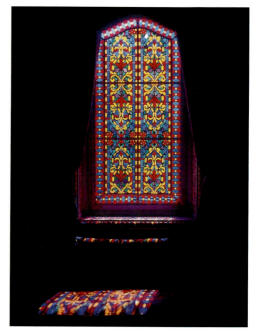

Stained glass window in the Turkish Hall

Turkish Hall in the King's House on Schachen

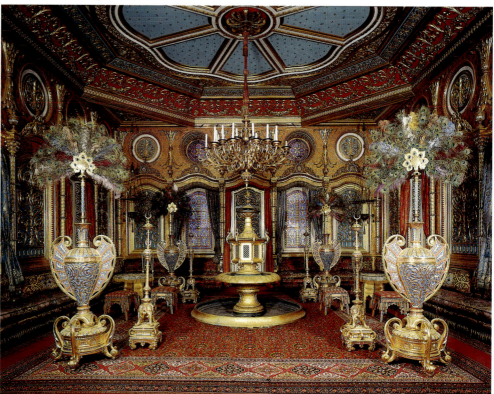

Ceiling fresco in the Hall of Victories, Dido receives Aeneas

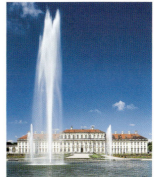

Neues Schloss und
Hofgarten Schleißheim

i Schloss- und
Gartenverwaltung
Schleißheim-Dachau
Max-Emanuel-Platz 1
D-85764 Oberschleißheim
Tel. (+49/0) 98/31 58 72-0
Fax (+49/0) 89/31 58 72-50
sgvschleissheim@
bsv.bayern.de

☉ April – September:
9 am–6 pm
October – March:
10 am–4 pm
Closed on Mondays

Fountains:
April – mid September:
10 am–4 pm
Audio-guide available

♿ Lift available

Baroque Court Garden

A State Gallery

⊞ Museum shop

✕ Schlossgaststätte

DB Munich

Ⓢ S 1 Oberschleißheim

Schleißheim New Palace

Hall of Victories

The New Palace built at Schleißheim for Elector Max Emanuel of Bavaria (r. 1680–1726) culminates in a ceremonial suite of grand stairs, festive halls and a picture gallery.

The Hall of Victories, appointed in 1723–1725 under the French-trained court architect Joseph Effner, is a synthesis of Bavarian, French and Italian stylistic features typical of late baroque court art in Bavaria. The walls are lined with carved panelling – implemented under the aegis of court joiner Johann Adam Pichler – which ranks among the finest interior decorations in the French Régence style. Nine monumental paintings by Franz Joachim Beich proclaim Max Emanuel's victorious battles in the Turkish Wars. Over the cornice Herculean herms of stucco alternate with cherubs bearing trophies. The letters on their shields make up Max Emanuel's name. The ceiling fresco by the Venetian Jacopo Amigoni is one in a major series of frescos glorifying the elector.

Panelling in the Hall of Victories, Schleißheim New Palace

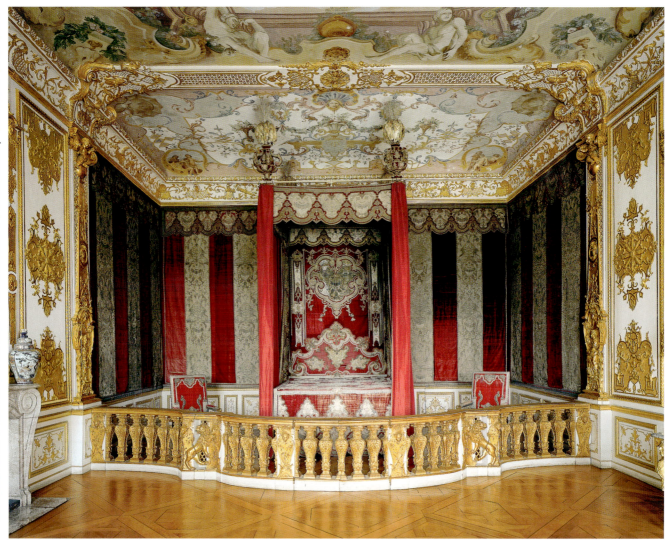

Elector Max Emanuel's State Bedroom, Schleißheim New Palace

Elector Max Emanuel's State Bedroom

Elector Max Emanuel of Bavaria's State Bedroom in the New Palace at Schleißheim is an impressive specimen of late baroque interior art. A curving balustrade divides it into an ante-room and an alcove at the rear reserved for the elector and containing the bed.

Few bedsteads have been preserved in such authentic condition as the imperial bed of this elector. In accordance with contemporary etiquette, the cloth on the bed of state, the covers on the seating and the wall coverings in the alcove are made of the same material – silk velvet with silver brocade and heavy gold embroidery. The bed is entirely clad in textiles and was the most luxurious item of furnishing in the suite. White panelling, gilt carvings and crimson cloth blend in this, the most important room in the elector's apartment, to create a triad of supreme ceremonial dignity.

The ceiling painted by Jacopo Amigoni with a slumbering Mars was a baroque topos and a reference to the resting monarch.

The Chamber Chapel

The Chamber Chapel is a private oratory in the apartment of the Elector's wife. Like another small room, the Stucco Cabinet, its walls were lined with scagliola (stuccolustro inlays) brought to Schleißheim in 1724 from the Munich Residence. A craftsman's mark indicates that is was produced in 1629 by Maximilian I's famous marble specialist Wilhelm Pfeiffer, nicknamed "Fistulator". Scagliola was a much-admired artistic technique typical of the Munich court at the time. These colourful stuccolustro insets were used in particular to appoint small rooms and to cover tables.

In Schleißheim this precious antique was combined with an innovative ceiling design. The famous Bavarian stucco and fresco artist Johann Baptist Zimmermann created the fine stucco work for the ceiling and the four elegant statues of the cardinal virtues balancing on the lantern's parapet. Peter Paul Rubens painted the altar scene depicting the Assumption of Mary.

B. L.

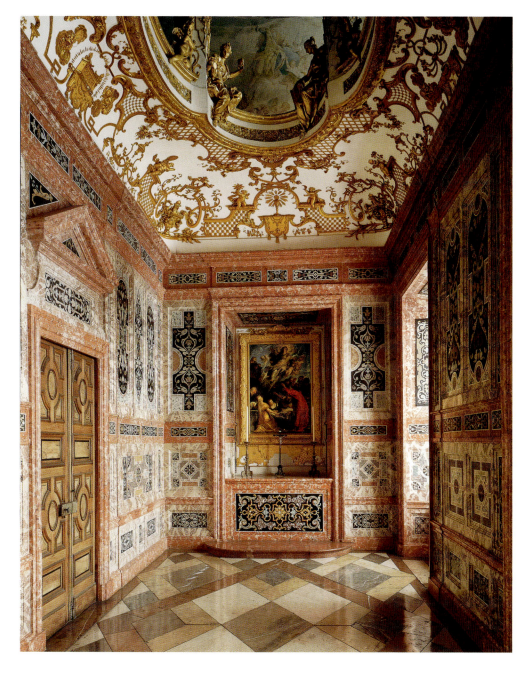

The Chamber Chapel Schleißheim New Palace

BAYERISCHE VERWALTUNG DER STAATLICHEN SCHLÖSSER, GÄRTEN UND SEEN

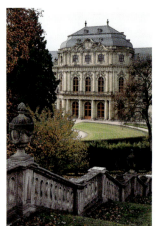

Residenz und Hofgarten Würzburg

ℹ Schloss- und Garten-
verwaltung Würzburg
Residenzplatz 2, Tor B
D-97070 Würzburg
Tel. (+49/0) 931/3 55 17-0
Fax (+49/0) 931/5 19 25
sgvwuerzburg@
bsv.bayern.de

🕙 April – October:
9 am–6 pm
November – March:
10 am–4 pm
Guided tours

Guided tours outside
opening times on request

Garden tours on request

♿ Lift available for disabled
visitors

Court Garden

Rosenbach Park

🄰 Martin von Wagner
Museum
(University of Würzburg)
in the South Wing

⊞ Museum shop

✗ Residenzgaststätte

Unesco World Heritage Site

🄿

🄳🄱 Würzburg

Würzburg Residence

The Stairway

The Würzburg Residence is one of Europe's major baroque palace complexes. The skeleton for the former residence of Würzburg's prince-bishops was constructed from 1720 to 1744 and took until 1780 to furbish. The initial client, Prince-Bishop Johann Philipp Franz von Schönborn, entrusted the project to Balthasar Neumann, who was still unknown. The gifted architect later also served Johann's brother, Friedrich Carl von Schönborn, and the two prince-bishops who followed him until completion of the huge ensemble. The architectural highlight of the Residence is Neumann's much celebrated stairway. Beneath the unbuttressed cavity vault, itself a tremendous technical feat with a maximum height of 23 metres and a base plan of 18 x 30 metres, he arranged three flights of stairs and a perimeter gallery. Giovanni Battista Tiepolo was summoned from Venice to paint the vault in 1752/53 with the largest ceiling fresco ever created. With brushwork of supreme delicacy he depicts the exotic worlds of

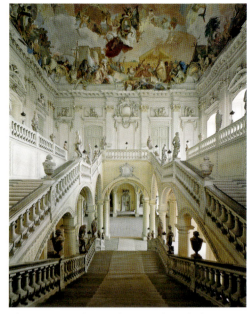

The Stairway in the Würzburg Residence, looking towards the allegory of Europe

the Asian, American and African continents, personified as princesses. The work culminates in the allegory of Europe showing the court at Würzburg as a garden of the arts.

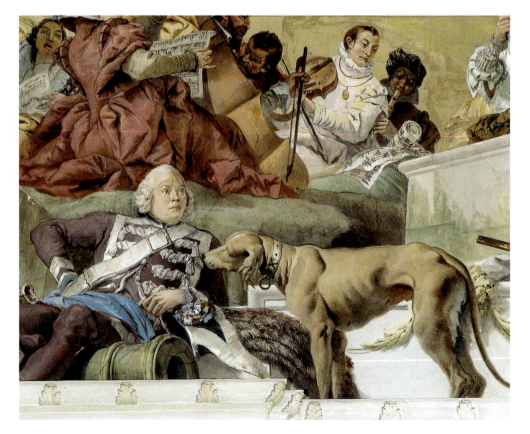

Portrait of the architect Balthasar Neumann, fresco over the Stairway, Würzburg Residence

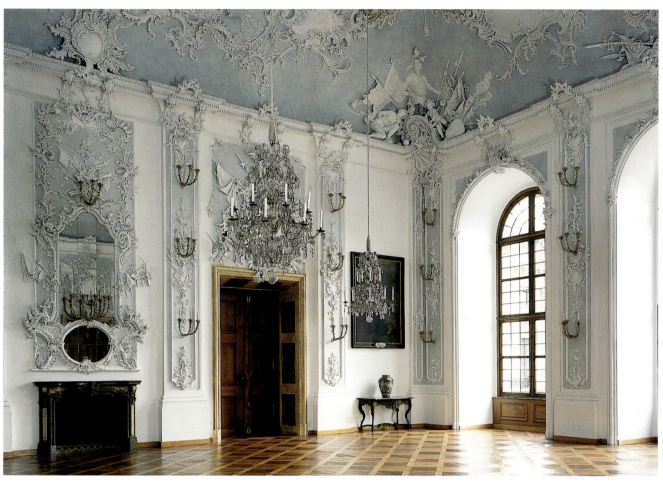

The White Hall, Würzburg Residence

The White Hall

The deliberate absence of colour in the White Hall, decorated in 1744/45, poses a contrast to the polychrome splendour of the stairway fresco and the glittering gold of the Imperial Hall. Antonio Bossi's stucco work shines white on a pale grey background. A few details are set off by discreet toning. The play of shadows alone creates a multitude of white and grey nuances.

In just a few months Bossi filled the huge surface of this towering vault with astonishingly imaginative variety. He teased the rocaille, essentially conceived for the decoration of smaller, intimate spaces, into monumental dimensions without sacrificing its vivacious levity. Bossi's stucco achieves an extraordinary plasticity and for all its versatility establishes a clear organising structure for the room. The hall's original use by the prince-bishop's Guard is reflected in the armoury, weapons and sovereign emblems and the martial divinities Mars and Bellona worked into the stucco relief.

The war god Mars, detail from the stucco ceiling of the White Hall

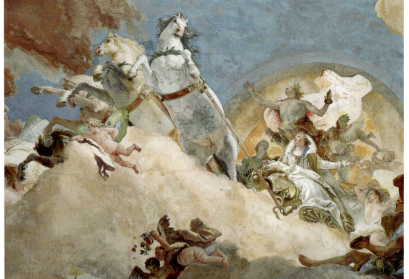

The bridal chariot bearing Beatrix of Burgundy, detail from the ceiling fresco in the Imperial Hall

The Imperial Hall

With 20 half-columns nearly eight metres tall and a high oval dome, Balthasar Neumann ensured that the Imperial Hall would be the stately highlight of this spatial sequence. The vault was constructed in 1742 and in 1751/52 Giovanni Battista Tiepolo applied his frescos. The furbishing arts contribute together here to produce one of the most beautiful and harmonious secular interiors of the baroque period. Tiepolo's three great frescos depict the political history of the Würzburg diocese within the Holy Roman Empire in the days of Emperor Friedrich Barbarossa. The central ceiling fresco shows Apollo in his four-horse sun chariot bringing the bride Beatrix of Burgundy to the emperor's throne. The two side frescos show the Bishop of Würzburg marrying Barbarossa and Beatrix in 1156 and the Bishop of Würzburg being unvested in fief with the Duchy of Franconia in 1168. The paintings over the doors with exemplary scenes from the lives of Ancient emperors were by Tiepolo's son Domenico. Antonio Bossi made the four life-size stucco figures of Neptune, Juno, Flora and Apollo in the niches along the narrower walls.

The Imperial Hall, Würzburg Residence

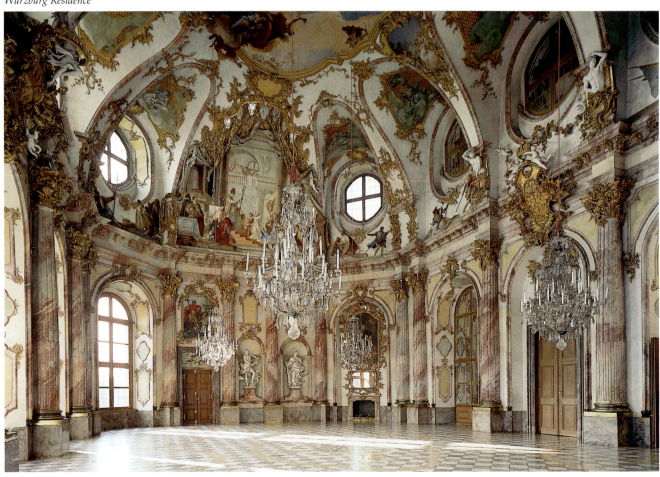

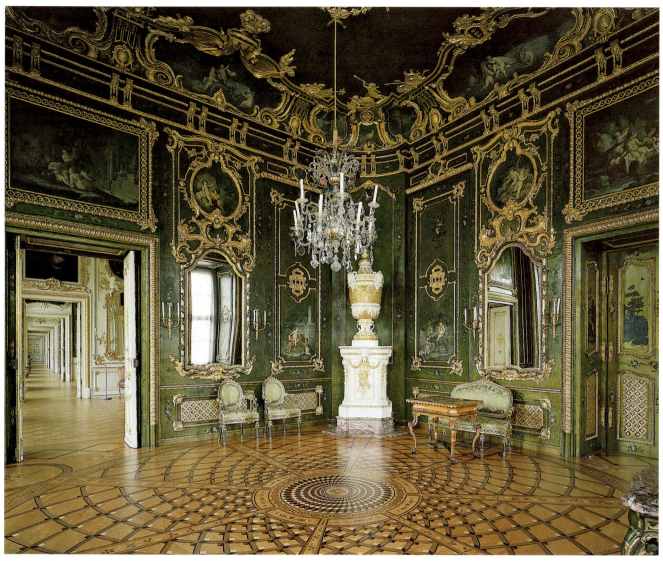

The Green Lacquered Room in the Würzburg Residence

The Green Lacquered Room

The Green Laquered Room is a corner structure which terminates the 165-metre suite of northern and southern imperial rooms in the Würzburg Residence. It was appointed in 1769–1772 during the transition from late Würzburg rococo to early neo-classicism. Its unique colouring is produced by transparent green Lacquer over a silver background. Against this backdrop with its delightful contrast of gilt stucco, there are brightly coloured cherub scenes and floral festoons. The painted decoration was by Georg Karl Urlaub, Christian Popp and Ernst Schwab, and the gilt stucco work by Materno Bossi. The seats and wall tables were finished in matching colours. The floor is inlaid with patterns that play on perspective and the original was by Balthasar Hermann, the court ébeniste from Bamberg. Franz Paul Acker built the faience stove with its vase-shaped top. – Following war-time fire damage in 1945 the walls required partial replacement and large areas of the ceiling and floor had to be renewed.

The Court Church

Although it is quite small the Court Church consecrated in 1743 is ranked among the most perfect sacred buildings of 18th-centiry Germany by virtue of its

The Court Church,
Würzburg Residence

sophisticated spatial structure and the supreme artistic quality of its decoration. Behind the palace façade with four rows of windows preserved on the outside in the south-west corner of the Residence, architect Balthasar Neumann succeeded in implanting a thoroughly surprising room with three oval domes and exclusively curving walls. The superb decoration, implemented in 1735–1743, was based partly on designs by his rival Lucas von Hildebrandt. The furbishing was done for the most part by court artists from Würzburg: Rudolph Byss and his pupils painted the ceiling frescos (renewed after war damage), Antonio Bossi provided the stucco work and stucco figures, and Johann Wolfgang van der Auwera made the marble statues of SS. Kilian and Burkard next to the high altar. The panels for the side altars, "Fallen Angel" and "Assumption of Mary", were painted by Giovanni Battista Tiepolo in 1752. W. H.

St Mary Magdalene and two cherubs at the foot of the Cross, Court Church

Source of illustrations:
Foto Alfen, Aschaffenburg: p. 65 unten
Bayerische Verwaltung der staatlichen Schlösser, Gärten und Seen: pp. 59, 61, 62, 63, 64, 65 top, 66, 67 right, 68, 69, 70, 71, top, 71 bottom (Frahm), 73, 74, 75, 76, 78, 79 top (Ulrich Pfeuffer), 79 bottom (Maria Scherf), 81, 82 (Ulrich Pfeuffer), 83, 84 top, 84 bottom (Mayr), 85, 86, 87, 88 top, 88 bottom (Maria Scherf/Heidi Mayer), 89, 91, 92, 93, 94 left, 95, 96 top (R. Mayer), 96 bottom, 97, 98, 99, 100, 101, 102 top, 103 top right, 104 bottom and left, 105, 106, 107, 108, 109, 110 bottom, 112 right
Achim Bunz, München: p. 77, 94 right
Caretta, Rom: p. 103 top
Herpich: p. 90
Edmund von König Verlag, Dielheim: p. 111
Feuerpfeil Verlags GmbH, Bayreuth: p. 67 left
L. Keresztes: p. 103 bottom
Mathews: p. 72
Wolf-Christian von der Mülbe, Dachau: pp. 80, 110 top, 112 left
Elmar D. Schmid: p. 104 right
Schöning & Co., Lübeck: p. 102 bottom

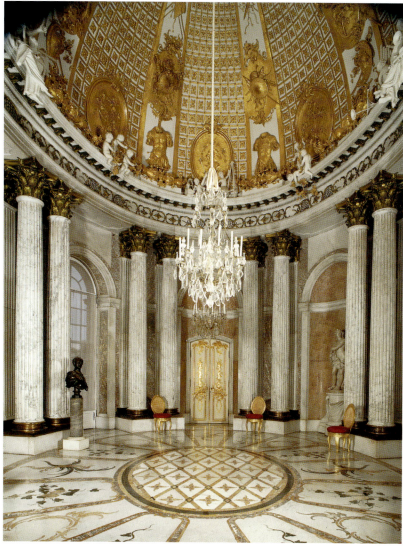

Berlin-
Brandenburg

 Stiftung Preussische Schlösser und Gärten Berlin-Brandenburg

Prussian Palaces and Gardens Foundation Berlin-Brandenburg

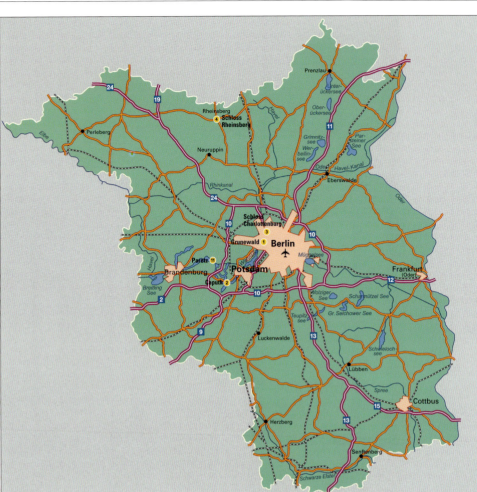

Grunewald – Berlin
1 Hunting Lodge (p. 115)

Caputh
2 Schloss Caputh (p. 116)

Charlottenburg – Berlin
3 Schloss Charlottenburg
 (pp. 117–124)

Rheinsberg
4 Schloss Rheinsberg
 (pp. 125–126)

Sanssouci – Potsdam
5 Schloss Sanssouci
 (pp. 127–130)
6 Park Sanssouci
 (pp. 131–132)
7 New Palace (pp. 133–138)
8 New Chambers (p. 139)

New Garden – Potsdam
9 Marble Palace
 (pp. 140–142)

Pfaueninsel – Berlin
10 Schloss Pfaueninsel
 (pp. 143–144)

Paretz
11 Schloss Paretz
 (pp. 145–147)

Charlottenhof – Potsdam
12 Schloss Charlottenhof
 (pp. 148–149)

Babelsberg – Potsdam
13 Schloss Babelsberg
 (p. 150)

Sanssouci – Potsdam
14 Schloss Sanssouci (p. 151)

Cecilienhof – Potsdam
15 Schloss Cecilienhof
 (p. 152)

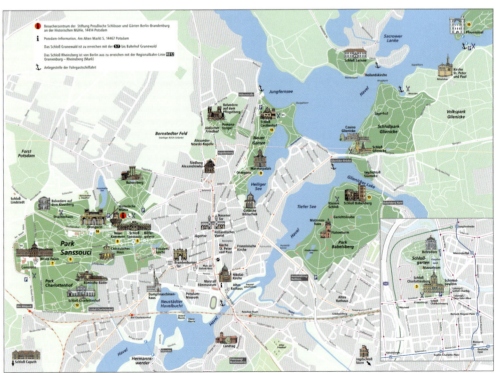

For information about other
sites managed by Stiftung
Preußische Schlösser und
Gärten Berlin-Brandenburg:
www.spgsg.de

◁ *The Marble Hall in Schloss Sanssouci, G.W. von Knobelsdorff, 1745–1748*

The Hunting Lodge
Great Hall of Court

Although the principal royal palace, the Berliner Schloss, has been destroyed, a tour of the remaining Prussian residence in Berlin and Potsdam can still begin – albeit modestly – with a Renaissance interior. The Great Hall of Court in the Hunting Lodge at Grunewald, built for Elector Joachim II in 1542 by Caspar Theis, once disappeared under baroque conversions by Martin Grünberg in 1705-1708, but in 1973/74 it was rediscovered and stripped of the overlay. The room is divided by a double arcade, and the wooden ceiling, now restored, creates a coffered effect by means of simple black and white chequering. The floor of red brick tiling was recreated from original evidence in 1974. Baroque stucco ceilings have been preserved in some of the other rooms. Few of the 16th-century door and window jambs have survived. Today's interior derives its quality, rather, from a high-calibre museum collection, with a wealth of works by Lucas Cranach the Elder and the Younger and other 16th-century paintings. 17th-century Dutch artists provide the bridge to an overview of Berlin art from the 17th to the 19th century. Hunting scenes from this period form a focus of their own. The furniture is also not from the original inventory.

B. G.

ℹ Jagdschloss Grunewald
Hüttenweg 100
(am Grunewaldsee)
D-14193 Berlin
Tel. (+49/0) 30/8 13 35 97
Fax (+49/0) 30/8 14 93 48

🕐 15 May – 15 October:
10 am–5 pm
Admission ceases at 5 pm
Closed on Mondays
16 October – 14 May:
Sa/Su, public holidays
Guided tours at
11 am, 1 pm and 3 pm

🚌 Bus X10 from Berlin Zoo to
Königin Luise Str./
Clayallee or
U3 to Dahlem Dorf, bus 110
to Königin Luise Str./
Clayallee

🍴 Restaurant Forsthaus
Paulsborn

🅿 Restaurant Paulsborn or
Clayallee/Königin Luise
Str.

Grunewald Hunting Lodge, Great Hall of Court

STIFTUNG PREUSSISCHE SCHLÖSSER UND GÄRTEN BERLIN-BRANDENBURG

Schloss Caputh
Strasse der Einheit 2
D-14548 Schielowsee
Ortsteil Caputh

ℹ Besucherzentrum an der
Historischen Mühle
Postfach 60 14 62
D-14414 Potsdam
Tel. (+49/0) 331/
9694-200/-201
Fax (+49/0) 331/9694-107
Besucherzentrum@spsg.de

🕐 15 May – 15 October:
10 am–5 pm
Admission ceases at 5 pm
Closed on Mondays
16 October – 14 May:
Sa/Su 10 am–4 pm
Last tour at 4 pm

✗ Restaurant Kavaliershaus
in Schlossgarten Caputh

🅿 Car park outside the
Schloss

🚌 Bus 607 from Potsdam Hbf.

🚆 RB 22 to Caputh-Geltow,
then on foot

Schloss Caputh
Festive Hall, Summer Dining Room

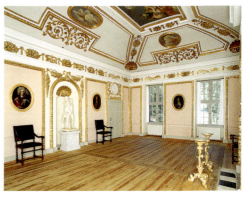

*Festive hall with portraits and Bartholomäus Eggers'
"Rape of Persephone"*

The Schloss we see now was originally a simple country seat built on Lake Templin near Potsdam in 1662 by the Elector's quartermaster-general Philipp de Chièze. It was later repurchased by the Elector, who gave it to his wife Dorothea in 1671. She converted and expanded it into a prestigious summer residence. We do not know the architect's name, but despite serving other functions for many years the Schloss has preserved its baroque floor plan with apartments for both the Elector and his lady consort. Indeed, it is one of the finest specimens of secular architecture to have survived from that period in Brandenburg, with ceilings painted in the 1680s by Jacques Vaillant and Samuel Theodor Gericke and richly adorned with stucco work. The most impressive room is the festive hall with its high trough vaulting. Its stucco decoration, touched up in places in the early 20th century, probably dates back to the years just after Dorothea acquired the property in 1671. The ornate paintings consist today in part of original features, such as the portraits of Roman emperors, including Rubens' "Caesar", in part of canvases which hung in the palace at Potsdam around 1700, and in part of works by artists known to have con-tributed to the early interior. The furniture has been put together using contemporary pieces from stately buildings that have since been destroyed. The porcelain chamber contains examples of Oriental china, but also marble statues like those known to have stood here. Nothing remains of the leather wall coverings or textile drapes.

The vaulted summer dining room in the basement was begun by King Friedrich I, but it was the soldier king Friedrich Wilhelm I who, around 1720, bestowed upon it the present design with approximately 7,500 blue and white Dutch tiles. B. G.

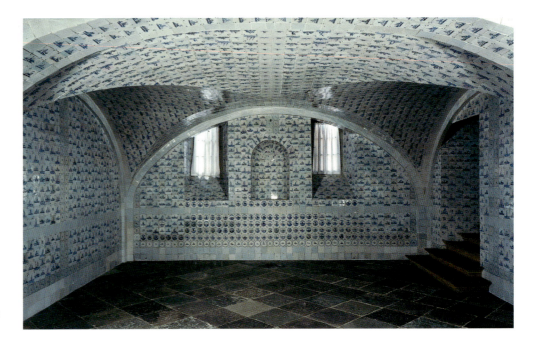

*Summer dining room with Dutch
faience tiles, c. 1720*

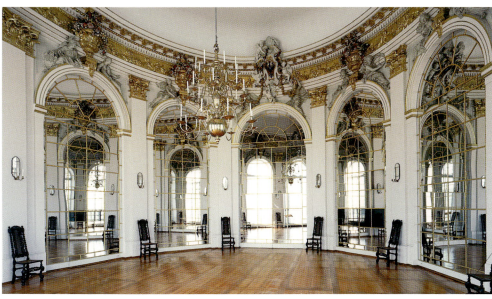

Oval Hall of Mirrors on the upper floor, 1699/1705 (reconstructed)

Charlottenburg
Spandauer Damm 20–24
(Luisenplatz)
D-14509 Berlin

ℹ Besucherzentrum an der
Historischen Mühle
Postfach 60 14 62
D-14414 Potsdam
Tel. (+49/0) 331/
96 94-200/-201
Fax (+49/0) 331/96 94-107
Besucherzentrum@spsg.de
Info-line (+49/0) 30/
3 20 91-405/-406

⊘ Altes Schloss:
Tel. (+49/0) 30/3 20 91-440
Fax (+49/0) 30/3 20 91-400
All year round: 9 am–5 pm
Guided tours
Last tour at 5 pm
Closed on Mondays

Silver Chamber, Crown
Cabinet and Friedrich
Wilhelm IV's apartment:
No guided tours
All year round: 9 am–5 pm
Admission ceases at 5 pm
Closed on Mondays

🚌 Buses X21, 109, 145, 210
from Berlin Zoo to
Luisenplatz

⊞ Musem shop Charlotten-
burg
Tel. (+49/0) 30/32 60 39 46
Info@museumsshop-im-
schloss.de

🅿 Car park at the main gar-
den entrances

Schloss Charlottenburg

Altes Schloss, Glass Boudoir, Upper Oval Hall

The original summer residence at Lietzenburg for the Elector's wife Sophie Charlotte was begun by Arnold Nering in 1695 and completed by Martin Grünberg in 1699. Of today's triple-wing complex, it contained only the central section with its decorative half-columns. The section was completely destroyed by bombs in 1943, apart from a few fragments of interior decoration, but in the 1950s/60s the ground floor and the two upper-storey halls were reconstructed. The other rooms on the upper floor, and some of the ground floor, were rebuilt in a neutral museum format. Sophie Charlotte's apartment embraced the whole of the ground floor. With its low stucco ceilings, inspired by the repertoire of Italian stucco artists that was so popular in Brandenburg in the 1680s and early 1690s, it contrasts starkly with the high-vaulted official suites begun by Johann Friedrich Eosander in 1701 when he set about an extension.

Sophie Charlotte's "glass boudoir" was one of her most important rooms. The walls are lavishly composed of mirror strips and swathes of green damask divided by decorative gilt bars. The rich furnishings recorded in the inventory which was drawn up when, now queen, she died in 1705 emphasised the particular status of this room. Even after the palace extensions, it was distinguished by its strikingly rich silver furniture, and also functioned as the second ante-chamber before the hall of audience. In deference to this tradition, it now accommodates a large silver mirror from Augsburg by A. Biller and gilt sculpted furniture. The upper festive hall, two storeys high, was restored to its original form with mirror-lined niches based on the Gallery of Mirrors at Versailles. It boasts ten painted chairs, as recorded in the inventory of 1705.

Sophie Charlotte's glass boudoir, 1699 (reconstructed)

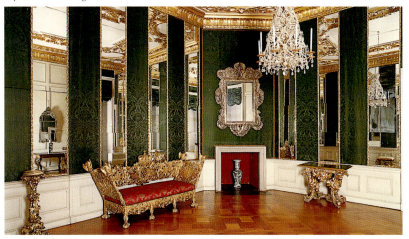

Altes Schloss, Great Gallery, Red Damask Chamber

The Elector was crowned "King in Prussia" in 1701. Before the year was out Eosander – now back from France – produced a model for spacious extensions to the little summer residence at Lietzenburg. The eastern kitchen wing built in 1700, probably by A. Schlüter, was integrated into the city side of a triple-wing complex framing a cour d'honneur. A long garden front was constructed Versailles fashion to showcase the two main storeys and mezzanine established in Nering's plans. This merely meant extending the royal rooms downstairs along an enfilade of 140 metres, its high vault degrading the upper floor into a mezzanine in this zone.

Lietzenburg, renamed Charlottenburg when Sophie Charlotte died in 1705, had originally been her private refuge, but these extensions transformed it into a palace with suites for the king and queen, halls of audience, galleries and sumptuous state apartments. One of the most important rooms was the Great (or Ancestral) Gallery, flanked by two square salons, one to become the queen's hall of

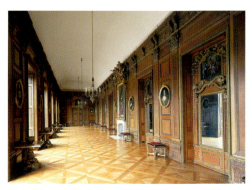

Great (Ancestral) Gallery, J.F. Eosander, after 1705

audience and the other the banqueting chamber. The three rooms derive cohesion from their similar design, based on English prototypes, with oak panelling structured by pilasters, carvings and doors probably made by the English wood sculptor Charles King, appointed in 1703. When Friedrich I died, the ceilings remained unfinished. An amber gallery, clad in the "Baltic gold", had been planned for the western apartment as a chamber of state conceivable only in Prussia. In 1709 it was still not finished and received instead its gold-braided red damask wall covering.

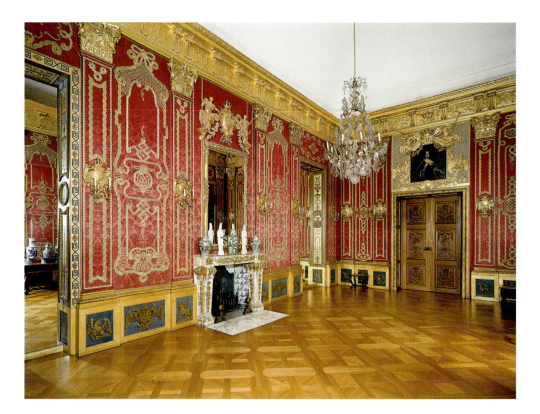

Red Damask Chamber (proposed Amber Gallery), Friedrich I's smoking room, J.F. Eosander, after 1705/1709

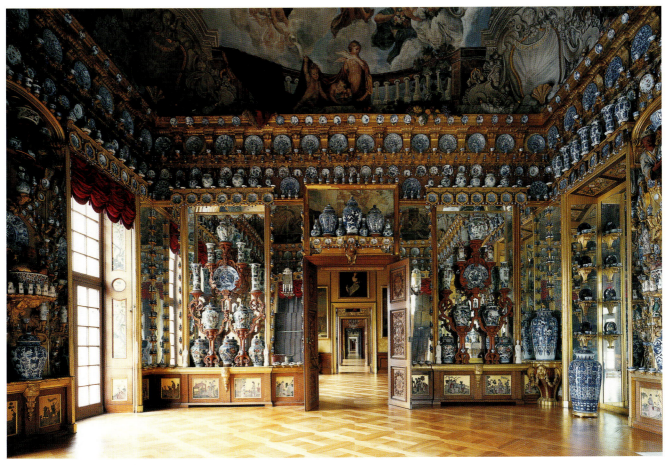

Porcelain Chamber, J.F. Eosander, 1706

Altes Schloss, Porcelain Chamber, Chapel

In the enfilade behind the king's bedroom, the western apartment terminated in the finest sight of the baroque palace, the Great Porcelain Chamber. An abundance of Oriental china to each side, some 3,000 pieces altogether, basks in light from six windows and from walls and niches hung with splendid mirrors. Above a wide cornice the radiant ceiling glorifies the rise of Prussia's royal dynasty and the virtues of its monarch. It is framed by trompe l'oeil architectural features, such as balustrades and cartouches, and in places by stucco detail in haut-relief.

Passing through a looking-glass door in one of the niches, we reach the king's box in the chapel, and from here we enter the chapel itself, probably the most imposing room in the palace. Rising through two storeys into tall vaults, it is the crowning glory of the baroque apartment. It was severely damaged by high-explosive bombs but fully reconstructed in 1960–1977. The walls are shaped by stucco pilasters of lapis lazuli hue with gilt relief. They open eastwards onto an aisle-like space with galleries above. A similar architectural effect is created on the opposite side by trompe l'oeil. On the north wall with the king's box, cherubs hold the drapes of a baldachin, while trumpeting angels present an oversized Prussian crown beneath a lofty Prussian eagle. The pulpit and altar on the south wall are by Charles King. The centre of the east wall highlights the organ display with its sculpted adornment. Amid the rich plastic and visual representations of Biblical scenes, recurring insignia – the crown, sceptre, sword and eagle – glorify the recent institution of kingship and the deceased queen.

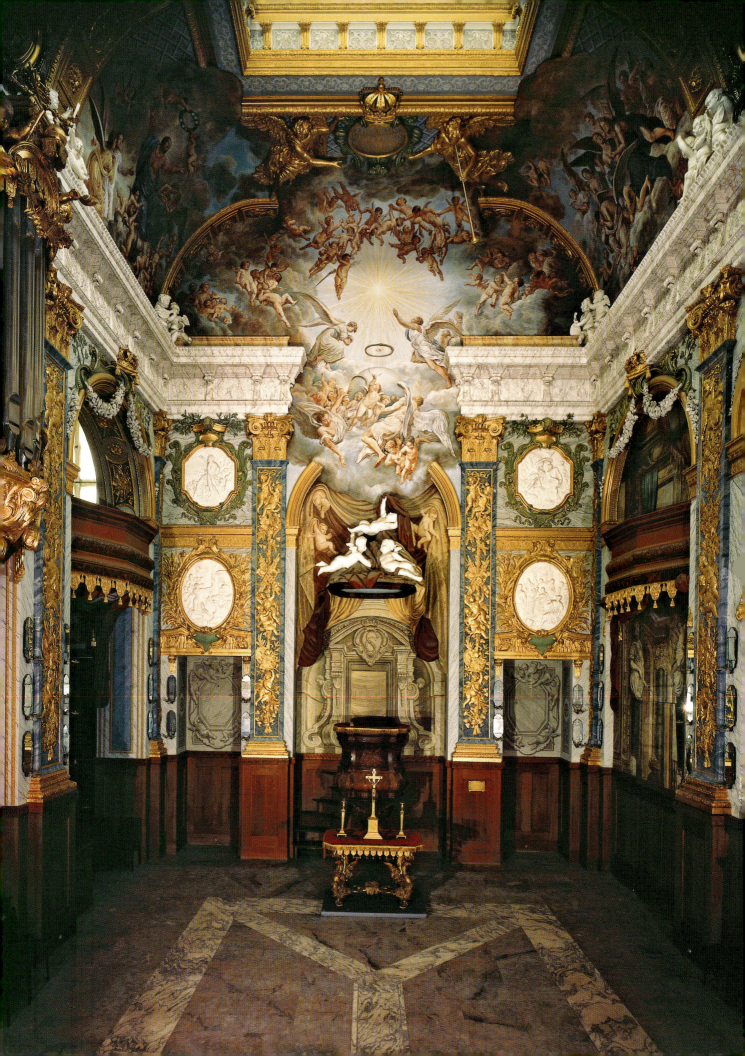

Great (Golden) Gallery in the New Wing, 1742–1746 (reconstructed)

New Wing, Friedrich II's Library, Golden Gallery

In the last years of Friedrich I's reign, the Schloss became a dominant landmark by acquiring a copper tower. Of the two proposed orangeries, however, only the western one had been built when the king died in 1713. When Friedrich II later ascended the throne he immediately asked G.W. von Knobelsdorff to build a new summer residence, eventually known as the New Wing (1740–1742), on the site of its absent eastern counterpart. The earliest interior creations of Friderician rococo in the 1740s include the gallery-style king's library. It was destroyed in the Second World War all but for a few fragments and reconstructed in 1961. The silver-coated ornamentation on the walls was designed by a hitherto unidentified artist, but we know that J.A. Nahl, who arrived in Berlin in 1742, was responsible for the ceiling. The six bookcases, cedar with bronze profiles, originally held mirrors in their doors and were probably acquired by Friedrich in the 1730s, when he was crown prince. They now house the contents of the king's library from Schloss Potsdam. The silverplated wall-mounted table was also part of the original furnishings and is an outstanding example of the quality of sculpted furniture in the early Friderician period.

The Great (or Golden) Gallery created by Knobelsdorff and Nahl in the New Wing in 1742–1746 is one of the most magnificent specimens of an early Friderician

interior and also one of the finest achievements of European rococo. Golden ornament in endless variations criss-crosses the green stuccolustro walls and the ceiling with its pale green background, its fields of pink treillage and its rosettes, creating a garden-like environment with all the hallmarks of a blossoming landscape. Even the window niches are integrated into the ornate decorative system. Stuccolustro and mirrors alternate on the piers between the eleven window axes, the plaster accompanied by Ancient busts on marble plinths and the glasses by wall-mounted tables and narrow sofas. In 1943 this fine room was destroyed but for fragments of stucco decoration from its walls, but reconstruction was facilitated by the many surviving casts of this work and comprehensive photographic records.

⊖ New Wing
(Knobelsdorff Wing)
Tel. (+49 / 0) 30 / 32091 453
Tours with audio-guide
1 April – 31 October:
10 am–5 pm
Admission ceases at 5 pm
Closed on Mondays
1 November – 31 March:
11 am–5 pm
Admission ceases at 5 pm
Closed on Mondays

Library of Friedrich II's first suite in the New Wing, 1742 (reconstructed)

◁ *Palace chapel, J.F. Eosander, 1706*

Second Hautelice Room (concert room) in Friedrich Wilhelm II's Winter Chambers on the upper floor of the New Wing, 1797

New Wing, Winter Concert Room

In 1788 Friedrich Wilhelm II had six ground-floor rooms on the garden side of the New Wing, just behind Queen Elisabeth Christine's apartment, redesigned in the Chinese and Etruscan style as a summer residence. Friedrich Wilhelm III also used them in conjunction with the rooms on the city side. In 1943 only the last three rooms by the old palace (Altes Schloss) survived the bombing.

Seven rooms on the south side of Friedrich II's first apartment were redecorated between November 1796 and August 1797 to serve as winter quarters for Friedrich Wilhelm II. Five of them were totally destroyed in 1943, but as the movable furniture had been almost entirely preserved they were reconstructed in 1983–1993. They are among the most notable achievements of early neo-classicism in Berlin. The improvements, actively guided by Countess Lichtenau, were headed by August Friedrich Voss as director of buildings. Many artists and craftsmen were required to complete the work so quickly. The walls of two rooms sport tapestries from the Don Quixote series designed by C.A. Coypel. They were made at the gobelin manufactory in Paris in the workshop of M. Audran and P.-F. Cozette and given by the French king to Prince Heinrich, who passed them on to his nephew Friedrich Wilhelm II. The original suite of furniture for the second Hautelice Room was based on prototypes by Hepplewhite.

New Wing, Queen Luise's New Bedroom

As Friedrich Wilhelm II died in November 1797, Queen Luise was the first person to live in the Winter Chambers. Friedrich Wilhelm III moved into the suite of rooms below in the New Wing, where the rococo furnishings had been preserved and were now replaced only gradually as contemporary furniture was purchased and surfaces repapered or repainted. The royal couple also brought several items of furniture from the Marble Palace to cater for their requirements.

After the king and queen returned from Königsberg at Christmas 1809, K.F. Schinkel was charged in 1810 with designing a new bedroom in the simpler interiors of the Winter Chambers. He drew on the long-established fashion for silk draping, familiar to Queen Luise from the Royal Palace (Königlicher Palais) in Berlin and a room on the ground floor of the New Wing.

His originally more lavish design was implemented with greater modesty by eliminating an alcove arrangement and merely draping white voile before a wall painted pale red. Instead of installing a tiled stove, the older fireplace that still stands here was transferred, probably from the Berliner Schloss. The ceiling painted by Johann Harper was destroyed in 1943. The bed designed by Schinkel and the new bedside tables were combined with older furniture. The room now also contains the clock and two incense burners from the royal palace in Berlin.

Queen Luise's new bedroom in the Winter Chambers, K.F. Schinkel, 1810 (renewed voile draping)

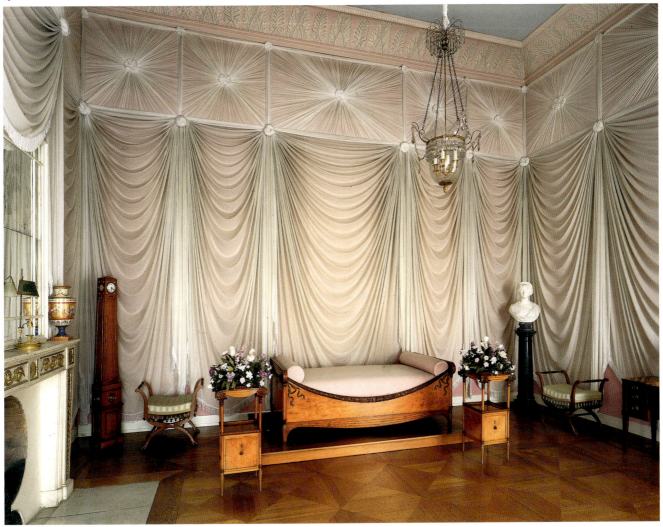

⊙ New Pavilion
(Schinkel Pavilion)
in Schlossgarten
Charlottenburg:
Tel. (+49/0) 30/32091 443
All year round:
10 am–5 pm
Admission ceases/last tour
at 5 pm
Closed on Mondays

New Pavilion, Salon, Friedrich Wilhelm IV's Library in the Altes Schloss

After his Italian journey in 1822, Friedrich Wilhelm III asked K.F. Schinkel to build the New Pavilion in 1824/25 to serve him as a private residence. His model was the Villa Reale Chiatamone, where he had stayed while in Naples. A.D. Schadow, court building director and a pupil of Schinkel, took charge of the project. The upper floor housed the king's living rooms, study, conference room and bedroom. Small social occasions were held in the salon downstairs and an adjoining room on the west side. The pavilion was gutted by fire in November 1943 and the furniture and fittings were destroyed but for a few remnants. It was rebuilt in 1957–1970. The vestibule with the stairs, salon and adjoining red cabinet were reconstructed. Fireplaces, wall mouldings and wallpaper borders were recreated wherever possible in the other

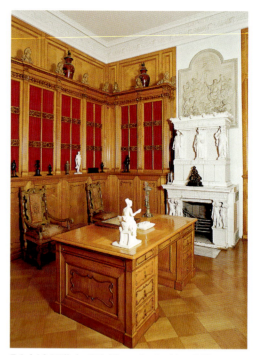

Friedrich Wilhelm IV's library in the Altes Schloss, J.H. Strack, 1845/1846

rooms, but in most cases only the original colour scheme was restored. The salon is highlighted in its functional status by the large exedra, a direct reference to an ancient marble bench in Pompey. Today the Pavilion is essentially a museum of Berlin art during Schinkel's day, with notable portraits, landscapes, Historical paintings, vedute, sculpture and applied art.

Upon taking office in 1840 Friedrich Wilhelm IV had an apartment installed for himself and his wife, Queen Elisabeth, on the upper floor of Nering's wing and the adjacent rooms. Most of the original decoration remained untouched and was merely complemented by new additions, but bigger alterations were undertaken in the more austerely furbished rooms. The rooms in the Nering wing were destroyed in 1943 and rebuilt as a neutral museum. The new interiors included the king's library, furbished in 1845/46 to designs by J.H. Strack, merely damaged in 1943 and restored and improved in 1989–1992. The furniture removed to Potsdam for safety during the Second World War was returned after German unification.

B. G.

Salon in the New (Schinkel) Pavilion, K.F. Schinkel, 1824/25 (reconstructed)

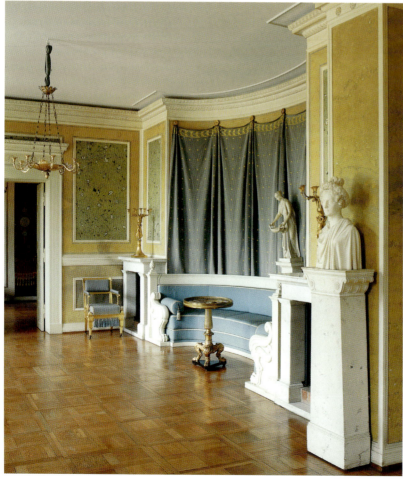

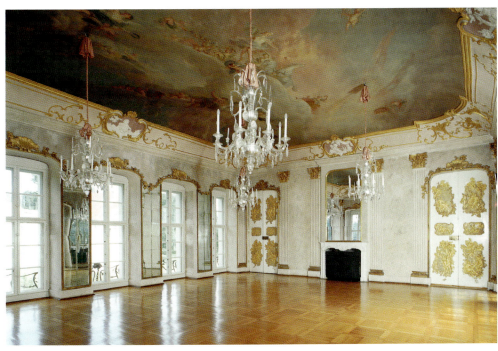

Great Hall (Hall of Mirrors), designed by G.W. von Knobelsdorff, 1737

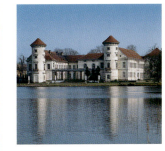

Schloss Rheinsberg
D-16381 Rheinsberg

i Schloss Rheinsberg
Postfach 1128
D-16381 Rheinsberg
Tel. (+49/0) 3 39 31 / 7 26-0
Fax (+49/0) 3 39 31 / 7 26-26

⊘ 1 April – 31 October:
10 am–5 pm
Closed on Mondays
Admission ceases at 5 pm
1 November – 31 March:
10 am–4 pm
Last tour at 4 pm
Closed on Mondays

⊞

✕ Restaurants nearby

P Car park nearby

DB RB 6 from Berlin
Charlottenburg
RB from Berlin Lichtenberg
in summer

Schloss Rheinsberg
Great Hall, Picture Gallery, Prince Heinrich's Bedroom,
Cabinet of Antiquity

Friedrich Wilhelm I purchased the rural seat on Lake Grienerick in 1734 as a residence for Crown Prince Friedrich and his wife. He instructed Johann Gottfried Kemmeter, chief architect at his Brandenburg court, to begin the conversions and extensions for this 16th-century building. In 1737, after returning from his Italian journey, Georg Wenzeslaus von Knobelsdorff continued the work, and the exten-

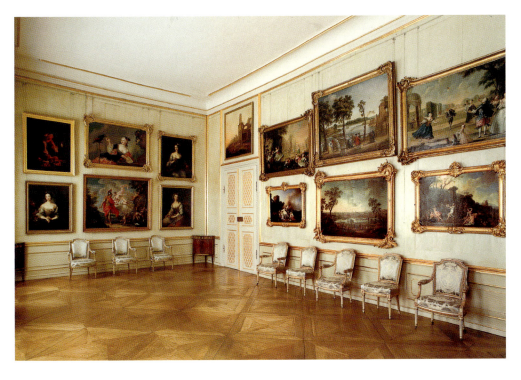

Prince Heinrich's picture gallery, 1763

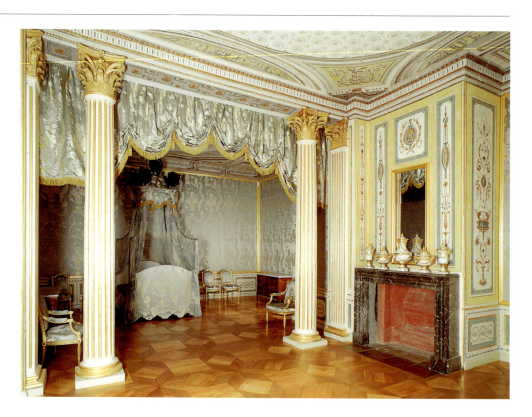

Prince Heinrich's bedroom, 1786

sions were completed with the north wing in 1740, the year Friedrich II ascended the throne. The two pavilions to the east were added later under Prince Heinrich of Prussia, who occupied the Schloss from 1744 until 1802.

The rooms within the Schloss offer some splendid specimens of the earliest Friderician rococo. These include the ballroom, the Crown Princess's ante-chamber and a number of others with ornate doors and no fewer than five ceilings painted by Antoine Pesne. Among the achievements of Heinrich's 50-year incumbency are the interiors designed by Carl Gotthard Langhans in the 1760s, most of them still predominantly rococo in style but with severer traits emerging in, for example, the great stairwell and the Hall of Shells. From 1785, after the prince's first journey to France, we note an incipient neo-classicist inspiration, such as in the bedroom and library, which are among the earliest examples of this new style to be found in Prussia's palaces. In 1772 two of the oldest ground-floor rooms, which still had vaulted ceilings, were transformed into grottos, one devoted to Antiquity and the other resembling a landscape, by the fantastical paintings of J.F. Reclam.

After 40 years as a sanatorium, the Schloss was acquired in 1991 and has since been carefully restored. In some cases the original art works have been recuperated from other former stately homes, where they had been preserved. The aim in most rooms is to restore the Schloss as a museum in situ, but a few rooms serve to display extraneous items, notably the collection from the prince's Berliner Palais.

B. G.

Vaulted chamber
(Cabinet of Antiquity), 1772

Schloss Sanssouci

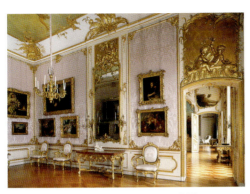

Hall of Audience or dining room, 1745–1747

Hall of Audience / Dining Room, Little Gallery

The history of Sanssouci began in 1744 when the king had a terraced vineyard planted on a desolate elevation. Guided by the king himself, Georg Wenzeslaus von Knobelsdorff drew up plans for a summer palace, which was built in 1745–1747 and named "SANS SOUCI". It was the owner's private retreat with twelve rooms in the manner of a French "maison de plaisance". The interior furbishing has been preserved largely as it was.

The central section houses the vestibule of stuccolustro and the domed hall, resplendent in precious varieties of marble. It combines the king's passion for works in this noble stone with a desire to project regal status and has resulted in one of the most beautiful creations of interior space in Europe. The precious material for the walls, columns and floor was selected with a meticulous eye for matching colour. Additional decorative highlights are set by mercury-gilt bronzes and carved doors. White stucco allegories of the arts and sciences contrast strikingly with the gilt stucco of the curving dome. The eastern half of the palace accommodates the king's own apartment in four rooms to the south – an ante-chamber (both Hall of Audience and dining room), the ceremonial chamber (concert room), a study-bedroom and a library. They are exquisitely elegant with an abundance of movable decoration: paintings, sculp-

tures, chandeliers of rock crystal, ornate wall candelabras, furniture, French clocks and fire surrounds.

From the Marble Hall we enter the Hall of Audience and dining room. The decorative tone is set here by the paintings, their ornately carved gilt frames standing out effectively against the pale lilac of the silk damask beneath. All the works here are by French masters. They notably include Antoine Watteau's "Concert" and the "Declaration of Love" by Jean-François de Troy.

The Little Gallery to the north was one of the first rooms devoted by Friedrich II to accommodating specific collections. It displays works by Antoine Watteau and his successors Nicolas Lancret and Jean-Baptiste Pater along with Ancient sculptures from the Polignac collection acquired by the king in 1742.

Schloss Sanssouci
Maulbeerallee
D-14469 Potsdam

i Besucherzentrum an der
Historischen Mühle
Postfach 60 14 62
D-14414 Potsdam
Tel. (+49/0) 331 /
96 94-200 / -201
Fax (+49/0) 331 / 96 94-107
Besucherzentrum@spsg.de

Little Gallery, 1745–1747

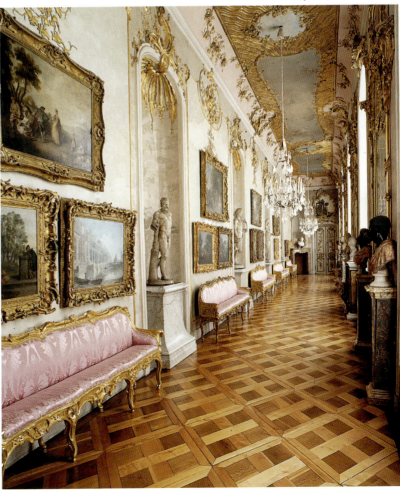

⊙ Guided tours only
Please come early due to
restricted viewing capacity
1 April – 31 October:
9 am–5 pm
Admission ceases at 5 pm
Closed on Mondays
1 November – 31 March:
9 am–4 pm
Last tour at 4 pm
Closed on Mondays

Ladies' Wing:
15 May – 15 October:
Sa/Su 10 am–5 pm
Admission ceases at 5 pm

Palace kitchens:
1 April – 31 October:
10 am–5 pm
Last tour at 5 pm
Closed on Mondays

🚌 Bus 695 from Pdm. Hbf to
Schloss Sanssouci
Tram 94, 96 to Luisenplatz
(walk through park)
Bus 605, 606 from Pdm. Hbf
to Luisenplatz (walk
through park)

Concert Room

The white panelling with its lavish gilt carvings, which Johann Michael Hoppenhaupt the Elder made from the drawings of Johann August Nahl, blends with the five wall paintings by Antoine Pesne illustrating scenes from Ovid's "Metamorphoses" and with the lively filigree stucco work on the ceiling to create one of the most magnificent interiors in the rococo style. Mirrored niches in the back wall reflect the landscape seen from the windows, while looking-glasses facing one another on the long walls extend the space with countless repetitions. By opening onto the surrounding scenery, a feature reinforced by the paintings and even the overdoors, this room with its latticework ceiling resembles a garden trellis. Within the apartment sequence this is the ceremonial chamber, devoted above all to daily music-making.

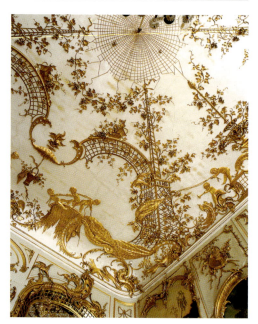

Concert room ceiling (detail)

Concert room, designed by J.A. Nahl, 1745–1747

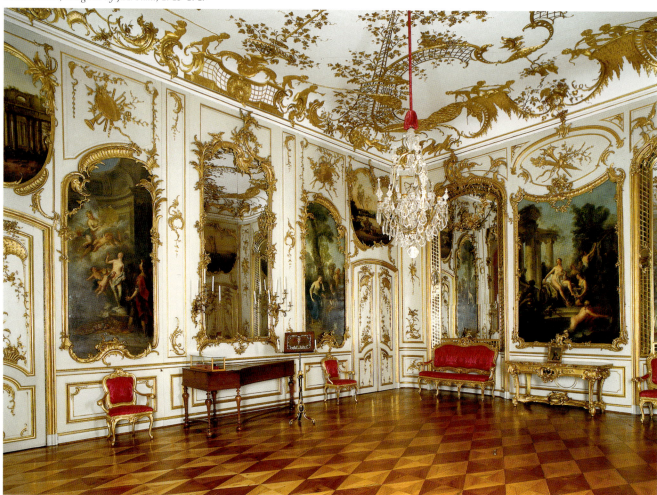

Library

The Library, hidden away at the end of the palace beyond the enfilade, was the king's private refuge and as long as he lived nobody was permitted to enter without his express orders. This circular room with its low bookcases in precious cedar panelling with mercury-gilt bronze ornamentation, the gilt bronze mountings with busts of the Ancients overhead and, above these, gilt bronze bas-relief depicting allegories of the arts together constitute one of rococo's most perfect interiors. Incorporating the door into the array of books furthers its rare atmosphere of studious concentration. Indeed, two terrace doors seem to provide the only link with the garden. The cupboards house the original library collection, which consists almost entirely of Greek and Roman poetry and history (in French translation) and French literature of the 17th and 18th centuries.

⊞ Museum shop Sanssouci
Tel. (+49/0) 30/32 60 39-46
Info@museumsshop-im-schloss.de

✕ Mövenpick restaurant
Zur Historischen Mühle

🅿 Car park by the Visitor's Centre (behind the Old Mill)

Library, designed by G.W. von Knobelsdorff, 1745–1747

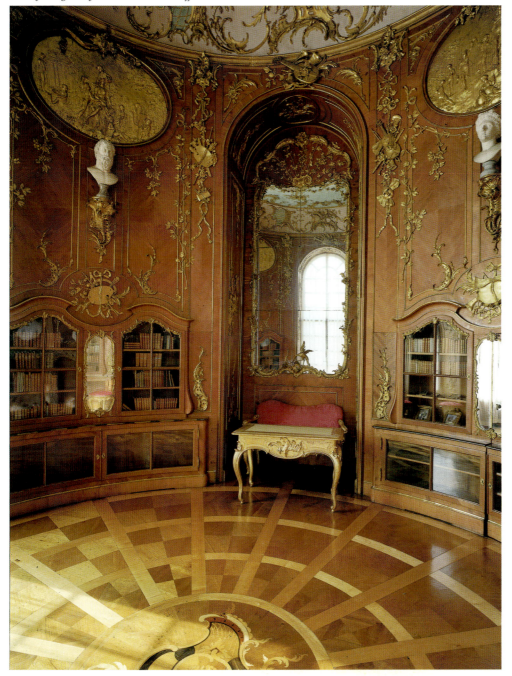

Study bedroom, designed by F.W. von Erdmannsdorff, 1786/87

Fourth Guest Room (Voltaire's Room), Study Bedroom

The western half consists of five guest-rooms with alcoves and rooms for the servants. They are much more simply furbished, with gilding applied more thriftily to the carvings and few pieces of gilt and sculpted furniture (the other chairs are painted white), and more modest light fittings, wall coverings and floors. Only the decorative paintings,

Fourth guest room (Voltaire's room), designed and furbished by J.C. Hoppenhaupt jun., 1752/53

almost all of which have survived, are similarly ornate. The first, fourth and fifth rooms originally boasted chinoiseries painted by Friedrich Wilhelm Höder. The fourth, which tradition ascribes to Voltaire, was redecorated in 1752/53 by Johann Christian Hoppenhaupt the Younger, acquiring richly carved panelling finished in yellow with hanging flowers, shrubs, fruit and animals hand-painted in naturalist fashion. The floral decoration continues across the ceiling, suspended in places in the form of wired stucco. After the early Friderician designs by Knobelsdorff and Nahl, the younger Hoppenhaupt was now on the ascendancy with a novel, more naturalistic approach that became a hallmark of the later interiors.

After Friedrich the Great died in 1786, his successor Friedrich Wilhelm II commissioned Friedrich Wilhelm von Erdmannsdorff from Dessau to redesign the Study Bedroom in the early neo-classicist style that was also sweeping Prussia. As the interiors designed by Erdmannsdorff for the King's Chambers in the Berliner Schloss have been destroyed, this remains the only testimony to his work for Berlin. Few specimens of the classical furniture have survived.

B. G.

Park Sanssouci

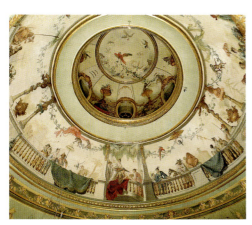

The dome in the Chinese House

hand-painted yellow silk wall covering has been reconstructed in the eastern cabinet. All that remains of the cabinets' original furniture is a cased clock by Melchior Kambly with tortoiseshell veneer and gilt bronze decoration.

Chinesisches Haus
Park Sanssouci
D-14469 Potsdam

ℹ same as Schloss Sanssouci

🕐 15 May – 15 October:
10 am–5 pm
Admission ceases at 5 pm
Closed on Mondays

Ⓢ Tram 94, 96 to Luisenplatz,
walk

🚌 Bus 605, 606

🅿 Car park by the New Palace
or the Visitor's Centre

Chinese House

Built in 1754–1763 by Johann Gottfried Büring, allegedly from a lost sketch by Friedrich the Great, the Chinese House is one of the finest small architectural gems in the park at Sanssouci. It seems that the king's floor plan was inspired by a structure built by architect Emanuel Heré for Poland's former monarch Stanislaus Leszynski in Lunéville. In Potsdam, however, the result was quite different. The architecture of this pavilion in Sanssouci, like the rich sculpture and painting that adorns it, are freely imaginative creations of the mid-18th-century European fashion for things thought Chinese. The statues in front of the façades and the figures seated around palm trees in the porches look like characters in a European opera or ballet rather than authentic Orientals. Between the three porches around the circular dining room at the centre of the building are three little cabinets fronted by regularly arranged parterres. Through the porches, the room itself, with its nine glazed doors and tall windows, remains cool and reserved with its pale green walls of stuccolustro, its white and gold, its resplendent wall lights, chandeliers, china wall brackets and gilt dining chairs. It can be flooded by sunlight thanks to six windows in the dome painted by Thomas Huber (1755/56) from drawings by Blaise Nicolas Le Sueur. A

Dining room in the Chinese House, 1757

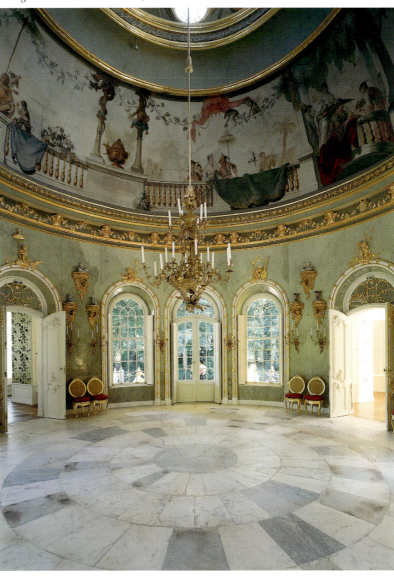

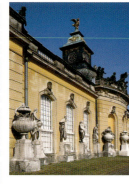

Bildergalerie
Park Sanssouci
D-14469 Potsdam

i Besucherzentrum an der
Historischen Mühle
Postfach 60 14 62
D-14414 Potsdam
Tel. (+49/0) 331/
96 94-200/-201
Fax (+49/0) 331/96 94-107
Besucherzentrum@spsg.de

🕐 15 May – 15 October:
10 am–5 pm
Admission ceases at 5 pm
Closed on Mondays

🚌 Bus 695 to Schloss
Sanssouci

P Car park by the Visitors'
Centre (behind the
Old Mill)

Sanssouci Picture Gallery

Since the early 1750s Friedrich II had been harbouring ideas about creating a gallery for the great Renaissance and baroque masters whose works he had been collecting. In 1755–1763 Johann Gottfried Büring constructed this purpose-built gallery, one of the oldest surviving museums in Europe, to the east of Schloss Sanssouci as a pendant to Knobelsdorff's orangery on the west side. Inspired by the orangery, it was nevertheless crowned by a dome and sported a wealth of decorative plastic art. The monumental interior space derives a certain articulation from the darker, domed central section but without the overall impact being diminished by interruption. It is striking for its abundance of light and its festive decoration of precious marble with ornate gilt stucco work filled by the array of paintings. This is one of the world's most beautiful galleries, not least thanks to the figurative stucco on the ceiling with allegories of the arts and their attributes. The marble sculptures by the big doors were commissioned by the king from Guillaume Coustou junior, Jean-Baptiste Lemoyne and Louis-Claude Vassé in Paris. The entire furnishings are still extant, with four wall-bracketed tables, twelve corbels supporting Ancient busts and sculptures and eight benches originally used for sitting to contemplate. The Ancient sculptures were passed on to the Royal Museum in Berlin back in 1830 and were replaced by others, but the original paintings were decimated when Soviet troops transported many back home in 1945/46. Some were returned in 1958, and today masterpieces by Peter Paul Rubens, Anton van Dyck, Caravaggio and Maratti, along with many other interesting works, fill the Gallery and the Cabinet.

B. G.

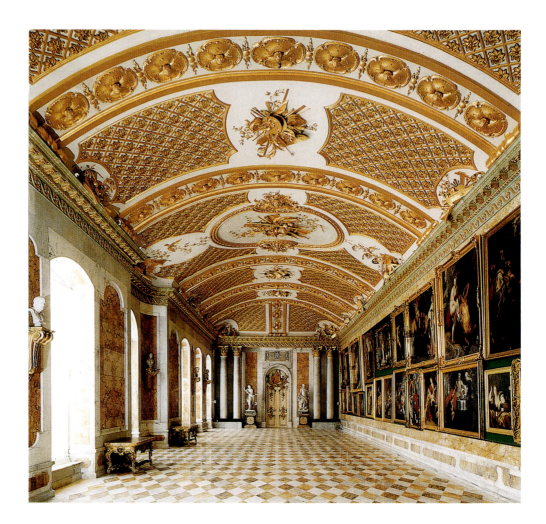

*Hall of the Picture Gallery,
1755–1763*

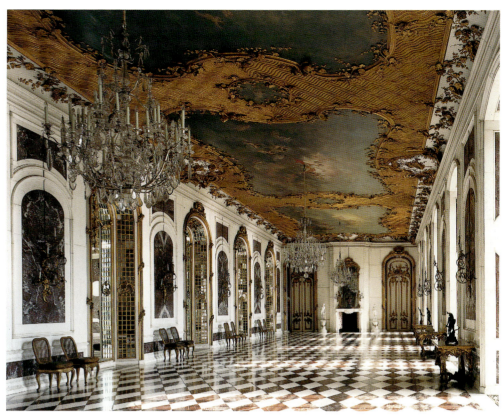

Marble Gallery, designed by Carl von Gontard, 1765/69

Neues Palais von Sanssouci
Am Neuen Palais
D-14471 Potsdam

i Besucherzentrum an der
Historischen Mühle
Postfach 60 14 62
D-14414 Potsdam
Tel. (+49/0) 331/
96 94-200/-201
Fax (+49/0) 331/96 94-107
Besucherzentrum@spsg.de

🕗 1 April – 31 October:
9 am–5 pm
Admission ceases at 5 pm
Closed on Fridays
1 November – 31 March:
9 am–4 pm
Last tour at 4 pm
Closed on Fridays

🚌 Bus 605, 606, 695 to Neues
Palais

🎫 Museum shop Neues Palais
Tel. (+49/0) 30/326039 46
Info@museumsshop-im-
schloss.de

✖ Restaurant/Café Drachen-
haus in Park Sanssouci

P Car park near the Schloss

DB RB 1 to Park Sanssouci

New Palace Sanssouci

A "new palace of Sanssouci" on the banks of the River Havel, opposite Friedrich the Great's summer residence, was first conceived in the early 1750s in order to receive and entertain his summer guests in appropriate fashion. Construction was not begun, however, until after the Seven Years' War (1756–1763). A new site was selected in 1763 at the western end of the main avenue across the park of Sanssouci before Johann Gottfried Büring and Heinrich Ludwig Manger commenced their work. When Büring left, Carl von Gontard took on the supervision of works from 1765. Like other artists and craftsmen from Bayreuth, he had followed the call to Potsdam. Completed along with its lavish furnishing within just six years, the building was intended to demonstrate to the world that Prussia's power was unbroken by the war. It was to be the king's biggest architectural project and includes the most imposing latter-day Friderician interiors. The building also fulfilled another objective, this time of economic policy, as Prussia's greatest "job creation scheme" of the period, restoring an income and livelihood to all the region's trades. The original design was complemented by the Communs, functional buildings in the form of splendid pavilions with domes, elongated wings and mews courtyards. These were erected in 1766–1769 to designs by Jean Laurent Le Geay and Gontard himself. Their purpose was to accommodate the kitchens, utility rooms, the court retinue and their servants. A colonnade planned to link the wings of the cour d'honneur was built instead between these functional structures. The interior design of the banquet rooms was primarily the work of Gontard, while Johann Christian Hoppenhaupt the Younger took responsibility for the apartments and theatre, drawing occasionally on older blueprints by Johann Michael Hoppenhaupt the Elder or, possibly in response to the king's personal request, prototypes from his existing palaces.

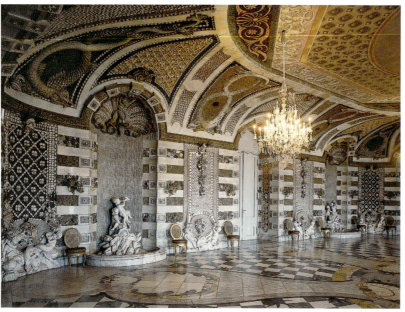

Grotto Hall, designed by Carl von Gontard, c. 1766

Blue Chamber (king's first ante room), designed by J.M. Hoppenhaupt sen., c. 1750, implemented after 1765

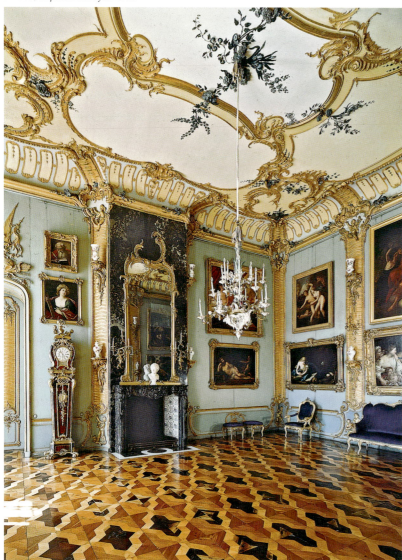

Grotto Hall, Marble Gallery, Blue Chamber

Apart from the four festive halls in the central section and the adjoining galleries, the king's apartment in the small south wing and prestigious guest suites in the corps de logis, the palace above all incorporated large apartments for members of the royal family and a large number of guest rooms entered via four stairways. Official access to the king's apartment and the suite for high-ranking guests of state was from the cour d'honneur via the lower vestibule and through the Hall of Grottos. The original design, with groups of statues and fountains, marble strips, glass slag, simple local minerals and imitation stalactites combined with ornamental patterns of shells was enriched in the 19th century by semi-precious stones, rare minerals, fossils and sea shells and snail shells from all over the world, which remained until the monarchy was abolished.

The brightly sunlit marble gallery which adjoins it to the south with its decoration of white and red Italian marble and mirror niches, led to the king's rooms and served as a large dining room. Its original furbishing has been largely preserved.

The Blue Chamber is the first ante room before the king's own suite. Like most ante rooms it is adorned by a wealth of paintings, including works by Peter Paul Rubens, Pompeo Batoni, Jean-Baptiste Pater, Jean Raoux and Jean-François de Troy. Whereas the other ante rooms are modest by comparison, this one is based on a design by Hoppenhaupt the Elder for a hall of audience. In addition to the gilt lesenes that structure the walls, it has a double row of corbels supporting vases of Dresden china. The furniture ranks among the masterpieces of German rococo. The clock and the chest of drawers by Melchior Kambly, like many of the paintings and the chandelier of Berlin china, were part of the original inventory.

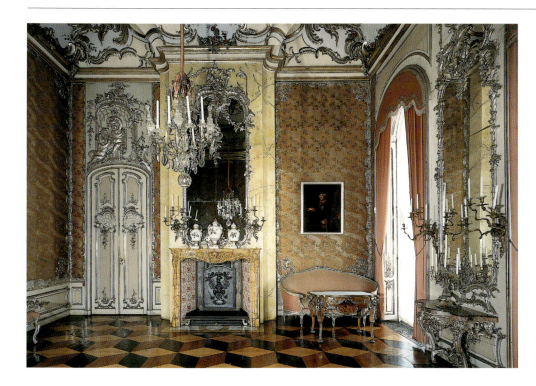

King's study, designed by J.C. Hoppenhaupt jun., wood carvings by Peter Schwizer, 1765

Friedrich the Great's Study and Bedroom

The king's study is one of the rooms that have managed to retain almost all the original furbishing, not only the complete upholstered suite, the desk, the chandelier, the set of vases over the hearth, the mounted table with its mosaic top and lamp, but also the most magnificent chest of drawers in German rococo style, with tortoiseshell veneer and inlays of mother-of-pearl and ivory. It was made by Heinrich Wilhelm Spindler the Younger and boasts lavish silver-plated bronze from the workshop of Melchior Kambly. The rich silver brocade on the walls, curtains and furniture, an outstanding product of the Berlin silk industry that was in its heyday in the 18th century, was replaced by a copy in 1900 (walls only).

The blue silver brocade wall covering in the bedroom was also replaced by a copy in 1900, but the seating has retained the original material. The "Polish" bed was brought here in 1900 from the Crown Prince's apartment, and for utilitarian reasons no copy of the silver brocade was made. The seating was made by the younger Hoppenhaupt. In the Kaiser's day, most baths, toilets and central heat-ing were cleverly integrated into the floors of window niches. Electrification was also introduced around this time, but by the abdication in 1918 it had not yet reached the king's suite, which was being used for guests. The king was particularly fond of silver-plated decoration, which is found more frequently in the New Palace. In the king's rooms, the silver-coated stucco ceilings with their naturalistic floral arabesques are especially striking.

King's bedroom, designed and furbished by J.C. Hoppenhaupt jun., 1765

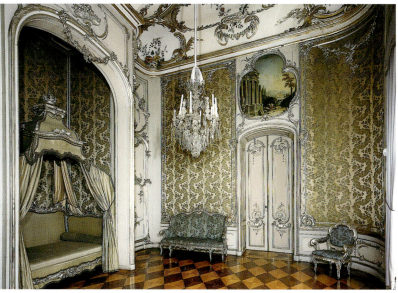

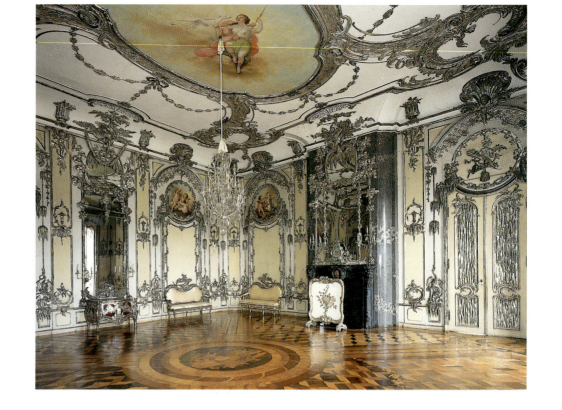

Concert room in the Suite of Princes, designed by J. M. Hoppenhaupt sen., c. 1750, implemented 1767/69

Concert Rooms in the Suite of Princes, Palace Theatre

The concert rooms in the quarters reserved for visits by high-ranking princes stand out from the other reception rooms by virtue of their size. The pan-elling is based on an earlier design by J.M. Hoppenhaupt the Elder. Silver-coated sculptural work against a painted background of pale yellow and grey provides vertical organisation in the form of spouting herons, grottos and tree trunks. The hunting theme is reflected in weaponry,

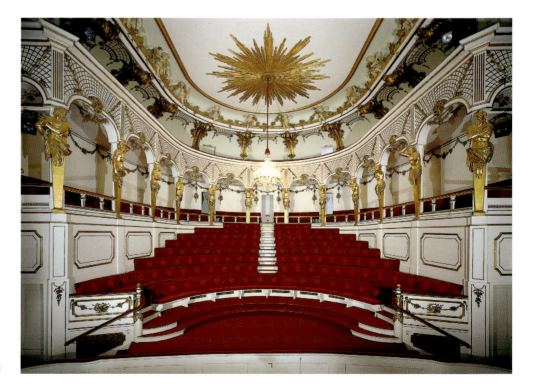

Schlosstheater, designed by J.C. Hoppenhaupt jun., c. 1767/69

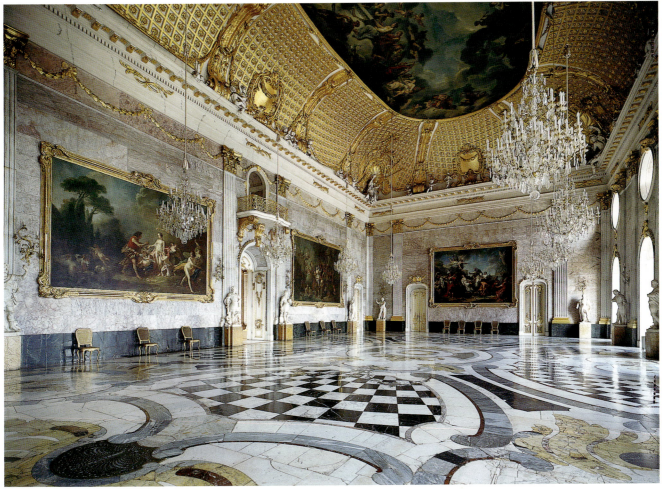

Marble Hall, designed by Carl von Gontard, 1765–1769

falcons, a head of the goddess Diana and a ceiling painted by Johann Christoph Frisch that also depicts Diana. The theme is echoed in the floor by the Spindler brothers with its rich marquetry showing dogs and emblems of the hunt. The sumptuous chest of drawers by Heinrich Wilhelm Spindler the Younger, with tortoiseshell veneer, inlays of ivory and colourful mother-of-pearl and ornate silver-coated bronze ornamentation from Melchior Kambly's workshop, was part of the original furniture, as were the embroidered fireplace hood, the vases over the hearth (made in the Berlin manufactory in 1768) and the two sofas (of which there were once four). The grand piano by Burkard Tschudi (London, 1766) was acquired for the new palace along with other specimens of the master's output.

Apart from the Royal Opera House in Berlin built in 1740–1742, Friedrich the Great commissioned theatres for the Berliner Schloss, his winter residence in Schloss Potsdam and the new palace here in Sanssouci. Only this one, known as the Schlosstheater, has survived. J.C. Hoppenhaupt designed it as an amphitheatre. The unbroken lower circle is articulated by carved, gilt herms holding the upper circle. Palm trees frame the stage. The prototype for this theatre in Schloss Potsdam was designed by G.W. von Knobelsdorff, but by 1800 it had been converted for residential purposes.

Marble Hall and Upper Gallery

The Marble Hall of 600 square metres occupies the full width of the central risalto and is two storeys high. It was designed by Carl von Gontard in the manner of the marble hall in Schloss Potsdam and was similarly faced with various types of Silesian marble. The marble floor with its rich incrustations is by Melchior Kambly. Whereas the king had its coun-

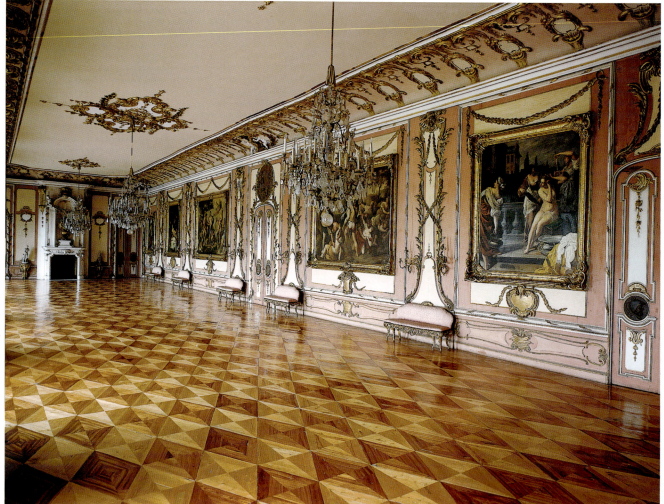

Upper Gallery, designed by J.C. Hoppenhaupt jun., 1765–1769

terpart in his winter residence restyled as a hall of glory to honour his great-grand-father, the Great Elector, his aim here was to project his own image as a regal patron of the arts. To this end he granted commissions before the Seven Years' War to three well-known Parisian artists and his own court painter Antoine Pesne. This homage to the king was echoed by court painter Charles Amedé van Loo, who illustrated "Ganymede introduced to Olympus by Hebe" on the ceiling he painted in 1769. The original furbishing was confined to the ornately framed paintings, chandeliers, wall candelabras and chairs, but in 1950 an ancestral gallery of baroque statues showing the Electors of Brandenburg was brought here from the palace in Berlin, where Bartolomäus Eggers had made them for the main banqueting hall in the 17th century. The adjoining Upper Gallery, designed by J.C. Hoppenhaupt, apparently served as a ballroom. It also provided official access to the crown prince's apartment. The later genesis of the Neues Palais is particularly noticeable in the decoration here, with the advent of early neo-classical motifs (the form of the garlands, bronze-coloured round medallions, vases over the fireplaces). The principal decorative features in this room are the six paintings by Italian masters (Guido Reni, Artemisia Gentileschi, Luca Giordano). Like the three wall-mounted tables, they formed part of the original inventory. B. G.

New Chambers in Sanssouci Park
Jasper Hall, Great Marquetry Cabinet

Great Marquetry Cabinet, Spindler brothers, 1771–1775

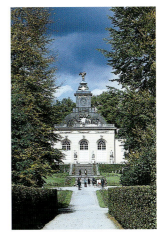

In 1771–1775, at the request of Friedrich the Great, Johann Christian Unger converted the orangery built next to Schloss Sanssouci by Knobelsdorff in 1747 into four ornately decorated halls for festive occasions and a series of guest apartments to complement the palace. These are the last expressions of Friderician rococo, almost coinciding with Schloss Wörlitz as the first example of mature early neo-classicism in Germany. The architect pulled out all the stops to cater for the king's rococo tastes and the craftsmen responded with their customary con-summate skills. In three of the halls stuccolustro sets the tone in various guises: lapis lazuli, yellow and the king's beloved green chrysoprase. Meanwhile, at the heart of these, the Jasper Hall is a particular majestic setting, combining precious marble from the recently acquired province of Silesia with busts of Antiquity. In the Ovid Gallery, the brothers Johann David and Johann Lorenz Wilhelm Räntz from Bayreuth illustrate the poet's "Metamorphoses" with 14 themes in gilt stucco bas-relief against a faded green background, enhancing the festive atmosphere in conjunction with large mirror-lined niches. The chairs and some of the mounted tables reflect the 18th-century furnishings.

Most guest suites originally consisted of a living room and a bedroom with alcoves. They were designed as cabinets, painted or hung with paintings, with 18th-century views of Potsdam. In two of these, the brothers Johann Friedrich and Heinrich Wilhelm Spindler of Bayreuth produced masterpieces of 18th-century marquetry panels with festoons of flowers, birds and fruit, fine-meshed latticework and cartouches. B. G.

Neue Kammern
Maulbeerallee
D-14469 Potsdam

ℹ Besucherzentrum an der
Historischen Mühle
Postfach 60 14 62
D-14414 Potsdam
Tel. (+49/0) 331/
96 94-200/-201
Fax (+49/0) 331/96 94-107
Besucherzentrum@spsg.de

☉ 1 April – 14 May:
Sa/Su and public holidays
10 am–5 pm
Admission ceases at 5 pm
Closed on Mondays
15 May – 31 October:
10 am–5 pm
Admission ceases at 5 pm
Closed on Mondays

🚌 Bus 695 to Schloss
Sanssouci

🅿 Car park by the Visitor's
Centre (behind the Old
Mill)

Jasper Hall, 1771–1775

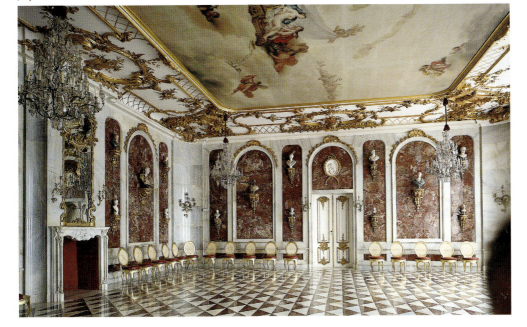

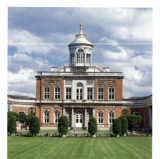

Marmorpalais
Im Neuen Garten
D-14469 Potsdam

New Garden – Marble Palace

Stairs, Grotto Hall

The Marble Palace was built in 1787–1793 when the New Garden was laid out. The original structure, a villa on a square floor plan, was the "Sanssouci" of Friedrich the Great's successor, Friedrich Wilhelm II. It was constructed by Carl von Gontard, the most eminent architect of the great monarch's latter years. Friedrich Wilhelm II entrusted the interior to Carl Gotthard Langhans, the new director of the Royal Court Architects Department. The wings added in 1797 by Michael Philipp Boumann were not furbished until 1844–1847, when the plans were supplied by Ludwig Persius and Ludwig Ferdinand Hesse. Along with the King's Chambers in the Berliner Schloss, no longer extant, Langhans' Marble Palace interiors rank among the finest specimens of early neo-classicism in Berlin. They display a pronounced variety of decoration. Panels of veneer and marquetry alternate with hand-painted, ornamented counterparts, wall coverings of silk, wall-size landscape paintings and stuccolustro. The palace underwent many uses in the 19th and early 20th century, but in the 1920s the original furniture was returned to view as completely as in the New Palace. Extensive restoration and reconstruction was required after the loss of many movable objects in 1945 and the use of the rooms as an officers' canteen for the Soviet Army until 1955 and as an Army Museum until 1988. Since the main building re-opened in 1997 it has functioned as a public museum in situ, although only the ground floor can lay claim to much of its original furnishings. On the upper level, with the exception of a few original pieces, many replacements have been transferred from other palaces.

The vestibule feeds into a stairwell lit from above. With its curving marble stairs this is one of the finest creations by Carl Gotthard Langhans.

The Grotto Hall behind it echoes the cool atmosphere of the stairway in its walls of stuccolustro. This room with its engaged piers, a feature frequently exploited by Langhans, is optically enlarged by four mirrors facing each other in pairs. The seats are from the library pavilion and the concert room in the New Garden orangery.

Stairs, designed by Carl Gotthard Langhans, 1789

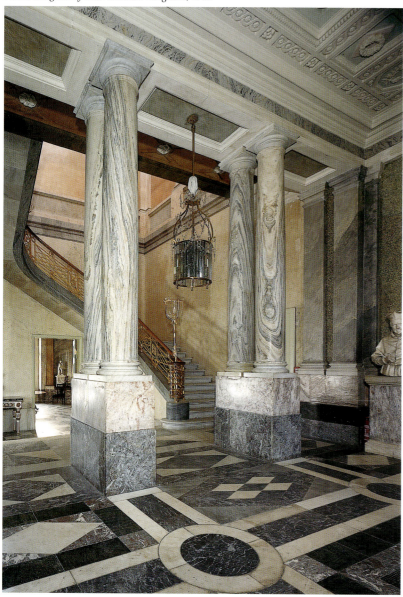

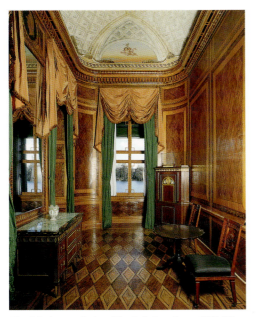

King's bedroom, designed by C.G. Langhans, 1789/90

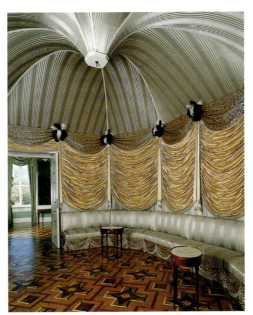

Oriental cabinet, designed by C.G. Langhans, 1789/90

i Besucherzentrum an der
Historischen Mühle
Postfach 60 14 62
D-14414 Potsdam
Tel. (+49/0) 331/
96 94-200/-201
Fax (+49/0) 331/96 94-107
Besucherzentrum@spsg.de

🕐 1 April – 31 October:
10 am–5 pm
Admission ceases at 5 pm
Closed on Mondays
1 November – 31 March:
Sa/Su 10 am–4 pm
Last tour at 4 pm

Ⓢ Tram 90, 92 or 95 to
Reiterweg/Alleestr.,
15 min. walk

✕ Orangerie Sommercafé

Kolonie Alexandrowka
Restaurant Russische
Teestube

🅿 Car park near Schloss
Cecilienhof

Oriental Cabinet, Bedroom

The inner rooms are clustered around the central stairs. The most intimate rooms in the palace, including the dressing room and bedroom, are those which have been least altered, apart from the renewal of precious silks. Marble fireplaces purchased for Friedrich Wilhelm II in Rome by F.W. von Erdmannsdorff were inte-grated here. The specimen in the dressing room has ornamental bronze fittings and inlays of Roman cone mosaics. The Wedg-wood mantles – jasperware, black basalt and other types – have been preserved complete in every room.

The panelling in the ground-floor study and bedroom is inlaid with yew and other species of wood often encountered in Berlin's early neo-classical interiors. The

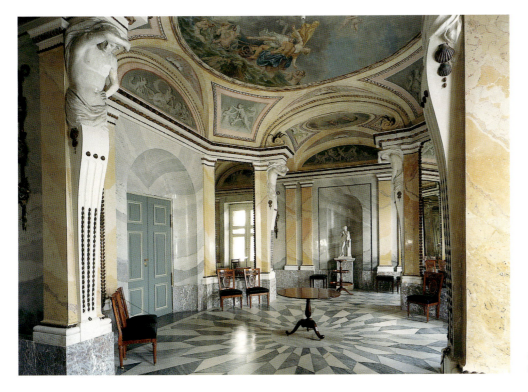

*Grotto Hall, designed by
Carl Gotthard Langhans, 1789*

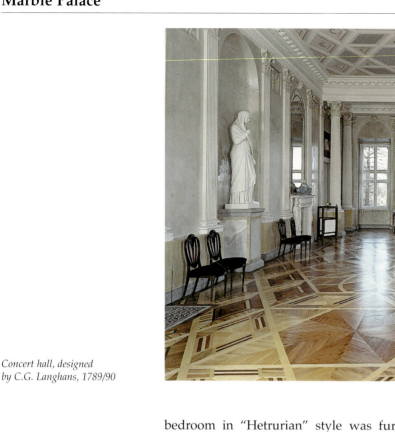

Concert hall, designed by C.G. Langhans, 1789/90

bedroom in "Hetrurian" style was furbished by Johann Gottlob Fiedler, the outstanding ébeniste of the period in Berlin. The contract for all boxed furniture on the ground floor was evidently awarded to David Hacker, a pupil of David Roentgen, who began trading in Berlin in 1791 and drew on material from the celebrated Neuwied workshop to produce these items, including the corner cupboard and chest of drawers for the bedroom.

Green Chamber (dressing room), designed by C.G. Langhans, 1789/90

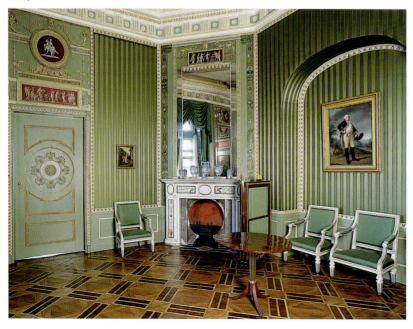

Concert Hall, Oriental Cabinet

The principal room in this palace is the concert hall on the upper floor. The walls were formed with white and originally light blue stucco, and the three window fronts reach over the lake, affording the best landscape views right across to Pfaueninsel. It contrasts with the square rooms, being elongated like a gallery, but this effect is alleviated by engaged columns and the partitioning of the ceiling into three zones, although unfortunately the paintings here fell prey to structural damage. The ceiling, painted to create an illusion of stucco divisions, has been reconstructed, as has the floor.

The Oriental cabinet, furnished to resemble a tent, reflects the Turkish fashion which had spread again in the late 18th century, with blue and white striped satin extending across the ceiling and gathered curtains of tiger-like printed silk with glass fringes. A similar cabinet was planned for the south wing but never implemented.

B. G.

Schloss Pfaueninsel

Otaheiti Cabinet, Tea Room

The little palace on Pfaueninsel (the "isle of peacocks") was known in the 18th century as the "Roman country house". It was built in 1794–1795 by Johann Gottlieb Brendel, a carpenter from Potsdam who wore the hats of architect, site supervisor and general contractor. The records only indicate two occasions involving the chief court architect Michael Philipp Daniel Boumann. There is no conclusive evidence that the festive hall was inspired by Carl Gotthard Langhans or a Potsdam architect. The interior was planned under the guiding influence of Friedrich Wilhelm II's confidante and former mistress Madame Ritz, the future Countess Lichtenau. The location of the building, with a mock façade to resemble historical ruins, was determined by sightlines from the Marble Palace. The initial inspiration seems to have been a view of the island of Capri contained in a set in the king's library, but the implementation takes its cue rather more from English garden folly.

The interior offers the most unadulterated sample of early neo-classicism in Berlin, and even the inventory has been preserved to an unprecedented degree. After 1797 the ground floor was earmarked for courtiers and the first floor for the "royals".

BERLIN-BRANDENBURG

Schloss Pfaueninsel
Nikolskoerweg
D-14109 Berlin

ℹ Besucherzentrum an der
Historischen Mühle
Postfach 60 14 62
D-14414 Potsdam
Tel. (+49/0) 331/
96 94-200/-201
Fax (+49/0) 331/96 94-107
Besucherzentrum@spsg.de

🕐 1 April – 31 October:
10 am–5 pm
Last tour at 5 pm
Closed on Mondays

⛴ Pfaueninsel Ferry
Tel. (+49/0) 30/80586831
Nov. – Feb. 10 am–4 pm
March, Oct. 9 am–6 pm
April, Sep. 9 am–7 pm
May – August 8 am–9 pm

🚌 Bus 218 from Berlin
Wannsee
Bus 116 from
Potsdam/Glienicker Brücke
to Nikolskoer Weg, then
bus 218 or 25 min. walk

✕ Wirtshaus zur Pfaueninsel

🅿 Car park at the end of
Nikolskoer Weg

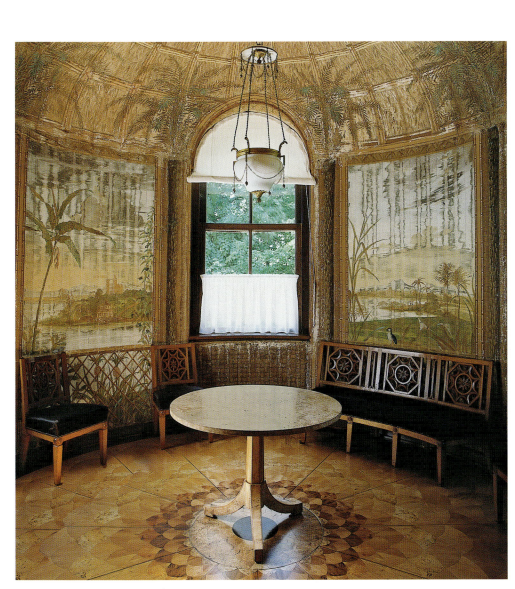

Otaheiti cabinet, 1795

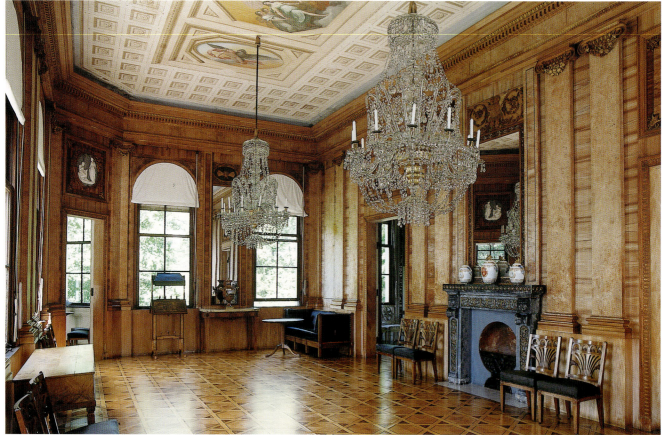

Festive hall, 1795

Festive Hall, Tower Room

The round "Otaheiti cabinet" was painted to resemble a bamboo hut. Four fantastical landscapes by Peter Ludwig Lütke transform the River Havel into an exotic tropical setting and transport the viewer to Tahiti, where Schloss Pfaueninsel and the Marble Palace are seen surrounded by palms, pineapples and parrots. The furniture was purpose-made, as elsewhere in the building.

The original wallpapers and textile wall coverings have been preserved in all the rooms.

The festive hall occupied the full width of the palace, opening generously onto the landscape through seven windows. Friedrich Wilhelm II also envisaged its use as a concert hall, as the virginal and double music stand demonstrate. This room, with its panelling of wooden inlays and mounted carvings, is one of the most significant and ambitious examples of interior decoration in Berlin in the 1790s. The challenge is underscored by the ornate marble fireplace and painted ceiling.

The tower room which adjoins it to the west was used by Friedrich Wilhelm III as a study. Countess Lichtenau and Friedrich Wilhelm II were responsible for its meticulous furbishing, with ornamental wallpaper trim, furniture and fourteen watercolours of Vatican museums by Giovanni Volpato with frames and glass to match the circular setting.

Tower room (king's study), 1795

B. G.

Schloss Paretz

Schloss Paretz
Parkring 1
D-14669 Paretz

i Besucherzentrum an der
Historischen Mühle
Postfach 60 14 62
D-14414 Potsdam
Tel. (+49/0) 331/
96 94-200/-201
Fax (+49/0) 331/96 94-107
Besucherzentrum@spsg.de

☉ Easter:
11 am–5 pm
Admission ceases at 5 pm
15 May – 31 October:
11 am–5 pm
Admission ceases at 5 pm
Closed on Mondays
1 November – 14 May:
Sa/Su and public holidays
11 am–4 pm
Last tour at 4 pm

🚌 Bus 614 from Potsdam Hbf.

✕ Local restaurants in
Paretz/Ketzin

🅿 Car park near the Schloss

Vestibule, designed by David Gilly, 1797 (reconstructed)

Vestibule, Garden Room

The estate was purchased in 1797 by the Prussian Crown Prince, the future Friedrich Wilhelm III. That same year David Gilly, aided by his son Friedrich, began building a new palace over the old foundation walls. The building was completed in 1798 and the entire village had been remodelled by 1805.

The rooms inside owed their particular importance to their unique abundance of wallpaper, both hand-painted and printed, all of them from manufactories in Berlin. Only here, thanks to the diversity of patterns and brushwork, was it possible to gain a broad picture of the status of the wallpaper industry in Berlin around 1800, which research now recognises as a key European centre of the highest standards. The Schloss was later respectfully preserved as the rural seat of Friedrich Wilhelm III and his queen Louise, but totally disfigured after the Second World War by use as an agricultural college. Fortunately the precious wallpapers in the royal home were removed for safety to Sanssouci in 1947.

The acquisition of Schloss Paretz in 2001 meant that the effects of conversion could be reversed and the interior restored with Luise and Friedrich Wilhelm's original decoration. Following the loss of all other palaces with wallpaper of the early neo-classical period in Berlin, unique hand-painted and printed specimens can now be displayed here (thanks to a donation from the Cornelsen Arts Foundation). Only a few pieces of the furniture were looted at the end of the Second World War. They have been replaced by contemporary work from other palaces.

Garden Room, wallpaper from the Aaron Wessely manufactory, Berlin, 1797

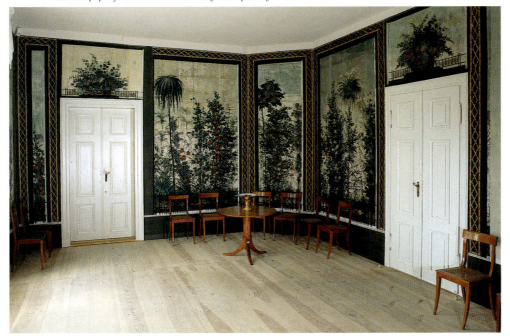

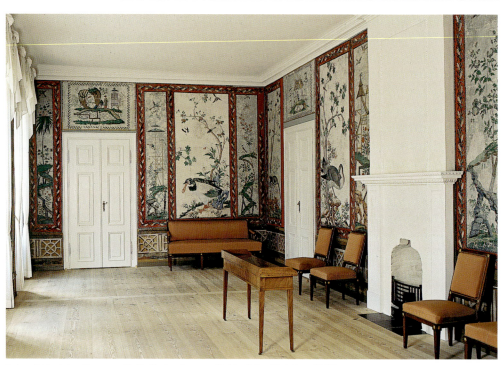

Salon, Oriental wallpaper with Berlin border, supplied by John Christian, 1797

Salon, Living Room

The vestibule is one of the grandest rooms in the palace with its painted stuccolustro, the ornaments crowning its doors and the niches which once housed etageres and flowering pots. The effect is reinforced by the marble floor. Today the youthful royal couple welcome visitors in the shape of full-size portraits by Wilhelm Böttner. One original chair remains.

The central risalto also accommodates the Garden Room. Apart from the wallpapers with fantastical garden landscapes and blossoming trees from Aaron Wessely's manufactory in Berlin, it has retained fragments of the stucco ceiling moulding. The chairs are of the same model as that listed in the inventory.

Adjoining it is the Salon, the largest room in the palace and used for receiving guests. The wallpaper painted in Chinese fashion with exotic birds and plants was supplied by the English wallpaper maker John Christian, known to have traded in Berlin from 1782. He also provided the edging with "Turkish wheat" (maize).

The living room had originally served as a bedroom. That is why it only boasted monochrome blue wallpaper with a rich border of flowering lilac, also from John Christian. The wall ornaments, like the wallpaper and pier mirrors, belonged to the original furbishing, but the furniture has been replaced by similar items.

Bedroom, King's Study

The hand-painted wallpaper landscapes with views of the Marble Palace and Schloss Pfaueninsel was supplied by the manufactory of Isaak Joel and Heirs for this bedroom initially intended as the living room. It fully reflects the traditions of 18th-century wall painting. The English virginal is from the original palace inventory.

Living room with lilac trim by John Christian, 1797

A fortunate find during building work brought to light sizeable fragments of John Christian's paper border with vine leaves from the study. It was enough to permit a reprint faithful to the original using a number of models. Few remained of the many prints that had decorated the walls, but the missing specimens were replaced by additional purchases and similar items from the collection. The pier mirrors and chest of drawers are old incumbents. The bookcase containing remnants of Queen Luise's library, the desk and the chairs have been substituted.

These interiors created just before 1800 mark the transition from the early neoclassicism of the 18th century to the early work of Karl Friedrich Schinkel, which only survived the Second World War in the form of Queen Luise's bedroom at Schloss Charlottenburg (p. 123).

B. G.

King's study, border paper from the manufactory of John Christian, 1797 (reconstructed)

Bedroom (originally living room), hand-painted wallpaper from the manufactory of Isaak Joel & Erben, 1797

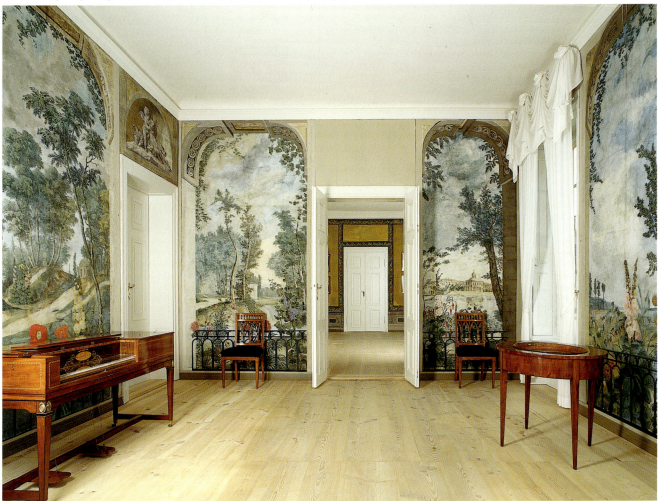

Schloss Charlottenhof
Geschwister-Scholl-Str 34a
Park Sanssouci
D-14471 Potsdam

ℹ Besucherzentrum an der
Historischen Mühle
Postfach 60 14 62
D-14414 Potsdam
Tel. (+49/0) 331/
96 94-200/-201
Fax (+49/0) 331/96 94-107
Besucherzentrum@spsg.de

☉ Easter:
10 am–5 pm
Last tour at 5 pm
15 May – 15 October:
10 am–5 pm
Last tour at 5 pm
Closed on Mondays

Ⓢ Tram 94, 96 to Schloss
Charlottenhof

🚌 Bus 605, 606 to Schloss
Charlottenhof

🅿 Car park by the New Palace
or the Visitor's Centre

Schloss Charlottenhof
Vestibule, Living Room, Salon, Tent Room

When Crown Prince Friedrich Wilhelm (IV) was given Charlottenhof, an outlying estate on the southern margins of Sanssouci Park, as a Christmas present from his father in 1825, he immediately set to work redesigning the grounds and the house with Karl Friedrich Schinkel and Peter Joseph Lenné. This was to become his "Siam", his private sphere of the Potsdam palace complex. The interiors of the manor house, converted and refurbished by Schinkel in 1826–1829

Living room, K.F. Schinkel, 1826–1829

*Vestibule, K.F. Schinkel,
1826–1829*

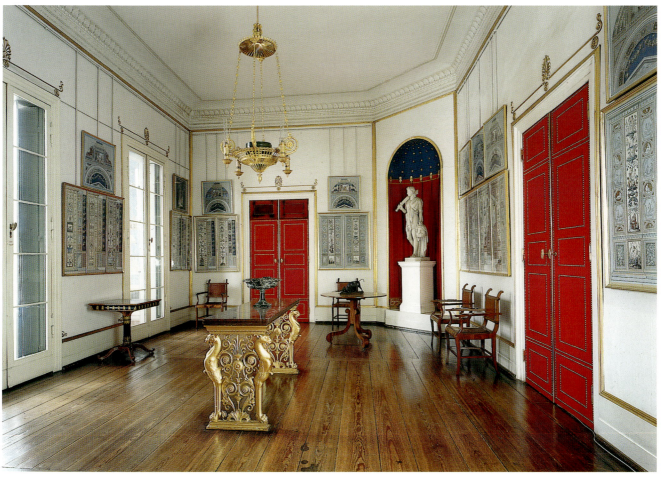

Salon, K.F. Schinkel, 1826–1829

using modest resources, have preserved their original furniture and fittings, although in many cases these simple objects were probably being put to their second use in the summer residence. One of the most striking rooms is the Crown Princess's study and considerable effort was invested in this little corner room with its purpose-built furniture, ornate doors and a frieze of Pompeian dancers added a little later. A spartanly furnished bedroom for ladies-in-waiting preserves the late 18th-century and Empire tradition of often lavishly decorated tent rooms. The initially modest vestibule was not endowed with marble until after 1840. The Roman Bath complex with the gardener's house includes the lakeside pavilion built by Schinkel in the 1830s. It still boasts the original furniture designed by the architect and most of the original paintings.

B. G.

Tent room, K.F. Schinkel, 1826–1829

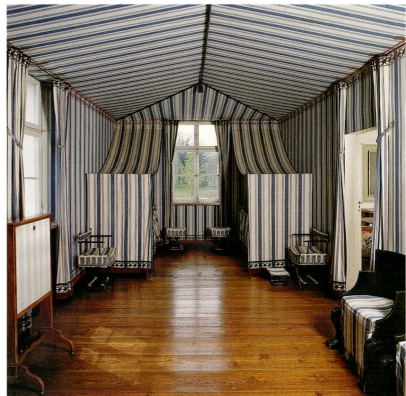

STIFTUNG PREUSSISCHE SCHLÖSSER UND GÄRTEN BERLIN-BRANDENBURG

i Besucherzentrum an der
Historischen Mühle
Postfach 60 14 62
D-14414 Potsdam
Tel. (+49/0) 331/
96 94-200/-201
Fax (+49/0) 331/96 94-107
Besucherzentrum@spsg.de

🕑 Closed for restoration!

🚌 Bus 694 from Potsdam
Hbf./S Babelsberg to
Schloss Babelsberg

✕ Café and restaurant
in Kleines Schloss

P Car park nearby

Schloss Babelsberg
Ballroom

Of the plans for a big neo-Gothic summer residence for Prince Wilhelm of Prussia (later Kaiser Wilhelm I), designed by Karl Friedrich Schinkel to reflect the wishes of Princess Augusta, financial constraints only permitted the initial implementation in 1834–1835 of a small cottage with but a few living rooms and a dining room, for which Schinkel also conceived the interior. When his childless elder brother Friedrich Wilhelm IV ascended the throne in 1840, Wilhelm became heir to the throne, and Ludwig Persius promptly began upscaling Schinkel's original idea into an extension with a ballroom, dining room, new suites for children and guests and a flag tower. The work began in 1844 and was continued upon Persius' death by Johann Heinrich Strack (1845–1849). The octagonal ballroom two storeys high designed by Persius is one of the finest achievements of neo-Gothic architecture in Germany. The stellar vault resting on columns clustered before the piers resembles the apse of a Gothic cathedral on all sides. The other interiors, including Schinkel's rooms, were furbished by Strack under the prevailing influence of Princess Augusta. The couple used this as a summer residence for over 50 years, so that gifts and new purchases were constantly added, blurring the architect's original blueprint. Later generations did not use the palace, so that until 1945 the interiors that had evolved so organically remained uniquely unaltered, making this the very model of a Historicist summer residence. In 1945/46 most of the furnishings were transported to the Soviet Union and only some were returned in 1958. Most of these items seem to have been privately looted by military personnel. After its restoration the palace is to serve as a Historicist museum in situ.

B. G.

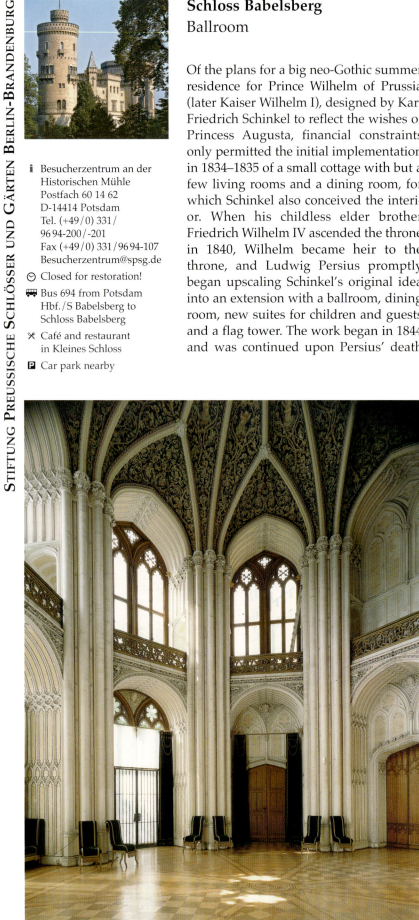

Ballroom, designed by L. Persius, before 1845

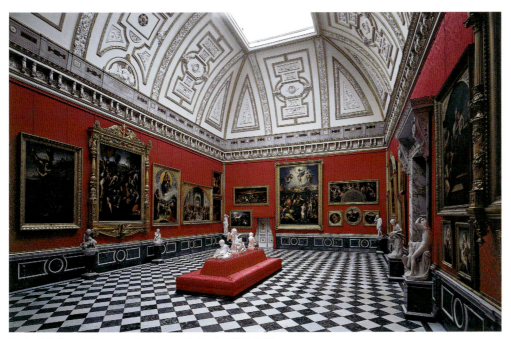

Raphael Hall, modelled on the Vatican's Sala Regia, 1851–1858

Orangerieschloss
Park Sanssouci
D-14469 Potsdam

i Besucherzentrum an der
Historischen Mühle
Postfach 60 14 62
D-14414 Potsdam
Tel. (+49/0) 331/
96 94-200/-201
Fax (+49/0) 331/96 94-107
Besucherzentrum@spsg.de

⊙ 15 May – 15 October:
10 am–5 pm
Last tour at 5 pm
Closed on Mondays
Orangery viewing tower:
1 April – 14 May:
Sa/Su and public holidays
10 am–5 pm
Admission ceases at 5 pm
15 May – 31 October:
10 am–5 pm
Admission ceases at 5 pm
Closed on Mondays

🚌 Bus 695 to Orangerie

P Car park by the Visitor's
Centre

Orangery Palace Sanssouci
Raphael Hall, Bedroom

When Knobelsdorff's orangery was converted into the New Chambers, accommodating the citrus plants in the park of Sanssouci became a matter of improvisation for several decades. This prompted Friedrich Wilhelm IV, who had begun using Sanssouci as a summer residence again, to cherish plans for a new, sizeable orangery, wielding his own pencil with enthusiasm alongside the architects August Stüler and Ludwig Ferdinand Hesse. At the edge of the park it was to form the culmination of a grandiose project to build a triumphal avenue in honour of Friedrich the Great. It was built in 1851–1864, but without its companions. The palatial central tract housed a residential suite and a splendid hall lit from above and modelled on the Vatican's Sala Regia. It was dedicated to Raphael and contained 49 copies of his works. On the outside the building was inspired by Italian Renaissance villas, such as those of the Medici and Pamphili. It was furbished in the latter-day style of the second rococo, accompanied in its panelling by details which owe more to the Regency and neo-classicism. The complexity of the surviving interiors make these rooms a noteworthy example of discerning courtly art during the period, unique in Brandenburg-Prussia and rare in Germany as a whole. Sumptuous suites of upholstery in the second rococo style, some with boulle inlays, set the tone in conjunction with panelling, damask wall coverings, curtains of dark red, deep blue and violet, marble statues, 18th-century china figurines and worked Russian malachite.

B. G.

Bedroom (Malachite Room), 1851–1858

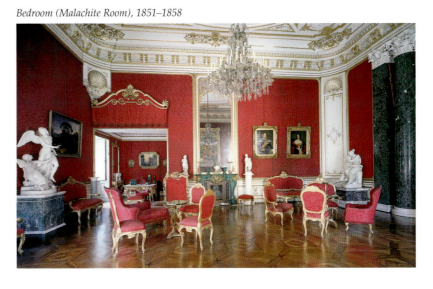

STIFTUNG PREUSSISCHE SCHLÖSSER UND GÄRTEN BERLIN-BRANDENBURG

Historische Stätte der
Potsdamer Konferenz
Schloss Cecilienhof
Im Neuen Garten
D-14469 Potsdam

i Besucherzentrum an der
Historischen Mühle
Postfach 60 14 62
D-14414 Potsdam
Tel. (+49/0) 331/
96 94-200/-201
Fax (+49/0) 331/96 94-107
Besucherzentrum@spsg.de

☉ 1 April – 31 October:
9 am–5 pm
Admission ceases at 5 pm
Closed on Mondays
1 November – 31 March:
9 am–4 pm
Admission ceases at 4 pm
Closed on Mondays
Crown Prince's apartment
(with guide only):
tours at 11 am, 1 pm and
3 pm all year round

Ⓢ Tram 90, 92 or 95
to Rathaus,
🚌 then bus 692 to Schloss
Cecilienhof

🏛 Museum shop Cecilienhof
Tel. (+49/0) 30/32 60 39-46
Info@museumsshop-im-
schloss.de

✕ Schlosshotel und
Restaurant Cecilienhof
Restaurant Meierei–
Brauhaus im Neuen Garten
GmbH

Ⓟ Car park near the Schloss

Schloss Cecilienhof
Conference Hall, Ship's Berth

This palace was built for Crown Prince Wilhelm in 1913–1917 in the style of an English manor house, the last palace commissioned by the royal dynasty of Prussia. On the shores of the Jungfernsee it takes its place in the New Garden, in the cultural landscape where Berlin and Potsdam meet. The architect Paul Schultze-Naumburg was responsible for implementation with his Saaleck workshops. He and the young couple had designed the building for year-round use. The complex is grouped around five courtyards, the largest with its central driveway having originally been reserved for the Crown Prince and Princess, the eastern half around the Princes' Court for the children and the closer court retinue. The interiors reflect the style of the period, alternating between contemporary English design in the rooms of the Crown Prince and forms associated with Louis XVI in the White Salon of the Crown Princess. Older English prototypes prevail in the Great Hall, with its Danzig baroque stairs, its beamed ceiling and the hint of a Tudor arch in the fireplace niche. From 17 July to 2 August 1945 the three Allies who had just defeated Hitler met in these rooms for their Potsdam Conference. The family of the former Crown Prince fled in March 1945, and Soviet officers brought furniture, lamps and carpets from other palaces and private villas to fill the former state apartments and prepare the Great Hall as a meeting room. Today it can be visited as the venue of the conference. A sequence of six private rooms on the upper floor was restored in the 1990s and furnished, partly with original pieces or items from the ground floor. The Crown Princess's dressing room and the ship's berth next to her ground-floor study, a gift to her from North German Lloyd (designed by Paul Ludwig Trost), are still furnished

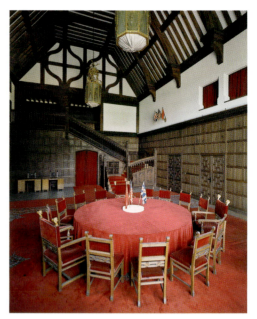

Great Hall, venue of the Allies' Potsdam Conference at the end of the Second World War (1945)

Ship's berth given to the Crown Princess by North German Lloyd

almost completely as they were originally. They convey the impression of an elevated style of living in the early 20th century without any particular traces of court.

B. G.

Source of illustrations:
Fotothek der SPSG Berlin-Brandenburg, photographs taken by (inter alia) Roland Handrick, Wolfgang Pfauder, Hans Bach, Ulrich Frewel and Gerhard Mutza

Hesse

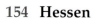

STAATLICHE SCHLÖSSER UND GÄRTEN HESSEN

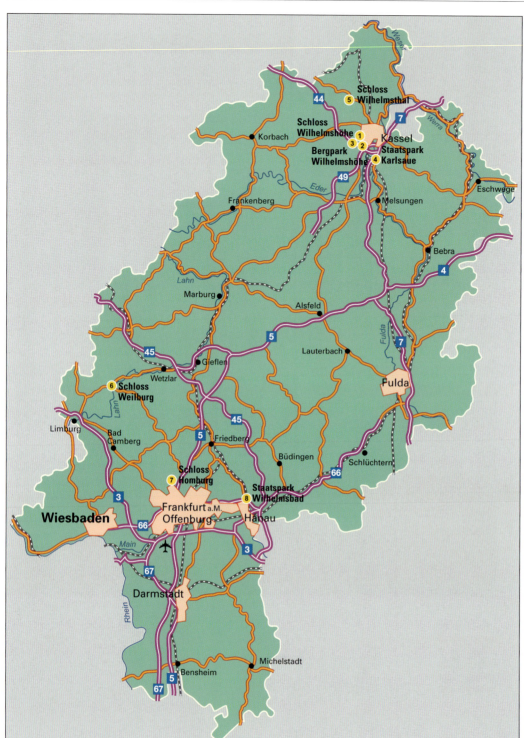

Kassel
 1 Schloss Wilhelmshöhe,
 Weißenstein Wing
 (pp. 155–158)
 2 Wilhelmshöhe Hill Park,
 Ballhaus
 (p. 159)
 3 Wilhelmshöhe Hill Park,
 Löwenburg
 (pp. 160–163)
 4 Karlsaue Park,
 Marble Baths
 (pp 164–165)

Calden
 5 Schloss Wilhelmsthal
 (pp. 166–169)

Weilburg
 6 Schloss Weilburg
 Orangery
 (pp. 170–172)

Bad Homburg vor der Höhe
 7 Schloss Homburg
 (pp. 173–175)

Hanau
 8 Wilhelmsbad Park,
 Castle and Prince's Palace
 (pp. 176–178)

For information about other sites managed by Staatliche Schlösser
und Gärten Hessen: www.schloesser-hessen.de

◁ *Schloss Weilburg, enfilade (view into the dining room)*

HESSE

Schloss Wilhelmshöhe
Weißenstein Wing

The summer palace of Wilhelmshöhe lies above the town of Kassel at the heart of a hill park unlike any other in Europe. Landgrave Wilhelm IX built the three-wing structure in 1786–1798 to drawings by architects Simon Louis du Ry and Heinrich Christoph Jussow. Although the corps de logis was gutted by fire in the Second World War and now houses collections belonging to the Kassel State Museums, the Weissenstein Wing survived intact and – apart from Wilhelmsthal – is now the only palace in Hesse to display stately apartments so finely furnished in the early neo-classical and Empire styles.

Today's Weissenstein Wing was constructed as a fully functional palace with all the suites required for a prince to spend his summer there, including rooms for public occasions and living quarters for the landgrave, landgravine and guests. Elector Wilhelm I resided in these rooms until his exile in 1806.

The dining room in the suite for social occasions is faced with stuccolustro rather than silk wall coverings. Precious textiles were the most expensive item of furbishing in those days, and here they would have been exposed to smells and heat. The dining table, now laid out in festive manner, used to be put out specifically for

i Schloss Wilhelmshöhe
D-34131 Kassel-
Wilhelmshöhe
Tel. (+49/0) 3 16 80-2 00
Fax (+49/0) 3 16 80-2 66
www.schloesser-hessen.de
info@schloesser.hessen.de

⊘ Weißenstein Wing
March – October
Tu–Su 10 am–5 pm,
Last tour at 4 pm
November – February
Tu–Su 10 am–4 pm,
Last tour at 3 pm
In December only open at
weekends and by prior
arrangement
Closed:
24/25 December, 1 January

Guided tours:
Weissenstein Wing and
connecting structure
Reception rooms and living
quarters

Dining room. The double columns form a mediating partition against the buffet tables in the roundel

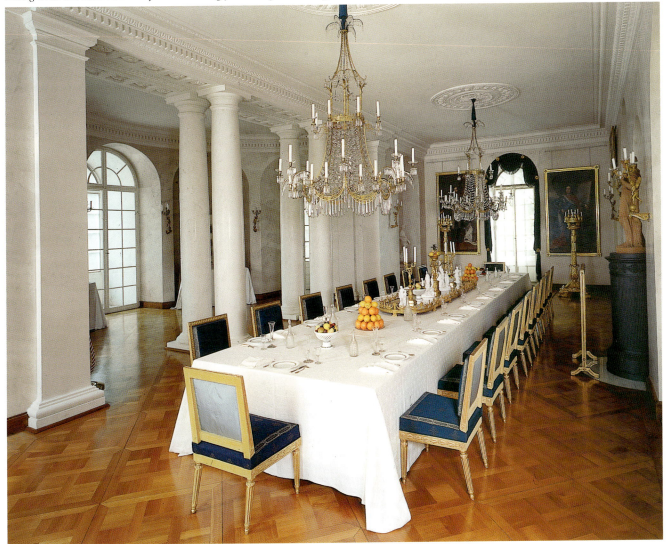

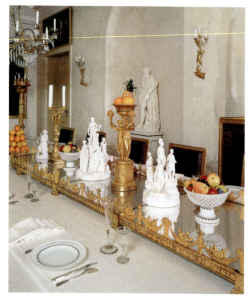

Pierre-Philippe Thomire's superb surtout

banquets and packed away again after the meal was over. The table arrangement at Wilhelmshöhe boasts a particularly mag-

nificent centre-piece by Pierre-Philippe Thomire, bronzer in Paris under Napoleon Bonaparte. The inset mirrors reflected the light of the two big crystal chandeliers, casting a ceremonial radiance over the table's contents.

The rooms in the connecting structure still have their old wall fittings with original Berlin stoves in niches adorned with stucco. After the corps de logis and the residential palace in Kassel were both destroyed, a new home was found here for precious items of furniture. This includes Elector Wilhelm II's bedroom with the imperial bed of 1823. With its lavishly gilt bronze ornamentation and monumental four-poster, this room was more than a place to sleep. As part of the elector's ceremonial suite it played its part in demonstrating the prestige of the regional overlords.

C. O. / F. B.

Semi-circular cabinet in the landgravine's apartment, ▷
bel étage, Weissenstein Wing

Elector Wilhelm II's bedroom with its late Empire bed of state

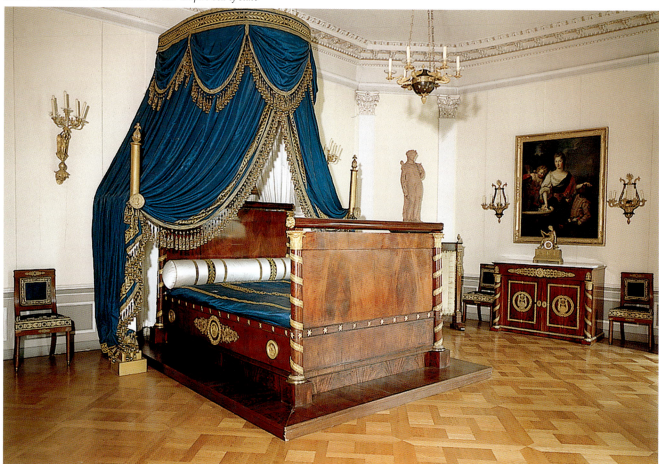

Schloss Wilhelmshöhe, Weißenstein Wing, Picture Gallery

Schloss Wilhelmshöhe, southern connecting structure, Jérôme Room

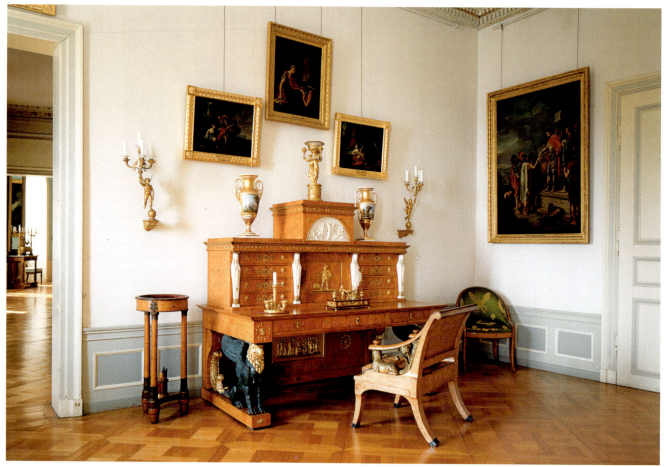

Wilhelmshöhe Hill Park
Ballhaus

i Wilhelmshöhe, Ballhaus
D-34131 Kassel-
Wilhelmshöhe
Tel. (+49/0) 5 61/3 16 80-2 00
Fax (+49/0) 5 61/3 16 80-2 66
www.schloesser-hessen.de
info@schloesser.hessen.de

Open only in summer
during special exhibitions

In the early 19th century Europe was in the grip of a passion for dancing as the Viennese waltz spread across the continent. Elector Wilhelm II responded by appointing Johann Conrad Bromeis in 1828 to convert the little court theatre at Wilhelmshöhe, an early work by Leo von Klenze, into a ballroom. It was initially intended for public use, the old dance hall nearby having been demolished in 1824, but in the end it was reserved for court society.

In contrast to the simple outer structure, the visitor enters a spacious interior bathed in daylight or, at night, grandly illuminated. The walls and ceiling are richly painted with arabesques. The colourful frieze over marbled three-quarter columns displays parrots, cockatoos, golden pheasants and ravens between acanthus festoons. The original furniture included six divans no longer extant. The curtains were faithfully recreated from surviving drawings.

Although the French occupation was now over, the elector chose to appoint the hall in Empire style, opting for the French taste that still prevailed at European courts. As a result, after the war-time destruction at the Residence and in the corps de logis at Wilhelmshöhe, he gave us one of the few remaining late Empire stately interiors in Kassel. F. B.

The ballroom at Schloss Wilhelmshöhe

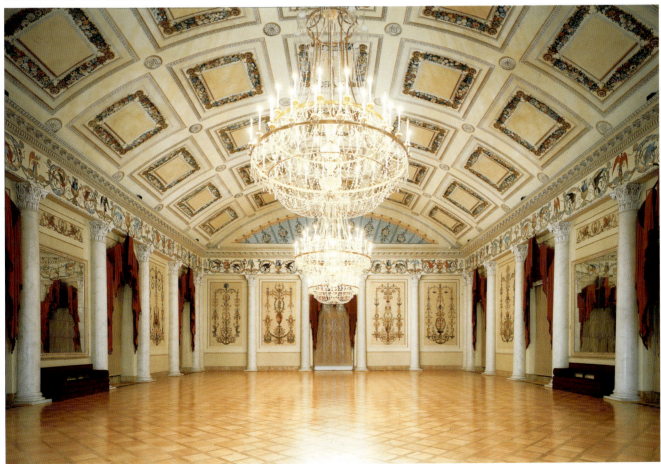

STAATLICHE SCHLÖSSER UND GÄRTEN HESSEN

i Wilhelmshöhe, Löwenburg
D-34131 Kassel-
Wilhelmshöhe
Tel. (+49/0) 561/3 16 80-2 45
Fax (+49/0) 5 61/3 16 80-2 22
www.schloesser-hessen.de
info@schloesser.hessen.de

☉ March – October
Tu–Su 10 am–5 pm,
Last tour at 4 pm
November – February
Tu–Su 10 am–4 pm,
Last tour at 3 pm
In December only open at
weekends and by prior
arrangement
Closed:
24–25 December, 1 January

Guided tours:
Ladies' and gentlemen's
apartments, stables, castle
chapel, weapons room

Löwenburg

Within the hill park at Wilhelmshöhe there stands what appears to be a medieval castle. However, the Löwenburg (or "Lions' Castle") was built for Landgrave Wilhelm IX in 1793–1801 as a romantic ruin. This is one of the first major neo-Gothic structures in Germany. Behind the crenellated ramparts, the gates secured with drawbridges and the tall towers we find a pavilion for retreats from the bustle of court. Although the ground plan is full of nooks and crannies, the layout inside observes the palace conventions of the day with a baroque apartment sequence.

The Löwenburg was not intended to ward off enemies but as a monument to the history of Hesse and its ruling dynasty. Wilhelm IX endowed the building with all manner of collector's items and artistic curiosities. They derive from various stately homes and churches in Hesse and recall Wilhelm's forefathers. He wanted the rooms to be as medieval as possible in style, although the appointment is neither purely neo-Gothic nor a reflection of medieval life. In fact, many of these objects testify to a Renaissance or baroque style. The Löwenburg was not simple a pavilion to relax in, but also an artistic showcase exhibited to high-ranking guests over tea while touring the park to demonstrate the history and prestige of the owner's family.

One integral component of this stage management was the Weapons' Room. Pride of place goes to the "Black Knight", a suit of fluted armour from Maximilian's reign in the early 16th century, which was worn by a standard-bearer at the funeral procession whenever the current landgrave of Hesse died. The last occasion was in 1821 when Wilhelm IX himself was buried. Wilhelm was an accomplished soldier who had fought to defend the old order against the French Revolution. The weapons and armour here show whose footsteps he trod in with his military career and his almost chivalrous commitment as the noble son of one of the oldest princely dynasties in the Holy Roman Empire.

The Löwenburg rooms were sumptuously furbished. The castle became a genuine ruin in the Second World War and so few have remained in their historical condition. Others, like the Pearl Tapestry Room in the ladies' wing, have been reconstructed taking the old chambers as a guide. The Pearl Tapestry Room, where

Löwenburg, bedroom in the Knight's Apartment

Opposite page: 16th- and 17th-century arms and armour in the Weapons' Room

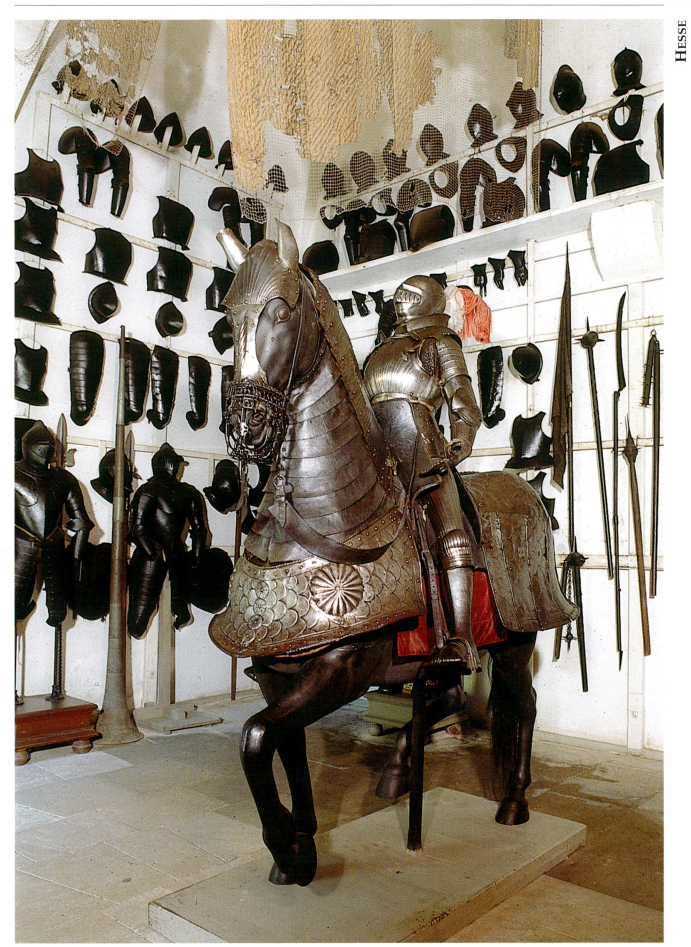

The pearl tapestry: detail showing two Osman dignitaries. The tapestry took its name from its tiny glass beads

the ladies once gathered socially and for games, is a telling example of how the Löwenburg was compiled from unusual and even curious units. The tapestry was made in the early 18th century and contains many little pictures of court figures in old-fashioned Renaissance costume.

The stove in this room is a typical specimen of the Löwenburg's stylistic mix. The clay body with its pseudo-Gothic forms rests on a cast-iron box with rococo ornament. It was made specifically for the castle to create a medieval atmosphere in the room. By way of a contrast it was crowned with a neo-classical vase.

C. O.

Pearl Tapestry Room with baroque furniture

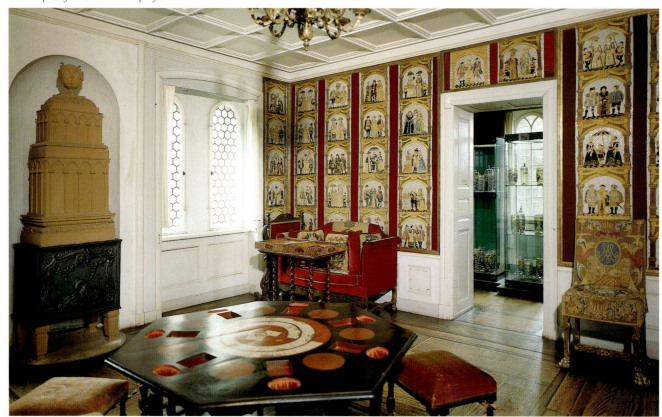

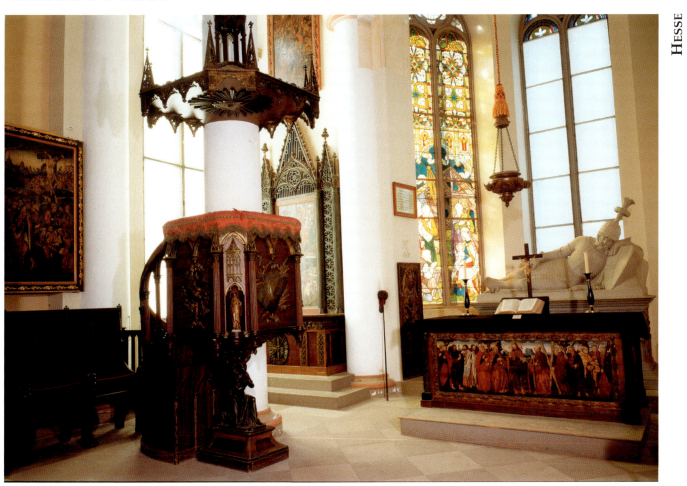

Löwenburg, palace chapel

Löwenburg, elector's bedroom

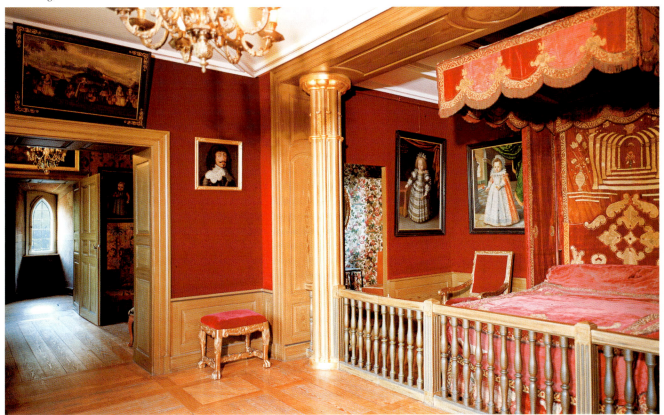

STAATLICHE SCHLÖSSER UND GÄRTEN HESSEN

ℹ Kassel, Staatspark Karlsaue
D-34121 Kassel
Marble baths and Western
Pavilion in the Orangery
Tel. (+49/0) 5 61/31 68 06 25
Fax (+49/0) 5 61/31 68 06 26
www.schloesser-hessen.de
info@schloesser.hessen.de

🕐 1 April – 3 October:
Tu–Su 10 am–5 pm
Guided tours on the hour,
last tour at 4 pm

Karlsaue Park
Marble Baths

This unusual room was built as a stately bathroom between 1722 and 1728 under Landgrave Karl (1654–1730). With its splendid polychrome marble wall cladding, its groups of marble statues and the stucco work on the walls and dome, it was conceived as a separate pavilion alongside the Orangery, the new palace built from 1702 by the landgrave as a summer residence on the Fulda floodplain. To this end Landgrave Karl recruited the Roman sculptor Pierre Etienne Monnot (1657–1733), one of the most celebrated sculptors of the late 17th century. Monnot has created a striking themed experience with his virtuoso marble sculpture and bas-relief. Even today, upon entering this palatial bath-house, visitors are transported to an enchanted Ancient world. The multi-coloured incrustations that adorn the walls and the statues and bas-relief of white Carrara marble are reflected in the shining marble floor. Exploring this magnificent place of ceremonial ablution we are still captivated by Ovid's metamorphic conditions: falling in love, persecution and transformation into another being. The Marble Baths are one of the finest surviving late baroque specimens of stately bathing.

S. S.

The little faun Ampelos tries in vain to tug a bunch of ▷ grapes from the hands of Bacchus

Around the central pool Monnot narrates scenes from Ovid's Metamorphoses in sculpture and bas-relief

i Schloss und Schlosspark
Wilhelmsthal
D-34379 Calden
Tel. (+49/0) 5674/6898
Fax (+49/0) 5674/4053
www.schloesser-hessen.de
info@schloesser.hessen.de

⊙ Palace
March – October:
Tu-Su 10 am–5 pm, last tour
at 4 pm
November – February:
10 am–4 pm, last tour
at 3 pm

In December only open at
weekends and by prior
arrangement.

Closed: 24/25, 31 December,
1 January

Guided tours: Corps de
logis and kitchen wing

Between Ascension Day and
3 October the rococo
fountains are switched on
after tours of the palace
with about 370 sources by
the canal and grotto. Special
tours of the park by
arrangement.

P

Schloss Wilhelmsthal

In 1742 the future Landgrave Wilhelm VIII began building Wilhelmsthal in the midst of extensive gardens as a summer pavilion and hunting lodge where he could withdraw from court business. The family of the landgraves of Hesse-Kassel and their entourage used it in summer, when court etiquette was less formal. The palace is symmetrical. On each side of a large hall, two apartments occupy the ground and upper floors, each with ante-chambers, a bedroom, a cabinet and a cloakroom. Accommodation for courtiers was installed on the attic floor and in the side wings. Wilhelm, at the time governor on behalf of his brother Friedrich, King of Sweden, was an art-lover. He had his favourite residence furbished in the customary rococo fashion. The architecture, decoration and furniture were designed as a coherent whole following the principles of "convenance" (appropriateness) and "commodité" (comfort). To this end he employed the most sought after artists of the age, entrusting the Paris-trained Munich court architect François de Cuvilliés with the overall planning. The sculptor and decorator Johann August Nahl, who had demonstrated his prowess at Schloss Sanssouci, devised ornamental forms for the interior. Johann Michael Brühl of Weimar provided the stucco work. Kassel's court artist Johann Heinrich Tischbein also made a major contri-

bution to the final look with his numerous oil paintings. Many of the magnificent pictures here were his, including the ladies' portraits in the first and second ante-chambers of the landgravine's apartment. So interlocked are the ceilings, walls, mirrors and frames by asymmetric shells, flora and fauna that they seem to merge and dissolve. The walls are decorated with carving and painting, but also with drapes and cloth coverings. The colours of preference are pale blue, pink, pale green and above all gold. The wall fittings and furniture constitute an ensemble. Luxurious items of furniture and small works of art of glass and porcelain complete the scene. One vivid example of this artistic interplay is the Landgrave's Cabinet on the ground floor. This sea-green and gold room with its abundance of rocaille and floral ornamentation on walls and ceiling was a more intimate place, away from the ceremonial tract, as the family picture over the splendid "peacock feather" chest testifies. In this sumptuously furnished cabinet the landgrave did his writing and held small meetings. The Hall of Muses, the festive highlight among the first-floor interiors, is quite the opposite in character. This is a hall of serene gaiety with its vivacious ceiling stucco work, the carvings of masks and musical instruments on the wall panelling and a series of paintings depicting the

*Opposite page:
the Landgrave's Cabinet.
The precious peacock feather chest
was an original item*

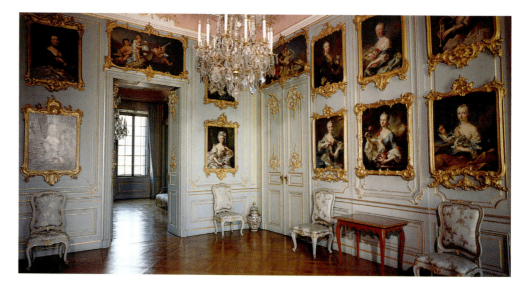

*Schloss Wilhelmsthal, ladies'
portraits in the first ante-chamber
of the landgravine's apartment*

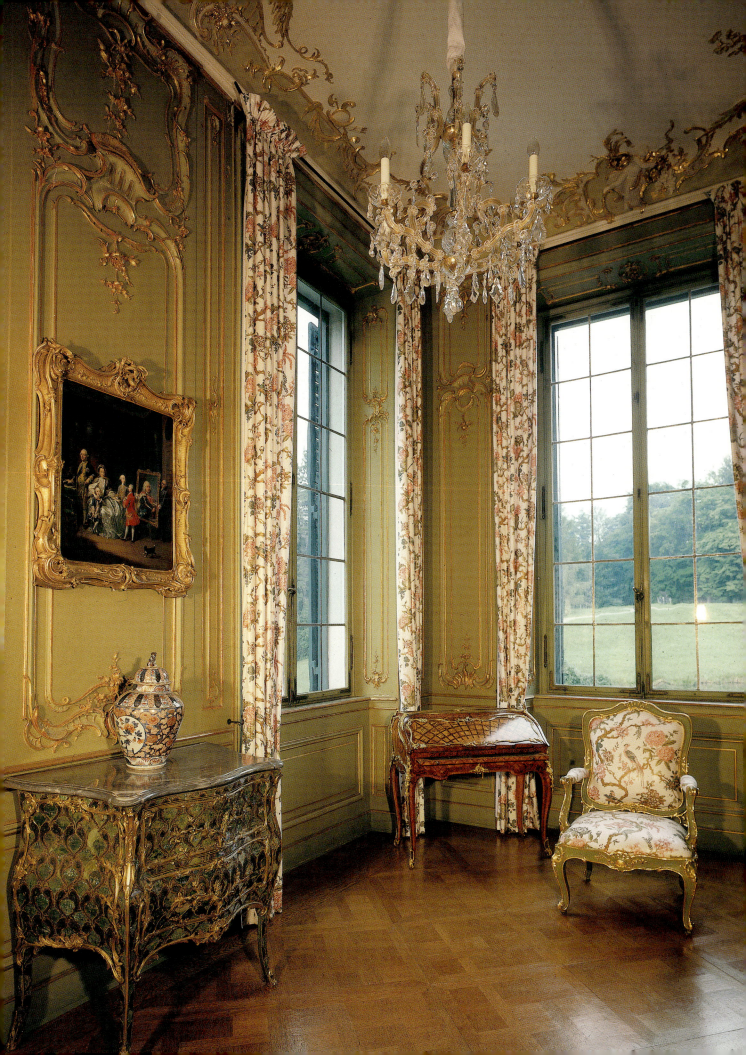

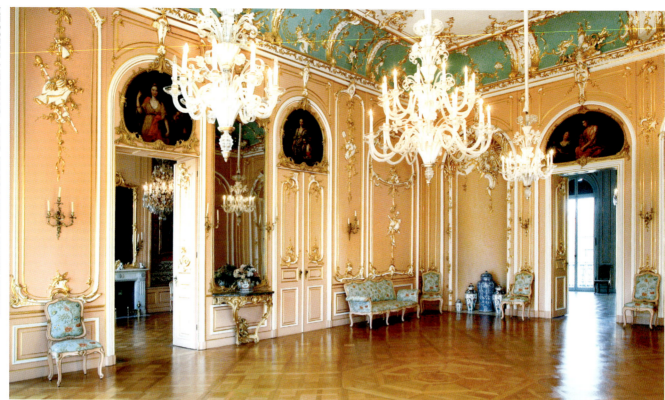

Hall of Muses on the first floor

new Muses. The cabinet on the upper floor of the southern apartment, used by guests, stands out for its inventive carvings. Parrots and other species of bird adorn the panelling finished in green, gold and white. Guests would have enjoyed the cheerful sight of a bright-hued macaw playfully nibbling a grape or the budgerigar cheekily stealing a cherry from outside his cage. Fortunately the palace has been spared any major conversions. Even if Wilhelm VIII's successors replaced the furniture in certain rooms, Wilhelmsthal still breathes the spirit of an 18th-century summer retreat, just as its original owner intended. S. S.

Detail from the Cabinet of Parrots

The corner cabinet in the first-floor guest apartment, known after its decorative theme as the Cabinet of Parrots

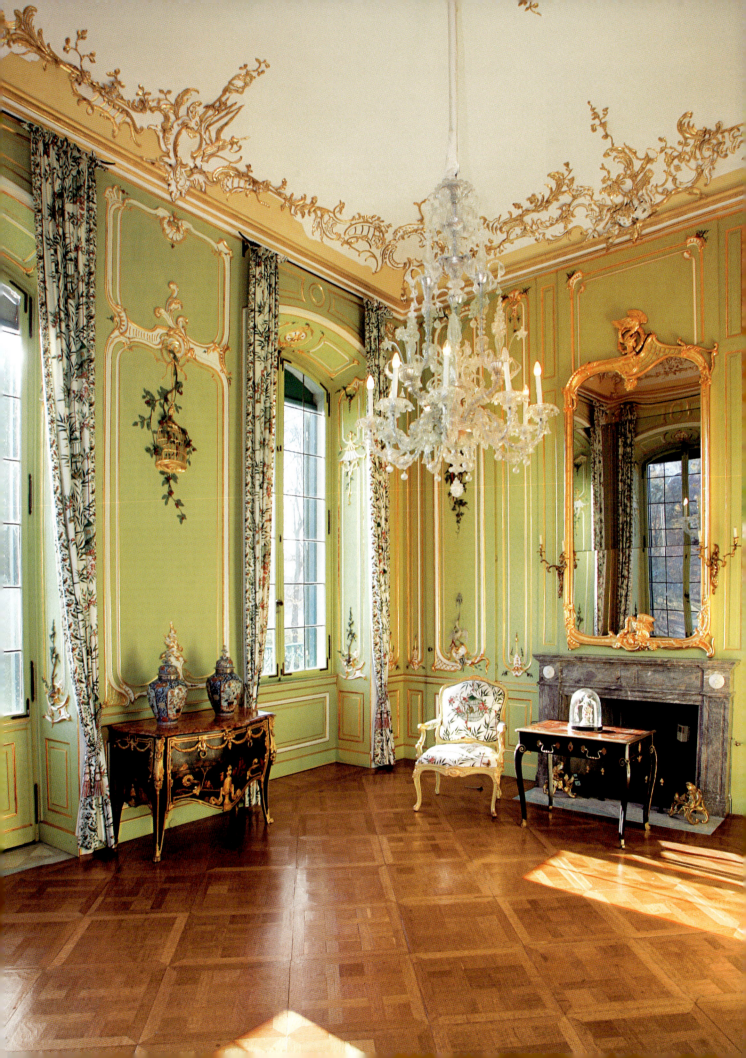

i Schloss und Schlossgarten
Weilburg
D-335781 Weilburg/Lahn
Tel. (+49/0) 64 71/91 27-0
Fax (+49/0) 64 71/91 27-20
www.schloesser-hessen.de
info@schloesser.hessen.de

⊘ Palace
November – February
Tu-Su 10 am–5 pm,
last tour at 3 pm
March, April and October
Tu-Su 10 am–5 pm, last tour
at 4 pm
Guided tours: West, North,
East and South Wings
Upper Orangery
Visitors may climb the
Piper's Tower by
arrangement.

Schloss Weilburg

Weilburg dominates the landscape, perched high above the River Lahn on a massive spur. The 16th-century palace is one of the best preserved residences in the many little principalities that existed on German soil in the early Modern era. The four Renaissance wings were developed into a proud baroque mansion in the early 18th century under Count Johann Ernst of Nassau-Weilburg.

The four wings of the main building are at the heart of the overall complex. The suites of rooms here fulfil all the essential domestic and ceremonial functions required of such a seat. The counts and dukes of Nassau-Weilburg looked back on a history steeped in tradition, and this is graphically reflected in their stately apartments.

The spacious ground-floor halls with their ribbed vaults and Renaissance paintings recall the birth of the palace in the middle of the 16th century. The living quarters and ceremonial chambers for the duke's family were on the first floor. The original furbishing was permanently altered in the course of the 18th and 19th centuries.

The most sumptuous example of a baroque interior is the Chinese Cabinet, which owes its name to the gilt wall etageres displaying Chinese porcelain. The lavishly decorated room belonged to the duchess, linking Maria Polyxenia's apartment to that of her husband Duke Johann Ernst. The conjugal coat-of-arms is inlaid in the floor surrounded by filigree festoons. The wall panelling and doors display colourfully painted grotesques. Stucco ornament finished in white and gold adorns the allegories of the Four Seasons on the ornate stucco ceiling. The gold-framed portraits recall the ducal couple.

The Great Hall on the ground floor

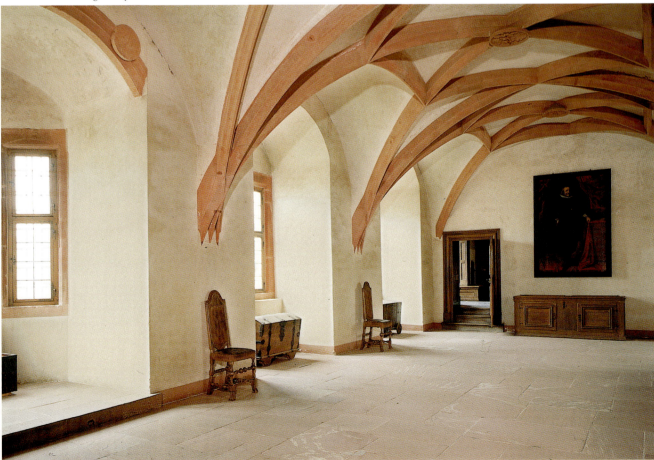

The magnificent bedroom in the apartment of state was primarily for ceremonial purposes. The marquetry of the star-patterned parquet floor reflects the period when the room was built around 1701. The doors and wooden wall panelling are painted with chinoiseries. Gold-painted stucco work crowns the two doors. The wall coverings of red velvet and the gold-embroidered portieres endow this room with dignity. The ceremonial bed with its high canopy of red velvet and gold-embroidered brocade is the focal attraction. The sumptuous furniture and mural decoration blend here to create an impressive and harmonious court interior.

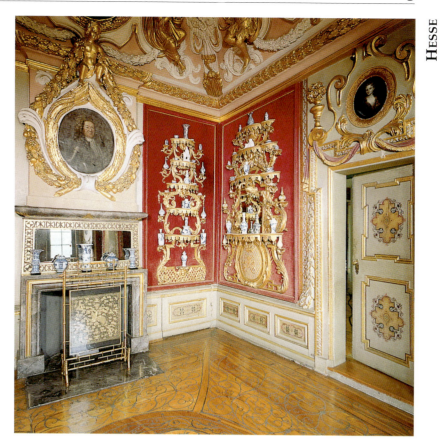

The Chinese Cabinet

The bedroom with its magnificent ceremonial bed

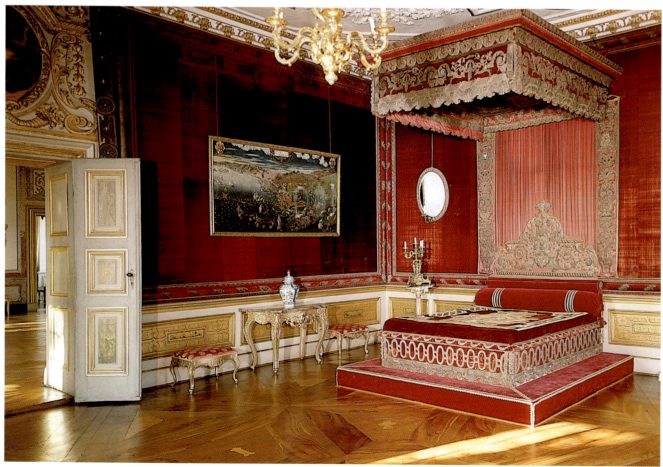

⊙ Garden
May – mid-October
7 am–dusk
Mid-October – April
8 am–dusk
Guided tours
May – September
Mo–Th 10 am–4 pm by
arrangement

Events:
Weilburg Palace concerts,
stage plays
www.weilburger-
schlosskonzerte.de

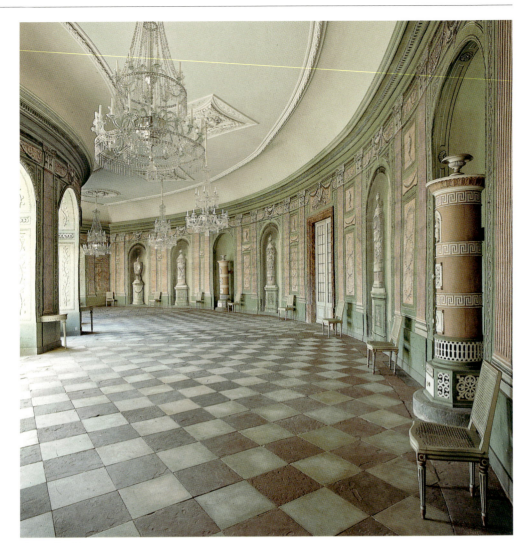

The south gallery

The Upper Orangery

The gardens of Schloss Weilburg stretch southwards in terraces. Between 1703 and 1713 Count Johann Ernst had architect Julius Ludwig Rothweil construct an Upper and Lower Orangery, thereby dividing the garden into two separate levels. During the cold season the orangeries were used to keep the citrus and other plants warm, but in summer this was the scene of festive court entertainments.

The Upper Orangery is the more lavish of the two. It links the palace itself to the palace and parish church, its large French windows acting as a mediating buffer between the artistic interior and the outdoor environment. Two semi-circular galleries flank a central hall two storeys high with a continuous musicians' gallery. Ionic plasters, rich stucco ornamentation and a ceiling painted with allegories contribute to the particular splendour of this hall.

The north gallery is clad with imitation tiles painted on canvas. Its appeal lies above all in its wealth of detail, as each tile displays a different figurative or ornamental motif.

The neo-classical wall decorations of the south gallery were implemented in 1790, creating an optical illusion of depth with red and green trompe l'oeil architecture: grooved pilasters, festoons and stoves set in niches. D. S.

Schloss Homburg

Homburg's lofty landmark is the free-standing White Tower in the middle of the multiple-wing palace built from 1621 to 1866 as the seat of the landgraves of Hesse-Homburg. In 1678 Landgrave Friedrich II, immortalised by Kleist in his play "Prince Frederick of Homburg", began converting the late medieval structure into a two-storey baroque residence. The often sumptuous furnishings were inspired by the great courts of Europe, although the wall decorations and furniture always followed the changing fashions of their age. The greatest impact was exerted by the new building and stately interiors implemented from 1830 onwards thanks to the wealth injected by the British princess Elizabeth, who had married Friedrich VI. Finally, from 1866 to 1918, the Schloss was used as a summer

ℹ Bad Homburg
vor der Höhe
Schloss und Schlosspark
D-61348 Bad Homburg v.d. Höhe
Tel. (+49 / 0) 61 72 / 92 62-1 47
Fax (+49 / 0) 61 72 / 92 62-1 48
www.schloesser-hessen.de
info@schloesser.hessen.de

⊖ King's Wing, Stag Walk Wing, Library Wing
November – February
Tu–Su 10 am–4 pm
Last tour at 3 pm
March – October
10 am–5 pm
Last tour at 4 pm
June – August
Mo 10 am–5 pm
Last tour at 4 pm

⊖ Elisabeth Wing and Palace Church
Su 11 am–3 pm hourly,
all year round
Closed on
24–26 December,
31 December and 1 January
White Tower
November – February
9 am–3 pm
March – October
9 am–4 pm

The Cabinet of Mirrors in the King's Wing

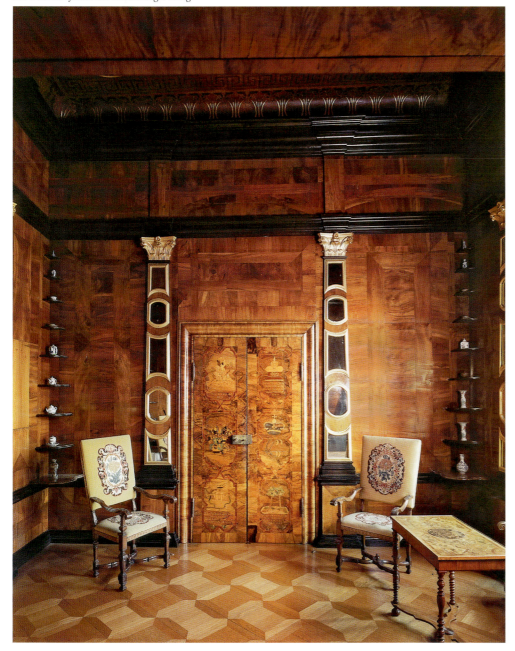

STAATLICHE SCHLÖSSER UND GÄRTEN HESSEN

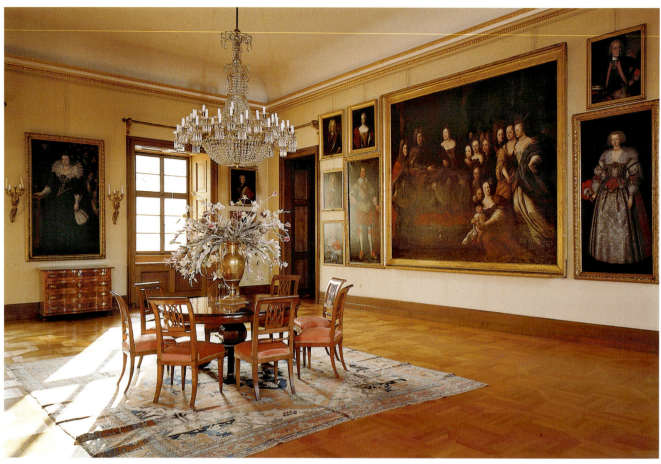

The Hall of Ancestors with portraits of the landgrave dynasty

residence by the Prussian kings and German Kaisers. The furniture of Wilhelm II's only apartment to have survived in Germany conveys a graphic impression of the domestic comforts enjoyed by the Kaiser and his consort Augusta.

Not many traces remain of the living quarters and rooms of state as they looked in the 18th century. One valuable relic typical of interiors at the time is the Cabinet of Mirrors in the King's Wing. Tradition maintains that the wooden panelling with its elegant marquetry was a gift from the joiners' guild in Homburg on the occasion of Landgrave Friedrich III Jakob's marriage to Countess Christiane of Nassau-Ottweiler.

Around 1830 the Darmstadt architect Georg Moller (1784–1852) was asked to undertake an artistic overhaul of the rooms of state. The sequence of vestibule, stairway and dining room still bears his hallmarks. The dining room was appointed in neo-classical style by Moller between 1835 and 1841. The table is laid for 26 people using the Iron Cross service. Landgrave Ludwig Wilhelm received this from the Prussian king Friedrich Wilhelm III in 1821 in acknowledgement of his military services.

The library and ancestral hall in the library wing were also revamped by Moller. Four stucco columns structure the broad library, whose walls were once completely lined with bookcases. These have been reconstructed using Moller's drawings, which have survived, so that the room looks almost authentic today. The adjacent Hall of Ancestors (or Hall of Paintings) adds an element of family identity by illustrating the long history of the Hesse-Homburg dynasty.

The English Wing

After Friedrich VI died in 1829 Landgravine Elizabeth, daughter of George III of England, made her widow's seat in the English Wing at Schloss Homburg. The spacious, richly furnished apartment was a suite of seven rooms: the entrée, bedroom, study, blue room, hall of audience, dining room and former library. The landgravine was a keen collector. Her artistic interests and her particular fondness for architectural and decorative designs are clearly reflected in her furniture and fittings. The dining room is a prime specimen of a neo-classical interior. The decorative artist Johann Daniel Scheel (1773–1833) painted the walls with arabesques in Pompeian style. D. S.

A wall painted with arabesque motifs

The dining room with Pompeian wall paintings

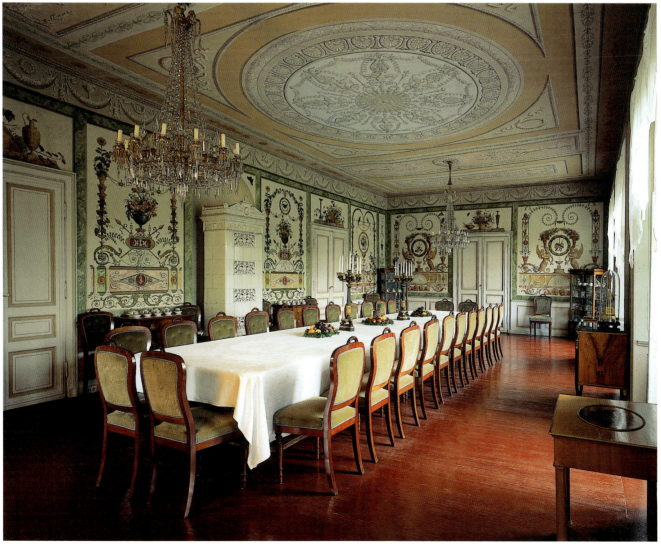

ℹ Burg und Fürstenbau
D-63454 Hanau-
Wilhelmsbad
Tel./Fax (+49/0)
6181/833376
www.schloesser-hessen.de
info@schloesser.hessen.de

◔ Castle
Guided tours:
April – October
Sa 2–4 pm
Su 11 am–4 pm
Last tour 4 pm
Also open to groups
outside normal hours by
prior arrangement:
Tel. (+49/0) 69/59 58 18

◔ Prince's Palace and
Information Centre
Tel./Fax (+49/0)
6181/90 66 295
April – October
Tu–Th 2–6 pm
Sa 1–6 pm
Su 10 am–6 pm
November, December,
March
Sa and Su 1–5 pm
(as weather permits)
Admission free

Anton Wilhelm Tischbein
(1730–1804), Crown Prince
Wilhelm of Hesse-Kassel, in the
castle's ancestral gallery

Wilhelmsbad Park
The Castle and Prince's Palace

The once fashionable spa and its well pre-served park are set in one of Germany's oldest landscaped gardens. The entrepre-neurial crown prince Wilhelm of Hesse-Kassel had this laid out between 1777 and 1781, marketing the venue professionally with advertising material.

Retreating to a small island, the crown prince sought a refuge for his "favourite place". From the outside the castle resem-bles a medieval ruin, but inside the living quarters and ceremonial rooms are sur-prisingly elegant. The prince's apartment downstairs includes an ante-chamber, two cabinets, a bedroom, the "retirade" and a cloakroom. The furniture, textiles and marble fireplaces were commis-sioned in Strasbourg. The large, neo-clas-sical domed hall on the upper floor pro-vided gaming tables for entertainment, but was also an ancestral gallery record-ing the long history and traditions of the Hesse-Kassel dynasty.

The "Lodge", originally one of the overnight pavilions on the spa prome-nade, was reserved from 1796 for use by the landgrave's court in Kassel, when it became known as the Prince's Palace. The crown prince himself resided in one of the apartments from 1779 until his castle was finished. Its major feature is the painted landscape wallpaper dating from the con-struction period, depicting both Ancient architecture and ruined German castles, an inspiration perhaps for the future cas-tle structure. F. B.

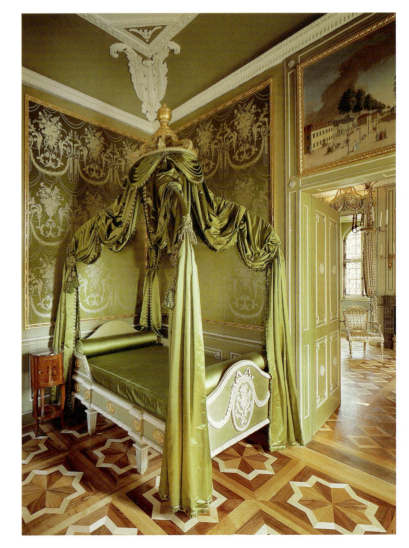

Wilhelmsbad,
a bedroom in the castle

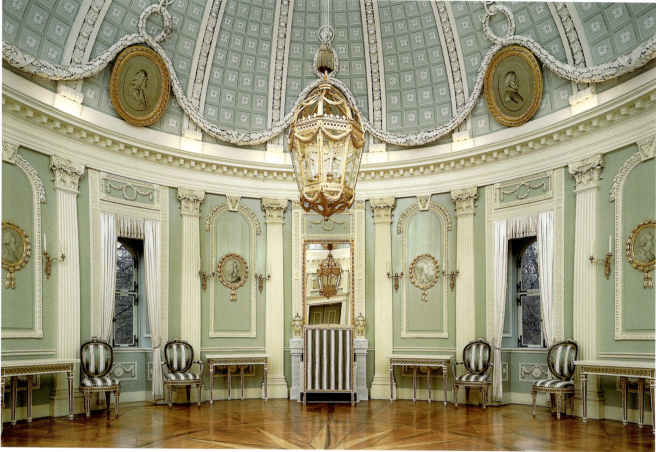

Domed hall in the castle with ancestral gallery

The living room in the Prince's Palace with landscape wallpapers, c. 1780

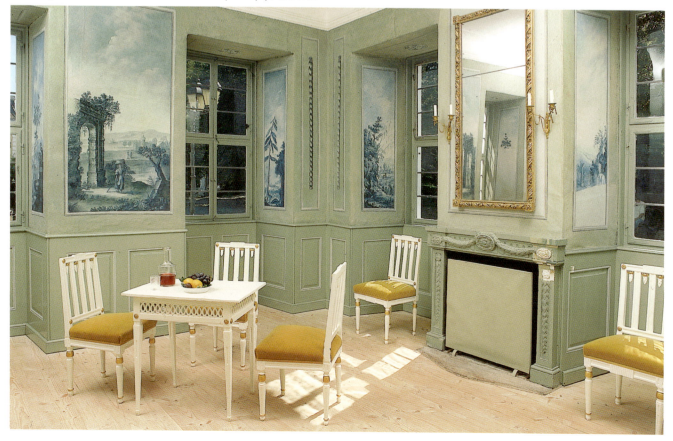

STAATLICHE SCHLÖSSER UND GÄRTEN HESSEN

Wilhelmsbad, a landscape wallpaper in the living room of the Prince's Palace

Source of illustrations:
The rights to all illustrations are held by Staatliche Schlösser und Gärten Hessen.
Photographers: Roman von Götz, Gerd Kemmerling, Jörg Lantelmé, Frank Mihm, Christian Ottersbach, Uwe Rüdenburg

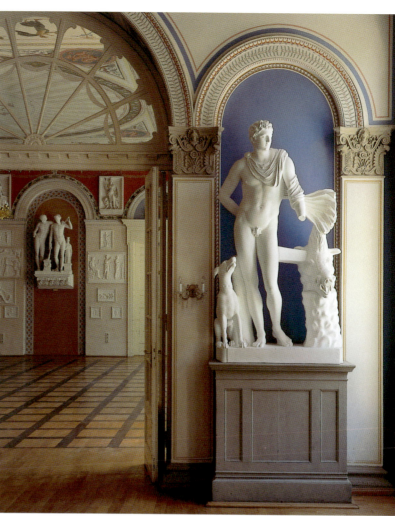

Mecklenburg-Western Pomerania

STAATLICHE SCHLÖSSER
UND GÄRTEN
MECKLENBURG-VORPOMMERN

STATELY HOMES AND GARDENS OF
MECKLENBURG-WESTERN POMERANIA

STAATLICHE SCHLÖSSER UND GÄRTEN MECKLENBURG-VORPOMMERN

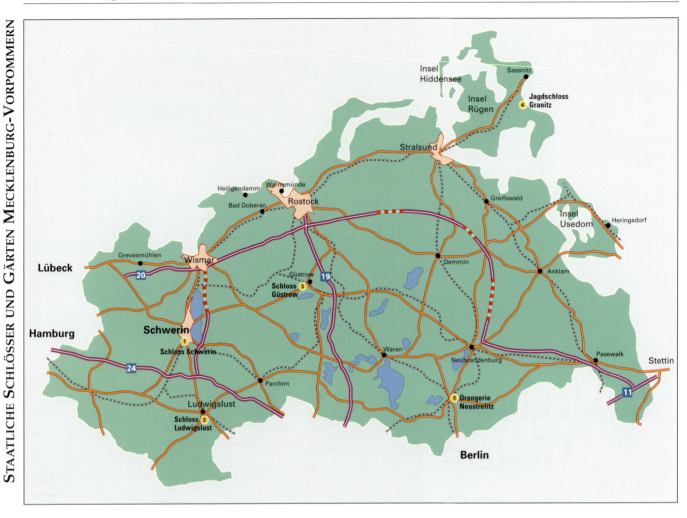

Schwerin
 1 Schloss Schwerin (p. 181)

Ludwigslust
 2 Schloss Ludwigslust (p. 182)

Güstrow
 3 Schloss Güstrow (p. 183)

Granitz
 4 Hunting Lodge (pp. 184–185)

Neustrelitz
 5 Orangery (p. 186)

For information about other sites managed by Staatliche Schlösser und Gärten Mecklenburg-Vorpommern, see www.mv-schloesser.de

◁ *Neustrelitz Orangery, the Blue Room*

Schloss Schwerin
Throne Room

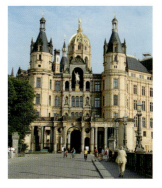

Schloss Schwerin in its romantic island location is regarded as one of the most significant expressions of Historicist architecture. It acquired its striking contours during the last conversion project from 1845 to 1857 under architects Georg Adolph Demmler, Friedrich August Stüler and Hermann Willebrand, when older buildings were incorporated into an imposing stately whole.

The elaborate façade and the appointment of the festive halls reflect the long-established traditions of the dynasty. The throne room on the reception floor is considered the most impressive hall of state. Friedrich Lisch, Counsellor for the Archives, recommended that it should make references to the history of Mecklenburg and its ruler. Stüler accordingly endowed the hall with an abundance of municipal heraldry, allegories of worldly and Christian virtues, figures symbolising the region's prime economic activities, the emblems of Orders and the coats-of-arms of nobility.

The two galleries before the throne room prepare us for this rich iconographic programme. The Gallery of Palaces displays views of residences held by the territorial overlords. The Gallery of Ancestors offers a complete sequence of all dukes of Mecklenburg to reign from the 14th to the 18th century.

Since 1990 Schloss Schwerin has been home to the state parliament of Mecklenburg-Western Pomerania. The historical rooms in the bel étage and the reception floor now house the museum. H.K.

i Schlossmuseum
Lennéstr. 1
D-19053 Schwerin
www.schloss-schwerin.de
www.landtag-mv.de
www.mv-schloesser.de
Tel. (+49/0) 385 / 52 529 20

⊙ 15 April – 14 October
Tu–Su 10 am–6 pm
15 October – 14 April
Tu–Su 10 am– 5 pm

✕ Schlosscafé, Orangeriecafé
Schlossgartenpavillon

P Multi-storey car parks
in the town centre

DB

Schloss Schwerin, the throne room

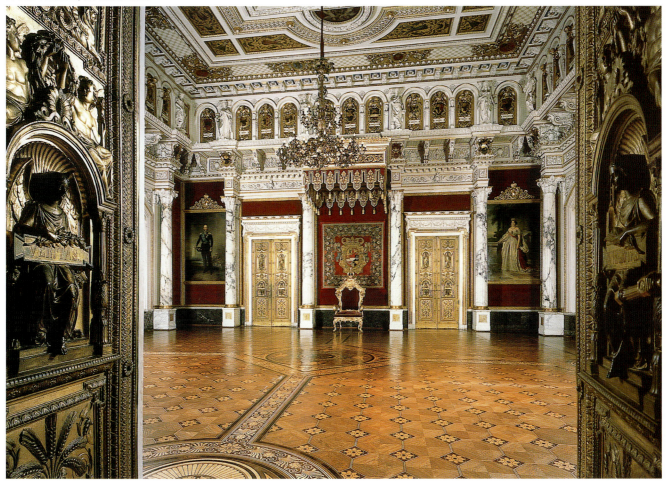

STAATLICHE SCHLÖSSER UND GÄRTEN MECKLENBURG-VORPOMMERN

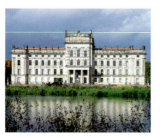

ℹ Schloss Ludwigslust
Schlossfreiheit
D-19288 Ludwigslust
Tel. (+49/0) 3874/5719-0
Fax (+49/0) 3874/5719-19
www.schloss-
ludwigslust.de
www.mv-schloesser.de

🕐 Tu–Su, public holidays
15 April – 15 October
10 am–6 pm
16 October – 14 April
10 am–5 pm

✗ Schlosscafé in the Jagdsaal

🅿 Friedrich-Naumann-Allee

DB

Schloss Ludwigslust
The Golden Room: rococo turns neo-classical

Ludwigslust was probably the last residence to be founded in Northern Germany. Duke Friedrich of Mecklenburg-Schwerin began laying out the town in 1765 following an idealised plan. The layout is dominated by major axes, and at the centre stands the Schloss, built from 1772 to 1776 by court architect Johann Joachim Busch.

The central tract includes the richly decorated ballroom. Colossal Corinthian columns emphasise the majestic height of the two-storey hall. Almost all the gilt adornments are made of papier maché. The use of this material was a peculiarity of the region. Blossoms, vases and masks have been preserved in abundance on the ceiling of the Golden Hall. The frames of mirrors, doors and windows display golden ornaments of papier maché. The gold, the wealth of mirrors and the bright prisms on the chandeliers lend the room its magnificent radiance. The great mirrors also extend the space by illusion, granting the architecture its lightness and apparently dissolving the spatial confines.

The Golden Hall was used as a ballroom and concert room. With its outstanding acoustics it remains a favourite venue for chamber music. The adjoining rooms illustrate the arts fostered at court and how its members lived.

H.K.

Schloss Ludwigslust, the Golden Hall

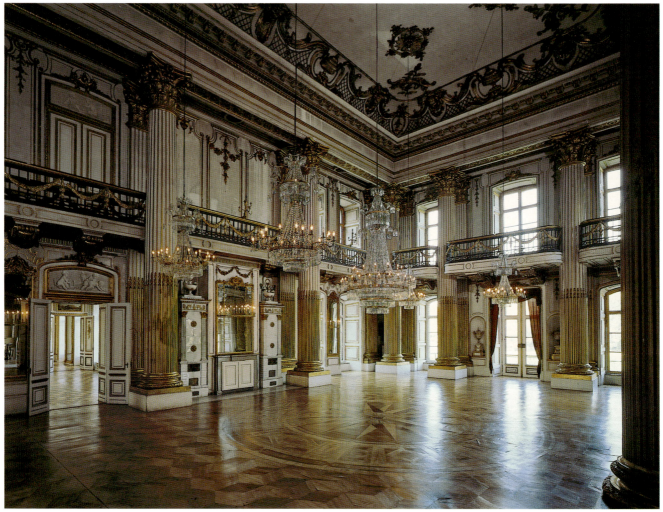

Schloss Güstrow
Banqueting Hall

Schloss Güstrow is one of the few surviving Renaissance palaces in Northern Germany. Duke Ulrich of Mecklenburg initiated building in 1558. Master builders Franz Parr and Philipp Brandin achieved a unique synthesis of Italian, French, Dutch and German architectural principles.

The sculpted frieze of red deer in the banqueting hall is a major artistic accomplishment. It shows animals leaping and lying down, sporting genuine antlers. Just above this scenic frieze coats-of-arms and inscribed names recall the duke's forefathers. The direct link between the hunting theme and the genealogical cartouches stresses his legitimate rights to his title,

for hunting was an inherited privilege, the prerogative of the territorial overlord and passed down for many generations, as the imagery in the hall demonstrates. The stucco ceiling, which replaced the original free supporting beams, was made in 1620. It contains 43 separate scenes of the hunt or of fighting animals. Some of the figures in these very detailed compositions are implemented in haut-relief. The quality of this hall is comparable with the Knights' Hall built around 1600 for Schloss Weikersheim.

Following extensive restoration between 1963 and 1978 the historical rooms house the collections of the State Museum in Schwerin. H.K.

i Schloss Güstrow
 Franz-Parr-Platz 1
 D-18273 Güstrow
 Tel. (+49/0) 3843/7520
 Fax (+49/0) 3843/682251
 www.schloss-guestrow.de
 www.mv-schloesser.de

☉ Tu–Su 9 am–5 pm
 Guided tours:
 Tu–Su 11 am and 2 pm
 and by arrangement

✕ Schlosscafé

🅿 on Schlossberg

DB

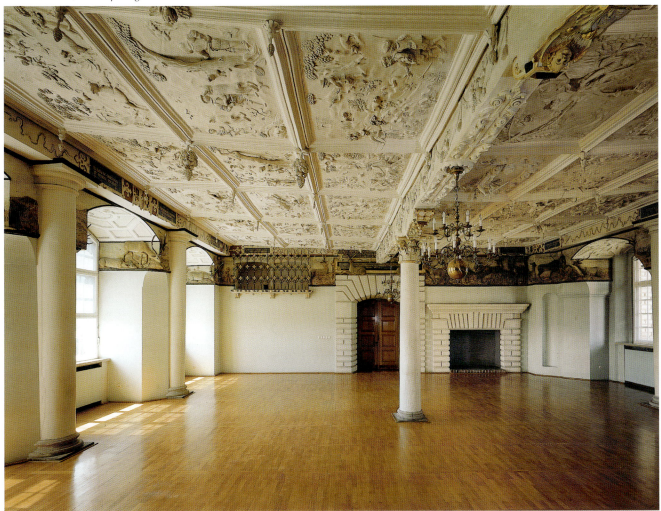

Schloss Güstrow, the banqueting hall

i Jagdschloss Granitz
PF 1101
D-18609 Binz
Tel. (+49/0) 3 8393/22 63
Fax (+49/0) 3 8393/21 283
www.mv-schloesser.de

🕘 May – September
Daily 9 am–6 pm
October – April
Tu-Su 10 am–4 pm

✕ Gewölberestaurant
in the Schlosskeller
Waldbiergarten

P P+R Süllitz, express shuttle
to Jagdschloss

Hunting Lodge
The spiral stairs: a masterpiece of Prussian cast iron

Granitz Hunting Lodge on the Isle of Rügen receives some 300,000 guests a year, making it the most visited palace in Mecklenburg-Western Pomerania. It was built from 1837 to 1851 for Prince Wilhelm Malte I of Putbus. He was given much advice by his friend the crown prince of Prussia, the future King Friedrich Wilhelm IV, who sent the senior official in the Prussian building department, Karl Friedrich Schinkel, to design the viewing tower. The implementing architect was Johann Gottfried Steinmeyer, who had studied with Schinkel.

The main attraction is the cast iron spiral staircase with its filigree steps. The self-supporting structure, put together in modular fashion, is an aesthetic masterpiece of artistic cast iron design in Berlin. Whereas the 18th century had used stairs as prestigious sets for purposes of state, the stairs at Granitz Hunting Lodge are an impressive advertisement for Prussia's aspiring cast iron industry and an indication of the owner's progressive views. Climbing the 154 steps will be rewarded by a picturesque view across Germany's largest island. H.K.

Granitz Hunting Lodge, spiral stairs ▷

Granitz Hunting Lodge, the base of the spiral stairs

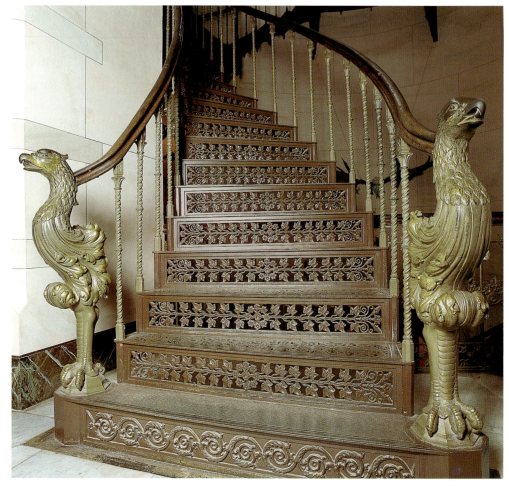

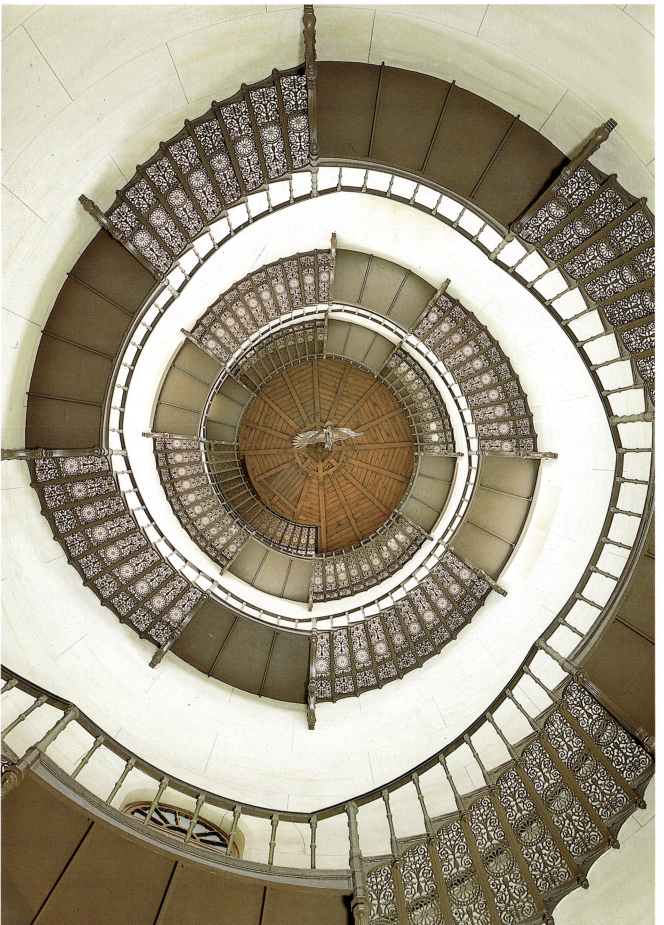

ℹ Orangerie Neustrelitz
An der Promenade 22
D-17235 Neustrelitz
Tel. (+49/0) 39 81 / 23 74 87
www.mv-schloesser.de

🕐 1 April – 30 September
Daily 11 am–9.30 pm
1 October – 31 March
Tu–Su 11 am–9.30 pm

Ⓟ

DB

The Orangery
A gem of neo-classical design

The town of Neustrelitz was laid out from 1733 as a planned community in the late baroque manner. Until 1918 it was the main residence of the dukes and grand-dukes of Mecklenburg-Strelitz. The Schloss suffered war damage in 1945 and was later demolished, leaving the Orangery as the most significant building in its precincts. This had been built in 1755 as a winter shelter for exotic plants. In 1842 Grand Duke Georg, the favourite brother of Queen Luise of Prussia, appointed Friedrich Wilhelm Buttel to redesign the Orangery as a showcase for his family collection of Antique statuary. With the aid of Karl Friedrich Schinkel the simple structure was transformed into a gem of neo-classical interior architecture. At the heart of the Orangery are three superb rooms finished in the duchy's colours – blue, yellow and red. Pompeian motifs dominate Bernhard Rosendahl's painting. The walls draw structure from blind round arches where statues rest on consoles. Numerous works of bas-relief are embedded in the narrow side walls. Copies of Ancient works alternate with casts of neo-classical sculpture, reflecting the tastes of the age. In the Yellow Room, for example, a sacrificial scene from Antiquity stands alongside a Bacchus made in relief by Christian Daniel Rauch in 1834. In the Red Room a Victoria by Rauch surveys a gallery of Ancient goddesses.

The Red and Blue Rooms are available for catering, whereas the Yellow Room is reserved for cultural events.　　　H.K.

Neustrelitz Orangery, Yellow Room

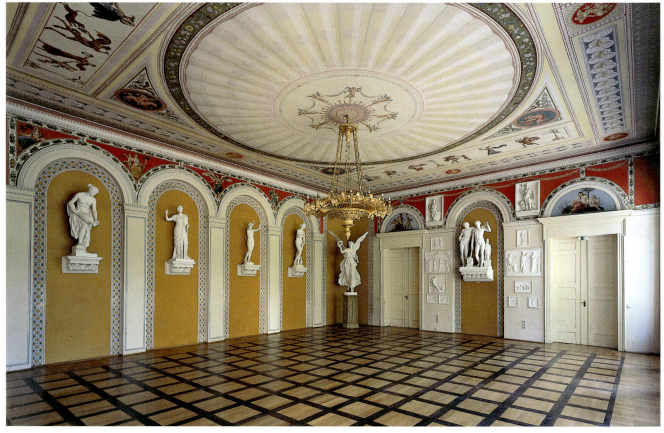

Source of illustrations:
Achim Bötefür: p. 179, 184 top, 186 bottom, rear cover (Neustrelitz Orangery); Lothar Steiner: p. 181; Stephan Rudolph-Kramer: p. 181 top;
Heike Kramer: p. 182 top; Elke Walford: p. 182 bottom, 183 bottom; Wolfgang Gerstner: p. 183 top; Thomas Grundner: p. 184 bottom, p. 185;
Doreen Hennig: p. 186 top

Rhineland-Palatinate

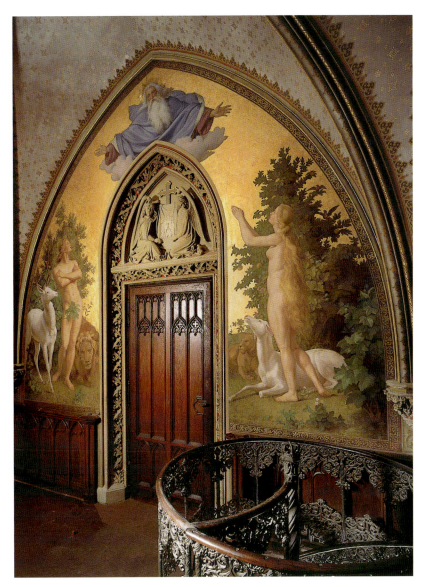

BURGEN, SCHLÖSSER, ALTERTÜMER
RHEINLAND-PFALZ

CASTLES, STATELY HOMES
AND ANCIENT MONUMENTS
OF RHINELAND-PALATINATE

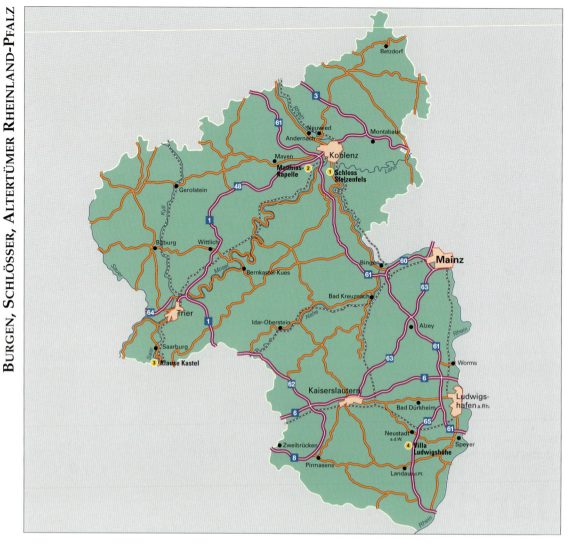

Stolzenfels
1 Schloss Stolzenfels (pp. 189–192)

Kobern
2 St Matthew's Chapel (p. 193)

Kastel-Staadt
3 Hermitage Chapel (p. 194)

Ludwigshöhe
4 Villa Ludwigshöhe (pp. 195–196)

For information about other sites managed by Burgen, Schlösser,
Altertümer Rheinland-Pfalz: www.burgen-rlp.de

◁ *The chapel balcony, Schloss Stolzenfels*

RHINELAND-PALATINATE

Schloss Stolzenfels

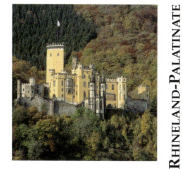

Greater Knights' Hall

Prussian Crown Prince Friedrich Wilhelm, from 1840 King Friedrich Wilhelm IV, was a Romantic on a royal throne. He had this ruined medieval castle transformed in 1836–1847 into one of the finest neo-Gothic palaces of the High Romantic age. Planning was undertaken by the Berlin architects Karl Friedrich Schinkel (until 1841), Ludwig Persius (until 1845) and, for the chapel and appointment, Friedrich August Stüler (until 1847). The Greater Knights' Hall, built to Schinkel's drawings of 1836, was inspired by the summer banquet hall of the medieval Marienburg in Western Prussia. Two columns of polished black Lahn marble support the rich Gothic ribs emanating from two intertwining stars. The neo-Gothic furniture of pale oak was made in Neuwied in the workshop of Johann Wilhelm Vetter. The hall is extravagantly decorated with historical items from the Middle Ages to the baroque period. The owner wanted this room to be a "new

structure in medieval masonry" that appeared to have been furbished over the centuries. Suits of armour stand in corners, swords and crossbows are ornamentally arrayed along the walls. Over the wainscot and on the sideboard stand precious 17th- and 18th-century glasses and stoneware jugs, painted and sculpted, from Creussen and Waldenburg. The picture window overlooking the courtyard explains the idea that prompted the king to restore this ruin: the elderly owner of the medieval castle, Archbishop Arnold of Isenburg, draws the ground plan on a stone slab with the pommel of his sword. The other figure, a youthful knight with a Prussian banner, bears the model of the reconstructed castle. Prussia is presented as the rightful successor to the medieval electors of the Rhineland. Schloss Stolzenfels embodies a political manifesto.

The Düsseldorf artist Caspar Scheuren painted watercolours of the Schloss between 1840 and 1847. For all his Romantic enthusiasm, the rooms are rep-

i Schloss Stolzenfels
D-56075 Koblenz
Tel. (+49/0) 261/51656
Fax (+49/0) 261/5791947

⊙ 1 April – 30 September:
10 am–6 pm
1 October – 30 November,
1 January – 31 March:
10 am–5 pm
Closed in December and on
the first working day of
each week
Last admission 60 minutes
before closing
Viewing restricted to
guided tours

P In Stolzenfels town,
approx. 15 minutes on foot

Schloss Stolzenfels, Greater Knights' Hall

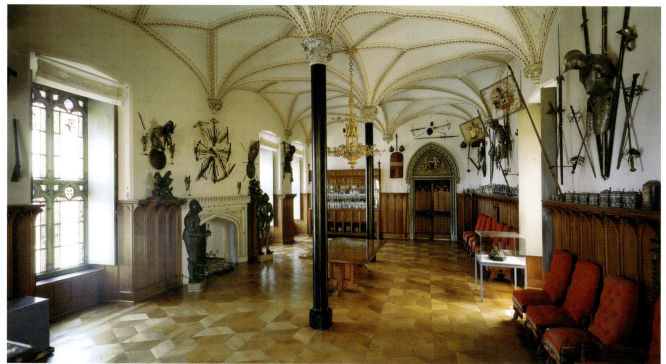

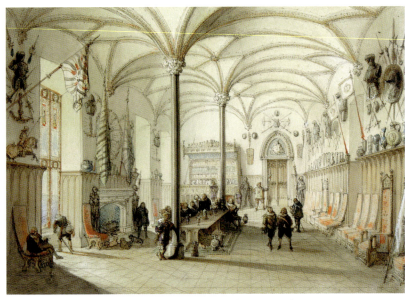

Schloss Stolzenfels, Greater Knights' Hall, watercolour by Caspar Scheuren

resented with great accuracy. They show how the king regarded the work he had commissioned.

A Renaissance retinue is assembled in the Greater Knights' Hall. The weapons, vessels and antiques on the ledges and shelves can still be identified. Entire collections of ancient objects were acquired to furnish the Schloss. The most important event in its history took place in this room on 15 August 1845: a festive concert in honour of Britain's Queen Victoria, conducted by Giacomo Meyerbeer with Franz Liszt at the piano and Jenny Lind singing. The most celebrated musicians of the day and a magnificent court entourage were assembled in the Knights' Hall to hear it.

Schloss Stolzenfels, Lesser Knights' Hall

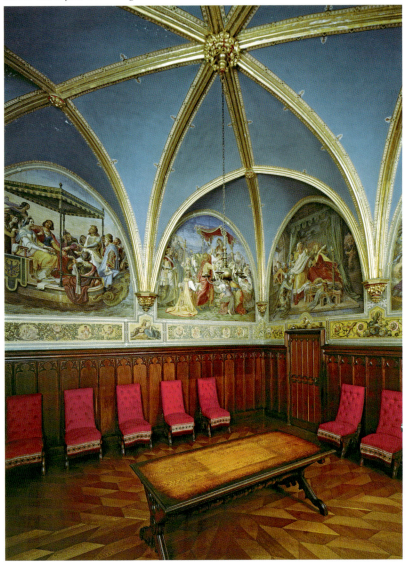

Lesser Knights' Hall

The Lesser Knights' Hall is in the medieval residential tower that was incorporated into the redevelopment. It functioned as a salon, with two doors leading to the roof terrace over the chapel. Hermann Anton Stielke, a Berlin artist trained at the Academy in Düsseldorf, was commissioned in 1842 to decorate the room with frescos illustrating the medieval history of the German Empire. This resulted in one of the most significant cycles of High Romantic Historicist painting. It venerates King Friedrich Wilhelm IV as a chivalrous, magnanimous and art-loving monarch. The client's values are reflected in historical episodes: the death of John, the blind Bohemian king, at the Battle of Crécy (1346) symbolises courage. John's fate moved the king deeply. Other historical scenes depict endurance, justice, poetry, courtly love and fidelity. The Lesser Knights' Hall is the only residential room with fresco painting. Around 1850 tourists to the Rhine were guided from here to the palace chapel. The rooms at Schloss Stolzenfels were conceived as a stage to impress visitors with their owner's qualities.

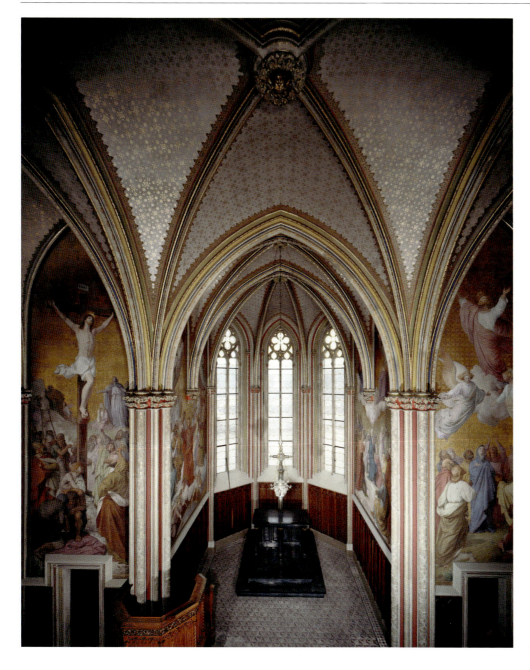

Schloss Stolzenfels, chapel

The Chapel

The chapel is a scenic landmark above the Rhine valley. It was added retrospectively from drawings by Friedrich August Stüler and consecrated on 3 August 1845, the birthday of the owner's late father, King Friedrich Wilhelm III. The architecture surpasses the requirements of a chapel. Ernst Deger, a painter of the Düsseldorf School, decorated the church interior between 1851 and 1860. The iconography was prescribed by the king and tells of God's redeeming grace from the Garden of Eden to the Last Judgment. This is the most luxurious church interior of the Late Romantic period. The artist was inspired by Florentine Early Renaissance frescos, but the gold background was requested by the king. The series begins at the king's balcony with the Old Testament and culminates in the choir with the miracle of Whitsun and the Last Judgment. The original appointment has been fully preserved with its brick mosaic floor and chair coverings. The Roman-style underfloor heating adds a final flourish.

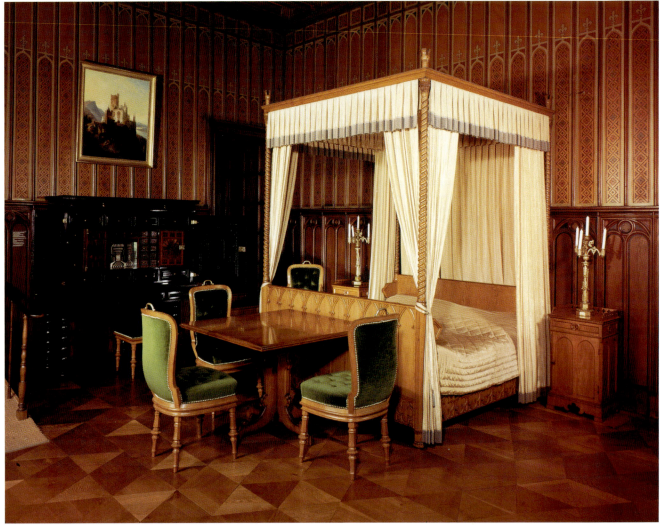

Schloss Stolzenfels, the royal couple's bedroom

The Royal Couple's Bedroom

The shared bedroom is the link between the adjacent king's suite and its mirror image, the queen's suite. Friedrich August Stüler's design foresaw a consistent pattern of wooden panelling up to the ceiling over a half-height neo-Gothic oaken wainscot. The view of the pergola garden and the Rhine valley provided by the huge window is a feature in itself. The furbishing remained unchanged after completion of the Schloss. The elegant neo-Gothic furniture of pale oak was sup-plied by Johann Wilhelm Vetter of Neuwied. The historical furniture was intended to convey the impression that the room had evolved organically over centuries. Friedrich Wilhelm was given a large 17th-century ebony cabinet by his cousin, the Dutch king, to mark the completion of works. Queen Victoria and Prince Albert of England slept here in August 1845. The royals no doubt appreciated the flushing toilet next door with its leather seat, a luxury in German palaces at the time.

J. M.

Oberburg above Kobern
St Matthew's Chapel

St Matthew's Chapel, a Late Romanesque masterpiece, is far too sumptuous for an ordinary castle chapel. In 1221, after a failed Crusade, Count Heinrich of Isenburg brought the head of the disciple Matthew – called to replace the traitor Judas – home to the River Mosel. The chapel was built by 1240 so that the relic could be properly worshipped. The hexagonal central plan with an ambulatory and a steep, sunlit interior was no less than a reliquary in architectural format.

For the last 600 years the apostle's head has been kept in Trier. The spatial articulation is so complex that the solid masonry seems to dissolve. Loosely clustered columns with ornate acanthus capitals support the pointed arches of the central lantern, beneath which the shrine once stood. This interior bathed in light graciously defies gravity and is one of the finest gems of latter-day Rhenish Romanesque.

J. M.

i Matthiaskapelle
auf der Oberburg
D-56330 Kobern

☉ From the Sunday before Easter to All Saints Day: Sundays and public holidays
11 am–5 pm
Guided tours by arrangement:
Visitor's Service
Tel. (+49/0) 261/9 74 24-40

✖ Restaurant at the castle:
Tel. (+49/0) 26 07/86 47
Fax (+49/0) 26 07/96 34 38

P In town, approx. 15 minutes on foot

RHINELAND-PALATINATE

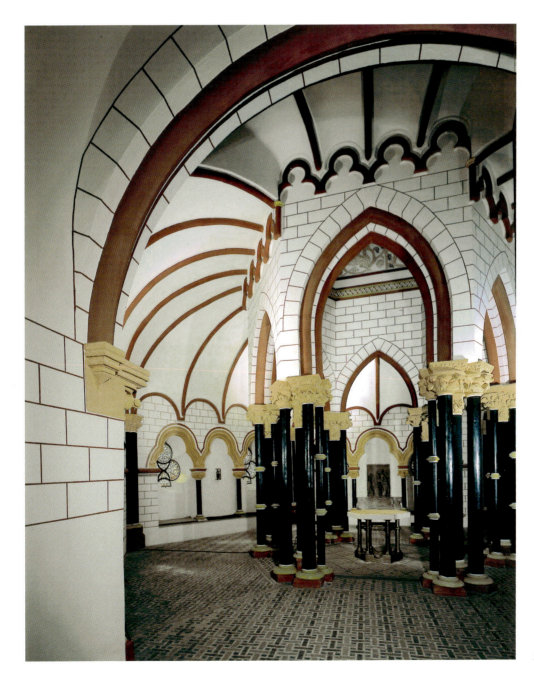

Inside St Matthew's Chapel

ℹ Klause Kastel
Saarblickstr. 2
D-54441 Kastel-Staadt
Tel. (+49/0) 6582/535
Fax (+49/0) 6582/989275

🕐 1 April – 30 September:
10 am–1 pm and 2–6 pm
October and March:
10 am–1 pm and 2–5 pm
November and February:
10 am–4 pm
Closed in December and
January and on the first
working day of each week
Last admission 30 minutes
before closing

🅿 On the approach road,
approx. 5 minutes on foot

The Hermitage Chapel

This hermitage, perched high above the Saar Valley, tells a great deal about the ideas of Prussia's Crown Prince Friedrich Wilhelm, from 1840 King Friedrich Wilhelm IV. In 1835–1838 this "Romantic on a king's throne" restored the ruins of a hermit's chapel built around 1600 as a place of rest for John the Blind, King of Bohemia and Count of Luxembourg. He had fallen at the Battle of Crécy on 26 August 1346. The grave was destroyed during the French Revolution and in 1833 the Crown Prince acquired the bones from a factory owner in the Saarland. Karl Friedrich Schinkel designed the chapel down to the last detail, although with active input from the prince. The black marble sarcophagus stands in the middle of the chapel below heavily ribbed vaults. Four dainty bronze lions bearing the coat-of-arms of Luxembourg support the marble slab of the tomb displaying the crown of the Bohemian king in bronze. The chapel interior shimmers in the yellow and blue light of glass stars in Schinkel's windows. A wall painting of medieval heraldic emblems explains the genealogy which linked the Crown Prince and Crown Princess Elisabeth to the medieval king. J. M.

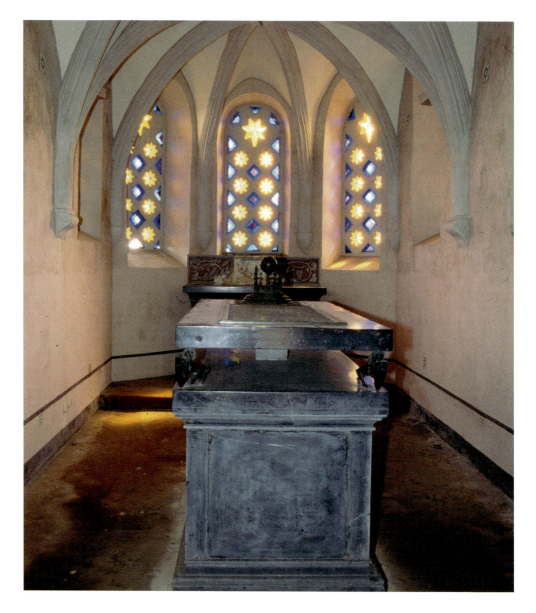

Hermitage near Kastel, the chapel

Villa Ludwigshöhe

"A villa in the Italian manner, designed only for the warmer season and in the mildest region of the kingdom": the Bavarian king Ludwig I expressed this wish in 1826 and Villa Ludwigshöhe near Edenkoben is the wish come true. Built in 1846–1852 amid vineyards and chestnut groves to plans by Munich court architect Friedrich von Gärtner (1792–1847), its architecture and appointment are reminiscent of Italy.

Dining Room

The large "Pompeian" dining room is on the ground floor in the central axis. Like the display frontage as a whole, it faces the valley. The exquisite floor is made of thin tabs of precious woods in different colours, placed together like an Ancient mosaic. The ceiling has also been painted in accordance with Classical prototypes encountered particularly in Pompey.
On the walls individual and paired figures are suspended against fields of the typically Pompeian red. The zone above displays fantastical architecture on a white background. The scheme and the various motifs echo wall paintings of Antiquity, although the elements have been freely compiled. The floating figures betray neo-classical features. Evidently they were not based on Classical originals, but on early 19th-century representations. Recent research suggests that the ceilings were painted as soon as the villa was finished, but the walls not until 1899, although the designs probably existed beforehand.

Salon

The two paintings in the middle – scenes from the life of Dionysos, the god of wine – are copies of wall paintings in Herculaneum. The tiny works of still life with vessels at the sides are typical of Ancient wall painting, as are the little rectangular landscapes, although these, unlike their prototypes, show castles in the vicinity.

RHINELAND-PALATINATE

ℹ Villa Ludwigshöhe
Villastraße
D-67480 Edenkoben
Tel. (+49/0) 63 23 / 9 30 16
Fax (+49/0) 63 23 / 9 30 17

🕐 1 April – 30 September:
10 am–6 pm
1 October – 30 November,
1 January – 31 March:
10 am–5 pm
Closed in December and on the first working day of each week
Last admission 30 minutes before closing

Access to historical rooms only with guided tours

✗ Coffee bar on the Villa terrace in summer

𝐀 Museum
Max Slevogt Gallery /
Mainz Regional Museum
Tel. (+49/0) 61 31 / 2 85 70

Villa Ludwigshöhe, Pompeian Room

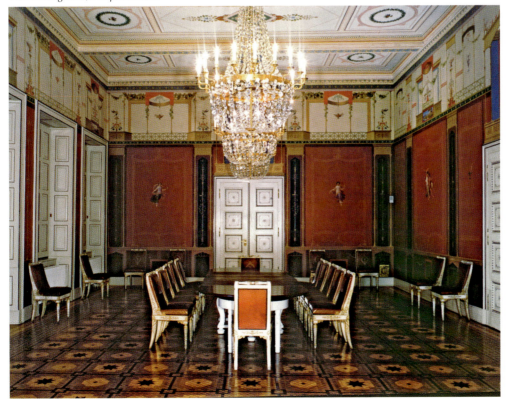

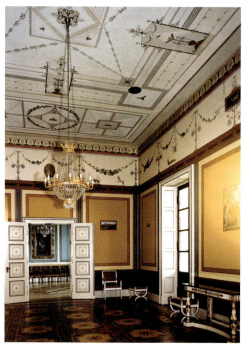

Villa Ludwigshöhe, salon

The motifs in the upper zone also make reference to wine – and thus to the Palatinate – with stems of vine leaves, leaping goats, vessels and other attributes of the wine god.

Another wooden tab "mosaic" adorns the floor. The ceiling dates from the construction period, whereas here again the walls were not painted until 1899.

Kitchen

Although the kitchen equipment was relatively modern, motifs from Antiquity are also found here. The large grill, framed by pilasters and crowned by a palmetto frieze, resembles a Classical portal, and a meander ribbon encompasses the vessel for preparing hot water. One of the tiles displays an "Instruction for Use" by "Jos. Schmid sen., master potter, in Munich 1852", explaining how to fire the stove. This would have been most helpful, as the king and his staff only visited the villa every two years.

A. A.-B.

Villa Ludwigshöhe, kitchen

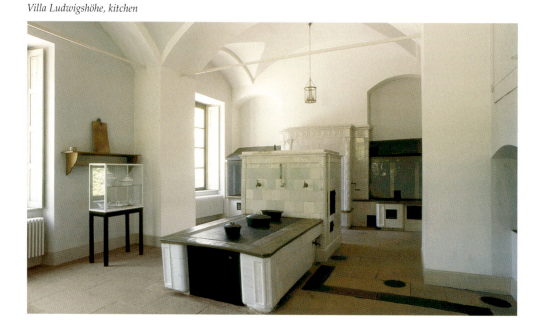

Source of illustrations:
Gauls, Koblenz: p. 187, 191
Landesamt für Denkmalpflege Rheinland-Pfalz, Heinz Straeter: p. 189 top, 194 top, 195 top, 195 bottom, 197
Landesamt für Denkmalpflege Rheinland-Pfalz, Sigmar Fitting): p. 189 bottom, 190
Metz, Tübingen: p. 192
Michael Jeiter: p. 193 top
Landesmedienzentrum Koblenz: p. 193 bottom, 196 top
Axel Brachat: p. 194 bottom, 196 bottom

Saxony

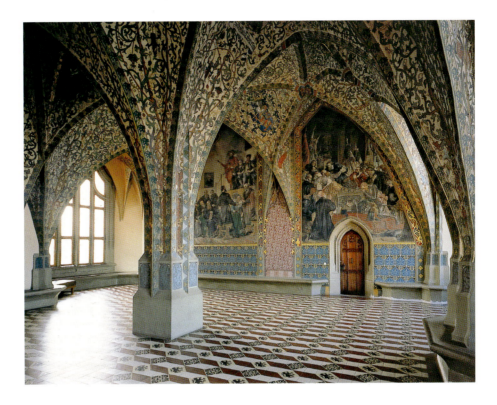

SCHLÖSSERLAND SACHSEN
STAATLICHE SCHLÖSSER, BURGEN UND GÄRTEN

PALATIAL SAXONY
STATELY HOMES, CASTELS
AND GARDENS

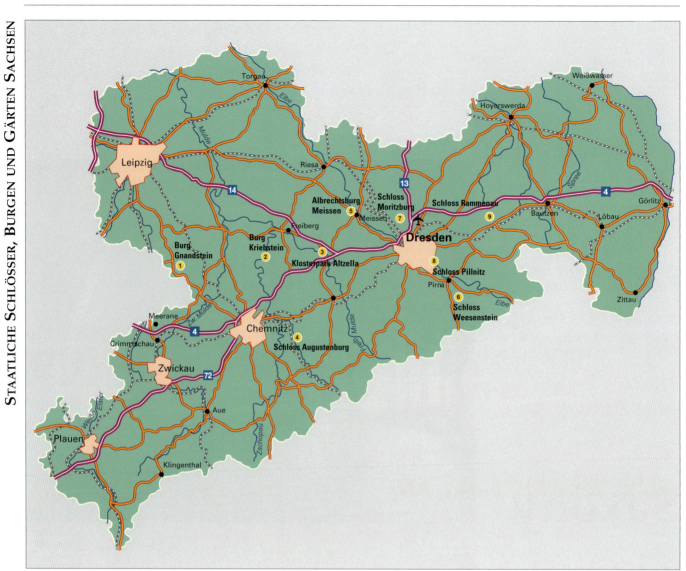

Gnandstein
 1 Gnandstein Castle (pp. 199–200)

Kriebstein
 2 Kriebstein Castle (pp. 201–202)

Altzella
 3 Altzella Abbey (p. 203)

Augustusburg
 4 Schloss Augustusburg (p. 204)

Meissen
 5 Albrechtsburg (pp. 205–206)

Weesenstein
 6 Schloss Weesenstein (p. 207)

Moritzburg
 7 Schloss Moritzburg (pp. 208–209)

Pillnitz
 8 Pillnitz Palace and Park (pp. 210–211)

Rammenau
 9 Baroque Palace (p. 212)

For information about other sites managed by Staatlichen Schlössern, Burgen und Gärten Sachsen: www.schloesser.sachsen.de

◁ *The Great Hall of Court*
in the Albrechtsburg at Meissen

Gnandstein Castle

The Great Hall

The Great Hall in the oldest section of the castle was built around 1230. It conveys the character of that period with impressive authenticity. The actual hall of state, the pivot of proceedings, is on the third floor. It measures 15.6 metres x 5.6 metres, which is modest by comparison with other Romanesque halls that have survived in Germany. What is striking about it, however, is that almost all the window openings have remained just as they were, notably two triple-arcade windows on the south side, one with two floral capitals. The hall was heated by two fireplaces. The flooring and roofing we see now were probably fitted during conversions in the late 14th century. The room has been furnished – including a removable table and chests used for storage and seating – to recreate a plausible medieval situation based on visual traces of the historical condition.

ℹ Burg Gnandstein
D-04655 Gnandstein
Tel. (+49 / 0) 3 43 44 / 6 13 09
Fax (+49 / 0) 3 43 44 / 6 13 83
Burg.Gnandstein@
t-online.de

🕗 January:
Sa | So 10 am–4 pm
February – April /
November:
Tu–Su 10 am–5 pm
May – October:
Tu–Su 10 am–6 pm
December:
Tu–Su 10 am–4 pm

✕ Burggaststätte

By car: motorway A4, exit at Chemnitz-Nord, B 95 towards Leipzig, exit at Dolsenhain towards Gnandstein / Kohren-Sahlis

🅿 below the castle

Gnandstein Castle, the Great Hall

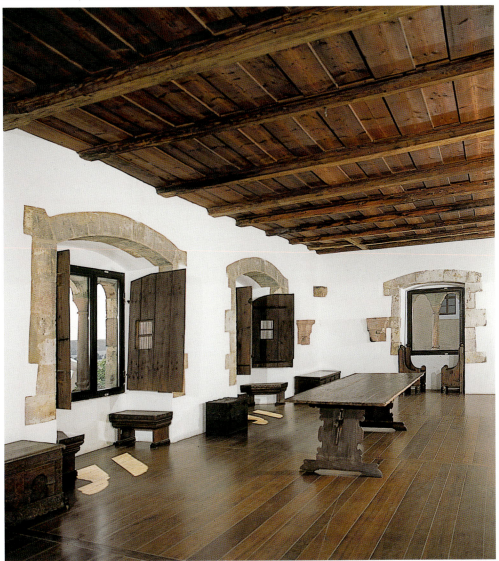

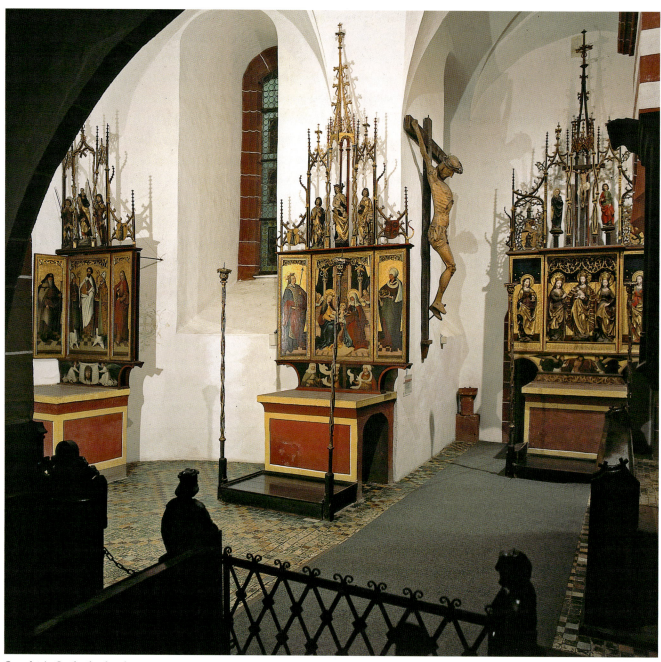

Gnandstein Castle, the chapel

The Castle Chapel

The late Gothic chapel was built at the end of the 15th century during conversions affecting large sections of the castle precincts. It was commissioned by Heinrich the Pious of Einsiedel (1435–1507). The ground plan was adapted to the fortifications of the lower castle to the north. The cell vaults and window jambs adhere closely to the architectural principles established by Arnold of Westphalia (d. 1482). With its fully preserved late Gothic fittings the chapel is a wonderful testimony to the religious practice of Saxon aristocrats in the years before the Reformation and its expression in interior design. A noteworthy example are the three winged altars from the Zwickau workshop of Peter Breuer (1472–1541). Other features that bring the period to life for us so directly are the decorative ceramic floor of yellow, brown and green glazed tiles (a very early specimen from the Kohren potteries) and the original oaken choir stalls with versatile carvings of branches and figures.

I. G.

SAXONY

Kriebstein Castle

The Kriebstein Room

The residential tower at Kriebstein Castle was built at the end of the 14th century. On the third floor there is an excellently preserved room of painted boards which has been dated 1423 by dendrochronology. This Kriebstein Room measures 3.0 m x 4.25 m and its wooden beam ceiling is richly decorated with arabesques. On the walls – including the tower's stout outer masonry – these forms are complemented by figures. One highlight is the scene depicting the Annunciation based on the Gospel of St Luke. The base zone has been painted to resemble curtains. We do not know who the artist was, but the style suggests this work was done just after the chapel had been painted. The room prob-

ably served as a private prayer room for the lords of the castle. As a piece of architectural history, it exemplifies the interaction between the exterior stonework of a tower and the timber carpentry which created the interior spaces, sometimes lavishly decorated. In the Modern age this room was used for storage and as an armoury. In 1902 the three painted timber walls were removed to the Museum of Decorative Arts in Dresden for conservation and public display and stayed there until 1997. The beam ceiling and the original wooden floor remained in the castle. In 1999 the Kriebstein Room was reinstated at its original site in Kriebstein Castle.

i Burg Kriebstein
D-09648 Kriebstein
Tel. (+49/0) 3 43 27/95 20
Fax (+49/0) 3 43 27/95 222
burg-kriebstein@t-online.de
www.burg-kriebstein.de

☉ May – October:
Tu–Fr 9 am–5 pm
Sa/Su/public holidays
10 am–5.30 pm
February – April/
November:
Tu–Su, public holidays
10 am–4 pm

✕ Burggaststätte

By car: motorway A4, exit at Hainichen towards Mittweida, exit towards Talsperre Kriebstein or Waldheim, castle signposted from Kriebethal

P below the castle

The Kriebstein Room in Kriebstein Castle, long timber wall with the Annunciation

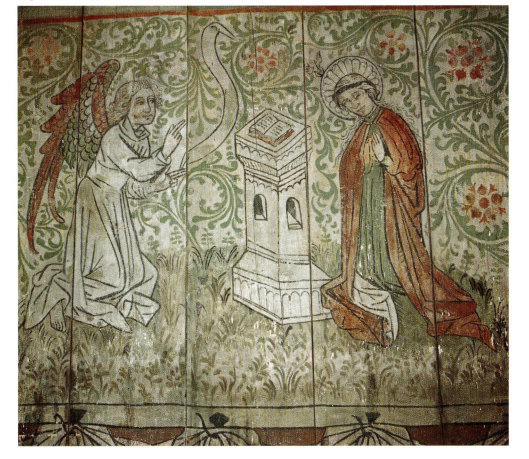

The Castle Chapel

Along with its counterpart in the Kriebstein Room, the wall art in the chapel at Kriebstein Castle ranks as a major example of late Gothic interior painting in Germany. They are impressive for the wealth of depiction, their self-contained harmony and their well preserved condition on all the wall and vault surfaces. The square room of almost 8 m x 8 m is spanned by four bays of shallow cross vaulting divided by transverse arches and supported at the centre by a plain square pillar. The walls were probably painted between 1400 and 1410. Their central theme is the adoration of the Virgin Mary. In addition to the symbols of Mary we find motifs from the Passion cycle and the Last Judgment and a number of saints. The 18 coats-of-arms in the spandrels were probably added in the last decade of the 15th century to display the genealogy of the castle's current owners, the Schleinitz family. The overall iconography thus combines late medieval religious ideas with aristocratic self-projection. The fact that it has survived is due to overpainting during the Renaissance and restoration efforts from the 1930s until recently. I. G.

Kriebstein Castle, the chapel

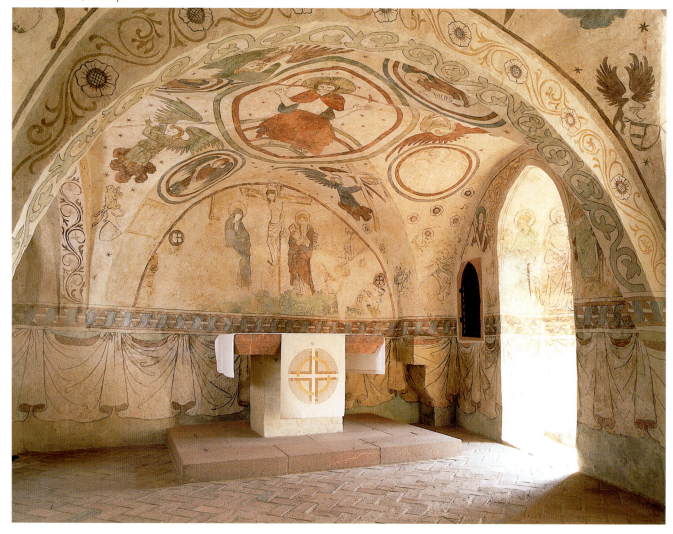

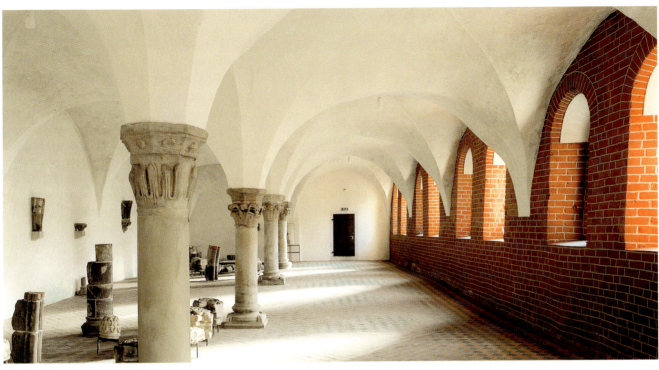

Altzella Abbey, the refectory in the laymen's house

Altzella Abbey
The Lay Refectory

The laymen's house in the former Cistercian Abbey at Altzella is the only building from the abbey period to have survived almost intact. It was presumably added on the west front of the abbey church, consecrated in 1198, during the first quarter of the 13th century. Much of the west wall of the refectory has been built with bricks in alternating red and white, the heraldic colours of the Cistercian Order, a graphic way of reminding travellers whose walls they were entering.

The double-aisle refectory on the ground floor measures approx. 28.5 m x 10 m and was used by the lay brothers. After the abbey was dissolved it then served for centuries as a cow byre, but its late Romanesque features have nonetheless been well preserved. The room is divided into five vaulted bays, with two round-arch windows in each to let in sunlight from the west. The vaults rest on four columns with "Attic" bases and sepal capitals. The floor was reconstructed from traces of the original and laid out in alternating red and black bricks. The overall impact of this hall-like interior reflects the cultivated architecture fostered by the Cistercians, with simple but convincingly expressive devices. Around the middle of the 15th century the monks began using the room as their own winter refectory.

I. G.

ℹ Kloster Altzella
D-01683 Nossen
Tel. (+49/0) 3 52 42 / 50 430
oder 50 450
Fax (+49/0) 3 52 42 / 50 433
info@schloss-nossen.de
www.kloster-altzella.de

☉ March – September:
Mo–Fr 10 am–5 pm
Sa/So, public holidays:
10 am–6 pm
October/November:
Mo–So: 10 am–4 pm
Closed December–February

By car: Motorway A4, exit at Siebenlehn towards Nossen, Abbey is signposted

🅿 within the Abbey

i Schloss Augustusburg
D-09573 Augustusburg
Tel. (+49/0) 3 72 91/38 00
Fax (+49/0) 3 72 91/38 024
augustusburg-schloss@
t-online.de
www.augustusburg-
schloss.de

☉ April – October:
9.30 am–6 pm
November – March:
10 am–5 pm

P Parking at the bottom of the
hill or to the southeast
opposite Wirtschaftshof

Schloss Augustusburg
Hares' Hall

When the elector built his new hunting lodge at Augustusburg (1568–1572) his court artist Heinrich Göding (1531–1606) took charge of an ambitious programme of painting. The pictorial cycles contained in the ornamental scrolls and mountings typical of the late Renaissance offer plenty of insights into the thinking and beliefs of the late 16th century. This is particularly evident in the House of Hares with its chain of motifs in which hares allegorically perform human activities. Elector August (1526–1586), for whom the construction was undertaken, is regarded as the author of these pictorial themes.

About a quarter of the paintings have been preserved, most of them in the room known as Hares' Hall. This is a topsy-turvy world, with hares slipping into public and clerical functions to carry out a wide variety of actions on trompe l'oeil portals, fireplaces and window frames. They sit in judgment, declare war on hunters or as the "seven swans" turn a great spear against a hare monster, this being the oldest known depiction of the story. The cycle – thought to be an allegorical rewrite of Elector August's conduct during the Grumbach Quarrels (1566/67) – ultimately results in the restoration of the old order. I. G.

Schloss Augustusburg, Hares' Hall

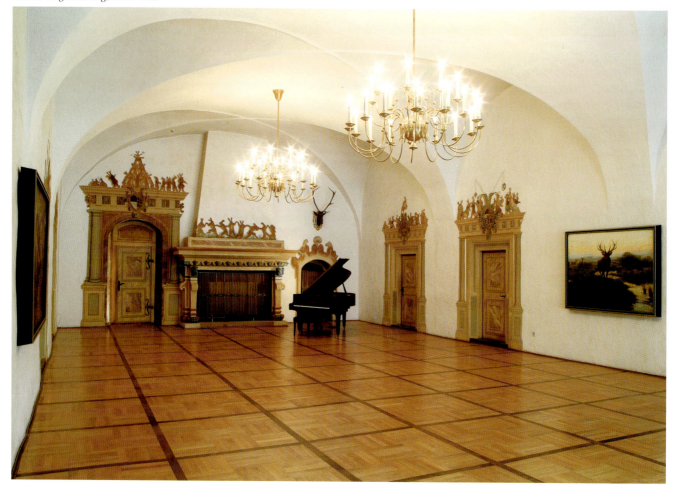

SAXONY

Albrechtsburg Meissen
The Great Hall of Court

Together with the Grand Salon, the Great Hall of Court on the first floor of the Albrechtsburg's north wing forms the stately centre of this palace begun in 1471. The two halls are linked by a passage which, in its upper part, contains a balcony-like recess known as the trumpeter's chair. The late Gothic interior designs exert a spatial effect of their own. The architecture alone can be regarded as a work of art, and the rooms feel like a huge sculpture.

The interiors were developed from the mid-19th century with their conservation in mind. They were redecorated in neo-Gothic style with ornamental surfaces and in the window niches quotations from courtly love songs. The dominant feature on the Great Hall of Court are the five wall paintings depicting scenes from the childhood and youth of the brothers who built the palace, the dukes Ernst (1441–1486) and Albrecht (1443–1500). The paintings by Ernst-Erwin Oehme (1831–1907) and Alfred Diethe (1836–1919), like the statues in front of the polychrome engaged pillars, were added in the 1870s. All in all the Great Hall of Court documents how a Gothic palace architecture has been overlaid in multiple ways by painting, sculpture and new ideas reflecting a romanticised, Historicist nostalgia for the history of Saxony and, in particular, the Wettin dynasty. S. Sch.

ℹ Albrechtsburg Meissen
Domplatz 1
D-01662 Meissen
Tel. (+49/0) 3521/47070
Fax (+49/0) 3521/470711
info@albrechtsburg-meissen.de
www.albrechtsburg-meissen.de

☉ March – October:
10 am–6 pm
November – February:
10 am–5 pm
Closed: 24/25,
31 December,
10–31 January

✖ Schlosscafé, open
April – October
except Mo, Tu

Ⓢ Meißen Triebischtal

The Albrechtsburg in Meissen, Great Hall of Court

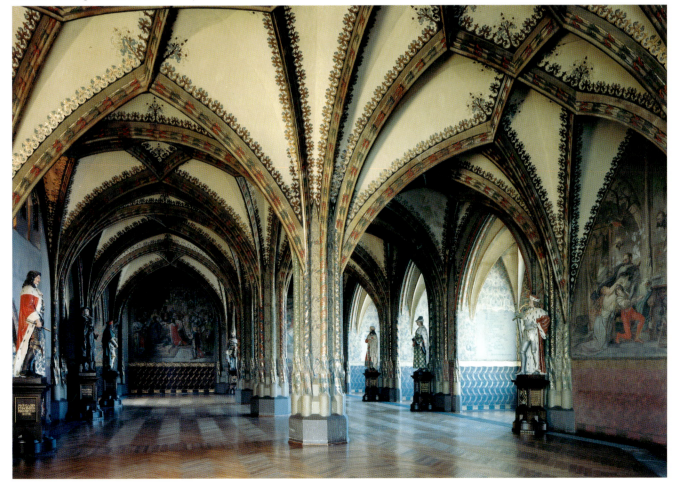

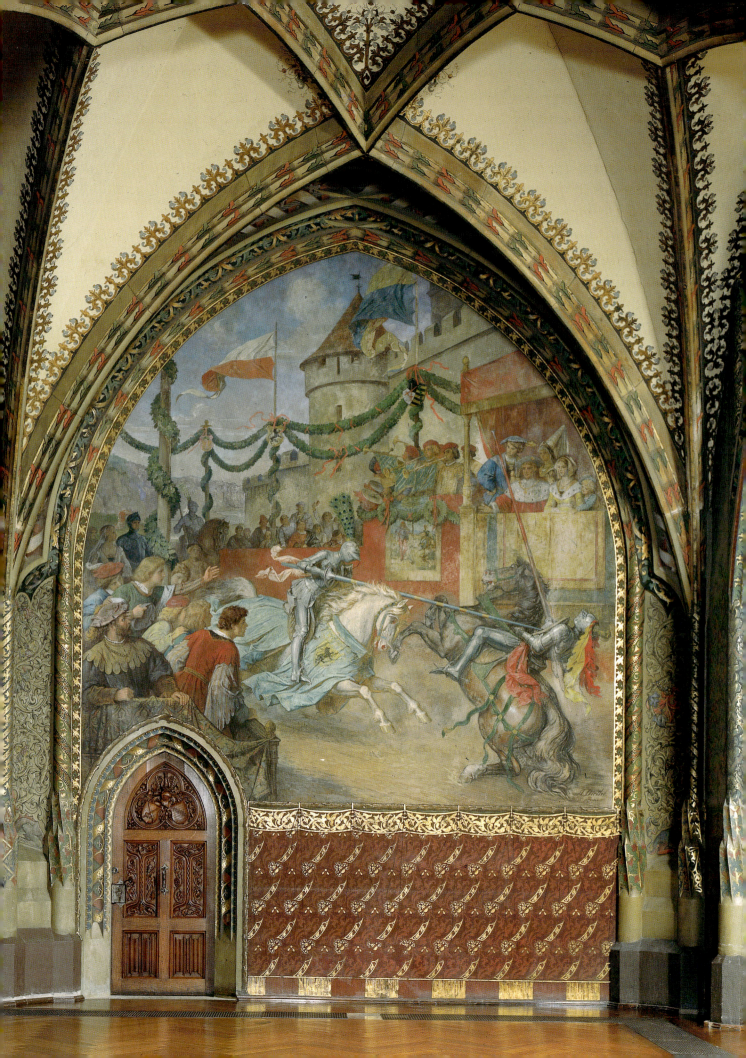

Schloss Weesenstein
The Chinese Salon

The Chinese Salon with its panoramic wallpaper on all sides played a pivotal role in the living quarters on the upper storey of the Village Wing at Schloss Weesenstein. It was entered from the adjacent apartments of Prince Johann of Saxony (1801–1873, king from 1854) and Queen Amalie (1822–1877). The royal couple came to this private palace to focus on family life. When the House of Wettin acquired this palace in 1830 the room was already papered with the Chinese Procession, purchased by the previous owner, Johann Jacob von Uckermann the Younger (1763–1836), after these rooms were damaged in the Napoleonic Wars. The wallpaper was probably made by Dufour in Paris around 1818 and printed in ten tones of sepia. In all likelihood the design was based on drawings by William Alexander (1767–1816), who travelled in China. The panorama depicts a historical landscape with exotic components and endowed this room with the dignity of a ceremonial setting.

S. Sch.

Schloss Weesenstein, Chinese Salon, a detail from the trading scene in the Chinese Procession

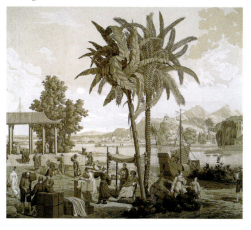

ℹ Schloss Weesenstein
Am Schlossberg 1
D-01809 Müglitztal
Tel. (+49/0) 3 50 27/62 60
Fax (+49/0) 3 50 27/6 26 28
info@schloss-
weesenstein.de
www.schloss-
weesenstein.de

🕑 open daily
November – March:
10 am–5 pm
April – October: 9 am–6 pm

✕ „Königliche Schlossküche"
Schlosscafé
Weesensteiner
Schlossbrauerei

By car: motorway A17

DB Branch line Müglitztalbahn,
regional service
Heidenau-Altenberg to
Weesenstein

🚌 VVS bus 201 Heidenau-
Glashütte to Gemeindeamt
Weesenstein

🅿 Car and coach parks

Schloss Weesenstein, Chinese Salon

*Opposite page:
Albrechtsburg in Meissen,
Great Hall of Court, Albrecht the
Brave's first jousting tournament
in Pirna, wall painting by Alfred
Diethe*

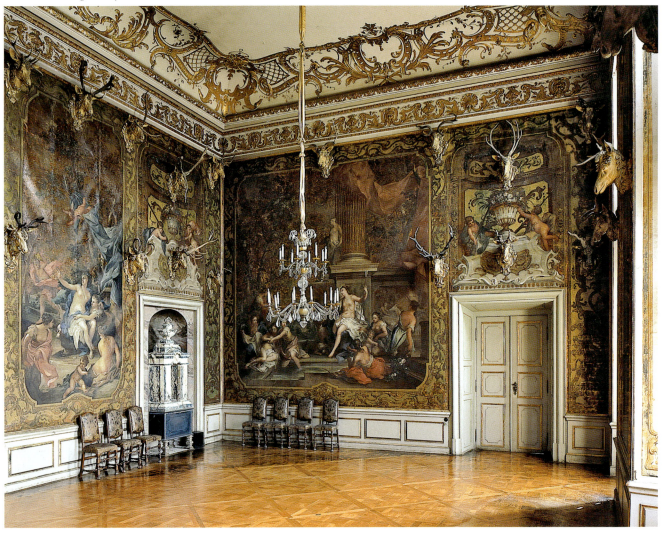

i Schloss Moritzburg
D-01468 Moritzburg
Tel. (+49/0) 3 52 07 / 8 73-10
Fax (+49/0) 3 52 07 / 8 73-11
schloss.moritzburg@
lff.smf.sachsen.de
www.schloss-moritzburg.de

🕐 April – October:
daily 10 am–5.30 pm
November, December
and March:
Tu–Su 10 am–4 pm
January / February:
restricted opening times

Schloss Moritzburg

Hall of Monstrosities

The Hall of Monstrosities was furbished around 1730 when the Renaissance hunting lodge was undergoing conversion into a royal hunting lodge and summer pavilion for August the Strong. The strange name given to this hall of audience derives from the deformed antlers on display here. The 66-point specimen gained particular fame as a hunting trophy belonging to King Friedrich I of Prussia. In fact the interior acquired its character rather more from the monumental oil paintings on leather-clad frames which extend the full height of the wall. In keeping with the building's function, they show scenes from the life of Diana, the goddess of hunting, based on Ovid's Metamorphoses, although here Diana is depicted as a protector of animals and guardian of chastity. In this respect the iconography offers a code of conduct. The paintings were done by the Venetian Lorenzo Rossi. An upper border is created by a gilt cornice with rich stucco work over a ribbon of palmetto and mascaron. The groove below the ceiling has been worked in stucco with gilt Régence-style ornamentation. The ensemble created by the walls, ceiling and furnishings distinguish this room as a notable baroque work of art.

Schloss Moritzburg, Hall of Monstrosities

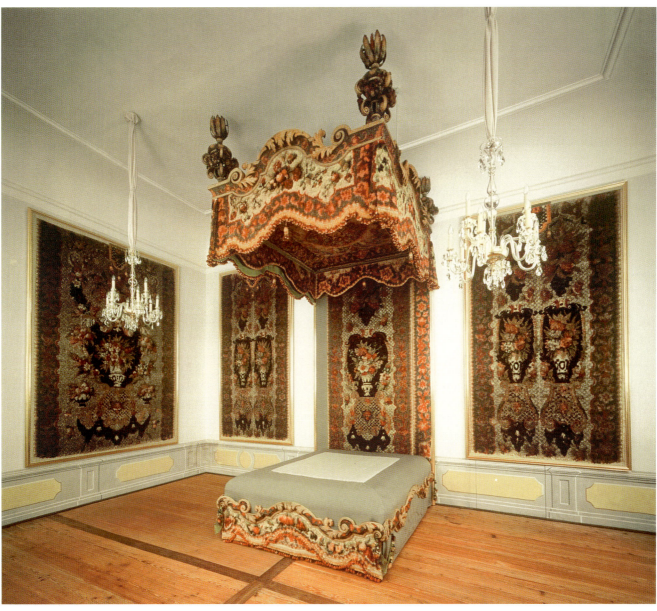

Schloss Moritzburg, August the Strong's Feather Room

The Feather Room

The central feature of the Feather Room is a ceremonial bed made in London in 1720 using a feathered material invented by Monsieur le Normand-Cany. Over a million feathers went into its making, contributing greatly to the novel impact of its exotic colour, brilliance and softness. The bed itself is of French inspiration, based on designs by Daniel Marot. In 1723 this ceremonial bed was listed in the inventory of the Japanese Palace as a complete interior decoration. August the Strong had the curtains around it removed and used instead as wall coverings to create a ceremonial bedroom for his Porcelain Palace. Since 1830 the Feather Room has been at Schloss Moritzburg, where it was showcased after meticulous restoration. One might say that a work of art made for a room became a room that was a work of art, an act reflected in August the Strong's radical transformation of a ceremonial bed per se into a ceremonial bed with a matching interior. D. W.

✕ Schlossrestaurant in the Schloss

By car: A13 (exit Radeberg), A4 (exit Dresden / Wilder Mann)

🅱 Dresden Neustadt, then bus to Schloss Moritzburg

🚃 Historical narrow-gauge railway from Radebeul-Ost to Moritzburg

🅿 in front of the Schloss

ℹ Schloss Pillnitz
D-01326 Dresden
Tel. (+49/0) 3 51/2 61 32 60
Fax (+49/0) 3 51/2 61 32 80
info-pillnitz@schloesser-
dresden.de
www.schloesser-dresden.de

🕐 November – December
10 am–4 pm
February – March
9 am–5 pm
April – October 8 am–8 pm

✗ Several restaurants near the
Schloss

By car: A13 or A4 (exit
Dresden-Hellerau)

🚌 ⛴ Bus 83, ship

🅿 in front of the Schloss

Pillnitz Palace and Park

The Chinese Pavilion

When Christian Friedrich Schuricht built the Chinese Pavilion in 1804 he came closer than most to implementing authentic Chinese principles in his architecture. He took guidance from drawings by William Chambers in his book "Designs of Chinese Buildings" (1757). But although Schuricht was familiar with these plans, it was only by recourse to illusionist painting for the pavilion interior that he managed to implement the fundamental Chinese idea that walls have no supporting function. The walls here vanish under large painted windows with views of eight actual landscapes. They are believed to be the work of Johann Ludwig Giesel and based on drawings by William Alexander, dispatched by King George III of England on a diplomatic mission to the Imperial Court of China (1792–1793). The use of these visual records reinforces Schuricht's desire for authenticity. From around 1839 the pavilion was used for meetings of the learned Academia Dantesca, led by Prince Johann of Saxony, where writer Ludwig Tieck would read from Johann's translation of Dante Alighieri's "Divine Comedy".

The English Pavilion

Inspired by Bramante's Tempietto in the monastery of San Pietro at Montorio in Rome and by later temple designs by William Chambers, Johann Daniel Schade built the English Pavilion in 1780 as a monument to Elector Friedrich August III. The iconography of the neo-classical wall design is a manifesto dedicated to the elector as a connoisseur and patron of Ancient and contemporary art and science. The focal theme on the ground floor is the relationship between sacrifice and the veneration of art. Johann Gottlob Matthiä shows in bas-relief how patronage of the building is bestowed in ideal fashion upon Apollo, god of the arts and doyen of the Muses, Diana and the Muses Clio and Urania, with sacrificial priests in attendance. The upper floor defines the pavilion as a studiolo. The caterpillars,

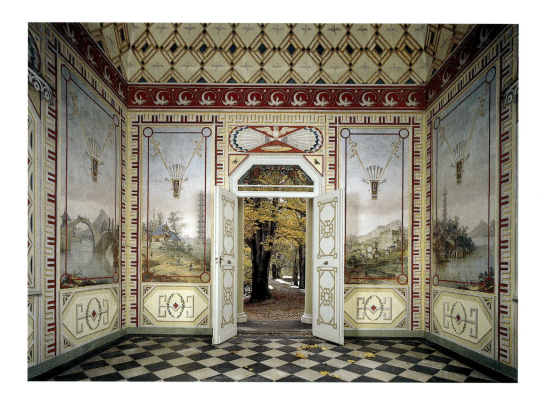

*Schloss Pillnitz,
Chinese Pavilion*

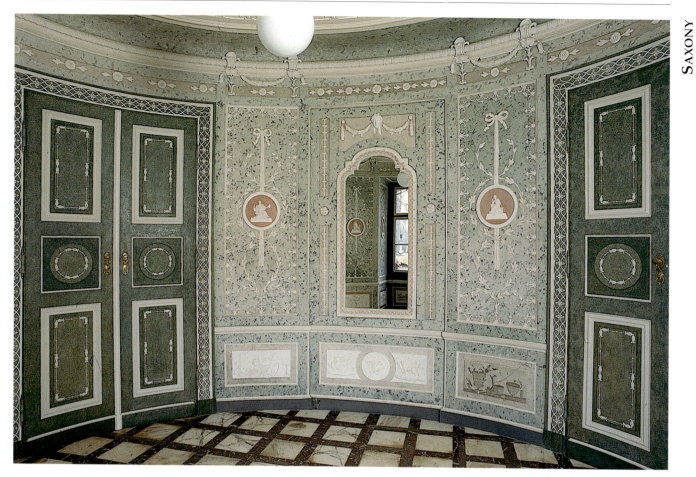

Schloss Pillnitz, English Pavilion

pupae and butterflies on the wooden panelling have been painted with the precision of natural science using illustrations from the collection of August Johann Roesel von Rosenhof. The artist was court painter Jacob Friedrich.

The Catholic Chapel

The New Palace was built between 1818 and 1830 after a fire at Pillnitz. The project was headed by Christian Friedrich Schuricht. The north wing of the palace embraced the Catholic chapel, a simple neo-classical room dominated by a cycle depicting the Virgin Mary painted between 1826 and 1829 by court artist Carl Christian Vogel von Vogelstein. The cycle indicates Vogel's efforts to reinforce religion by means of art. In typical Nazarene fashion Vogel endows his figures with force and confidence in that form is a pure expression of soul and the choice of colour is governed by symbolic and emotional values. This orientation towards late medieval and early Renais-sance prototypes results in the sentimental idealisation characteristic of a popular narrative visual idiom. The altar in the form of a sarcophagus with its painting of Mary as the Lady of Mercy, the wooden pulpit and the Jehmlich organ are all part of the original furniture. D. W.

Schloss Pillnitz, Catholic chapel, the Crowning of Mary

STAATLICHE SCHLÖSSER, BURGEN UND GÄRTEN SACHSEN

i Barockschloss Rammenau
Am Schloss
D-01877 Rammenau
Tel. (+49/0) 35 94/70 35 59
Fax (+49/0) 35 94/70 59 83
info@barockschloss-
rammenau.com
www.barockschloss-
rammenau.com

🕐 Summer season:
daily 10 am–6 pm
Winter season:
Sun–Fr 10 am–4 pm,
Sat: 12 noon–4 pm

✖ Several restaurants near the
Schloss

By car: A4 (exit Burkau),
B6 (via Bischofswerda)

P in front of the Schloss

The Baroque Palace
The Bulgarian Room

The baroque country mansion at Rammenau was built in the 1720s. Nobody quite knows how the Bulgarian Room acquired its traditional name, but it adds an unusual interior highlight. It was probably painted around 1830 under the influence of the Pompeian fashion. As a salon on the bel étage it was one of the grandest rooms in the palace. Its iconography was inspired by finds of Ancient paintings in Pompey, available to local artists in the form of various copper engravings.
In Rammenau the entire storey has fallen under this influence, although a peculiarity of the house has also set its stamp.

Alongside the modules copied with great attention to detail from the engravings, the paintings have incorporated the botanical knowledge of the palace's owner and commissioner of these works. Johann Centurius, Count of Hoffmannsegg, published "Flora Portugaise", a standard botanical reference work, and was probably behind the illustrations of plants, which can be readily identified and seem to have been prepared for the task.

D. W.

The Bulgarian Room in the baroque palace at Rammenau

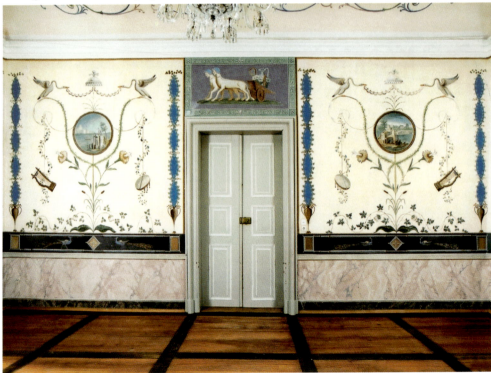

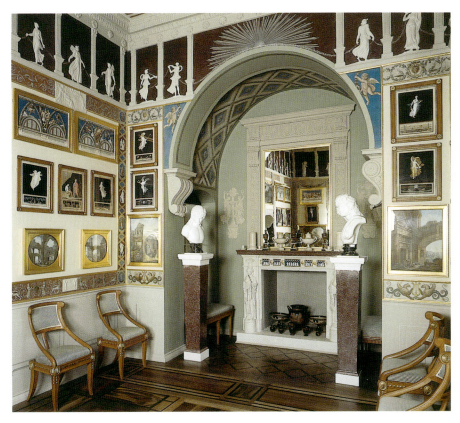

Saxony-Anhalt

Stiftung Dome und Schlösser
in Sachsen-Anhalt

**FOUNDATION FOR CATHEDRALS
AND STATELY HOMES IN SAXONY-ANHALT**

**KULTURSTIFTUNG
DESSAUWÖRLITZ**

**CULTURAL FOUNDATION
OF DESSAUWÖRLITZ**

STIFTUNG DOME UND SCHLÖSSER IN SACHSEN-ANHALT

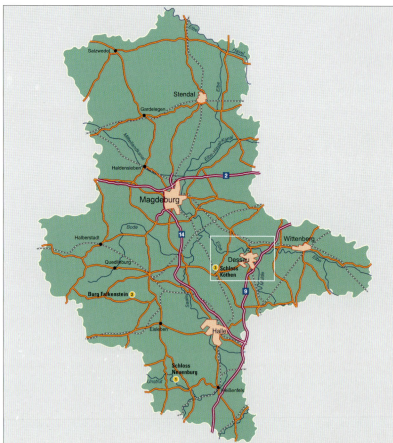

Selected sites managed by Stiftung Dome und Schlösser in Sachsen-Anhalt

 1 Schloss Neuenburg (p. 215)

 2 Burg Falkenstein (p. 216)

 3 Schloss Köthen (p. 217)

For information about other sites managed by Stiftung Dome und Schlösser in Sachsen-Anhalt, see www.dome-schloesser.de

The Garden Realm of DessauWörlitz

Dessau
 4 Schloss Oranienbaum (pp. 218–219)
 5 Schloss Mosigkau (pp. 220–221)

Wörlitz
 6 Schloss Wörlitz (pp. 222–223)
 7 Gothic House (pp. 224–225)
 8 Villa Hamilton (p. 226)
 9 Luisium (pp. 227–228)

For information about other sites managed by Kulturstiftung DessauWörlitz, see www.ksdw.de

KULTURSTIFTUNG DESSAUWÖRLITZ

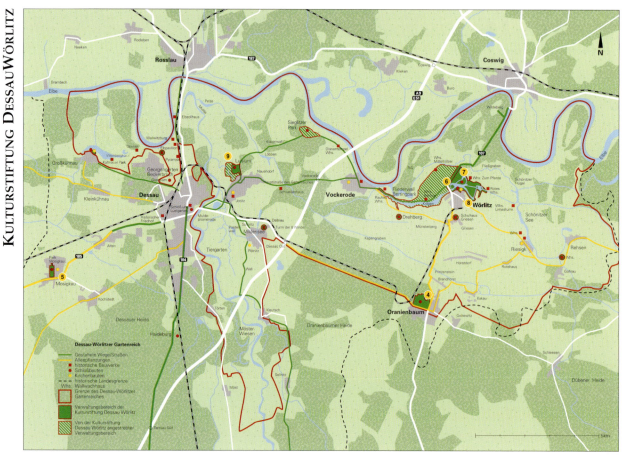

◁ *Villa Hamilton, the Fireplace Room*

Schloss Neuenburg
The Double Chapel

SAXONY-ANHALT

"The double chapel in the palace [...] at Freyburg on the Unstrut is outstanding less on account of its size than its artistic perfection. The capitals on the middle cluster of columns in the upper chapel and those of the corresponding wall columns and vault-bearing shafts are, with regard to their aesthetic and technical configuration, possibly the most perfect achievement we have among all our medieval ornamentation."

Ferdinand von Quast, 1852

The very first phase of construction (c. 1090–1150) included a single-storey hall church. When the complex was extended from around 1170 – as the landgraves of Thuringia were expanding their considerable dynastic power – it was raised to create a double chapel and integrated into the wing containing the Great Hall that was erected at this time. It was not until the first quarter of the 13th century that the chapel acquired its definitive and impressively artistic high medieval interior. In the reign of Landgrave Ludwig IV and his wife St Elizabeth, alterations were made to the two bays and three aisles under the vaults. The upper chapel then acquired its distinctive present form with a richly decorated central pier and serrated transverse arches.

Following restoration in the mid-19th century and again in 1990/92 the chapel remains the most artistic room in the castle.

J. P.

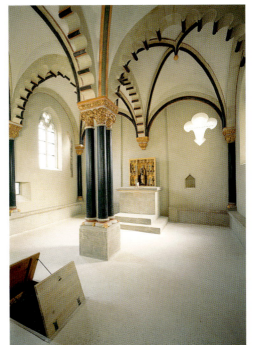

Schloss Neuenburg, the upper chapel

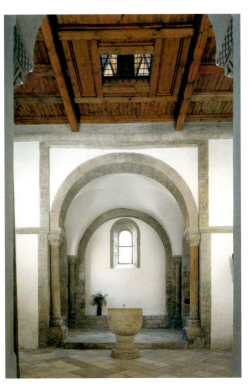

Schloss Neuenburg, the lower chapel

ℹ Museum Schloss
Neuenburg
Schloss 01
D-06632 Freyburg/Unstrut
Tel. (+49/0) 3 44 64/3 55 30
Fax (+49/0) 3 44 64/3 55 55
www.schloss-neuenburg.de
neuenburg@dome-
schloesser.de

☉ Tu–Su 10 am–6 pm
(April – October)
Tu–Su 10 am–5 pm
(November – March)
Last admission half an hour
before closing.
Closed on Mondays.
The keep (Fat William)
is open for viewing in
April – October.

� The museum has a café
(Alte Remise) and restau-
rant (Küchenmeisterey)
Tel. (+49/0) 34464/66200
and (+49/0) 34383/44664
www.heureka-gastro.de

🅿 Visitors' car park at
Berghotel Edelacker (5 min.
on foot from the castle)

DB Any Deutsche Bahn service
to Naumburg/Saale Hbf.,
then take the Burgenland
branch line to
Freyburg/Unstrut

STIFTUNG DOME UND SCHLÖSSER IN SACHSEN-ANHALT

i Museum Burg Falkenstein
D-06543 Falkenstein/Harz
OT Pansfelde
Tel. (+49/0) 3 47 43/5 35 59-0
Fax (+49/0) 3 47 43/
5 35 59-20
www.burg-falkenstein-
harz.de
falkenstein@dome-
schloesser.de

⊙ Tu–Su 10 am–6 pm
(April – October)
Tu–Su 10 am–4.30 pm
(November – March)
Last admission half an hour
before closing.
Closed all year on Mondays
(except on public holidays)
and on 24 December.

✕ Museum restaurant
(Krummes Tor)
Opening times as for
Museum Burg Falkenstein

🅿 by the Gartenhaus (25 min.
on foot)

Horse drawn coaches and
miniature railway available

Special attraction:
"Falkenhof" with hawk
displays during the season

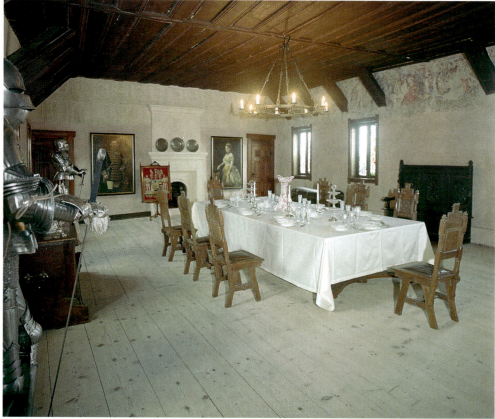

Burg Falkenstein, the Knights' Hall after its restoration in 1999/2000

Burg Falkenstein
The Knights' Hall

The Knights' Hall occupied the whole second floor of the castle's south wing, built around 1491. It was first mentioned in 1586 as the "new hall". The oldest surviving features originated around then: the stucco work on the end walls is dated around 1575 and the beam ceiling does not seem much older.

Around 1840 Count Ludwig I of Asseburg-Falkenstein, master of the Prussian hunt, commissioned a grander interior for hunting excursions and receptions. Architect F.A. Stüler obliged with a neo-Gothic appointment, but it was removed in 1925 as tastes had changed. Colourful ornamentation was added in part to the beams and a frieze was incorporated, at least on the south side, with motifs from the hunt and courtly love songs. The paint applied in the 1950s was a more sober affair, with whitewashed walls and dark wood varnish. Today this hunting and banqueting hall seeks to illustrate and preserve the various construction periods of former centuries.

J. S.

Burg Falkenstein, the Knights' Hall, postcard of around 1925

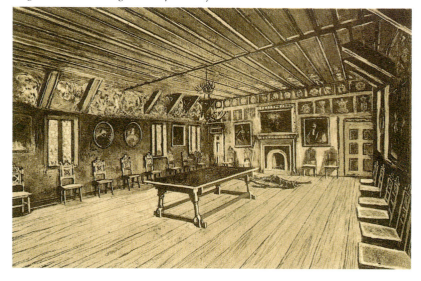

Schloss Köthen
The Hall of Mirrors

It was the Niuron brothers who built Ludwig's Wing around 1600, but the Hall of Mirrors on the second floor is the work of architect Gottfried Bandhauer (1790–1837). He had been appointed in 1820 to convert and extend the palace at Köthen, and in 1822 he redesigned the throne room, originally known as the Great Hall, in neo-classical style.

The walls are structured by sturdy pilasters that support the bulky entablature and provide frames for alternating mirrors, doors and windows. There is a particular elegance to the low barrel vaults with richly adorned stucco coffering, intersected in the middle of the room by a transverse barrel.

The Hall of Mirrors was, until the conversions in 1617, the venue for meetings of the "Fruitful Society". Johann Sebastian Bach made music here from 1717 to 1723. Today it combines with the chapel to provide a worthy framework for the internationally renowned Bach Festival and Bach competitions which are held here in Köthen. K. T.

Schloss Köthen, Hall of Mirrors

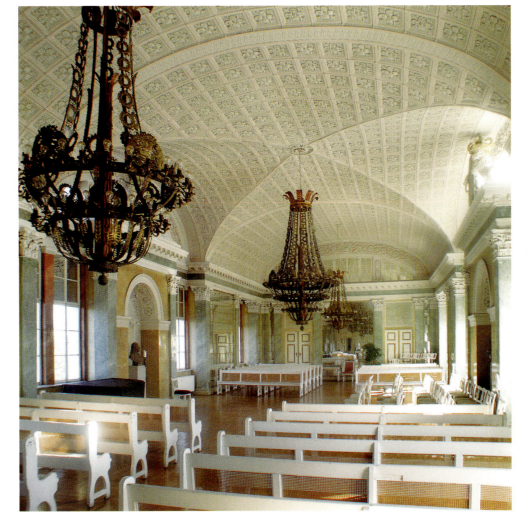

ℹ Historical Museum of Mittelanhalt and Bach-Gedenkstätte
Schlossplatz 4
D-06366 Köthen
Tel. (+49/0) 3496/21 25 46
Fax (+49/0) 3496/21 40 68
www.dome-schloesser.de
leitzkau@dome-schloesser.de

🅰 Naumann Museum Köthen
Address as above
Tel. (+49/0) 3496/21 20 74
Fax (+49/0) 3496/30 38 68

🕙 Opening times for all museums:
Tu–Sa 1–5 pm
Su 10 am–1 pm
and 2–5 pm
Closed all year on Mondays, and on 24/25 and 31 December, 1 January and Ascension Day

✈ in Köthen town

🅿 in Köthen town

DB Scheduled services to Köthen

KULTURSTIFTUNG DESSAUWÖRLITZ

i Kulturstiftung
DessauWörlitz
Schloss Großkühnau
D-06846 Dessau
Tel. (+49/0) 3 40 / 6 46 15-0
Fax (+49/0) 3 40 / 6 46 15-10
www.gartenreich.com
ksdw@ksdw.de

Schloss Oranienbaum
D-06785 Oranienbaum
Tel. / Fax (+49/0) 3 49 04 /
2 02 59

The Garden Realm of Dessau-Wörlitz

The Garden Realm of Dessau-Wörlitz, honoured in 2000 with the status of a UNESCO World Heritage site, was the result of a sweeping reform programme undertaken by Leopold III Friedrich Franz of Anhalt-Dessau (1740–1817) in the spirit of the Enlightenment. The underlying idea of a state pervaded by a universal humanist philosophy, which was guided by English experiments and informed by Ancient principles, not only embraced every aspect of civilisation and culture in the tiny model principality, but also set its stamp on large areas of the landscape. 142 sq. km., about a quarter of the land earmarked by Franz for his "scenic improvements", remain today. Its landmarks consist of pavilions, country houses, churches, temples, sentry houses, artificial ruins and much else besides, altogether far more than a hundred monuments. Undivided admiration for the prince's efforts, unmarred by ideological differences, has ensured the preservation of these buildings and their interiors. Some 70 rooms in palaces and other structures have retained about 90 per cent of their original substance.

Schloss Oranienbaum

The palace (like the town built at the same time on a symmetrical plan) was commissioned by Henriette Catharina of Oranien-Nassau (1637–1708), the wife of the Anhaltine prince Johann Georg II. She inherited tremendous wealth in the form

Schloss Oranienbaum, the Leather Tapestry Room, photograph of 1927

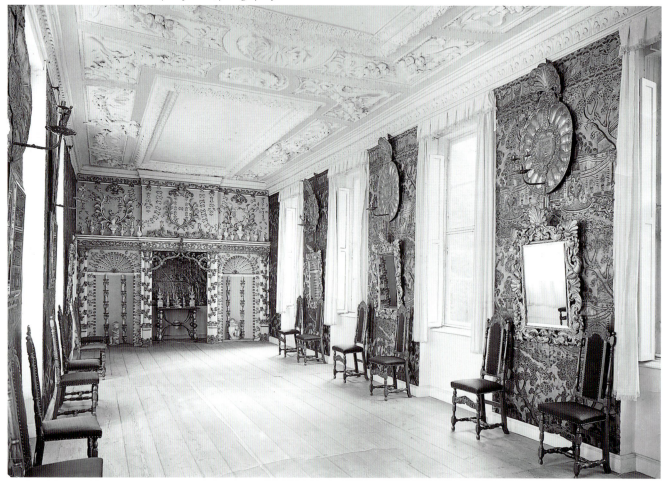

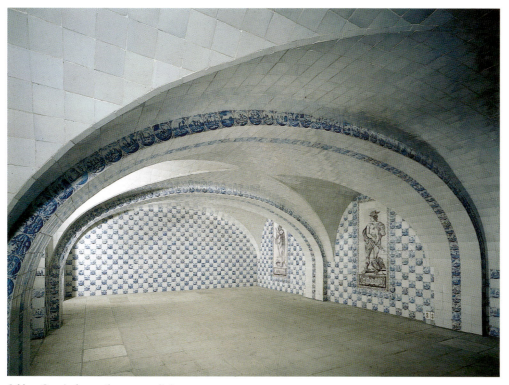

Schloss Oranienbaum, the summer dining room

April and October:
Sa, Su, public holidays
10 am–5 pm
May–September:
Tu–Su 10 am–6 pm
Open Easter Monday and
Whit Monday.
Guided tours outside
normal hours by prior
arrangement.

Subject to change

Pagoda in Anglo-Chinese
Garden, Oranienbaum

May–September
Su 2–4 pm and by prior
arrangement

Subject to change!

P in front of the Schloss

of art works and the products of various decorative crafts, and these supplied the truly regal furnishings for this country house built for her from 1683 by the Dutch architect Cornelis Ryckwaert. Today two rooms in particular demonstrate this luxurious baroque splendour. Franz integrated Schloss Oranienbaum into the Garden Realm as a baroque component. He only used it for occasional hunting trips, and about 90 years after its original construction he had several rooms refurbished in line with the fashion for chinoiserie, drawing on illustrations by Sir William Chambers, an English traveller in China.

The Leather Tapestry Room

The Leather Tapestry Room, in the north wing annexed to the corps de logis, is currently undergoing restoration. By 2006 it should look something like the situation recorded in 1927 on the photograph shown here. It was used entirely for offi-

cial functions with its powerful stucco ceiling ascribed to Giovanni Simonetti, its largely preserved Dutch leather tapestries and its woodwork inlaid with faience and finished in pale blue. Rather like its southern counterpart, which housed treasures of crystal, this room was an appropriate setting for the display of valuable collector's items.

The Summer Dining Room

In the warmer months this basement room with three cross-ribbed vaults and two transverse arches provided a cool place to eat. Its Dutch character derives from the lining of several hundred Dutch tiles, about half of them with pictorial motifs – mostly Biblical scenes but also children playing. The seven tile tableaux are a highly unusual feature. Two of them, in door jambs, depict vases of flowers, and the other five are devoted to the gods of the planets.

W. S.

*Schloss Oranienbaum,
leather tapestry sequence*

KULTURSTIFTUNG DESSAUWÖRLITZ

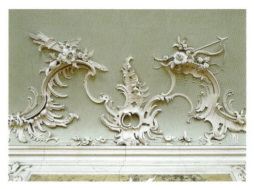

ℹ Kulturstiftung
DessauWörlitz
Schloss Großkühnau
D-06846 Dessau
Tel. (+49/0) 3 40 / 6 46 15-0
Fax (+49/0) 3 40 / 6 46 15-10
www.gartenreich.com
ksdw@ksdw.de

ℹ Schloss Mosigkau
Knobelsdorffallee
D-06847 Dessau
Tel./Fax (+49/0) 3 40 /
52 11 39

Viewing restricted to
guided tours.
Final tour begins approx. 1
hour before closing.

🕒 April – October:
Tu–Su 10 am–5 pm
May – September:
Tu–Su 10 am–6 pm
Open Easter Monday and
Whit Monday.
Guided tours outside
normal hours by prior
arrangement.

Subject to change!

🅿 in the vicinity

Schloss Mosigkau

Schloss Mosigkau is near Dessau, about eight kilometres west of the town centre. Its unmarried mistress was Princess Anna Wilhelmine of Anhalt Dessau (1715–1780), granddaughter of Henriette Catharina and the aunt of Prince Franz. Its affectionate nickname – "little Sanssouci" – is not inappropriate. True, the buildings and gardens created here in the heyday of German rococo cannot match the luxurious splendour of the more or less contemporary Friderician architecture in Potsdam, yet there is an incomparable appeal to their rustic charm and light elegance.

The Garden Room

The heart of this complex is the richly decorated Garden (or Gallery) Room, preserved almost as it was made with its wealth of paintings, in the corps de logis. This "picture gallery" was the focus of the rooms of state overlooking the pleasure garden and it contains works of major sig-

Schloss Mosigkau, ceiling stucco work in the Garden Room

nificance. Many were painted by well-known 17th-century Dutch and Flemish masters. They are part of the valuable estate of Orange (Oranien) in Dessau-Wörlitz. The collection acquired outstanding paintings by dint of their first-class origins, and they include the portrait of Wilhelm II of Oranien-Nassau painted when he was six by Anton van Dyck and the allegories with Flora and Zephyr that were the joint work of Jan Brueghel the

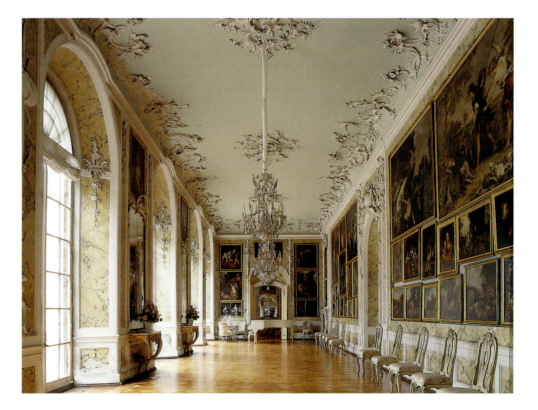

*Schloss Mosigkau,
the Garden Room*

Elder and Peter Paul Rubens. The way the paintings have been hung – large sections just as they were originally – is itself a valuable exhibit, as it is unique in Germany. Arranged edge to edge in recesses, they are the crowning glory of an artistic interior rich in rococo stucco work and stuccolustro.

The English Ladies' Chamber

If we now pass through the Yellow and Silver Cabinet, an enchanting rococoesque side room leading off the gallery, we enter the English Ladies' Chamber in the south-west corner of the building. This room still feels entirely baroque with its unpainted and unornamented wooden panelling up to the ceiling. It was primarily used for private purposes. This warm background delightfully sets off a Gallery of Beauty in twelve parts, each with a gilt baroque frame, depicting ladies at the English court. This, too, belonged to the Orange estate. The cycle is based on originals by Anton van Dyck and was implemented by one of his workshop assistants.

W. S.

Schloss Mosigkau, the Garden Room, Allegory with Flora and Zephyr by Jan Brueghel the Elder and Peter Paul Rubens

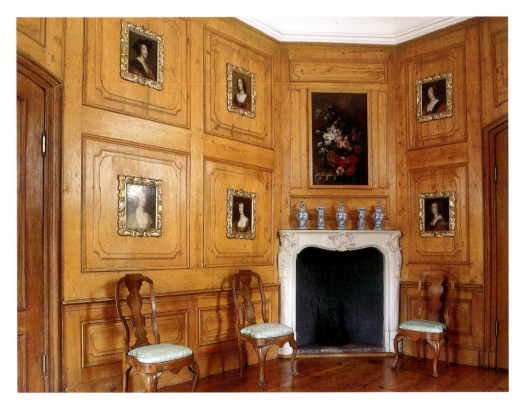

Schloss Mosigkau, the English Ladies' Chamber

KULTURSTIFTUNG DESSAUWÖRLITZ

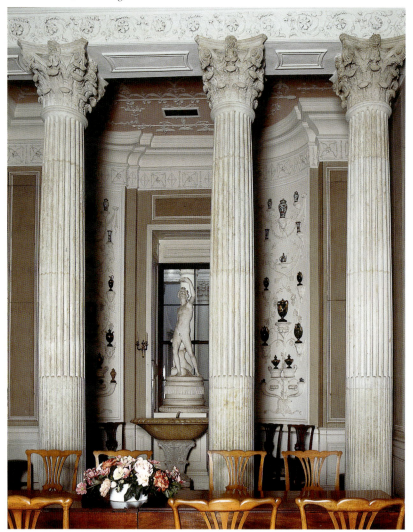

ℹ Kulturstiftung
DessauWörlitz
Schloss Großkühnau
D-06846 Dessau
Tel. (+49/0) 3 40/6 46 15 41
Fax (+49/0) 3 40/6 46 15 10
www.gartenreich.com
ksdw@ksdw.de

ℹ Schloss Wörlitz
D-06786 Wörlitz
Tel. (+49/0) 3 49 05/4 09-0
Fax (+49/0) 3 49 05/4 09-30

Viewing restricted to
guided tours.
Final tour begins approx.
1 hour before closing.

Schloss Wörlitz

The "country house" in Wörlitz Park, created between 1769 and 1773 by Prince Franz and his like-minded and widely educated friend, the architect Friedrich Wilhelm von Erdmannsdorff, is the artistic culmination of the Garden Realm of Dessau-Wörlitz. This building can be regarded as the foundation stone of neoclassicism in Germany and it was received enthusiastically by contemporaries. Even from the outside, its references to Antiquity and to the Palladian mansions of England were a radical break with the late baroque architecture that still prevailed. The four-pillared Corinthian porch in front with steps up to the main entrance is especially reminiscent of an Ancient temple. The unusual domed circular entrance hall, the first of many ground-floor rooms still exhibiting their original furbishing, sets the tone for the classical spirit of the interior with numerous casts of Ancient statues.

The Dining Room

The tour takes visitors around an atrium also inspired by classical architecture. After two rooms appointed in the mock Chinese fashion we reach the dining room. Here, where guests usually spent most hours, the prince confidently displayed portraits of his family, his wife and himself. He could look back with pride on a long dynastic history and some dignified and celebrated ancestors. Simple folding tables with the "Prince Franz chairs" designed by Erdmannsdorff were arranged in front of four fluted Corinthian columns. Apart from echoing the porch motif as a symbol of governance, they correspond through a window with the columns in the atrium. The two fireplaces and many wall consoles support precious vases of Antique style from the Wedgwood manufactory in England.

The Grand Hall

The two cabinet rooms which follow revive memories of Italian journeys with a variety of canvas and ceiling paintings, marble statues, vases and little bronzes, hoping to convey something of the experience to visitors. They lead to the Grand Hall, the biggest and stateliest room in the house. This lavishly appointed room is two storeys high. Its crowning glory are the paintings based on frescos by Annibale and Lodovico Carracci in the Galleria Farnese in Rome. Most of these scenes from mythology address the relationship between humans and gods. This may have been a reference to the source of the Prince's inspiration and the role in which he saw himself as a governor.

Schloss Wörlitz, the Dining Room

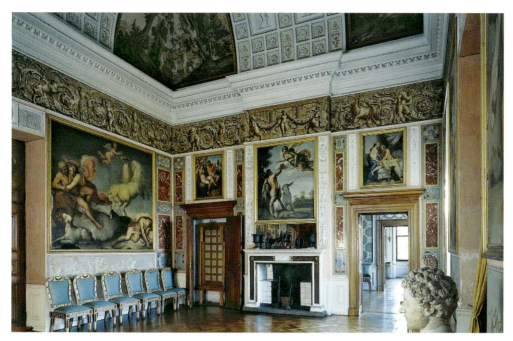

⊙ April and October:
Tu–Su 10 am–5 pm
May–September:
Tu–Su 10 am–6 pm
Open Easter Monday and
Whit Monday.
Guided tours outside
normal hours by prior
arrangement.

Subject to change

🅿 public car park on the edge
of the park

Schloss Wörlitz, the Grand Hall

The Princess's Cabinet

After two more rooms we enter the Princess's Cabinet, a little ante-chamber to her bedroom. This interior is once again so ornately decorated that it is hard to believe it functioned merely as a dressing room. The Pompeian motifs so recurrent within this building, the delightful pastel drawing of Venus by Francesco Pavona, the four Italian landscapes by P.J.C. Volaire, and above all the exquisite set of furniture from the workshop of David and Abraham Roentgen seem better suited to demonstrating the broadly educated and select taste of the prince and his advisor.

W. S.

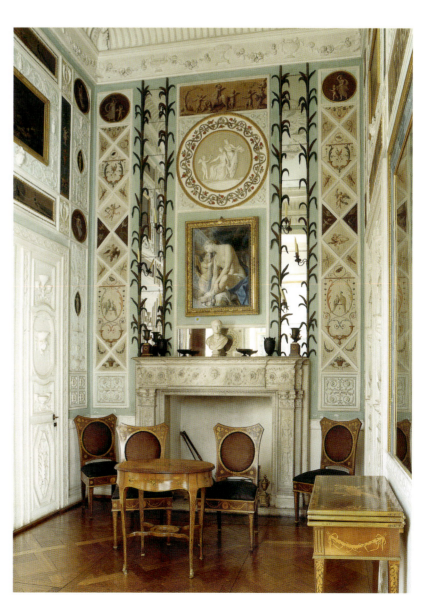

Schloss Wörlitz, the Princess's Cabinet

KULTURSTIFTUNG DESSAUWÖRLITZ

i Kulturstiftung
DessauWörlitz
Schloss Großkühnau
D-06846 Dessau
Tel. (+49/0) 3 40/6 46 15-0
Fax (+49/0) 3 40/6 46 15-10
www.gartenreich.com
ksdw@ksdw.de

Gotisches Haus
D-06786 Wörlitz
Tel. (+49/0) 3 49 05/2 03 02
Fax (+49/0) 3 49 05/4 09 30

Viewing restricted
to guided tours.
Final tour begins approx.
1 hour before closing.

The Gothic House

From 1773, around the time the neo-classical architecture at Schloss Wörlitz was nearing completion, work began on the Gothic House, proceeding in four phases until 1813 and incorporating various imitation Gothic styles. For the prince this was an illustrative reminder of an idealised bygone age. It was initially intended as a home for the Wörlitz gardener, but extensions enabled the prince to live here himself with his morganatic bride, the gardener's daughter Luise Schoch, and their three children. By contrast to the Schloss, this was to be his private refuge, where he could "live as himself with the world of the past amid his glorious forefathers", as August Rode put it when describing the house in 1818.

The prince was prompted to build his Gothic house by witnessing comparable neo-Gothic structures during his educational travels in England. The 14 rooms, by and large with their original furnishings and fittings, accommodate many treasures, including over 200 works of stained glass dating from around 1500 to the mid-17th century.

The Church Room

The principal room on the upper floor is a product of the first construction phase. It is known as the Church Room because of eight wall paintings depicting famous Gothic churches in Italy, France and England. The appointment heralds a significant new departure, as this is one of the earliest neo-Gothic interior designs anywhere, with mock Gothic tracery elements and grisaille painting against a light brown finish.

Gothic House at Wörlitz, the Church Room

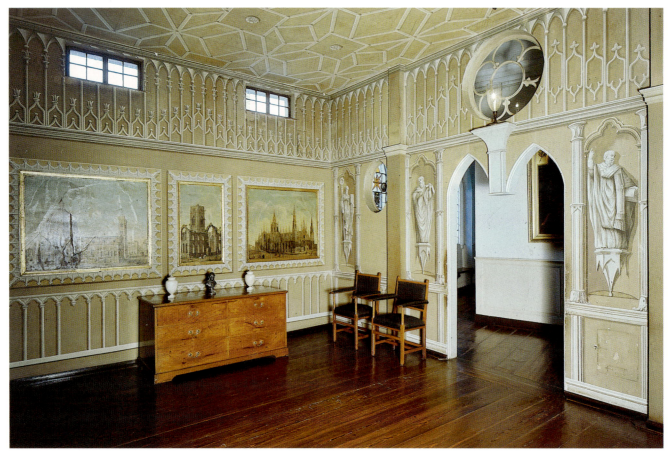

The Military Cabinet

Like the Church Room, the Military Cabinet remains almost unaltered. It was named after the lansquenets portrayed in the ceiling medallions. The original paintings have been almost completely recovered, the exception being a cardinal work, the Prince's Altar by Lucas Cranach the Elder, which was taken to the Anhalt Gallery in Dessau in 1928 along with other items from the Gothic House. One of the splendid display cases has also been preserved. Apart from antiques, it contains some rare varieties of fruit cultivated by 18th-century pomologists and an unusual souvenir from Rome, a marble imitation of the Column of Antonius.

W. S.

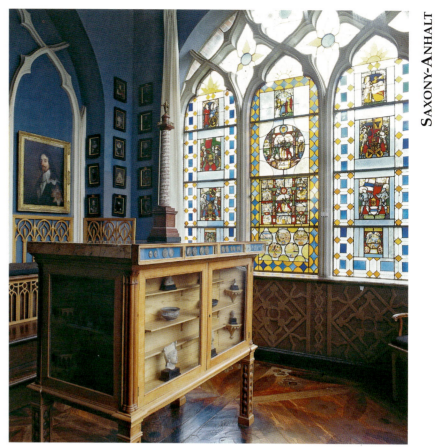

Gothic House at Wörlitz, the Military Cabinet towards the window

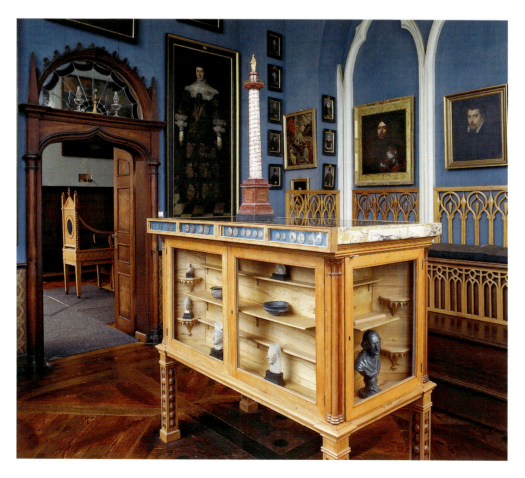

☉ April and October:
Tu–Su 10 am–5 pm
May–September:
Tu–Su 10 am–6 pm
Easter 10 am–5 pm
Open Easter Monday and Whit Monday.
Guided tours outside normal hours by prior arrangement.

Subject to change

🅿 public car park on the edge of the park

Gothic House at Wörlitz, the Military Cabinet towards the Knights' Hall

KULTURSTIFTUNG DESSAUWÖRLITZ

ℹ Kulturstiftung
DessauWörlitz
Schloss Großkühnau
D-06846 Dessau
Tel. (+49/0) 3 40 / 6 46 15-0
Fax 03 40 / 6 46 15-10
www.gartenreich.com
ksdw@ksdw.de

Villa Hamilton auf der
Felseninsel Stein
D-06786 Wörlitz
Tel. (+49/0) 3 49 05 / 4 09-0
(Schloss Wörlitz)
Fax (+49/0) 3 49 05 / 4 09-30
(Schloss Wörlitz)

Viewing restricted
to guided tours.
Final tour begins approx.
1 hour before the last ferry.

☉ Opening from September
2005:
April – October
Tu–Su 10 am–6 pm
Open Easter Monday and
Whit Monday.
Guided tours outside
normal hours by prior
arrangement.

Subject to change

Villa Hamilton
The Fireplace Room

Villa Hamilton was built from 1791 to 1794. The Fireplace Room is the first of three extremely ornate interiors restored with considerable fidelity in a recent major project. The villa was one component in the most curious structure at Wörlitz Park, the artificial island crag known as Stein (stone), an outstanding monument which combines the replica of a volcanic cone with that of an Ancient theatre. On the outside, Villa Hamilton imitates a villa on the shores of the Gulf of Naples which belonged to Sir William Hamilton, English ambassador, Classical scholar and volcano specialist. Its inner furbishing has hitherto resisted full interpretation, but it seems to cast light on Prince Franz's personal Enlightenment philosophy and to convey his thinking by means of his experience and knowledge of Italy, in particular its Classical remains. This could explain the iconography of the painted ceiling of this room.

W. S.

The Fireplace Room in Villa Hamilton on the island of Stein in Wörlitz Park

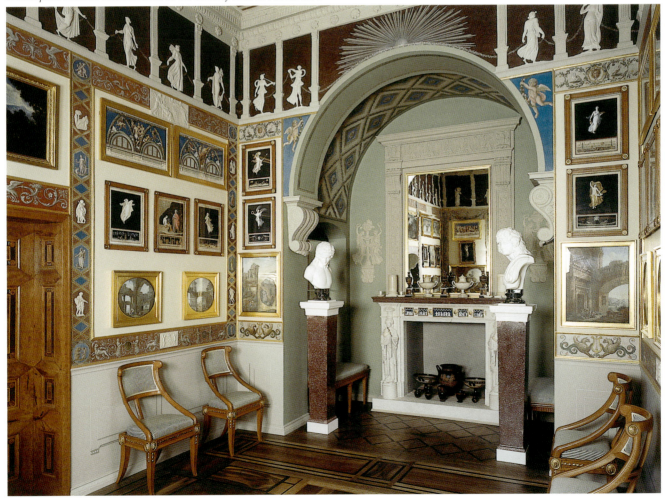

Luisium

The Luisium appears to us today as the most idyllic of the landscaped gardens between Dessau and Wörlitz. The little "neo-classical country house" built on a square plan from 1774 to 1778 is considered the greatest accomplishment of architect Friedrich Wilhelm von Erdmannsdorff by virtue of its clearly harmonious proportions and simplicity. Contemporaries called it "friendly" and "enchanting", praising its "feminine daintiness and niceness". Prince Franz gave the house to his lady consort, Princess Luise Henriette Wilhelmine of Brandenburg and Sweden (1750–1811).

Nine rooms have now been restored to their original splendour. Four are on the main floor, which was used for public functions: the entrance hall, the festive hall, a sideboard room (although its furniture has been lost) and a room used for gaming and dining.

The Festive Hall

The wall and ceiling paintings in the festive hall display allegories based on designs by Erdmannsdorff, with motifs such as the gentle spirit, the pure soul, the taming of desires and the virtue of moderation. This is why Erdmannsdorff called the house a "temple of female virtues".

The first floor *contains six rooms, all for the use of the Princess*. Although the surface area is very modest, this is a typical apart-

ℹ Kulturstiftung
DessauWörlitz
Schloss Großkühnau
D-06846 Dessau
Tel. (+49/0) 3 40 / 6 46 15-0
Fax (+49/0) 3 40 / 6 46 15-10
www.gartenreich.com
ksdw@ksdw.de

ℹ Schloss Luisium
D-06844 Dessau
Tel. (+49/0) 3 40 / 2 18 37 11
Fax (+49/0) 3 40 / 2 18 37 21
Viewing restricted
to guided tours.
Final tour begins approx.
1 hour before closing.

Schloss Luisium, the festive hall

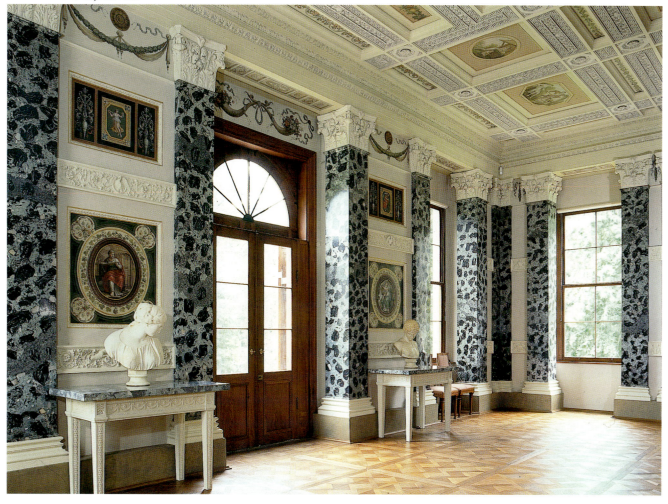

KULTURSTIFTUNG DESSAUWÖRLITZ

⊙ April and October:
Sa, Su, public holidays
10 am–5 pm
May – September:
10 am–6 pm
Easter 10 am–5 pm
Whitsun 10 am–6 pm
Open Easter Monday and
Whit Monday.
Guided tours outside
normal hours by prior
arrangement.

Subject to change

🅿 on the edge of the park

ment for a princess of the *ancien régime*. Climbing the narrow stairs we first reach a cabinet of copper engravings, used as an ante-chamber, in which *"copper engravings are applied even to the doors and ceiling"*. The adjacent cabinet of paintings was a bedroom for ladies-in-waiting, and there follows a room *"clad in red damask"*, the Princess's official bedroom and open to guests. We then enter the *"blue cabinet or library"*, adjoined by a *"cabinet of mirrors, in fact the dressing room…"* Coffee may have been taken in a richly adorned room only accessible from the first ante-chamber.

The Cabinet of Mirrors

Used for the lady's toilette, this cabinet was the only room with a fireplace. In the tradition of the baroque cabinet of mirrors, Ancient vases are displayed in wall consoles. The mirrors, structured like the large windows, reflect the natural world outside. This and the arabesques on the walls and ceiling evoke an arbour, the symbol of rural tranquillity and friendly companionship. W. S.

(quoted from C.U.D. Eggers,
1791 and K. Morgenstern, 1800)

Schloss Luisium, the Cabinet of Mirrors

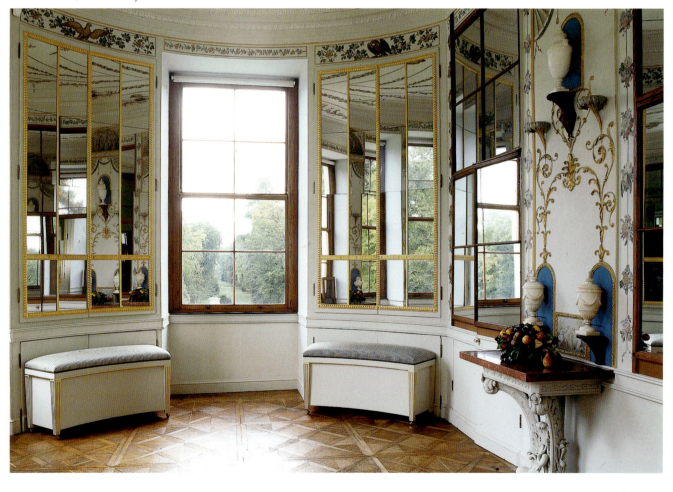

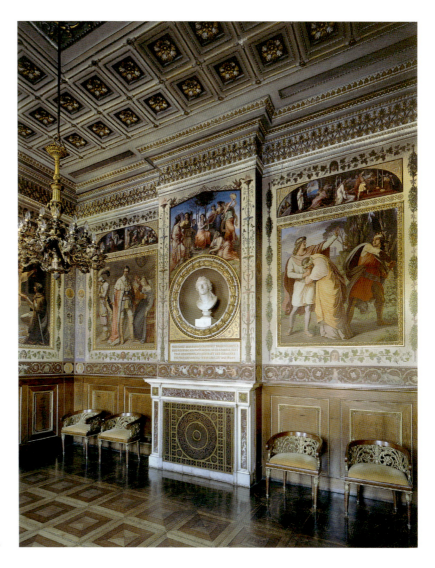

Thuringia

STIFTUNG
THÜRINGER SCHLÖSSER UND GÄRTEN

PALACE, CASTLE AND GARDENS
TRUST OF THURINGIA

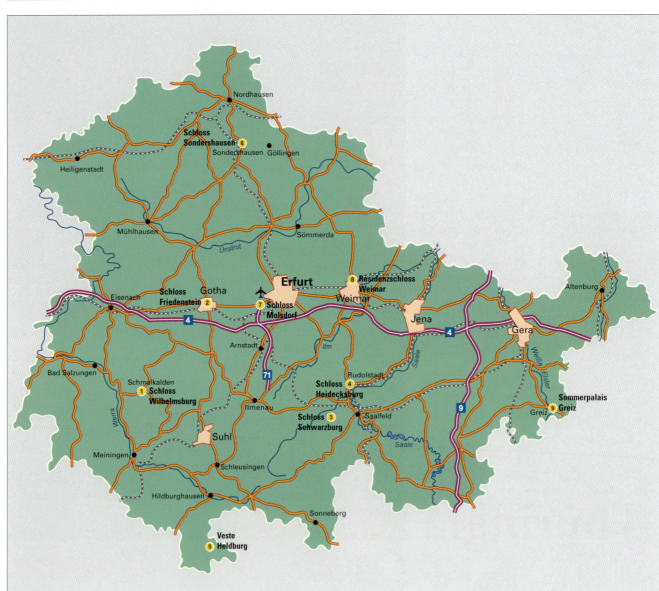

Schmalkalden
 1 Schloss Wilhelmsburg (pp. 231–233)

Gotha
 2 Schloss Friedenstein and Park (pp. 234–236)

Schwarzburg
 3 Schloss Schwarzburg (p. 237)

Rudolstadt
 4 Schloss Heidecksburg (pp. 238–241)

Heldburg
 5 Fort Heldburg (p. 242)

Sondershausen
 6 Schloss Sondershausen and Park (pp. 243–245)

Molsdorf
 7 Schloss Molsdorf and Park (pp. 246–247)

Weimar
 8 Residenzschloss (pp. 248–251)

Greiz
 9 Summer Palace and Park (p. 252)

For information about other sites managed
by Stiftung Thüringer Schlösser und Gärten,
see: www.thueringerschloesser.de

◁ *Residenzschloss Weimar, Schiller Room*

Schloss Wilhelmsburg

Schloss Wilhelmsburg above the town Schmalkalden on the southern rim of the Thuringian Forest is impressively furnished in the style of the Renaissance, when it was built, and the early baroque of subsequent decades. The four-winged complex was begun in 1585 under Wilhelm IV and Moritz as an additional residence for the Hessian landgraves and furbished with wall paintings and stucco work of great quality.

Great Hall or Giant Hall

The Great Hall, also known as the Giant Hall, boasts a large and imposing coffered ceiling containing 90 canvas paintings attributed to Jost vom Hoff. The frames around the doors and windows are richly painted, and most of this work dates from the original Renaissance period. It was later complemented by monochrome baroque painting around the windows and marbling for the walls. Another impressive feature are the larger-than-life portraits of the landrave's personal guards, the *Trabanten*, which flank the portals and the magnificent fireplace on the north wall, which dates from the construction period and was designed by Wilhelm Vernukken.

The Dining Room

The dining room is equally impressive, although it was furnished in three different periods. It was used for meals in a small, essentially family circle, and food motifs in the painting indicate the gastronomic setting. The decorations in the window niches are from the Renaissance. They were soon joined by voluminous baroque allegories of the virtues alongside the windows. The room's history would not be complete without mentioning its brief use as a throne room around 1821, and also the need to replace the ceiling with a copy in the latter half of the 20th century.

ℹ Schlossverwaltung
Schloss Wilhelmsburg
Schlossberg 9
D-98574 Schmalkalden
Tel. (+49/0) 36 83/40 19 76
Fax (+49/0) 36 83/40 86 44

🅰 Museum Schloss
Wilhelmsburg
History exhibitions on the
Schmalkaldic League and
Reformation, Courtly Life
and Arts, Construction and
Functions of the Castle and
Town; temporary
exhibitions of contemporary
art; concerts
Tel. (+49/0) 36 83/40 31 86
Fax (+49/0) 36 83/60 16 82
museum.sm@gmx.de

🕓 April – October:
10 am–6 pm daily
November – March:
Tu–Su 10 am–4 pm
and on public holidays

🅿 5 minutes

🚆 Wernshausen–Zella-Mehlis

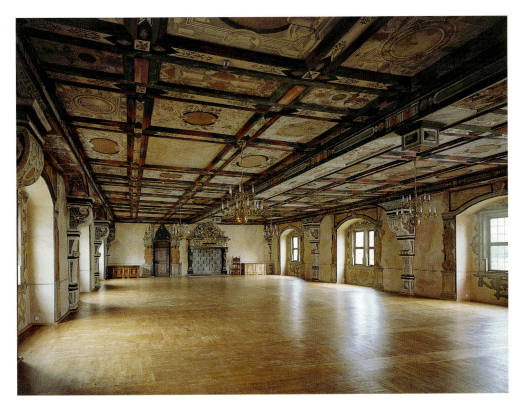

Schloss Wilhelmsburg, Giant Hall

Opposite page:
Schloss Wilhelmsburg,
palace chapel

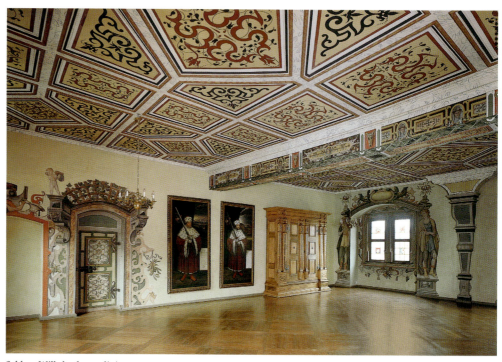

Schloss Wilhelmsburg, dining room

The Palace Chapel

The palace chapel is an interior of particular note, not only because it is one of the major achievements of German Renaissance architecture, but also because it set an early example of Protestant church-building for a courtly context. Like a court chapel it is built on different storeys, and like a Protestant church it focuses clearly on the liturgical elements of altar, pulpit and organ. Although the landgrave's balcony opposite enjoys an excellent position, it is still subordinate to an axis defined by the pulpit and altar. The parapets once displayed a sermon in pictures, a cycle of paintings with Biblical scenes, but this was removed by Calvinist descendants.

Schloss Wilhelmsburg,
Lord's Kitchen

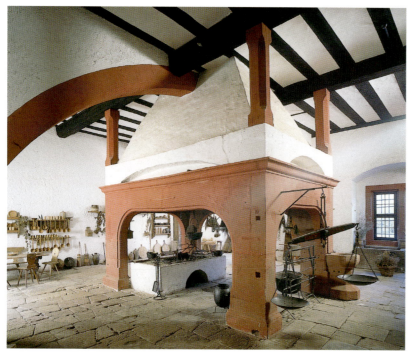

The Lord's Kitchen

On the ground floor of Schloss Wilhelmsburg we find the so-called Lord's Kitchen, where food was prepared for the landgrave's family and their guests. The dominant feature is the hearth open on four sides, an item worthy of any lord with its large dimensions and pleasing proportions. This kitchen is no ancillary room of inferior status, but palpably the place where Lucullean ceremonies were celebrated. Utensils such as the hotplate and spit are subordinate to the chimney, which presides over the room like a canopy.

H. E. P.

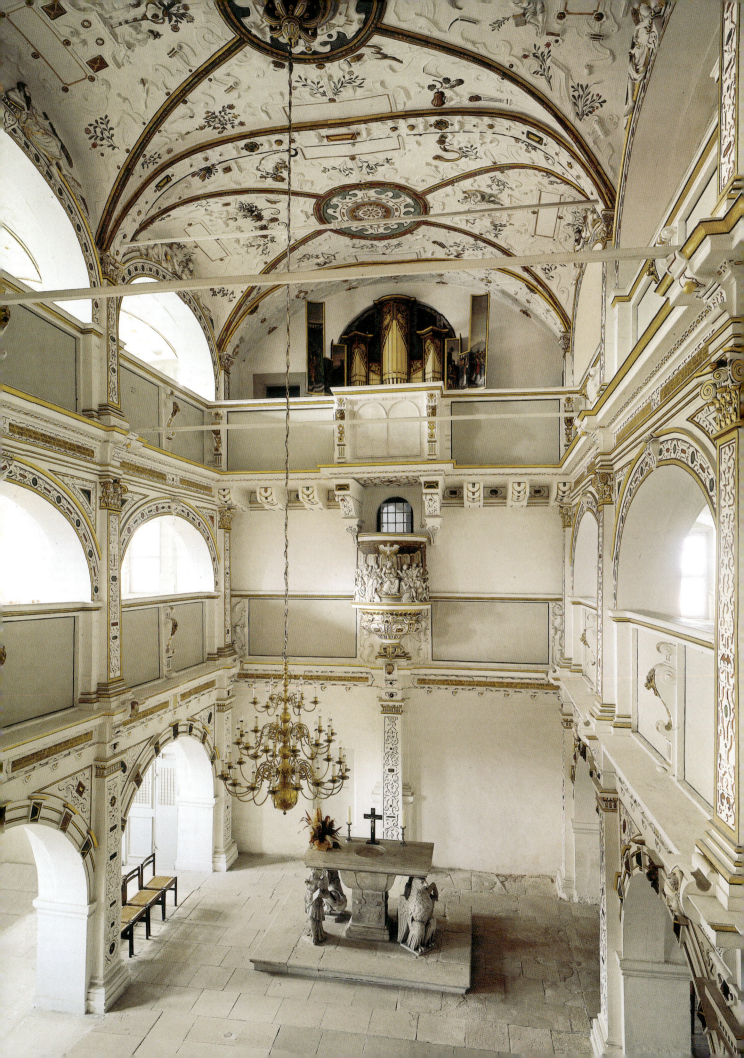

STIFTUNG THÜRINGER SCHLÖSSER UND GÄRTEN

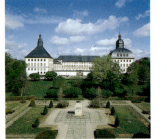

i Schlossverwaltung
Schloss Friedenstein
D-99853 Gotha
Tel. (+49/0) 36 21/82 34 64
Fax (+49/0) 36 21/82 34 65

A Schlossmuseum
Regional History and
Ethnology Museum
with Ekhoftheater
Tel. (+49/0) 36 21/82 34 51
Fax (+49/0) 36 21/82 34 57

Schloss Friedenstein

Schloss Friedenstein in Gotha was built from 1643, just before the end of the Thirty' Years War, and was the first early baroque palace in Germany. Duke Ernst the Pious commissioned an unusually large residence for the period because he wished to accommodate not only the living quarters his own rank demanded, but also all the functions of a court household and regional administration, rooms of state and a church. Various features remain from that time: the symmetric arrangement of the rooms along an axis, access via two grand stairways and continuous galleries skirting the courtyard, the church gallery on the upper floor of the north wing and the Privy Council Room. The duke's living quarters in the north-east corner of the wing were modernised only a few years after construction by Duke Friedrich I and fell prey to larger conversions from 1683.

The Banqueting Hall

The banqueting hall in the north wing was completed by 1696, replacing a much larger hall originally built with the palace. The space which thereby became available was turned into new rooms of state. This hall was used as a throne room and for festive occasions and banqueting. The rich iconography is devoted to the territory and the ascendancy of the Ernestine line with Gotha at its head. The herm pilasters on the walls display coats-of-arms and crests representing domains belonging to Friedrich I. Ancestral portraits in the window jambs draw attention to the noble descent of the major palace

Schloss Friedenstein, Banqueting Hall

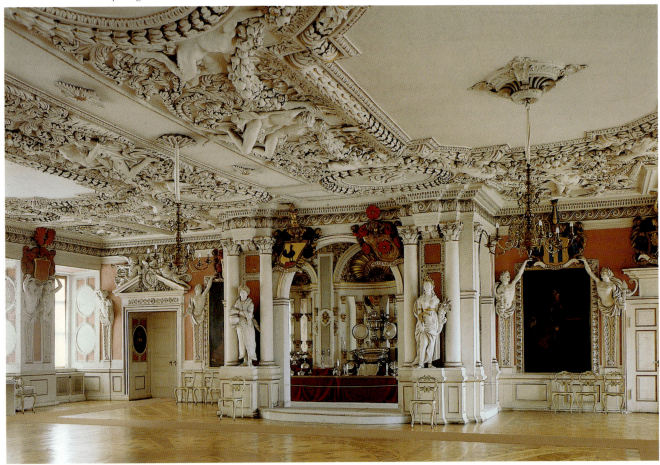

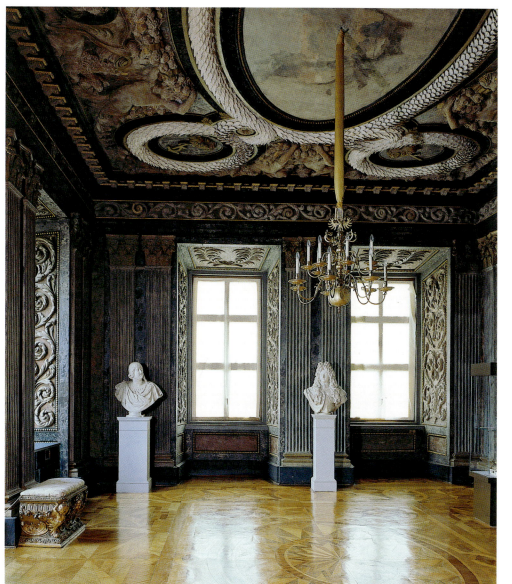

A Nature Museum
Tel. (+49/0) 36 21/82 30 17
Fax (+49/0) 36 21/82 30 20

⊙ May – October:
Tu-Su 10 am–5 pm
November – April:
Tu-Su 10 am–4 pm

✕ restaurant in Pagenhaus

P in town

DB Halle–Erfurt–Eisenach

*Schloss Friedenstein,
Duke's Hall of Audience*

patrons on the end walls. The stucco work, including four larger-than-life allegories of the seasons, is by Samuel and Johann Peter Rust. The silver tableware was once kept in the niches of the columned archways.

The Duke's Hall of Audience

The hall of audience appointed in 1683 in the north-east corner of the north wing was used to receive small diplomatic delegations. The magnificent interior with its trophies and Nike, goddess of victory, over the fireplace symbolised the political power of the ducal dynasty. The principal ornamental features – Corinthian double pilasters, acanthus festoons, garlands of fruit and laurel wreaths – were borrowed from Ancient Rome by the Italian stucco artist Giovanni Caroveri and evenly distributed around the walls and ceiling. This is an early specimen of such homogeneous decoration, for it was still customary in those days for walls to be covered with tapestries and hangings in contrast to the stucco ceilings.

The Duchess's Study

Unlike other Thuringian residences, Schloss Friedenstein does not have many domestic rooms furnished in rococo style. The appointment of the Duchess's study

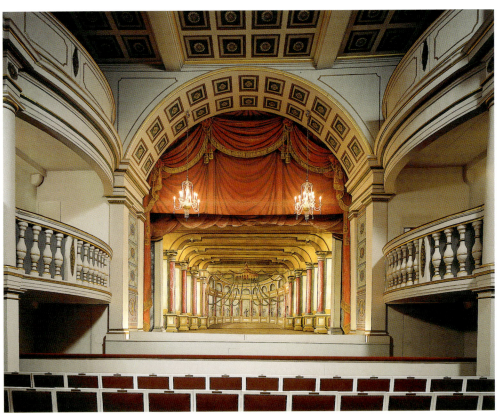

Schloss Friedenstein, Ekhof Theatre

dates from the years when the architect Gottfried Heinrich Krohne was working in Gotha (1747–1751). In contrast to the robust profiles of baroque decoration, we find light curvaceous forms. The ceiling panel is framed in typical rococo fashion by shell work, or "rocaille". The contemporary furniture includes a suite of seating, a desk, a tabernacle bureau, chests of drawers and cupboards. Some of the furniture is from Schloss Friedenstein. The items on the window wall are among the earliest known pieces by Abraham Roentgen, a leading marquetry specialist.

The Ekhof Theatre

One of the world's oldest surviving specimens of theatre technology can be found in the Ekhof Theatre in the west tower at Schloss Friedenstein. The theatre that Caspar Lindemann and Hans Hoffmann began building here in 1681 was one of the first where sets could be changed mechanically during the performance. The theatre is named after one of the greatest 18th-century actors, Conrad Ekhof. He was in the service of Duke Ernst II of Saxe-Gotha-Altenburg from 1774 until his death in 1778, founding the first permanent court theatre of note in Germany.

I. P.

Schloss Friedenstein, Duchess's Study

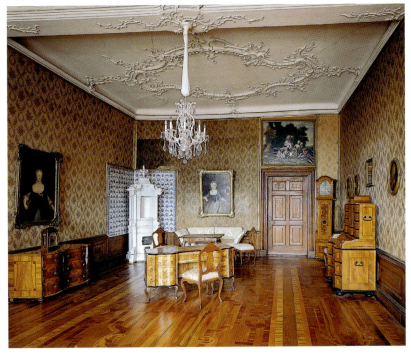

Schloss Schwarzburg

The Imperial Hall was built around 1700 during the construction of an orangery for Schloss Schwarzburg. It was part of a successful campaign by the Schwarzburg counts to be elevated to the Imperial aristocracy.

Ovid's Metamorphoses, a programme befitting the pavilions and orangeries of princes.

H. E. P.

The Imperial Hall and Sala Terrena

The multi-facetted iconography in the Imperial Hall, which drew its daylight from above in 17th-century fashion, is devoted to the achievement in 1710 of princely status for the House of Schwarzburg-Rudolstadt. On the upper surface of the lantern we see the legend of the dynasty's foundation. According to this a Roman legionnaire plunged his lance into the ground where the Schwarzburg now stands, whereupon it sprouted green leaves as a symbol of the dynasty's fertility. Around the sides of the lantern there is a gallery of the Holy Roman Emperors (the centralised power in Germany), among them Günther of Schwarzburg as the elected king and forefather of the Schwarzburg counts. By staging this spectacle in a festive hall of state, the Schwarzburgs hoped to demonstrate that their imperial ancestor made them worthy of elevation to the rank of princes. Meanwhile, in the Sala Terrena beneath, citrus trees were providing a botanical analogy to the miracle depicted in the lantern. They had been imported from the south, but it took all the skill of the orangery gardeners to waken their seemingly dead trunks back to life.

The Prince's Apartment

The prince and princess each had an apartment on opposite sides of the Imperial Hall, playing their own very real roles here in the long family history. The prince's living quarters were in three sections and they have essentially survived as they were. The paintings on the stucco living room ceiling show scenes from

Schloss Schwarzburg, a room in the Prince's Apartment

Schloss Schwarzburg, Imperial Hall

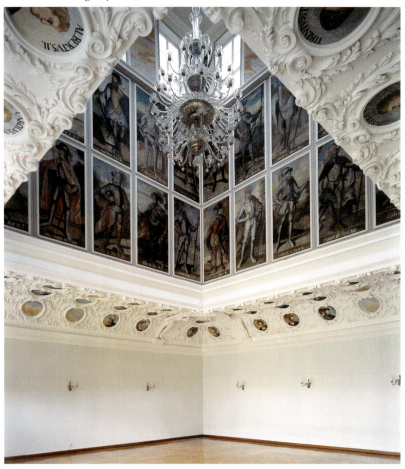

i Schlossverwaltung
Schloss Heidecksburg
D-07407 Rudolstadt
Tel., Fax
(+49/0) 3672/447210

A Imperial Hall at
Schwarzburg with gallery
of Holy Roman Emperors
Tel. (+49/0) 36730/22263
info@schloss-
schwarzburg.de
www.schloss-
schwarzburg.de

⊘ April – October:
10 am–6 pm daily
November – March:
school/public holidays
only 10 am–6 pm

P 600 m

DB Saalfeld–Katzhütte

STIFTUNG THÜRINGER SCHLÖSSER UND GÄRTEN

i Schlossverwaltung
Schloss Heidecksburg
D-07407 Rudolstadt
Tel. / Fax
(+49 / 0) 36 72 / 44 72 10

A Thuringian State Museum
Heidecksburg
Ceremonial halls and
apartments of the
Schwarzburg-Rudolstadt
Princes, Gallery of
Paintings, weapons
collection

Museum of Schwarzburg
history, natural history col-
lection, temporary exhibiti-
ons, palace concerts, guided
tours by prior arrangement
Tel. (+49 / 0) 36 72 / 42 90 10
Fax (+49 / 0) 36 72 / 42 90 90
museum@heidecksburg.de
www.heidecksburg.de

☉ April – October:
Tu-Su 10 am–6 pm
November – March:
Tu-Su 10 am–5 pm

✕ Schlosscafé

P Multi-storey car park on
castle hill, limited parking
outside Schloss

♿ Disabled parking 50 m

DB Nuremberg–Leipzig

Schloss Heidecksburg,
Cabinet of Mirrors

Schloss Heidecksburg

Schloss Heidecksburg, the former seat of the counts and princes of Schwarzburg-Rudolstadt, is one of Thuringia's most notable palaces. Apart from the Cabinet of Mirrors in the south wing, which is older, the finest interiors date from after the great fire of 1735 and are found in the west wing. The event presented an opportunity to build a new palace. After being elevated to princedom in 1710, the incumbents wanted a grander stately backdrop to reflect their greater prestige. Following the fire, work began in 1737 on reconstruction and a new west wing. When Dresden architect Johann Christoph Knöffel was dismissed due to faulty building work, he was replaced by Gottfried Heinrich Krohne, a servant at the court of Weimar.

The Cabinet of Mirrors

Around 1720 the prince followed the fashion of the time and had a cabinet of mirrors installed in the south wing, primarily as a setting for official state business. Wall mirrors make the room appear larger than it is and create an illusion that the precious porcelain has multiplied. Their slight curvature also causes deliberate effects of distortion. The Chinese fashion of the period inspired the painted wallpapers, which alternate with stucco work and mirror niches. The dynasty is symbolised by portraits inset in the walls and by the Schwarzburg coat-of-arms in the exquisite marquetry floor.

The Ballroom

The ballroom in the middle of the west wing was magnificently appointed by Krohne from 1743 to 1750. It exudes a serene dignity, any stiff formality being dispersed by sweeping concave and convex forms. Ornate stucco work by Giovanni Battista Pedrozzi frames the ceiling fresco of 1744 showing the council of gods

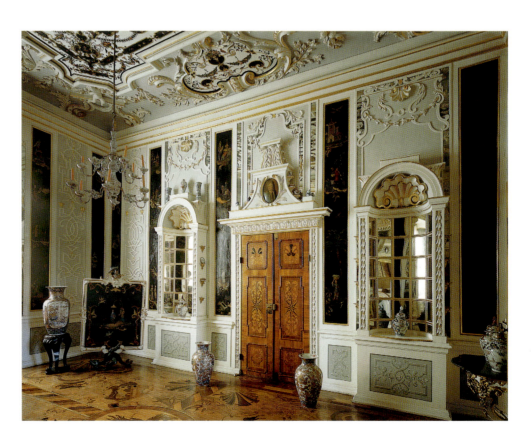

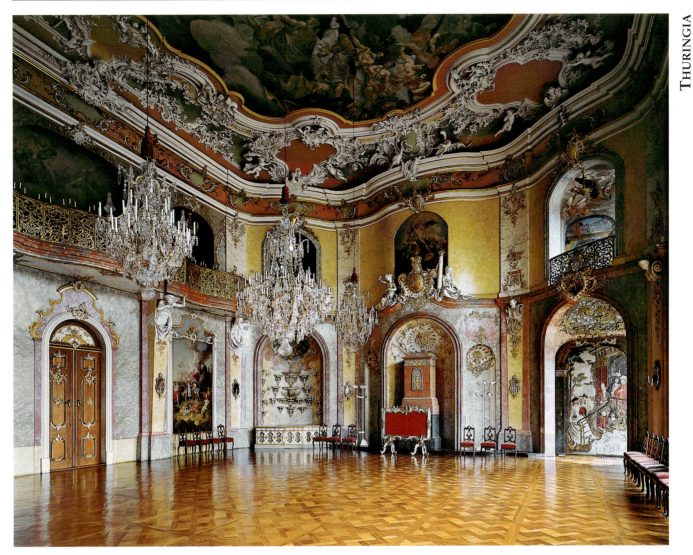

Schloss Heidecksburg, Ballroom

on Olympus. Niches in the corners and on the end walls either grant entrance to the apartments on each side or house the buffets. Parties and concerts were held here, as the musicians' gallery indicates, and there are boxes for courtiers over the niches. The paintings on the shorter walls apotheosise the princes of Schwarzburg-Rudolstadt. Cardinal virtues frame heraldic emblems of the prince and his lady consort.

The Red Apartment

The apartments to the north and south of the ballroom are laid out in the French manner as an "appartement double". Rather than being set out individually,

rooms are clustered to cater for the various needs of court ceremony. The Red Apartment to the south, with its antechamber, red room, red corner cabinet with alcove and cloakroom, was made for Prince Friedrich Anton von Schwarzburg-Rudolstadt. The suite was later used for purposes of state and the prince's guests were accommodated here.

The Red Room

The red room, hung with red damask, served as a hall of audience. Structure is provided by a niche for the stove and a fireplace. The stucco-framed ceiling fresco painted in 1744 shows the "Assembly of Virtues". Four corner cartouches symbol-

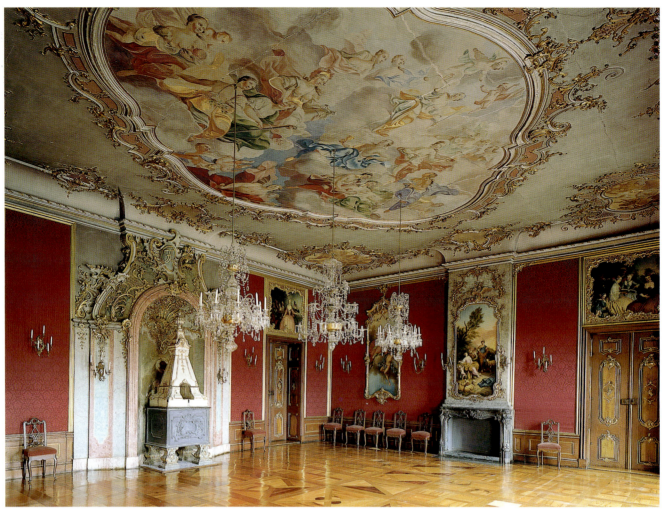

Schloss Heidecksburg, Red Room

Schloss Heidecksburg, Red Corner Cabinet

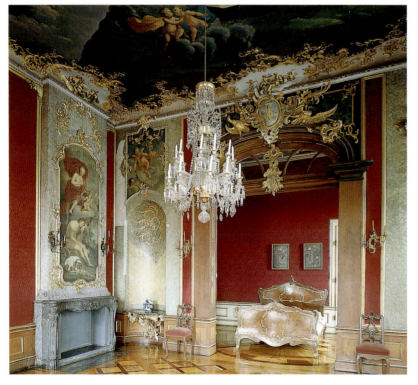

ise the four corners of the Earth. The furbishing also includes paintings over chimney cornices and doors dedicated to the themes of music, dance, theatre and conversation. Two depictions of spring and autumn were originally in the ballroom.

The Red Corner Cabinet and Alcove

Knöffel originally designed the bedroom as a rectangle, but Krohne added a partition wall with an archway. This created a smaller cabinet with an alcove for the bed. The paintings on the ceiling over these contain references to their functions, as do the wall paintings. A veneered desk, wall tables and a fireplace are on display in the cabinet.

The Green Apartment

The Green Apartment contains an ante-chamber, green room, green corner cabinet and cloakroom. The ante-chamber was not included in the original layout. These green rooms to the north of the ballroom were appointed from 1750 for Princess Bernhardine Christine Sophie. The corner cabinet and alcove were available to guests from 1793.

The Green Room

This room functioned as a hall of audience and also a dining and gaming room. Moderate gilt stucco adorns the ceiling instead of a painting. The ornamental pattern is echoed on panelled surfaces in shades of green. This wooden panelling, a novel feature, was considered more in keeping with the times and also more durable. On the narrower walls we see life-size portraits of the prince and princess. The overdoors symbolise literature, astronomy, religion, painting and music declare the prince's Enlightenment principles. This room was sparsely furnished. The four candelabras, inventoried in 1751, were brought here in the 19th century. S. R.

Schloss Heidecksburg, Green Room

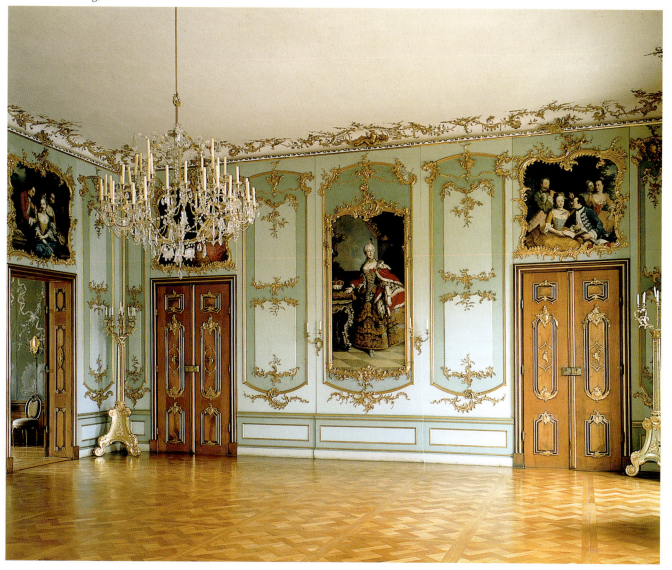

STIFTUNG THÜRINGER SCHLÖSSER UND GÄRTEN

i Schlossverwaltung
Veste Heldburg
Burgstraße 215
D-98663 Heldburg
Tel. (+49/0) 3 68 71 / 3 03 30
Fax (+49/0) 3 68 71 / 3 04 87

A Exhibition by Förderverein
Veste Heldburg on the
history of the fortress and
its construction, panoramic
tower, lady's bowers,
display of historical
furnishing
Tel. (+49/0) 3 68 71 / 2 12 10
Fax (+49/0) 3 68 71 / 2 01 99
veste@bad-colberg-
heldburg.de
www.bad-colberg-
heldburg.de

🕐 April – October:
Tu-Su 10 am–6 pm
November – March:
Tu-Su 10 am–4 pm
Admission ceases half
an hour before closing time
Guided tours by
arrangement

P 800 m

♿ Disabled parking 100 m

DB Hildburghausen–Heldburg

Fort Heldburg

Fort Heldburg, also known as the "Franconian Beacon", boasts an outstanding panoramic view. The fort experienced its heyday in the 16th century under Duke Johann Friedrich II, who entrusted the Saxon court architect Nikol Gromann with building the French Wing. In 1874 the "theatre duke" Georg II of Saxe-Meiningen had the castle developed into a summer residence and living quarters for himself and his third wife, the actress Ellen Franz and future Baroness Heldburg. Before the devastating fire in 1982 the fort was regarded as "a model example of romantic castle nostalgia in the late 19th century".

The Lady's Bowers

The room and side room on the second floor of the Commander's Wing, known as the Lady's Bowers, were built during Historicist extensions from 1887 to 1900. The plans were drawn up by Emanuel La Roche, an interior designer from Basle, but the owners exerted a considerable personal influence. The neo-Gothic room served Baroness Heldburg as a drawing room, where she received well-known artists and musicians. In 1951 the original furniture and fittings were removed, but in 1993 the furniture was replaced by similar items. The side room still has the original display cases for silver wedding gifts received by the duke and his wife in 1898.

S.R.

Fort Heldburg, Lady's Bowers

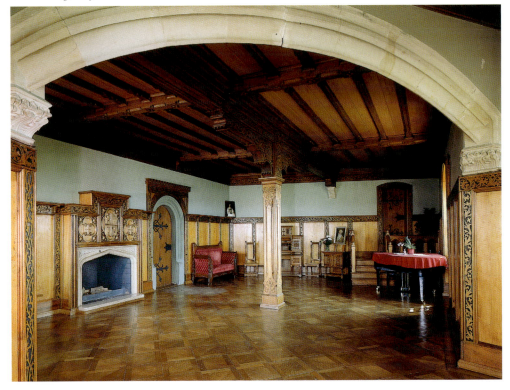

Schloss Sondershausen

As a specimen of architectural and art history, Schloss Sondershausen, once the residence of the princes of Schwarzburg-Sondershausen, is the most interesting palace complex in Northern Thuringia. Both the external structure and the interiors reflect a diversity of stylistic eras which can hardly be matched in the region.

The Vaulting by the Spiral Stairs

The vaulting by the spiral stairs, constructed around 1616 in the oldest section of the palace, is a unique example of mannerism. This superb space is lavishly decorated with auricular stucco. The allegorical and mythological iconography of the ceiling and the portrait of a noble patron over the fireplace suggest that this was once used as a study. There is no basis, however, for a recent theory that an apothecary must have worked here because of references to alchemy in the stucco work. The oaken wall panelling dates from the early 20th century.

The Hall of Giants

The Hall of Giants was installed from 1695 during baroque conversions to the southerly Renaissance wing. The iconography includes 16 huge statues of Ancient gods and over 20 mythological scenes on the ceiling. Nicola Carcani's workshop supplied the stucco work. The festive hall extends the full length of the wing, but is surprisingly low. In this it resembles the ballroom for Schloss Friedenstein in Gotha, created around the same time. The explanation is that both rooms were incorporated into existing structures. This hall was built by Count Christian Wilhelm of Schwarzburg-Sondershausen to celebrate his elevation to princely status in 1697.

The Blue Room

Schloss Sondershausen is unusually endowed with a second festive hall. The Blue Room on the first floor of the west wing was appointed in rococo style around 1770 while the old palace was

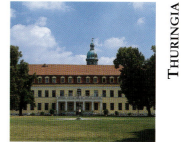

i Schlossverwaltung
Schloss Sondershausen
D-99706 Sondershausen
Tel. (+49/0) 36 32/66 30
Fax (+49/0) 36 32/66 31 04

A Schlossmuseum
Exhibition of original
interiors from Renaissance
to Historicist, regional
history, history of music,
Schwarzburg Portrait
Gallery, temporary
exhibitions
Tel. (+49/0) 36 32/66 31 20
Fax (+49/0) 36 32/66 31 10
schlossmuseum.sdh@
t-online.de
www.schlossmuseum.
sondershausen.de

☉ April – September:
Tu-Su 10 am–5 pm
October – March:
Tu-Su 10 am–4 pm
Guided tours daily at
10 am and 2 pm
Special tours by prior
arrangement

✗ Schlossrestaurant

P Two car parks and multi-
storey Parkhaus Galerie
on hill within 50–300 m

DB Erfurt–Nordhausen

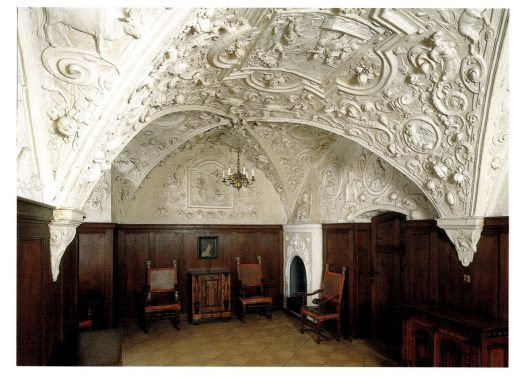

*Schloss Sondershausen,
vaulting by the spiral stairs*

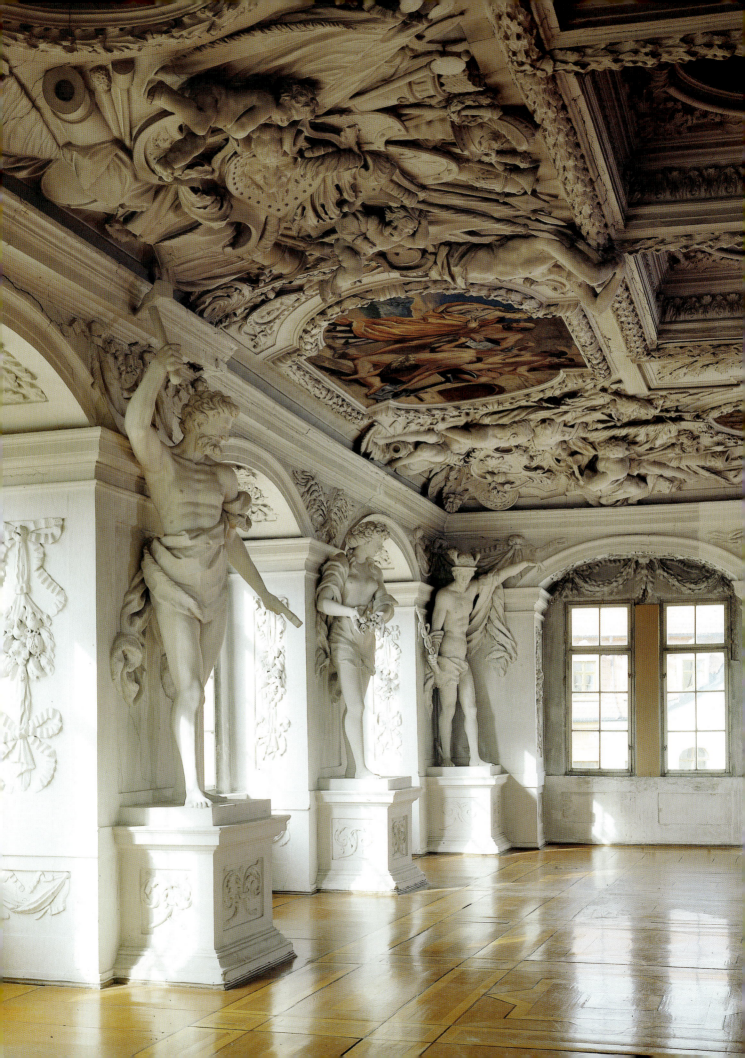

being extended into an irregular four-winged complex. Initially designed as a throne room between the two apartments for the lord and lady, this is the only interior to have survived neo-classical conversions in the west wing. The scene from the Callisto myth on the ceiling is a reference to Prince Christian Günther III's marital alliance with Charlotte Wilhelmine of Anhalt-Bernburg. The room is finished in blue and white, the heraldic colours of the territory.

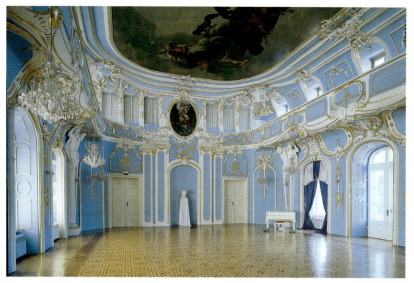

Schloss Sondershausen, Blue Room

The Octagon

The temple of Muses on an octagonal plan was built to the south-west of the palace in about 1709 as a terminal focus for the baroque pleasure garden. It offered a home to Venus, goddess of love and patron of gardens, and a musical venue to members of court. These functions essentially determine its appearance. The park exerts a strong presence through the numerous, regularly arranged windows. The building's character as a temple is reinforced by its octagonal shape with eight Corinthian columns and a large painting of gods on the ceiling. The floor originally rotated, enabling ladies-in-waiting on toy horses to amuse themselves catching hoops. During those baroque years roundabouts like this were set up in other gardens, such as Pillnitz, Ludwigsburg and Hanau-Wilhelmsbad. The recently restored Octagon is now one of the finest attractions at Schloss Sondershausen.

I. P.

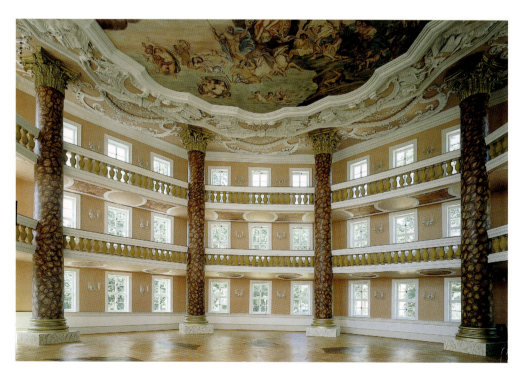

Opposite page:
Schloss Sondershausen,
Hall of Giants

Schloss Sondershausen, Octagon

ℹ Schlossverwaltung
Schloss Molsdorf
Schlossplatz 6
D-99192 Molsdorf
Tel. (+49/0) 362 02/2 20 85
Fax (+49/0) 362 02/2 20 84

🏛 Schlossmuseum
Exhibition of interior
decoration and furnishings,
temporary exhibitions
Tel. (+49/0) 362 02/9 02 05
Fax (+49/0) 362 02/2 20 84

🕐 Tu–Su 10 am–6 pm
Guided tours on the hour
and by arrangement

🅿 50 m

🚌 Local bus service
Erfurt–Molsdorf

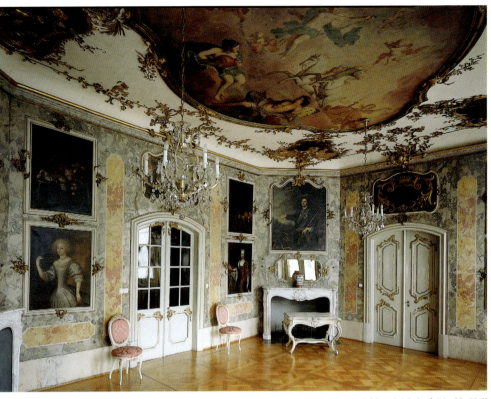

Schloss Molsdorf, Marble Hall

Schloss Molsdorf

Schloss Molsdorf south of Erfurt was transformed from a moated castle into a stately country seat when its owner, Gustav Adolph von Gotter, was knighted. For this project, which he began in 1734, Gotter was able to draw on his excellent contacts at court, recruiting Thuringia's leading baroque architect Gottfried Heinrich Krohne, the Prussian court painter Antoine Pesne, the painters Johann Kupetzky and Jacob Samuel Beck and the stucco artist Johann Baptist Pedrozzi. Their collective efforts resulted in one of the most beautiful baroque palaces in Thuringia, and it remained unaltered until the early 20th century.

The Marble Hall

The rooms at Schloss Molsdorf have been arranged in a very private manner, and the Marble Hall at the centre of the south wing was used for receptions. It also provided access to the adjoining rooms. It derives its name from the contemporary fashion for finishing interiors in pale grey stuccolustro. The ceiling fresco attributed to Antoine Pesne, where the goddess Aurora heralds the dawn, wishes visitors a sunny, carefree stay. Pesne painted the same theme in about 1740 on the ballroom ceiling at Schloss Rheinsberg for the future Friedrich the Great. Friedrich was still crown prince and the painting symbolised hopes of a golden reign. For a former commoner to select such a regal motif for his own stately home indicates considerable self-confidence on Gotter's part.

The Banqueting Hall

This festive hall in the south-west corner of the palace doubled as a dining room. To create a warmer atmosphere Gotter had the walls fitted with wood panelling in contravention of early 18th-century fashion. 33 portraits of Gotter's patrons are inset in these panels, testifying to his secure position at court. This uncustomary iconography replaced the ancestral galleries used by noble dynasties to parade their history, skilfully touching over Gotter's bourgeois origins.

The Marble Bathroom

Around 1910 the Countess of Gneisenau replaced an older and simpler bathroom with a neo-classical marble interior combined with elements of art nouveau. It is one of the few private luxury bathrooms to have survived in central Germany, but it illustrates how wealthy households lived in the early 20th century. The company that carried out the task, Saalecker Werkstätten, was founded by the architect Paul Schultze-Naumburg. He presumably produced the plans for this work.

I.P.

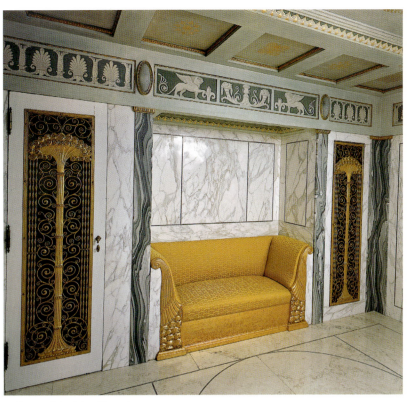

Schloss Molsdorf, Marble Bathroom

Schloss Molsdorf, Banqueting Hall

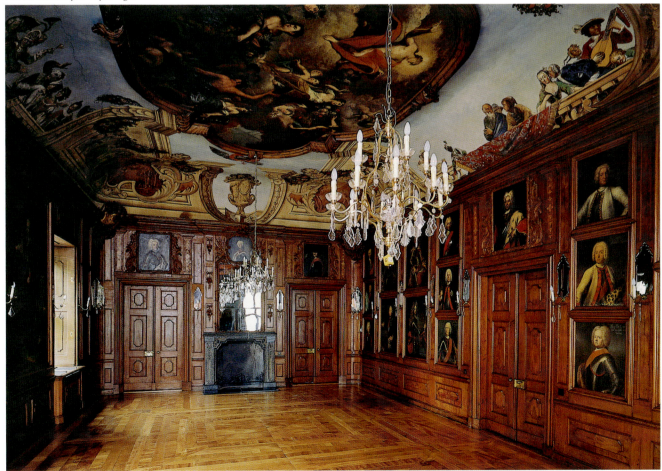

i Schlossverwaltung
Residenzschloss Weimar
Burgplatz 4
D-99423 Weimar
Tel. (+49/0) 36 43/54 59 81
Fax (+49/0) 36 43/54 59 02

A Schlossmuseum
Art gallery and ceremonial
halls, temporary
exhibitions, guided tours
by arrangement
Tel. (+49/0) 36 43/54 59 60
kommunikation@swkk.de
www.swkk.de

☉ April – October:
Tu–Su 11 am–6 pm
November – March:
Tu–Su 11 am–4 pm

P outside the Schloss

DB Leipzig–Erfurt
Jena–Erfurt

Residenzschloss Weimar

The palace in Weimar was once the principal residence of the Ernestine line of the House of Wettin in their Thuringian territories. The building we know today was built by several architects, supervised by Johann Wolfgang von Goethe, after a fire in 1774. Among these, Nicolaus Friedrich Thouret (from 1798) and notably Heinrich Gentz (from 1800) created some of the finest neo-classical interiors in Germany.

The Gentz Stairs

The palace was entered via a grand stairway in the east wing. Heinrich Gentz completed the work begun by Johann August Arens, placing a white hall of Doric columns inspired by Athenian propyla in front of the bel étage. The iconography applied to the stairwell by Friedrich Tieck reflects Goethe's ideal of the enlightened state, governed by freedom for the arts, the protection of citizens and universal prosperity.

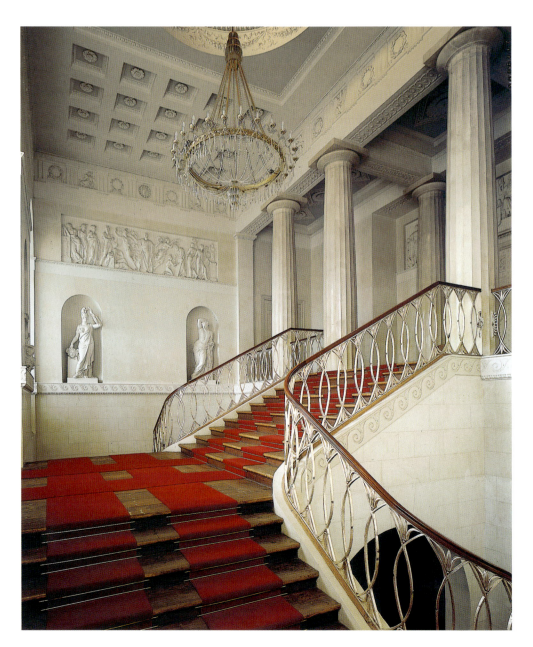

*Weimar Residenzschloss,
Gentz Stairs*

The Ballroom

Visitors reached the ballroom from the entrée and dining room. As a hall of Ionic columns it would have been seen in the architectural thinking of the period as a nobler interior than the Doric stairway, in keeping with its stately function. At Goethe's instigation, the perimeter gallery revives a motif from the baroque hall destroyed in the fire. The orchestra may have played here at the ball. Figurative ornament is confined to a few statues and a frieze in bas-relief. It draws on Egyptian and Roman prototypes and includes casts of two well known Ancient sculptural formations: the twins Castor and Pollux, and Caunos and Byblis. They are flanked by four statues of Muses by Friedrich Tieck. The ceiling was designed by Thouret but implemented by Gentz.

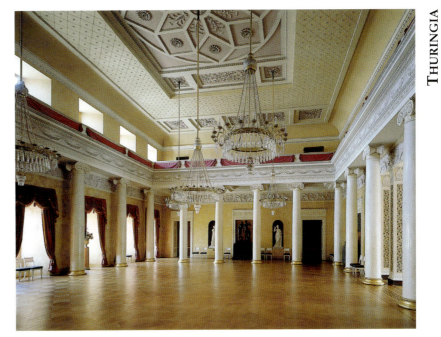

Weimar Residenzschloss, Ballroom

The Hall of Mirrors

One of the most striking interiors in the Weimar residence is the Hall of Mirrors, flooded in daylight and with rich polychrome decoration. It is entered through a passage in the east wall of the ball-room, offering an opportunity to withdraw from the festivities. The walls are organised by delicate pilasters with grapevine insets and capitals of bushy papyrus. Linking these capitals, a frieze with garlands of fruit and masks of

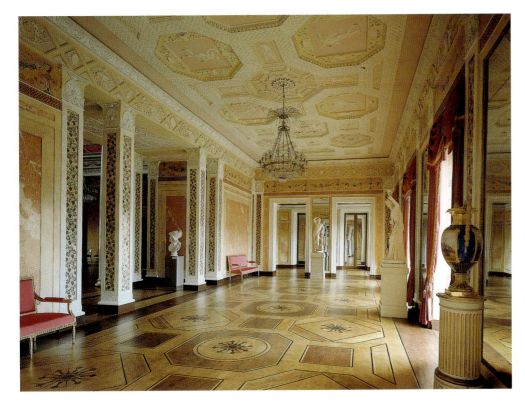

*Weimar Residenzschloss,
Hall of Mirrors*

satyrs and maenads draws on Roman predecessors. The ceiling quotes a specimen of stucco work dating from the 2nd century A.D. discovered in 1785. The basic patterns found in the ceiling are echoed in the parquet floor.

The Cedar Room

The only interior designed by Heinrich Gentz that has remained untouched is the drawing room for Maria Pavlovna, the tsar's daughter married to Crown Prince Carl Friedrich. It is named after the cedarwood wall panelling. Stuccolustro, mirrors, sculptured relief and paintings all play their part in decoration which is remarkable lavish for Gentz and covers the surfaces completely. The imagery reflects the room's function: it was here that the princess devoted herself to art, literature and discussion. Paintings of the Muses adorn the ceiling. Eight mythical scenes in stucco relief address the virtues and the destiny of a tsar's daughter living abroad. Hand-coloured copper engravings on a pitch-black background display small-scale copies of Ancient wall paintings and twelve personifications of the hours, whose invention is attributed to Raphael.

The Poets' Rooms

From 1834 to 1848, at Maria Pavlovna's behest, rooms on the south side of the new west wings were devoted to the memory of Goethe, Schiller, Wieland and Herder. Ludwig Schorn was the thematic and artistic director, and Karl Friedrich Schinkel designed the Goethe Gallery. Unlike the older neo-classical rooms, these are hung with large Historicist paintings depicting exemplary situations from the writers' works. Each writer is represented by a bust, linking this homage to their literary oeuvre with a personal tribute. It was the first time a palace had implemented a programme of this kind, but to achieve its aims it required an audience, and so these rooms were open to the public.

I. P.

Opposite page:
Weimar Residenzschloss,
Wieland Room

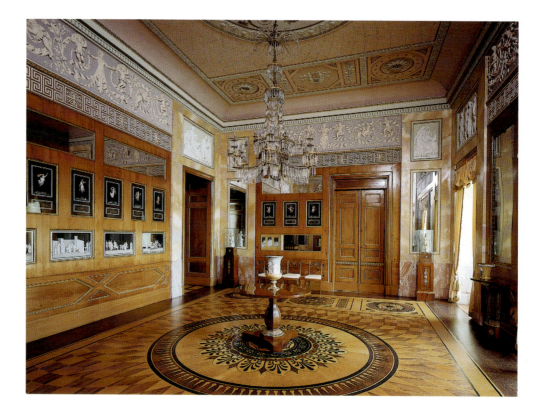

Weimar Residenzschloss,
Cedar Room

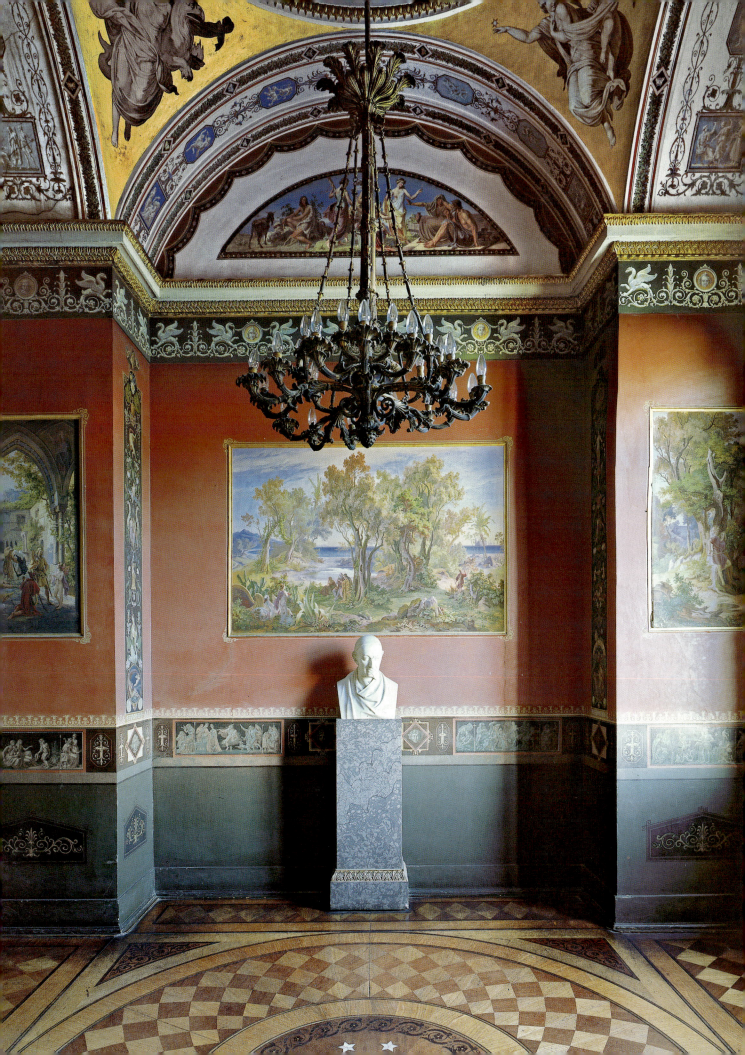

i Schlossverwaltung
Sommerpalais Greiz
Postfach 1146
D-07961 Greiz
Tel. (+49/0) 36 61/70 58 19
Fax (+49/0) 36 61/70 58 25

A State Collection of Books
and Copper Engravings
with Satiricum
Tel. (+49/0) 36 61/70 05 80
Fax (+49/0) 36 61/70 58 25
sommerpalais.info@
greiz.encotel.de

⊙ April – September:
Tu–Su 10 am–5 pm
October–March:
Tu–Su 10 am–4 pm
Open Easter Monday and
Whit Monday; closed
24/25, 31 December
and 1 January
Guided tours by
arrangement

Greizer Park
Tel. (+49/0) 36 61/70 35 10
Fax (+49/0) 36 61/70 35 98

Guided tours by
arrangement,
unrestricted access

✕ Café in Küchenhaus

🅿 300 m

Ⓓ Gera–Weischlitz

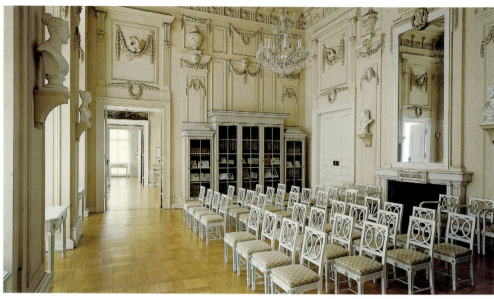

Greiz Summer Palace, Festive Hall

The Summer Palace

Heinrich XI of Reuss built the summer palace at Greiz when, in 1768, the Lower Greiz estates were left without an heir and Greiz was reunited under the Older Line. The significance of this event became clear ten years later, when Heinrich became a prince of the Empire. He called this cross between an orangery pavilion and a suburban villa his "maison de belle retraite".

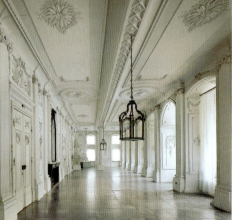

*Greiz Summer Palace,
Garden Room*

The Garden Room

And to ensure that he could retreat from the bustle of court, his apartment was hidden away behind a mock orangery façade. The reception area was not a stairway and vestibule, but a big garden room where plants were kept warm in winter. The fine "white" stucco appointment we see today was carried out in 1779 by Adam Rudolph Albini and Anton Pach. The early neo-classical changes marked Heinrich's princely elevation in 1778.

The Festive Hall

In terms of both architecture and interior design, the festive hall embedded in the first floor enfilade is the highlight of the prince's apartment. Raised by a mezzanine, it acquired its elegant Louis XVI stucco work in 1769.

H. E. P.

Source of illustrations:
Stiftung Thüringer Schlösser und Gärten, Constantin Beyer: p. 8, 229, 231, 232, 233, 234, 235, 236, 237 centre, 238 bottom, 239, 240, 241, 242, 243, 244, 245, 246 right, 247, 248, 249, 250, 251, 252
Stiftung Thüringer Schlösser und Gärten, Roland Dressler: 237 bottom
Stiftung Thüringer Schlösser und Gärten, Helmut Wiegel: 237 top, 238 top, 243, top, 246 left

Baden-Württemberg
Betrieb Vermögen und Bau
Staatliche Schlösser und Gärten
Baden-Württemberg
Rote-Bühl-Platz 30
D-70178 Stuttgart
Tel. (+49/0) 7 11 / 66 73-0
Fax (+49/0) 7 11 / 66 73-35 34

Office: Bruchsal
Schlossraum 22a
D-76646 Bruchsal
Tel. (+49/0) 72 51 / 74-0
Fax (+49/0) 72 51 / 74-27 40
www.schloesser-und-gaerten.de

Bavaria
Bayerische Verwaltung der staatlichen
Schlösser, Gärten und Seen
Schloss Nymphenburg
D-80638 München
Tel. (+49/0) 89 / 1 79 08-0
Fax (+49/0) 89 / 1 79 08-154
www.schloesser.bayern.de
info@bsv.bayern.de

Berlin-Brandenburg
Stiftung Preußische Schlösser und
Gärten Berlin-Brandenburg
Allee nach Sanssouci 5
D-14471 Potsdam
Tel. (+49/0) 3 31 / 96 94-200 / -201
Fax (+49/0) 3 31 / 96 94-107
www.spsg.de
besucherzentrum@spsg.de

Hesse
Verwaltung der Staatlichen Schlösser
und Gärten Hessen
Schloss
D-61348 Bad Homburg v.d. Höhe
Tel. (+49/0) 61 72 / 92 62-0
Fax (+49/0) 61 72 / 92 62-190
www.schloesser-hessen.de
info@schloesser.hessen.de

Mecklenburg-Western Pomerania
Verwaltung der staatlichen Schlösser und
Gärten im Betrieb für Bau und Liegen-
schaften Mecklenburg-Vorpommern
Werderstr. 4
D-19055 Schwerin
Tel. (+49/0) 3 85 / 5 09-0
Fax (+49/0) 3 85 / 5 09-124
www.mv-schloesser.de
info@mv-schloesser.de

Rhineland-Palatinate
Burgen, Schlösser, Altertümer
Rheinland-Pfalz
Festung Ehrenbreitstein
D-56077 Koblenz
Tel. (+49/0) 2 61 / 66 75-0
Fax (+49/0) 2 61 / 66 75-41 14
www.burgen-rlp.de

Saxony
Staatliche Schlösser, Burgen und Gärten
Sachsen
Stauffenbergallee 2
D-01099 Dresden
Tel. (+49/0) 3 51 / 8 27-0
Fax (+49/0) 3 51 / 8 27-46 02
www.schloesser.sachsen.de

Saxony-Anhalt
Kulturstiftung DessauWörlitz
Schloss Großkühnau
D-06846 Dessau
Tel. (+49/0) 3 40 / 6 46 15-0
Fax (+49/0) 3 40 / 6 46 15-10
www.ksdw.de
ksdw@ksdw.de

Stiftung Dome und Schlösser in
Sachsen-Anhalt
Schloss Leitzkau
D-39279 Leitzkau
Tel. (+49/0) 3 92 41 / 9 34-30
Fax (+49/0) 3 92 41 / 9 34 -34
www.dome-schloesser.de
leitzkau@dome-schloesser.de

Thuringia
Stiftung Thüringer Schlösser und Gärten
Schloss Heidecksburg
D-07407 Rudolstadt
Tel. (+49/0) 36 72 / 4 47-0
Fax (+49/0) 36 72 / 4 47-119
www.thueringerschloesser.de

INDEX